BRIEFKAART

(CARTE POSTALE)

Algemeene Postvereeniging

WITHDRAWN

AMSTERDAM
-8. 1.08.11-12N

Désirez-vous échanger des cartes postales avec la Hollande. ci - oui je suis toute à votre disposition. salutations

(Desverkiezende in te vullen.) (Indications facultatives.)

Afzender: (Expéditeur:)

naam.
(nom.)

POSTCARDS

POSTCARDS

ephemeral histories

of modernity

Edited by David Prochaska and Jordana Mendelson

THE PENNSYLVANIA STATE UNIVERSITY PRESS

UNIVERSITY PARK, PENNSYLVANIA

Published with the assistance of the Getty Foundation.

The editors would like to acknowledge the generous support they received from the
University of Illinois at Urbana-Champaign, which funded through its Faculty Research Board
the preparation of this volume. Central to bringing this volume to print was the
expert assistance the editors received, at various stages in the project, from their research
assistants, Charlotte Bauer and Miriam Kienle.

Chapter 1 was formerly published as Naomi Schor, "*Cartes Postales:* Representing Paris 1900,"
Critical Inquiry 18, no. 2 (1992): 188–244, reprinted with permission.

In chapter 10, the facsimile of Paul Éluard, "Les plus belles cartes postales," *Minotaure* 3–4
(Dec. 1933): 85–100, is copyright Paul Éluard's Estate. All rights reserved.

In chapter 11, the facsimile of Walker Evans, "Main Street Looking North from Courthouse
Square," *Fortune* 37 (May 1948): 102–6, is copyright Walker Evans Archive,
The Metropolitan Museum of Art.

Library of Congress Cataloging-in-Publication Data

Prochaska, David.
 Postcards : ephemeral histories of modernity / David Prochaska and Jordana Mendelson.
 p. cm. —(Refiguring modernism)
Includes bibliographical references and index.
Summary: "Examines postcards as images that are carriers of text, and textual
correspondence that circulate images across boundaries of class, gender, nationality and race.
Discusses issues concerning the concrete practices of production, consumption, collection
and appropriation"—Provided by publisher.
ISBN 978-0-271-03528-4 (pbk. : alk. paper)
1. Postcards.
2. Visual communication—Social aspects.
I. Mendelson, Jordana.
II. Title.

NC1872.P76 2010
741.6'83—dc22
2009021961

The Pennsylvania State University Press is a member of the Association of
American University Presses.

CONTENTS

ILLUSTRATIONS

*Jordana Mendelson and
David Prochaska*

Postcards have taken on a leading role within the larger move toward a consideration of visual culture in interdisciplinary research. As images that are carriers of text, and textual correspondence that brings images across boundaries of class, gender, nationality, and race, postcards are artifacts that provoke questions of discipline and subjectivity, especially as these relate to concrete practices of production, consumption, collection, and appropriation. Postcards provoke scholars to examine complex relations among subjects, producers, senders, and receivers, and to bring into question notions of authority, originality, class, gender, and power. By investigating these ephemeral pieces of visual culture, we confront deep-seated prejudices about forms of representation, the way they function, and our manner of reconstructing their history. Ultimately, the studies in this book raise questions about canon formation and the academy in order to closely examine material histories that compose, even as they challenge, bodies of knowledge.

Postcards form a constitutive part of the way in which the business of art, commerce, history, and identity is negotiated on a daily basis. In this volume we present significant work being done on these objects and take stock of some of the scholars and artists who have made postcard studies an integral part of their historical and theoretical investigations. Despite the range of scholarship and the rigor with which the contributors interpret the visual and textual content of postcards, it was not so long ago that researchers in the humanities, arts, and social sciences left the study of postcards, deltiology, pretty much to deltiologists. Professional dealers bought and sold postcards, sometimes in shops, often at flea markets. Amateur collectors bought and traded postcards. The leading journals in the field were primarily price guides; many of the important book publications included prices and tips on collecting. Postcards and postcard collecting were decidedly antiquarian pursuits. While photography underwent a shift in the early twentieth century, wherein selected photographs were reclassified as art and hung on museum walls for public delectation,[1] the academy and fine art museums held firm against the postcard. For the most part, postcards found their home in private collections, local historical museums, and libraries.

About twenty-five years ago, things began to change. On the one hand, book compilations of early postcards increasingly began to appear. Historical nostalgia combined with inexpensive collectibles to make original postcards and reproductions of them widely available. Soon prices for old postcards soared, pricing low-end buyers out of the

market and replicating a market-driven process that brings otherwise forgotten mass cultural forms to the attention of elite collectors and institutions. On the other hand, visual culture broadened the study of visual artifacts, including postcards, from images per se to the more densely woven context of their production and reception. Previously, a more traditional art history had regarded postcards as degraded images, as so many pieces of cultural detritus, literally ephemeral. This notion is rooted in the technological conditions and division of labor characteristic of postcard production; it sees the work of the reporter-photographer and artist-photographer as inferior to and as compromised by the work of the retoucher in manipulating the image (airbrushing) and otherwise "faking" it. Now the study of visual culture takes a broader, more inclusive approach that embraces such visual genres as postcards. With the opening of visual culture to disciplines and practices within and outside the academy, the shift toward a more inclusive frame for the study of images has impacted the acceptance of postcards as valuable objects for collecting and display by art museums. As evidence of this shift, note, for example, the increased number of recent exhibitions dedicated to postcards at leading institutions like the Museum of Fine Arts in Boston, the National Portrait Gallery in London, and the Metropolitan Museum of Art in New York.[2]

No longer dismissed out of hand, postcards, and what could be termed "postcard studies," are on the brink of broader recognition and engendering serious inquiry, as this volume attests. The literature on postcards can be characterized in terms of absences and presences—what is present or covered, and what is not. Thus, the scholarly literature on postcards still concentrates more on images and their interpretation than on production or reception, the cultural work postcards perform. Photographic or picture postcards receive a disproportionate amount of attention in contrast to other kinds of postcards. As a subset of photographs clearly made rather than "taken," as commodities meant to be sold, postcards are especially amenable to analysis as visual culture. Nevertheless, and even with lessons learned from visual culture, postcards still tend to be placed in a hierarchy defined implicitly according to aesthetic categories. Postcard analysis often focuses on the style or "look" of specific postcard publishers. And considerably more work has been done on European and North American postcards than on colonial and non-Western cards from the "South." The interconnected essays in this

book take a different approach and investigate specific case studies of different varieties of postcards, their designers and artists, and their audience; in the process the essays provide a range of methodological and interdisciplinary perspectives.

One of the main postcard genres, view cards feature primarily cities and urban environments. In this regard they are successors to earlier visual and photographic genres, from especially eighteenth- and nineteenth-century prints, drawings, maps, paintings, and topographical atlases to mid-nineteenth-century topographical cartes de visite and stereocards. With the lower costs postcard technology made possible, cities now were "postcarded," an international phenomenon as true for Naomi Schor's Paris (see below) as it was for Peoria or Dakar or Amsterdam. Regarding Amsterdam, the "cityscape underwent a rapid, continuous, and far-reaching renewal of its infrastructure, growing for the first time beyond its seventeenth-century boundaries" between the 1880s and 1920s, as Nancy Stieber delineates in her essay. She examines the obsessive visual documentation of the city that accompanied its most dynamic period of change, and investigates the contribution postcards made to the invention of a city that existed only in visual representations, the "Old Amsterdam" that was canonized during the last third of the nineteenth century. The tradition of collecting visual images of Amsterdam was an elite activity resulting in magnificent topographical atlases of prints, drawings, and painting, a practice that reached its heyday in the early nineteenth century. The postcard democratized that activity and made it possible for women and children, working and middle classes, to participate in a celebration of what was being lost and what was being added to the cityscape. The postcard emerges as a mediator of modernity, a means to identify and possess the totality of the city at a time when it was in fact fragmenting physically and socially. The preference for depicting the medieval core of the city, the selective inclusion of spectacular new buildings and relative exclusion of the new working-class districts, the desire for panoramic views, and the enshrinement of the canals as bearers of aesthetic value all evidence the postcard construction of Amsterdam, the visual story Amsterdam created about itself for itself.

A new postcard genre was invented at the turn of the twentieth century when a market developed for a new kind of postcard made directly from photographic negatives. These postcards, now known as real photo postcards, were made by professional photographers, itinerant photographers, and individuals. Rachel Snow describes the popularization of real photo postcards among amateur "snap

shooters" in America from 1900 to 1930 and their attempts to individualize the postcard format as they determined not only what to picture (the content or subject matter of the image), but also how to picture it (the unique way in which the subject would be photographed). As society became increasingly defined by mass production and the standardization of consumer goods, changes in lifestyle and thinking created an environment that was conducive to the popularity of real photo postcards. Photography constitutes one of many mass-produced and mass-marketed commodities made newly available to a class of upwardly mobile consumers that both encouraged and limited individual expression. Snow argues that middle-class consumers struggled to carve out individual identities and document their personal histories while negotiating (consciously or not) the influence of familiar photographic tropes and conventions in their own picture-making practices. Thus, a comparison of real photo postcards taken by amateurs and professionals demonstrates the degree to which personalized cards both adhered to and broke away from photographic conventions of the day.

Also early in the twentieth century, and another example of the ways in which amateur, artistic, and commercial postcard practices intersected, the Dadaist artists George Grosz and John Heartfield joined postcards and photomontage in a new way. It began when they made antiwar postcards during the First World War that they mailed to the front. On these postcards "photograph clippings had been assembled such that they said in pictures what would have been censored had it been said in words." How these mailed missives escaped the censor's gaze has to do with both the visual technique the artists utilized and the larger wartime context in which postcards were mailed. In juxtaposing photographs, magazine clippings, and other images in order to score a political point, the artists often escaped the censor because they simply reversed the intent of a long line of similarly photomontaged prowar propaganda postcards. Each day during the war Germans mailed an estimated five million postcards to the front and received over three million; many of these featured photomontaged images, a popular novelty.

Although some scholars have argued reductively that such postcards as those made by Grosz and Heartfield lead, ipso facto, to the photomontage characteristic of avant-garde modernism, notably postwar Berlin Dada, Andrés Zervigón shows that what actually happened is both more complex and more fascinating, although

postcards still played a pivotal role. Zervigón sketches the larger cultural context, which included, in addition to postcards, the principle of photomontage, a technique nearly as old as photography itself; the principle of collage, the assemblage of multiple realities, especially in the form of photo fragments; the use of both montage and collage in prewar advertising and journalism, as well as Cubism and Futurism. Yet it was wartime postcards that arguably served as the catalyst for the invention of avant-garde photomontage, insofar as artists such as Grosz and Heartfield saw that images could be appropriated and juxtaposed on postcards to communicate an antiwar message visually that could not be expressed verbally. What was significant, therefore, was that Grosz and Heartfield harnessed these visual possibilities to their antiwar politics using the medium of postcards at a historically specific moment. In their own absurdist and fragmented cards sent to friends at the front, these men not only satirized the heroic images they appropriated, but they also demonstrated how one photograph can change the meaning of another even when simply set incongruously side by side. One result was the birth of an avant-garde approach to montage that would soon dominate Berlin's Dada movement and high modernism as a whole.

A contemporary of Grosz and Heartfield, Franz Marc died in battle in the First World War. For most artists most of the time, postcards are a sideline, an incidental aspect of their oeuvre, and treated as such in the art-historical literature (which is to say little or not at all). Marc's postcards, Kimberly A. Smith argues, are different. Between 1913 and 1914, Marc made at least seven postcards for the expressionist poet Else Lasker-Schüler, mostly of animals—horses, donkeys, panthers, an ox, an elephant. Smith discusses the painterly qualities of the small-scale watercolor postcards in detail, but considers Marc's animals and so-called primitivism both in his postcards and in his large-scale oil paintings, for which he is best known, by looking at and through his postcards. Where previous commentators argue that the animal-filled paradisal postcard scenes refer to Marc's rural retreat where he lived with his wife in Germany, Smith contends that they refer in fact to Thebes, a fantasy world invented by Lasker-Schüler in which she took on the poetic identity of Prince Jussuf, the Old Testament's Joseph, in ancient Egpyt.

While Marc repudiated the capitalist materialism of prewar Germany and turned to a more spiritualized animal kingdom, Lasker-Schüler created an alternative Jewish identity different from contemporary Zionism in the figure of Jussuf/Joseph, a move that also

entailed gender transgression. In the postcards and correspondence between Marc and Lasker-Schüler, all of this is located in the exoticized setting of Thebes. Up to here this postcard exchange can be considered as challenging contemporary German society and culture by evoking a radical utopia that is made visible in a series of postcards. Smith takes the argument further, however, by teasing out the Orientalist and colonialist bases of this shared vision. Smith considers the postcards intertextual objects that mediate and are mediated by contemporary beliefs about Egypt and animals, which connect in turn to Orientalism and colonialism.

With Rebecca DeRoo's essay we move from Europe to the colonies to engage both Orientalism and gender in an analysis of colonial Algerian postcards published in Paris and collected especially by women in France. Drawing on a publisher's 1905 catalogue that lists more than fifteen hundred Algerian cards divided into the two main visual categories dominant at the time, "views" of major cities and "types and costumes" of Algerians, DeRoo demonstrates that the postcards reproduce the colonial segregation of European and Algerian urban space, as well as French racial categories, based on physiognomies, that were applied to Algerians. Women constituted the primary audience for postcards. DeRoo argues that French women collecting postcards of Algerian harem scenes was a rare socially sanctioned occasion for some bourgeois women to view and to display images of non-Western women in exhibitionist and sexually provocative poses. French women's exchange and collection of colonial Algerian postcards demonstrates, she contends, that they accepted colonial depictions, including racial hierarchies, degraded labor, and eroticized feminine stereotypes. Yet by reordering, recategorizing, and displaying the cards in collections, French women used them to displace and expand definitions of Western bourgeois femininity.

In her study of postcards in Palestine/Israel, Annelies Moors also examines gender and Orientalism in non-Western postcards. Moors breaks down picture postcard production into four stages: early twentieth-century commercial postcards, Zionist postcards from the 1920s and 1930s, Israeli commercial postcards from the 1970s and 1980s, and Maha Saca's Palestinian postcards from the 1990s. In early twentieth-century postcards, both Arabs and Jews were framed through an Orientalist discourse that produced otherness and distanciation. The development of the Zionist movement in Palestine

brought about a radical break with earlier postcard imagery. From the 1920s and 1930s on, Zionist postcards repudiated the Diaspora culture of East European Jewry, and the image of the pioneer became dominant. Where images of Palestinian Arabs on Israeli postcards continued to be quite similar to early twentieth-century Orientalist postcards, images of Jewish Israelis on Zionist postcards broke with earlier Orientalist and anti-Semitic depictions of Jews. The third stage occurred with the founding of Israel in 1948. Israeli depictions of Arabs remained Orientalist, but after the 1967 war, Israeli representations of the "tough Jew" displaced the earlier socialist-influenced Zionist "pioneer." Only in a fourth and more recent stage did Palestinian postcard producers emerge, such as Maha Saca, who developed an alternative Palestinian imagery.

Orientalism as an othering discourse is adumbrated in the essays by Smith, DeRoo, and Moors. Orientalism is a variant of the more general phenomenon of exoticism. David Prochaska moves the discussion from Orientalism to exoticism in the case of Hawai'i in his essay, which concerns the exoticist production of Hawai'i in postcards viewed from the perspective of colonial visual culture. The essay unsettles the popular image of Hawai'i because Hawai'i is not generally considered a settler colony in popular American discourse, and Hawaiian postcards, produced primarily for tourist consumption, are not generally viewed as exoticist imagery produced in a colonial situation.

Moreover, the essay is cast in the form of a mock museum exhibition proposal. This exhibition proposes to display exoticist postcard images of Hawai'i, to demonstrate the formal photographic practices used in constructing Hawai'i as exoticist, and to show implicitly how they are analogous to colonial and postcolonial practices elsewhere. The exhibition proposal stages these issues through formal museological and visual practices. Within each gallery area the visitor's gaze is directed to a number of focal points—for example, "postcarding the world of Hawai'i," "individuals and generic types," "postcard albums," "postcards and tourism." Thus, the exhibition moves away from a focus on images per se to demonstrate visually the ways exoticist postcard imagery is actually constructed in practice.

The focus on the intersection between postcards and the museum as an institution of culture continues in Ellen Handy's essay. Museum reproduction postcards are concrete embodiments of the abstraction of the canon; museums evaluate their holdings through choices about which works are to be reproduced. Handy interrogates

these postcards. How do we connect postcards of museum works to art history? What relationship does a postcard image have to the thing itself? How do these images empower people through the development of personal relationships to artworks, art history and the canon? She addresses these questions in relation to Walter Benjamin's skepticism about the destruction of the "auras" of artworks, and his enthusiasm for printed books as multiples; André Malraux's vision of a "museum without walls"; the codification of the artist's point of view in Joseph Cornell's museum "boxes," which appropriate art reproductions; and John Dewey's definition of "art as experience," which offers a transactionalist perspective on the role of the empowered viewer.

Throughout the early twentieth century, especially in the 1930s and 1940s, artists and poets reflected on the "golden age" of postcards before World War I. Their musings about popular culture spanned the elite art press and popular illustrated magazines. In this book we reproduce just two of the many essays that were published during this period as an indicator of the still largely unexplored archive of criticism on postcards that awaits historical review: Paul Éluard's "Les plus belles cartes postales" in *Minotaure* in 1933 and Walker Evans's "Main Street Looking North from Courthouse Square" in *Fortune* in 1948.

French Surrealist Paul Éluard (1895–1952), although known primarily for his poetry, was also actively involved with postcards at a time when few others considered them in depth or took them seriously. From 1929 until at least 1933, he collected cards, organized them in albums, and published an article based on his collection in an avant-garde journal. We reproduce the article here in facsimile and translation with an introduction by Elizabeth Heuer. In the early 1930s he formed a collection of some five thousand postcards gathered from kiosks, secondhand dealers, and the flea markets of Paris. He bought cards on vacation trips to Marseilles and Nice. He bought old photo albums and cannibalized them for postcards. He was aided in his collecting endeavors by Surrealist friends André Breton, René Char, Salvador Dalí, Roland Penrose, and Georges Sadoul. He traded individual and groups of cards with these and other friends. Breton jumpstarted Éluard's collection with a sizable gift from his own collection. Éluard traded a painting by Dali for two hundred prime cards. Along with other surrealists, Éluard shared an affinity for so-called found objects, trouvailles, pieces of urban detritus; these

oddities included postcards. The surrealists' interest in found objects echoed that of other modernist artists, from Picasso and Braque pasting scraps of paper onto their cubist paintings to Kurt Schwitters and Joseph Cornell utilizing these and similar objects.

To invest such pieces of popular culture with value required a new *optique*, or way of looking: postcards had to be seen, that is, noticed, before they could be sought out and appropriated. Heuer describes how Éluard arranged numerous cards he collected in at least seven albums. Éluard was largely uninterested in picture postcards or view cards; he concentrated primarily on nonphotographic and fantasy cards. The themes and subjects range widely, from flowers and ships to trains and holiday cards, but the largest number picture women. As he delineates it in his article, "Child-women, flower-women, star-women, flame-women, sea waves, great waves of love and dreams, flesh of poets, solar statues, nocturnal masks, white rose bushes in the snow, serving maids, dominatrixes, chimeras, illuminated virgins, perfect courtesans, legendary princesses, passersby." Éluard did not order his cards according to subject matter, themes, or chronology; instead he strived to create a nonlinear "poetic syntax."

Given that surrealism as an aesthetic "values fragments, curious collections, unexpected juxtapositions—that works to provoke the manifestation of extraordinary realities drawn from the domains of the erotic, the exotic, and the unconscious," Éluard's article on postcards fit right into *Minotaure* (1933–39), the glossy modern art journal bankrolled by publisher Albert Skira that followed earlier Surrealist efforts. Éluard contributed regularly to *Minotaure*. The issue in which his piece on postcards appeared also featured articles and portfolios by Man Ray, Nadar, Brassaï, André Derain, Breton, Dalí, and Tristan Tzara, not to mention Jacques Lacan. In his own poetic way, Éluard sums up both the value and limitations of postcards: "Ordered up by the exploiters to distract the exploited, postcards do not constitute a popular art. At most they are the small change left over from art and poetry. But this small change sometimes suggests the idea of gold."

Around the same time that Éluard was collecting postcards and publishing selections in *Minotaure*, Walker Evans was also collecting cards, publishing selections from his collection, producing his own cards, and otherwise incorporating them as part of his work in and reflections on photography. Where his interest in postcards is usually considered secondary to his other photographic work—in keeping with the generally low valuation assigned to postcards—for

Evans postcards were not peripheral but integral to his work as a photographer. First, he collected cards, especially in the 1920s and 1930s, just as he also collected other objects spawned by mass culture. His postcard collection grew to over nine thousand cards, which he filed into his own nearly thirty subject categories that mirrored commercial viewcard categories common at the time. Second, he rephotographed scenes depicted on cards from his collection during his travels as a photographer. Third, he published certain of his own photographs as postcards. In an on-again, off-again project with the Museum of Modern Art in the late 1930s, he eventually submitted more than twenty of his southern photographs and published seven. Straightforward black-and-white views of local vernacular architecture, such as churches, Evans's postcards differed from commercial ones chiefly in the way he emphasized a building's details, especially architectural ones, rather than the entire building. Fourth, in a photo essay he did for a travel book on Florida published in 1941, Evans photographed a postcard display rack and used it as the last photo in the book; it included postcards of Florida sights that figured in other of Evans's photos for the guide. Fifth, as a photo editor for *Fortune* from 1945 and later as a freelance writer for *Architectural Forum*, Evans produced three postcard essays illustrated with cards from his own collection, one of which we reproduce here in facsimile with an introduction by Elizabeth Heuer. In "Main Street Looking North from the Courthouse Square" (1948), Evans penned a brief paean to early twentieth-century postcards and reprinted eighteen cards in a four-page spread. "Main Streets" ranged from Salt Lake City and Tampa Bay to Belfast, Maine, and included brief but evocative postcard messages. A second *Fortune* spread, "When Downtown Was a Beautiful Mess," appeared in 1962 and featured one of his cards reproduced in a full two-page spread. In the same year Evans produced "Come on Down" for *Architectural Forum*, on grand turn-of-the-century resorts. Sixth, Evans developed a slide show using his postcards, which he started showing to friends in the 1950s in his New York apartment. In 1964 he was invited to present the slide show to the Yale Art Department, and in 1973 he presented a similar show at the Museum of Modern Art. None of the other figures discussed here engaged and put to use postcards in as many different ways as Walker Evans.

While Éluard and Evans wrote of the postcard's aesthetic pleasures and the poetry of its everydayness, Cary Nelson shows us in his essay that postcards also brought together poetry and violence.

His essay is the first account of wartime poem cards, postcards that feature printed poems, sometimes along with graphic illustrations or images. Like real photo cards and museum reproduction postcards, they have not received sustained attention from scholars. A small percentage of wartime poem cards featured poems by well-known authors ranging from Dante, Shakespeare, Goethe, Heine, and Kipling to Tennyson, Wordsworth, Tolstoy, Emerson, and Mayakovsky. The overwhelming majority, however, are by authors who are unknown or little known. Nelson traces the material history of poetry on postcards and related ephemera. Poetry, such as that which circulated on wartime poem cards, must be understood through the ways in which it was produced, circulated, and used. By introducing readers to a series of cards and the personalities who created, purchased, sent, and received them, Nelson presents a history of postcards that challenges canonical perceptions of poetry's social function. He argues that instead of being disseminated as a rarefied selection of academically sanctioned poets and topics, poetry, in all of its forms and functions, permeated the public's consciousness through the mass production and purchase of postcards. Cards were issued by governments and individuals, they were sent within and between nations, and reproduced both classic and newly scripted poems. Although these cards may be new to scholars of literature, they were fully appreciated at the time of their publication by political leaders as well as by individual citizens.

This volume shifts from hot war to cold war in John O'Brian's essay on atomic bomb imagery on postcards. A 1952 postcard pictures an above-ground bomb test at Yucca Flats in Nevada. At the apex of the mushroom cloud, rising vertically at a slight angle above the desert floor, a text in red is superimposed on the blast image: "Greetings from Los Alamos New Mexico." Among other things, such images are "postcards to Moscow," O'Brian argues, for the atomic arms race between the United States and the Soviet Union that underwrote the Cold War meant that the era was haunted by the specter of a mushroom cloud.

What is most compelling about many of these cards is the way they attract even as they repel the viewer. "Greetings from Los Alamos" is a representation of the technological sublime, O'Brian contends, an image that precariously balances terror with pleasure. It is a peculiarly American hybrid, a combination of technological progression and pastoral idealism. Key here was the decision to publish images in color rather than black and white. By deploying color, the postcard maintained the spectacle (the "awe"), at the same time as it softened the anxiety (the "shock"). O'Brian points out that

until at least the mid-1960s monochrome photography connoted to Americans ethical gravity, the "real" of documentary, while color photography connoted the "unreal" of consumerist pleasures and tourism, the toothpaste smiles of Madison Avenue. Americans not only feared the atomic bomb and its technology in the decades after Hiroshima and Nagasaki, they were also attracted to the bomb's protective power. Both the fear and the attraction are registered in the color postcards O'Brian discusses.

On the racks of postcard vendors and in the pages of albums, there is a short distance from the terrifying kitsch of some postcards to the banal frankness of others. Timothy Van Laar considers both the use of peculiarly banal postcards in his art works and the way they address some general problems in the use of postcards to make art. The typical postcard, with its aspirations to the beautiful, sublime, and heroic, usually delivers a heavy dose of nostalgia, sentimentality, and kitsch. How does an artist appropriate postcards in the making of new images and avoid or minimize the overwhelming ironies intrinsic to the use of these powerful clichés? One way is through the use of a particular kind of postcard, the postcard that fails to operate within the conventions. These postcards picture the mundane, commonplace, and unheroic; they arrive at this ordinariness by means of various, perhaps unintended, visual strategies. Van Laar moves from an informal taxonomy of the modern postcard to a consideration of this particular, seemingly inept, kind of postcard image. It is a kind of image, however, that has its own difficulties; for example, its naïve or amateur qualities can suggest the same sorts of "authenticity" attributed to the "primitive" or to outsider art. Van Laar also shows that cards that fail to meet conventional postcard expectations can themselves create ironies that have their own difficulty.

As a compendium, the essays in this volume, can be viewed as a series of individual cards arranged in a postcard album: each one is different but together they form a state-of-the-field album of postcard studies today. Yet the album has a prehistory, from which the essays by Éluard and Evans have been selected. Although we have included them above as part of our overview of the volume's contents, it is important to understand that they also would form part of any historical bibliography on postcards. If we look at the historiography, the history of the history of postcards, there are a number of moments that stand out as significant markers in tracing the postcard's intersection with the avant-garde, Orientalism, and urban studies; each of these moments in its own way has lead the editors to bring together the authors in this book.

Marcel Duchamp's *L.H.O.O.Q.* (1919) is arguably the first well-known art work based on a postcard. Duchamp (1887–1968) took a postcard reproduction, which he claimed he had purchased in a postcard shop on the Rue de Rivoli in Paris, of Leonardo Da Vinci's *Mona Lisa* (1503–5), perhaps the single most famous painting in the Louvre, and penciled on it a mustache, goatee, and title. Inspired by Dada, it became one of Duchamp's most famous so-called readymades. These were everyday objects—a urinal, a postcard— slightly altered and presented to suggest a new and different point of view. The letters "L.H.O.O.Q." were a scatological joke since when pronounced in French they sound like "Elle a chaud au cul" (She has a hot ass). By altering a postcard reproduction of a painting and declaring it a legitimate artwork, Duchamp was, first, collapsing the then still regnant distinction between high and low art. That Duchamp produced a number of versions of this work over the years only added further insult to injury by producing multiple original alterations of the oft-reproduced postcard. Primarily, *L.H.O.O.Q.* operates as a think-piece, a precursor to both conceptual and postmodern art. Duchamp took an art reproduction—and a lowly postcard at that—appropriated it by altering it, and then claimed that his altered postcard of a painting was itself an artwork. So now we have not only postcards of *L.H.O.O.Q.* that reproduce an altered postcard reproduction of the *Mona Lisa*, but also other works that rework Duchamp's postcard—for example, by Francis Picabia and Carol Selken—and reproductions in turn of these latter works. What better way to collapse high and low, deaestheticize the art object, than to appropriate a postcard, elevating its status from cheap, reproducible ephemera—a copy of an original—to a signed, original work of art that itself is open to reproduction and sale? In challenging the common view of postcards as degraded, less worthy art objects (in part because they are reproducible and sold in quantity), Duchamp's *L.H.O.O.Q.* at the same time fueled heated art-historical discussions concerning appropriation, reproduction, artistic genius, and high versus low culture.

Throughout the twentieth century, artists have returned to Duchamp's gesture and incorporated postcards into their work. Artists' files are full of postcards, used as correspondence, document, critical tool, and inspiration. For some, postcards have become source material in their studios, but for many more—including Joan Miró,

Roland Penrose, Ellsworth Kelly, Gerhard Richter, Buzz Spector, Martin Paar, and others—postcards have become protagonists in works that challenge strongly held notions of originality and authenticity to instead put into play an interrogation of art, commerce, and popular culture. As much as anyone else, artists have benefitted from the wide availability of postcards. When Éluard and his fellow Surrealists were collecting postcards, they were finding them in stalls and attics across Paris; some were inherited from family members as welcome artifacts from a prewar period seen to embody innocence and experimentation. Today, postcards are still readily available and, except for the most sought after by collectors, relatively cheap to purchase. Artists continue to appropriate old cards and publish new ones, each time provoking a different set of questions. As digital culture replaces analog, paper cards may become a sign of the past, but today's Twitters and tweets may be merely an extension of the already telegraphed messages that adorned the backs of picture postcards at the turn of the century.

Postcards, especially vintage cards from the late nineteenth and early twentieth century, have long been collectibles sold in venues such as flea markets and used bookstores. Books reprinting old cards have appeared increasingly over the last two or three decades, especially in France. The overwhelming majority of these compilations are nostalgic in tone and intent. They reflect anxiety about the accelerating rate of social and cultural change during the twentieth century, especially in turn-of-the-century scenes that document the changes to urban streetscapes and seek to preserve a record of rural folkways. In addition, many exude imperialist nostalgia for now-independent former colonies to which European colonials cannot realistically return.

When Malek Alloula's *The Colonial Harem* was published in French in 1981 and English in 1986, it was the first critical study of postcards, in both senses of "critical," to attract widespread notice. Critical in that it took postcards as cultural and colonialist objects worth serious scrutiny, it was also highly critical of the Orientalist, exoticist, and sexist imagery of French colonial postcards of Algerian women. Many reviewers applauded Alloula's critical stance; the book jacket included such encomia as "Imprisoned by the photographers' eye [these women] reclaim their historicity through the pages of this powerful book" (*Village Voice*); "By displaying and dissecting colonial pornography as an insider he [Alloula] brings into stark relief the violation of the patriarchal gaze at its harshest" (*Women's Review of Books*). Yet others argued that while ostensibly critical, Alloula ended up reproducing female stereotypes and the prevailing gender system under colonialism. Many images were reproduced significantly larger than postcard size, with the result that these derogatory images were again put into widespread circulation. While Alloula's book was clearly not imperialist nostalgia, strictly speaking, some feminists contended that it constituted a nostalgic or sexist view of male-female relations in Algeria: "If Algerian women were vulnerable and disgraced by their original display on colonial postcards, they are once again exposed by their display in this book."[3] His work more a literary than a historical or an art-historical analysis (he dedicated the text to the memory of Roland Barthes), Alloula chooses to discuss postcard representations of Algerian women as a whole and in general. He deliberately excludes information on postcard publishers, photographers, and processes of production, on iconography and postcard messages, on how many were printed and who collected them, as well as the geographical, ethnic, and historical context of these colonial Algerian images. A male Algerian, Alloula determined to speak for the female Algerian subjects of these early twentieth-century cards, intending to "return this immense postcard to its [French] sender." Yet he provides no information on actual senders or sendees. Instead, Alloula arranges the cards purposefully to produce a postcard compilation with a message. Arguing throughout that these postcard images of Algerian women are degrading, he makes his case by ordering them in an ascending order of offensiveness. His chapter headings clearly state his argument, from "Women from the Outside" (chapter 2) and "Women's Quarters" (chapter 4) to "Oriental Sapphism" (chapter 9), culminating in the last chapter with an "anthology of breasts."

In 1990 literature specialist Naomi Schor published a long, detailed, comprehensive essay on postcards in one of the most prestigious scholarly journals in her field, *Critical Inquiry*. As a sign of Schor's standing in academia as well as an indication that postcards had arrived as a subject of highbrow intellectual interest, *Critical Inquiry*—not otherwise known for its illustrations—accompanied Schor's essay with twenty-seven mostly full-page postcard reproductions. Schor focuses on turn-of-the-century Parisian viewcards produced by the Maison Lévy (Lucien and Ernest Lévy) under their trademark LL, but in fact her article is far more wide-ranging. She raises the issue of photographic realism; discusses postcard production; sketches a history of postcards; invokes critical theorists such as Walter Benjamin and Roland Barthes; suggests that the appeal of postcards

is largely nostalgic; broaches the issue of postcard messages; and underscores the gendered nature of, especially postcard collecting, as female. While we know much more now about the topics Schor addresses, we reprint her essay here as our first chapter because of her skillful framing of key issues.

While not the first book about postcards to be published by an academic press—academic and commercial presses have long contributed to making reproductions of postcards available to a wide array of readers, especially those seeking information about local contexts or specific categories of historical images—this is the first anthology to bring together scholars, artists, and critics from the humanities and social sciences to focus exclusively on postcards as significant objects of study worthy of sustained, critical analysis. The authors come from different disciplines and have applied a range of methodologies in their explorations; we have sought to respect these differences by presenting side-by-side texts that complement, contrast, and sometimes contradict each other. Each essay offers a window in to an even more expansive field of study. By incorporating reprints of select essays, both from the more distant and recent past, we have sought to provide readers with an indication that "postcard studies" is not an invention of this anthology, but rather a crucial part of a longer, more complex history of modernity wherein writers, philosophers, artists, anthropologists, historians and everyday collectors were all fascinated, troubled, and provoked by the startling ubiquity of the picture postcard.

CHAPTER ONE

..

CARTES POSTALES:

..

REPRESENTING PARIS 1900

..

..

Naomi Schor

Two widely shared but diametrically opposed views inform what theories we have on the everyday: one, which we might call the feminine or feminist, though it is not necessarily held by women or self-described feminists, links the everyday with the daily rituals of private life carried out within the domestic sphere traditionally presided over by women; the other, the masculine or masculinist, sites the everyday in the public spaces and spheres dominated especially, but not exclusively, in modern Western bourgeois societies by men. According to the one, the everyday is made up of the countless repetitive gestures and small practices that fall under the heading of what the existentialists called the contingent. According to the other, the everyday is made up of the chance encounters of the streets; its hero is not the housewife but the *flâneur*. In the words of Maurice Blanchot: "The everyday is human. The earth, the sea, forest, light, night, do not represent everydayness, which belongs first of all to the dense presence of great urban centers. We need these admirable deserts that are the world's cities for the experience of the everyday to begin to overtake us. The everyday is not at home in our dwelling-places, it is not in offices or churches, any more than in libraries or museums. It is in the street—if it is anywhere."[1]

On the whole, what with the current vogue enjoyed by the theoretical works of Walter Benjamin and the Frankfurt School, Guy Debord and the situationists, and other modern urban theoreticians of the everyday, I think it would be safe to say that the street version of the everyday tends to prevail. Of course, the difference between the street and the home is not ironclad: in Benjamin's own terms the privileged space of the *flâneur*, the arcade, straddles the inside and the outside, the public and the private. An extension of the bourgeois home, the arcade annexes of the chancy street to the sheltering intimacy of the apartment. Nevertheless, as Wolfgang Schivelbusch reminds us, there is a basic difference between the medieval and the modern street that involves precisely the reconfiguration of the street as a public space: whereas the street used to be "an extension of the space of the people who lived in the houses adjoining it," starting in the sixteenth century steps were taken—illumination, garbage clearance, and so on—to transform the street into the what it has become in modern times: "a public space for the flow of traffic."[2]

There are other quotidian spaces, the spaces studied by Michel Foucault (as well as Erving Goffman), that provide another and less reassuring instance of liminality: the public, indeed institutional spaces where the most intimate and often violent encounters between individual subjects occur in the merciless glare of publicity, spaces such as the asylum, the prison, the school, the barracks. Violence is,

of course, not absent from Benjamin's urban dreamworld. His urban arteries—following Georg Simmel's analysis of the metropolis[3]—are the sties of violent shocks, where the human subject is bombarded with unwelcome stimuli that assault his system and oblige him to resort to various coping strategies to survive. And yet, there is always the possibility that the mean streets will yield a chance encounter rich in erotic excitement or imaginative stimulation, not to say revolutionary potential. No such possibility exists within Foucault's tightly controlled prison environment. Now, what interests me is how the extraordinarily powerful discourse produced by the mapping of this grim, unrelenting disciplinary locus of daily activity has in recent years come to dominate our views of representations of everyday life, as though, to anticipate my critique, the street had been overtaken by the prison. What I will call the "carceralization" of our understanding of public space cuts across many fields, including history, critical literary and legal studies, photography—cultural studies in the broadest sense. My effort here will be to reclaim both the street as a site of the everyday and a certain modality of its photographic representation from the stifling and monolithic discourse of the disciplines.[4]

Much theoretical discourse on photography—like photography itself—has oscillated between a formalist and a strongly ideological mode, and it is with certain trends in this latter mode that I am concerned here. What I am calling the ideological analysis of photography has in recent years produced some wonderfully illuminating texts and articles: some of Roland Barthes's work; André Rouillé's Marxist analysis of the (necessary) birth of photography; Abigail Solomon-Godeau's fascinating feminist study of the Countess's legs; Allan Sekula's "Body and the Archive;" and many more.[5] The apparent mimetic transparency of photography has come under grave suspicion, and most educated analysts of the photograph have deployed enormous efforts to demonstrate just how photography does the work of ideology through its techniques of cropping, framing, lighting, manipulations of scale and perspective, as well as by the choice and positioning of subjects. In the general critique of representation that has occupied so many Western thinkers and scholars in the second half of the twentieth century, the critique of photographic realism has played a crucial role, since in a culture of the image such as our own, photography, given its extraordinarily referential weight, inserts the subject in important and commanding ways into the networks of power and the apparatuses of knowledge. And in the past decade no

body of theoretical discourse has been more influential in this respect than Foucault's, no concept has proved as productive as Foucault's Benthamite panopticon.

Following in Foucault's footsteps, scholars have discovered and/or recovered entirely new corpora of photographs that would have been disdained by a formalist, high modernist school of critics still haunted by the pictorial referent, not to say romantic ideas of the artist, the most important example being the corpus of photography that resides in the "filing cabinet[s]"[6] of the disciplinary archipelago: identity pictures of the poor, the criminal, the insane, the deviant; so-called documentary photography in the service of the liberal humanist political agenda (urban renewal, labor reform, the Works Progress Administration) when it is not war (Edward Steichen's aerial photography). A particularly symptomatic example of this sort of work, because it is so purely and, by its own admission, at times excessively Foucauldian, is John Tagg's *Burden of Representation*. The title of the book is in itself eloquent: for Tagg, photographic representation carries the leaden burden of ideology because it is an essential element in the setting-into-place of the disciplinary system, which comes to adhere to the social body like Deianira's robe, a suffocating all-enveloping second skin. According to this instrumental view of photographic realism, representation becomes unbearably heavy.

If Tagg's writings exaggerate, perhaps even caricature Foucault's insights, especially by yoking them with Louis Althusser's notions on the interpellation of the subject, they are, nonetheless, representative of a certain doxa and one that extends far beyond the field of photography. My discomfort with this body of theory, to which I have been and remain profoundly attracted and indebted, is that in its extraordinary totalizing it is ultimately both deeply satisfying and dangerously stultifying. My concern here is not, as it has been for so many of Foucault's critics, with the essential conservatism of the disciplinary model, the fact that it seemingly allows no room for resistance, subversion, and change, though this is a legitimate criticism, at least of the stage of Foucault's thinking represented by *Discipline and Punish*.[7] Nor am I particularly preoccupied by Foucault's "representationism," his endorsement of the widely shared view of representation as a powerful but essentially passive mimetic mode that, we are now told, needs to be replaced by a more pragmatic, that is, Aristotelian notion of representation as action, process.[8] What arouses my discomfort, my suspicions, is, perhaps perversely, the enormous pleasure provided by such an obsessive, not to say paranoid explanatory model that leaves no residue, no excess, no

waste, no detail, no small everyday gesture, however small and apparently insignificant, unaccounted for, unsaturated with dire meaning.

But beyond this possibly idiosyncratic response,[9] I have a more serious concern: like all explanatory models, the disciplinary model works better for some phenomena than others; indeed, as I have just noted, it actually produces new phenomena, new research materials, new archives, new histories, not to say new historicisms. What is unclear to me is how one can in this system account for representations of daily life that—and here I want to choose my words with special care—while shot through and through with ideology nevertheless exert their power over their viewer without coercion, in fact produce in the viewer a sense of pleasure that does not depend on occupying a predictably voyeuristic position. What, in other words, of that body of photography that inflects the real in the direction of the ideal; what are the means for understanding an idealization that while complicitous with that nebulous all-pervasive abstraction we call power, nevertheless does not participate in the disciplinary system as it has been defined? Can't we begin to unburden representation just a little in order to take into account other disdained archival materials, those that do not fit comfortably under currently available paradigms? Postcards, for example, for reasons I shall make clear in a moment, postcards of turn-of-the-century Paris?

That I should be moved to raise this question at this time may be symptomatic of a much larger trend Gilles Deleuze has identified in his most recent book, *Pourparlers,* that is, the waning of the disciplinary societies of the nineteenth century and the rise in the place of their postmodern modality, what he calls control societies (*sociétés de contrôle*). The main anchoring points of the disciplinary society—the family, the school, the barracks, the hospital, the factory, and, of course, the prison—are, he reminds us, now in crisis, while atopic, more diffuse models of control are being set into place through the wonders of modern technology.[10] Deleuze's model, is of course, just as totalizing as Foucault's, which it explicitly updates, but it has the virtue of reminding us that the disciplines need to be scrupulously historicized and that there exist lighter forms of control than the tentacular and invasive disciplines. The turn-of-the-century pictorial postcard, which functioned like a cross between the modern print and communications media, something like CNN, *People, Sports Illustrated,* and *National Geographic* all rolled into one, was, I will argue, a forerunner of these lighter modes of social control.

It is no accident that much work done under the influence of Foucault's *Discipline and Punish,* but also parts of *The History of Sexuality,* has to do with the body; for the instruments of power-knowledge specifically target the body, its pleasures and desires, its perversions and its reproductive powers, and this raises yet another question: what of representations of spaces devoid of human figures, or of spaces where—and this is of course not an insignificant qualification—the human figure is secondary, incidental, in extreme cases a subsidiary formal element indistinguishable from other, strictly architectural forms (fig. 1.1)?

Tagg does at least tacitly raise this issue when he moves from considerations of photographs used as evidence in courts of law to photographs used in large public works projects, such as slum clearance in Edwardian England or the WPA. However, because his application of Foucault puts an issue not merely, as in a more formalist approach, the representations themselves, but the discursive and institutional networks of power in which they take their place and meaning, the difference for him between an anonymous photograph of a prisoner and a photograph by Walker Evans of a small Mississippi town is not in fact all that great. As Tagg notes in his introduction,

We have to see that every photograph is the result of specific and, in every sense, significant distortions which render its relation to any prior reality deeply problematic and raise the question of the determining level of the material apparatus and of the social practices within which photography takes place. The optically "corrected" legal record of a building façade is no less a construction than the montage [made during the McCarthy era of an American senator conversing with communist politician Earl Browder], and no less artificial than the expressively "transformed" experimental photographs of Lois Ducos du Hauron or, in a different context, those of Bill Brandt.[11]

In a similar fashion, though in a slightly different context, in her introduction to Malek Alloula's *Colonial Harem,* Barbara Harlow asserts: "The French, during their colonization of the Maghrib, did not produce postcards exclusively of women in Algeria; a series of architectural representations of mosques, traditional houses, tombs, and fountains, highlighted by arabesques and *polygones étoilés,* might also provide material for cultural and ideological scrutiny. Landscape views are likewise of interest in cases where possession and occupation of the land are at stake."[12]

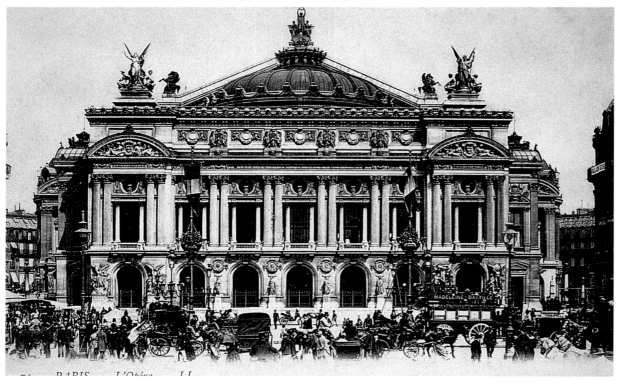

1.1. "Paris.—L'Opéra—LL."

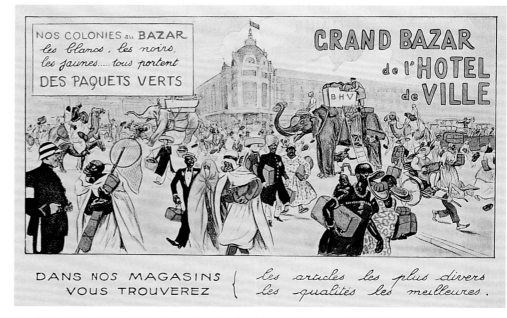

1.2. "Nos Colonies au Bazar." Advertisement for shopping at the Grand Bazar de l'Hôtel de Ville.

My question then becomes: but what of the cases when "possession and occupation of the land"—Harlow is alluding here to the situation in Palestine—are not at stake? Or, rather, they are at issue but not directly thematized, represented? What of the case when the purveyor of postcards—often the same man or company as the producer of the colonial cards—is not a foreign agent, an agent of the empire, but, at best one can tell, a member of the society he photographs? The body of postcards that I want to explore constitutes what we might call the *discourse of the metropolis,* understood here both as the urban center of a country (France) where the opposition between the capital and the so-called provinces is particularly marked, and as the seat of a colonizing power in full expansion. I want to examine how in the early part of this century Paris produced an iconography that was abundant, systematic, and cheap, and further offered its citizens (and proffered to the world) a representation of itself that served to legitimate in a euphoric mode its nationalistic and imperialistic ambitions. In order to grasp this discourse we will have to adopt a curious recursive perspective where what is plundered in the colonies is transformed into a glorifying attribute of metropolitan commerce, and the colonized returns in the guise of a satisfied customer, a self-consuming consumer (fig. 1.2).

But before going on to consider these cards, I want to contextualize them: first, by considering the very act of collecting, and second, by considering some information about the postcard itself, with special preference to France.

Collecting

Among the nineteenth-century social types studied by Benjamin, the collector occupies a privileged place: collecting, rather more than *flânerie,* is the activity that most closely approximates that of the author; collecting provides the link between the bourgeois childhood evoked in *Berlin Childhood* and the adult project of *Das Passagen-Werk.*[13] In one of his most charming texts, a public lecture entitled "Unpacking My Library" and subtitled "A Talk About Book Collecting," Benjamin writes: "Every passion borders on the chaotic, but the collector's passion borders on the chaos of memories."[14] Books or any other objects collected by what Benjamin calls a "genuine" or a "real" ("U," 59, 62) collector are treasure-houses of memories because each book-object evokes the precise memory of where it was acquired and under what conditions; further, each book evokes the original context

in which it was housed. Unpacking his books as day fades into night, Benjamin is overcome by a Proustian rush of memories of places and people, many now lost to him forever:

Memories of the cities in which I found so many things: Riga, Naples, Munich, Danzig, Moscow, Florence, Basel, Paris; memories of Rosenthal's sumptuous rooms in Munich, of the Danzig Stockturm where the late Hans Rhaue was domiciled, of Süssengut's musty book cellar in North Berlin; memories of the rooms where these books had been housed, of my student's den in Munich, of my room in Bern, of the solitude of Iseltwald on the lake of Brienz, and finally of my boyhood room, the former location of only four or five of the several thousand volumes that are piled around me. ("U," 67)

Inevitably for Benjamin the memories evoked by his books return him to his childhood, indeed to his mother. As he reaches the end of this addictive activity, unpacking, he comes to what is in fact the matrix of his entire collection, though as he admits they did not "strictly speaking" "belong in a book case at all: two albums with stick-in pictures which my mother pasted in as a child and which I inherited. They are the seeds of a collection of children's books which is growing steadily even today, though no longer in my garden" ("U," 66). The mother's albums, the boy's room, these are the privileged originary instances Benjamin recovers on unpacking his library.[15]

Collecting, when it is not unpacking, is for Benjamin a form of psychotherapy, a healing anamnesis, a means of remembering his fragmented past, of re-collecting a lost maternal presence, the plenitude of childhood—his mother's, his own. There is in fact a strong oedipal motif at work in this seemingly light piece: just before he comes upon the maternal albums, Benjamin describes at some length two diametrically opposite experiences in the auction house, a positive one where he, an impecunious student, snaps up a bargain ignored by more affluent bidders, and one he qualifies as negative. Yet here too Benjamin outsmarts the experts, so it is not his failure to acquire the desired book that marks the experience as negative; rather, it is the light it sheds on the workings of homosocial rivalry, on the mechanisms of mediated desire. In this second auction scene worthy of Dostoyevsky the coveted book occupies the space of the female (maternal) object desired by two males, one clearly more powerful because better heeled:

The collection of books that was offered was a miscellany in quality and subject matter, and only a number of rare works on occultism and natural philosophy were worthy of note. I bid for a number of them, but each time I noticed a gentleman in the front row who seemed only to have waited for my bid to counter with his own, evidently prepared to top any offer. After this had been repeated several times, I gave up all hope of acquiring the book which I was most interested in that day. …Just as the item came up I had a brain wave. It was simple enough: since my bid was bound to give the item to the other man, I must not bid at all. I controlled myself and remained silent. What I had hoped for came about: no interest, no bid, and the book was put aside. I deemed it wise to let several days go by, and when I appeared on the premises after a week, I found the book in the secondhand department and benefited by the lack of interest when I acquired it. ("U," 65–66)

Through self-control and cunning—"collectors," he observes, "are people with a tactical instinct" ("U," 6)—Benjamin wrests the object away from the threatening rival, but the oedipal triangle has invaded the world of the book collector. That the book occupies the maternal position in this triangle and is thus feminized in Benjamin's theory of book collecting—and collection theory; however underdeveloped, is, as we shall see in a moment, shot through with sexual, indeed, sexist metaphors—is confirmed by a striking analogy Benjamin employs to describe the collector's gesture of releasing a book from captivity: "One of the finest memories of a collector is the moment when he rescued a book to which he might never have given a thought, much less a wishful look, because he found it lonely and abandoned on the market place and bought it to give it its freedom—the way the prince bought a beautiful slave girl in *The Arabian Nights*" ("U," 64).

Whatever the memories evoked by his books, for Benjamin the activity of collecting is bound up with the act of rememoration, and that act is figured as profoundly magical. Thus in the envoi of this extended prose poem Benjamin once more evokes the supernatural world of *The Arabian Nights,* except that in this teasingly obscure instance the container of the captive spirits, of the genii is none other than the collector himself: "For inside him [the collector] there are spirits, or at least little genii, which have seen to it that for a collector—and I mean a real collector, a collector as he ought to be—ownership is the most intimate relationship one can have to objects. Not that they come alive in him; it is he who lives in them. So I have erected one of

his dwellings, with books as the building stones, before you, and now he is going to disappear inside, as is only fitting" ("U," 67).

But does Benjamin's theory of collecting apply to all collections? Do all objects possess the same mnemonic properties as those with which Benjamin endows his beloved books? Are books a typical or a special case?

For the past few years I have collected postcards: I have purchased them at specialized postcard fairs, from private dealers, at flea markets; a few have been given to me as gifts. Unlike other objects I collect, for example, a brightly colored turn-of-the-century porcelain known as majolica, my postcards are not possessed of the magical mnemonic properties Benjamin attributes to his books. With the exception of one or two real finds in my collection—whose acquisition was marked by a particular feeling of triumph—I would be hard pressed to say how I came by a particular card. When I open my albums or storage boxes time is not recaptured. How then am I to account for these cards' failure to produce memories, their mnemonic sterility? The answer is seemingly simple: postcards are organized in series and their very seriality negates their individual mnemonic properties; what matters in the case of my postcard collection is not the contiguity between an individual card and the environment from which it was detached; rather, it is the contiguity I restore between a single card and its immediate predecessor and follower in a series I am attempting to reconstitute, or the contiguity I create between cards linked by some common theme. The metonymy of origin is displaced here by a secondary metonymy, the artificial metonymy of the collection.

Benjamin was not entirely unaware of this secondary metonymy; it constitutes for him the antithesis of the chaos of memories in the dialectics of collecting: "there is in the life of a collector a dialectical tension between the poles of disorder and order," he notes ("U," 60). The pole of order is represented for Benjamin by the catalogue, which imposes seriality on the random purchases of the book collector.

Benjamin's dialectical scheme points to a possible explanation for the inapplicability of his theory to my postcard collection: his confusion or failure to distinguish between what Susan Stewart has described as the souvenir and the collection, two closely linked but radically different assemblages of objects. According to Stewart, then, Benjamin's books function more as souvenirs than as parts of a collection. The souvenir "speaks to a context of origin through a language of longing, for it is not an object arising out of need or

use value; it is an object arising out of the necessarily insatiable demands of nostalgia."[16] The souvenir serves to "authenticate a past or otherwise remote experience" (OL, 139). There are, of course, important differences between Benjamin's books and the typical souvenirs Stewart has in mind—antiques, exotic objects, replicas of the Eiffel Tower or the Liberty Bell—and yet there is an interesting convergence in a subcategory of the souvenir, "souvenirs of individual experience," which include "scrapbooks, memory quilts, photo albums, and baby books" (OL, 139). Benjamin's mother's childhood albums, while not composed of personal memorabilia, hover on the limit and as the original books in Benjamin's library, the books of origins, decisively inflect his collection in the direction of the personal, the originary, the unique, the auratic. They serve as the authenticating, naturalizing ground for his later acquisitions; they draw his collection like a vortex into the past, into a nostalgic longing for a missing maternal presence.

According to Stewart's paradigmatic opposition, Benjamin's collection is not in fact a collection, but a collection of souvenirs. His library qua souvenir overrides and very nearly cancels out its nature as a collection. What then defines the collection? It is, as we have already seen, seriality. What distinguishes the collection from the souvenir is that a collection is composed of objects wrenched out of their contexts of origins and reconfigured into the self-contained, self-referential context of the collection itself, and "this context destroys the context of origin" (OL, 165). In a parallel opposition of re-presentation and collecting, Dean MacCannell observes: "The idea behind a collection is to bring together and catalogue diverse examples of a type of object: Eskimo snowshoes, oil paintings, African masks. There is no effort to rebuild a natural, cultural or historical totality. Order is superimposed by an arbitrary scheme like the Dewey decimal system. Whereas re-presentations demand identification, collections require an esthetic."[17]

Clearly, in MacCannell's and Stewart's shared system of values, the collection is far more reprehensible than the souvenir, hence Stewart's eloquent chapter title: "The Collection, Paradise of Consumption." In her terms, the collection not only represents the destruction of an originary context connoted as natural but also, by the same gesture, the erasure of all traces of the process of production; it wipes out both labor and history: "In the souvenir, the object is made magical; in the collection, the mode of production is made magical" (OL, 165).

Stewart shares with Jean Baudrillard, from whom she draws, a judgmental discourse on collecting; for both, collection is a degraded form of consumption, but whereas Stewart's collector is a possessive bourgeois subject of late capitalism, Baudrillard's is a misfit who would be at home in Freud's Vienna, perhaps even in Freud's cabinet of antiquities. Whereas Stewart's analysis of collection is predominantly Marxist, Baudrillard's analysis of the collection passion is heavily psychoanalytic: collecting is a regressive (anal) activity with strong narcissistic and fetishistic traits; in this discourse to collect is to deny not so much labor and history as death and castration. Unlike Benjamin's collector who is merely childlike and Stewart's who is a late capitalist consumer, Baudrillard's is a neurotic: unable to cope with the struggles of intersubjectivity, Baudrillard's collector prefers to seek out instead the specular satisfactions afforded by inert objects (or domesticated animals); unable to deal with the irreversibility of time and the death it inevitably entails, the collector conjures them by living in a sort of collector's time, a time out of time; unable to desire others in their totality, the collector—and collecting here is viewed as a sort of poor or rather rich man's fetishism—invests part-objects with a largely sexual desire.

Before coming to what I consider most valuable in Baudrillard's psychology of collecting, I must comment on the extraordinary sexism of his analysis. In fact, the two aspects of his argument are intimately linked. For Baudrillard the collector—like the fetishist or the anal compulsive with whom he shares certain traits—is unquestionably male: thus Baudrillard compares the particular pleasure (jouissance) the collector experiences with the pleasures of the harem: "Master of a secret seraglio, man is never more so than surrounded by his objects."[18] The paradigmatic collector—as in the novel by the same name—is a man whose extreme castration anxiety leads him to a pathological need to sequester the love-object or loved objects: "What does the sequestered object represent?... If one lends neither one's car, nor one's pen, nor one's wife, it is because from the perspective of jealousy these objects are narcissistic equivalents of the ego: if this object is lost, if it is damaged, it's castration. One does not lend one's phallus, that's the heart of the matter" (SO, 139). Lacking the phallus, women, at least implicitly, cannot in Baudrillard's analysis collect.

Both Stewart's genderless and Baudrillard's insistently phallocentric theorization of collecting point up the need to think through the incidence of gender on collection and its theories. To do so it would be necessary to open up once again the vexed question of female fetishism, for as Emily Apter has recently argued, in the

nineteenth-century French novel collecting is the feminine form of fetishism par excellence;[19] furthermore, as she also demonstrates, in the extreme case of erotomania, the secure boundary between the male collector and the female collectible is dislocated, as the prostitute-collectible and the client-collector change places.[20]

And yet, for all their offensive phallocentrism, Baudrillard's sexual analogies do yield a crucial insight into the psychology of the collector, whether male or female: cast as an insatiable Don Juan or a master of the harem, Baudrillard's collector values objects only in that they can be inscribed into a series. Seriality is the crucial motivating factor of the true collector; even those collectors who are driven by the quest for the rare object are motivated by an intense awareness of the series. In this insistence on seriality Baudrillard remains, of course, profoundly structuralist; the pleasure of collecting is the pleasure of difference, as much as it is of a reassuring completion and illusory lack. To give pleasure the collector's object of desire must implicitly refer to a series. At the same time to perform its other psychic regulatory functions—and for Baudrillard collecting performs the same homeostatic functions as dreaming—the series must always remain open, for lack is the guarantor of life; to complete the series is to die:

Denied, forgotten, destroyed, [or] potential, the series is always there. In the humblest of everyday objects just as in the most transcendent of rare objects, it feeds the sense of ownership or the game of passion. Without it no game would be possible, thus no possession either and properly speaking, no object. The truly unique object, one that is absolute, without antecedent, without dispersion in a series—whatever series—is unthinkable. No more than a pure sound, it does not exist. (SO, 131)

Topographicals

A frequent theme in books on the art of postcard collecting is the bewilderment of the novice when confronted with the multiplicity of categories into which postcards are by convention divided. "Newcomers to the postcard-collecting scene are always puzzled about what to collect and how to go about starting," writes one author.[21] The lists of categories arrayed before the fledgling collector read like some Borgesian encyclopedia entry because in the words of one of its historians, "Postcards have shown, and continue to show, it all.… In a sense… this world of ours is a mosaic with each piece of the puzzle having its postcard representation."[22]

Clearly, part of the pleasure of the postcard collector consists in the crisscrossing of categorical boundaries, the reveling in the jarring juxtapositions characteristic of the postcard album:

Satirical humour, saucy comics, flag-bedecked patriotic and cruelly lampooned politicians, ingeniously devised novelty cards, romantic songs and sentimental hymns, colorful poster publicity, buxom beauties and glamorously slender ladies. Animals, birds, battle scenes and military uniforms, big ships, little ships, actors, actresses, and play pictorials, royalty, pageants, exhibitions, coin cards, stamp cards, reproductions of old paintings and the original work of new artists, and greetings galore for all conveniently recognized occasions.

North, south, east, or west. Brown skin, yellow skin, red, or white. Rich, poor. Laborer, president, king, Bedouin tribesman. Sunshine, snow, hurricane, volcanic activity. Beaches, palaces, grass huts. Politics, wars, social history. Holidays and humor. Street scenes and pastures. And always, always more. (PC, 137)

The problem posed by the endless proliferation of categories—the postcard world awaits its Linnaeus—is further complicated by the existence of multicategorical cards:

Surely, it is frequently argued, lighthouses, windmills, watermills, post-offices, trams, railways, shop-fronts, piers, fire-stations, children bowling hoops, etc., etc., must come under the general heading of topography? Indeed they do, but they also come under more specialized subjects as well.… Many a dealer has been faced with the poser of where to put what when confronted with a postcard with a post-office in the foreground, a railway station which can just be glimpsed at the back, and a reasonable view of a tram travelling down the middle. So a choice has to be made between three different classifications. (CP, 27)

The new collector is generally advised that the only way to Orient herself in this categorical or thematic maze is to zero in on a single theme or category, preferably topographicals or view cards—the largest and most popular category of postcards—representing familiar places: "The soundest advice to beginners is to concentrate on collecting views relating to the areas in which they live and work. From this modest base there will soon emerge a very wide choice of themes to suit individual tastes" (CP, 28). One's place of origin or the sites of one's daily life provided then the best foundation on which to build a postcard collection. Postcard collecting implies, at least at the

outset, a sense of identity strongly rooted in a specific place, a home. When postcard vendors exhibit their wares at different locations they tend to cater to local collectors' interests and tastes: trays and trays of postcards of New England villages at New England fairs and flea markets; trays and trays of postcards of Paris by *arrondissement* in Paris. Indeed, as one postcard historian notes, the craze for collecting hometown topographicals is particularly pronounced in France, where the topographical is the dominant category, a situation deeply bound up with the French sense of the *terroir,* of a national and personal identity rooted in a specific place of origin. Some French collectors, especially of Parisian postcards, are even said to push their sense of the local so far as to specialize in a single street, no doubt their own.[23]

Had I as a new collector followed this advice I should have begun by collecting cards of Providence, Rhode Island, where I worked and lived at the time I began my collection, or perhaps of New York, where I was born, raised, educated, and employed until my mid-thirties. In truth neither possibility ever occurred to me; from the outset I was drawn to postcards of a place where I neither live nor work, France, and very quickly within France, Paris. This choice suggests the inadequacy of a model based strictly on an unexamined notion of one's place of birth, work, or daily life as grounding one's identity, what Biddy Martin and Chandra Talpade Mohanty call the "unproblematic geographic location of home."[24] This model cannot account for the possibility of a dis-location constituting the foundation of one's being, or at any rate one's collecting, but as we have seen, for the collector being and collecting are intimately related. In Martin and Mohanty's text the "illusion of home," or of at-homeness is shattered by the realization that "these buildings and streets witnessed and obscured particular race, class, and gender struggles."[25] This is the post-modern, postcolonialist condition: what is at first experienced as a secure, identity-giving and sheltering space is revealed to be a place of bloody struggle and exclusion. Like the *unheimlich,* in whose semantic field it participates, *home* is a word whose positive connotations are undermined by an antithetical and negative meaning.

For me the home that is not home is Paris: but what is hidden there is a form of violence and racial struggle not generally understood today when the trinity of race, class, and gender is invoked. I am speaking of anti-Semitism, theirs not mine. Paris is the place that would have been my home but for the Holocaust. My parents, Polish Jews, left Poland in the late thirties with the intention of settling in Paris. In June 1940, they along with thousands of others fleeing Hitler's

impending arrival left Paris and headed south. They were among the lucky ones; unlike Benjamin and the countless others who did not make it, they eventually crossed the border between France and Spain and settled in New York. French was my first language and the language in which I was educated. In 1958 I visited Europe and Paris for the first time. Since then, as a professional student of the French language and culture I have been back often. Perhaps someday, I fantasize, I shall retire to Paris. For now I have chosen to write on it, in order to come to terms with a longing, a fascination, an ambivalence, unfinished business.

In Martin and Mohanty's superb reading of Minnie Bruce Pratt's autobiography, her sense of at-homeness is exploded by the realization that it is founded on the exclusion of others: blacks, Jews, members of the working classes. It is this realization that makes of her text an exemplary political narrative. But what if one discovers that one's sense of never being at home, of exile, is founded on a quite different disillusion: the realization that the longed-for home (that is, Paris) was in fact the place where those who were excluded were one's parents. My idealization of Paris (and France), fostered by my education and confirmed by my career, has for years blinded me to the realization not of my or my family's guilty participation in mechanisms of exclusion based on race—of course, being excluded does not prevent one from excluding—but—and this realization is equally devastating—of my willful denial of the hideous historical realities of French collaboration in the genocide of my "race." Let me be quite clear on this point: my realization was not of the Holocaust in general, but of the fact that some of the same people who sell me baguettes and croissants today, or their parents, would fifty years ago have happily shipped my parents off to Drancy. Today some of them vote for Le Pen. And I collect postcards of *belle époque* Paris.

As predicted in the how-to books, my collection of French, then Parisian postcards eventually took shape, became more focused, more specialized. As I sifted through box after box of cards, I began to notice one particular series of view cards of Paris that stood out from the rest: those bearing the mark LL. Speaking of "the enigmatic Frenchman who merely describes himself as L.L.," Dûval writes:

L.L. was a bit of a "Scarlet Pimpernel." His globe-trotting activities took him and his camera to many places foreign to his native shores with no one quite knowing where or when he would turn up next. But such is the clarity and sparkling animation of his work, it is instantly recogniz-

able even before those tell-tale initials have been sighted. And how those initials have tantalized the devotees of the work of L.L. So frustrated was one collector he dubbed them to mean "Little and Large" and so ended the speculation as far as he was concerned. (CP, 31)

The information about LL is sketchy at best. In a piece on postcards at the Paris exposition of 1900, a contemporary singles out the LL series as among the best, speculating that they are imported from Germany, which at the time dominated the postcard industry both in terms of quality and quantity, flooding the less-developed French market with its production. This suggests that even then the LL cards stood out, and also that in 1900 LL was a trademark unknown to the cognoscenti. What appears established today is that LL stands for the Lévy brothers, Lucien and Ernest, sons of J. Georges Lévy, and that the Maison Lévy et Ses Fils was winning gold medals for its photographs as far back as the Exposition Universelle of 1855.[26] It is also known that sometime around 1919 LL merged with one of, if not the major producer of postcards of Paris and its chief competitor, Neurdein Frères (ND), which means that between them Lévy-Neurdein produced several thousand views of Paris. LL advertisements, printed in professional journals or on promotional postcards, boast of the exhaustiveness as well as the quality of their views, not only of France but of major international cities (figs. 1.3 and 1.4). And indeed those distinctive initials, which function as a sort of modernistic logo, turn up on all manner of cards, including many of those included in Alloula's *Colonial Harem*.

However much one may pursue this line of research, it is unlikely that one shall ever completely clear up the enigma of that logo because manifestly, as in any large-scale documentary project (as Tagg demonstrates in the case of the WPA), LL stands less for a personal signature than for a protocol that can be carried out repeatedly and everywhere by any number of anonymous executants. The initials LL guarantee a certain uniformity of the products that bear its trademark. There is an LL look, and it is precisely this distinctive look, the LL way of framing and segmenting turn-of-the-century Parisian urban reality, that interests me rather than the promotion of LL as *auteur(s)*.[27]

But before speaking of these postcards and the questions they raise, some information about postcards—their history, production, and collection—is in order.

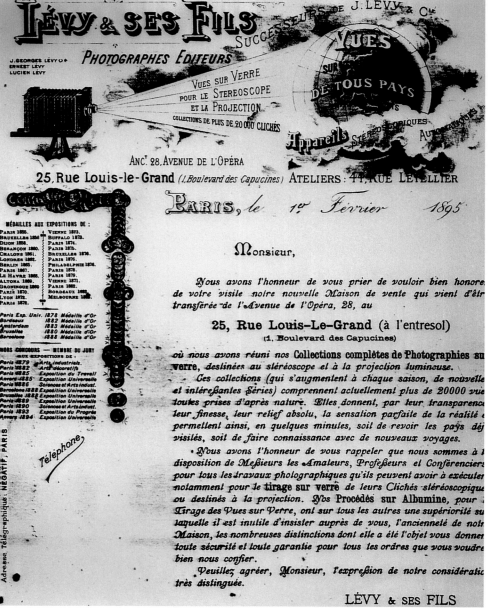

1.3. Advertisement for Lévy and Sons.

Inventing the Postcard

Depending on whether one adopts a continuist or discontinuist version of its history, one views the picture postcard either as a natural outgrowth of earlier forms of "illustrated paper"[28] or as a radical new invention of the age of such familiar indices of modernization as mass transportation and communication, rising literacy, expanding tourism, new mechanical means of reproduction. The continuist version of the history of the postcard is most authoritatively and persuasively argued by Frank Staff, who states categorically: "The postcard was not invented. It evolved."[29] An opposite approach, which is implicit in many other accounts of the postcard and its history, stresses instead the radical break introduced into the postal world by the invention of the postcard. However, the man most often credited with having "invented" the postcard, or at least having first conceptualized and named it, Heinrich von Stephan, later the postmaster general of Germany, himself adopts an evolutive model in his statement arguing the necessity of the postcard, or as he called it, the *offenes Postblatt* (open post-sheet): "The form of the letter, like many other human contrivances, has in the course of time undergone numerous modifications.... All the principal changes were gradual and passed through various transitional stages" (quoted in *PP*, 44). Because there is an intimate relationship between the material writing surface and the messages they bear, von Stephan argues that a new surface is in order to make possible briefer messages necessitated by changing times. It is thus the impetus of modernity toward increasingly brief communications that leads him to formulate the notion of the open post-sheet:

The present form of the letter does not however yet allow of sufficient simplicity and brevity for a large class of communications. It is not simple enough, because note-paper has to be selected and folded, envelopes obtained and closed, and stamps affixed. It is not brief enough, because, if a letter be written, convention necessitates some-thing more than the bare communication. This is irksome both to the sender and the receiver. Nowadays the telegram may be said to be a kind of short letter. People sometimes telegraph in order to save the trouble of writing and sending a letter....

These considerations suggest the need for a contrivance some-what of the following kind, as suitable for the present time:

Let there be sold at all Post Offices, and by all postmen, forms for open communications. (Quoted in *PP*, 44)

1.4. "Oui! La carte postale L.L. est moins chère á affranchir que la letter." Advertisement for Lévy and Sons.

The adoption of the postcard form did not fail to arouse opposition, in part precisely because of one of its most revolutionary aspects, its openness.[30] According to Staff, at least in England the main objections came from members of the upper classes who felt threatened by this new, more democratic epistolary device; it is easy to forget that until the mid-nineteenth century letter writing was a privilege of the mighty and the propertied:

They imagined that it would become all too easy for people to read other people's messages and private concerns, and that it would become easy for people to indulge in public libel and defamation of character as a means of venting spite or malice. There were others, too, who considered the use of a halfpenny postcard to be an insult, believing that if a penny was not paid for a message, then it was hardly worth sending at all; for many years the use of postcards was frowned upon by a certain class of person. (PP, 47)

Not surprisingly and for a number of reasons the despised new mode of communicating is associated with the feminine. Thus James Douglas, a prominent London journalist, affirms peremptorily in a long and fascinating article on the postcard written in 1907: "The Postcard has always been a feminine vice. Men do not write Postcards to each other. When a woman has time to waste, she writes a letter; when she has no time to waste, she writes a Postcard" (quoted in *PP*, 81). The association of femininity with postcard writing lends weight to the gradualist school of postcard historians, for what we have here is a transfer of the traditional association of femininity with letter writing to a new mode of written communication, further reinforced by the association of the feminine with the trivial, the picturesque, the ephemeral. But the association of the feminine and the postcard exceeds the traditional link between women and letters, for unlike the letter, the postcard is not just a means of communication; it is also, as we have seen, an object of collection, and this collecting activity secures the feminization of the postcard in the mind of its early commentators, such as the author of an 1899 article in the *Standard*: "The illustrated postcard craze, like the influenza, has spread to these islands from the Continent, where it has been raging with considerable severity. Sporadic cases have occurred in Britain. Young ladies who have escaped the philatelic infection or wearied of collecting Christmas cards, have been known to fill albums with missives of this kind received from friends abroad" (quoted in *PP*, 60).

Nor is this gendering of the postcard collection mania uniquely British. In 1900 we find the following observations in the advice column of *La Femme chez elle:* "A very feminine collection which has grown enormously in recent years is that of illustrated postcards.... Recently a veritable commerce of polite remarks and courtesies between young men and women has been established due to postcards. This pastime does not lack charm; for a well brought up young lady with a staunch heart and a cultivated mind, it provides thousands of ways of demonstrating her tact and savoir-faire."[31] If, as we saw earlier, collection is generally theorized as a masculine activity, the postcard constitutes an interesting exception to these laws of gendering; it is the very example of the feminine collectible.

Though the first official postcard was printed by the Austrian government in 1869, and the postcard industry continued to grow steadily throughout the late nineteenth century, it is not really until the turn of the century that the postcard developed into the mass means of communication and object of enthusiastic and cross-class collection it was to become in the period up to and including the First World War, generally considered the postcard's golden age. Throughout this formative stage of the postcard industry, which by the turn of the century had developed into a major economic sector employing some 30,000 people in France alone,[32] various changes took place that were to contribute to its immense popularity. These include the legislation of private as opposed to government-controlled production (1894); the lowering of postage rates; and the widespread dissemination of new reproductive techniques (notably *phototypie*). Perhaps no change was more momentous in its consequences than the crucial move to divide the postcard's back, which occurred in 1902 in England and 1903 in France.[33] Prior to this innovation, the entire back of the illustrated card was reserved for the address, leaving in effect little room for a message other than a brief salutation or signature often superscripted on the illustrated side of the card; however, the image rarely took up the entire space, leaving a whited-out space for the message. With the division of the card's back the relationship between the two sides of the card was transformed. As a result, the hierarchy between the two sides of the card was inverted, so much so that front and back changed places; the recto became the verso: "from 1904 on, the address side, which was still called recto, will be authorized to carry a message on half its surface. Little by little, it is no longer what one writes which is primary but the illustration, and following common practice it is this side which will henceforth be referred to as the recto, the message side coming to occupy second place and to be called verso."[34] The gradual

promotion of the iconic face of the illustrated postcard to primacy can be considered a sign of the rise of the culture of the image; it does not, however, signify that the message side of the card is of any lesser interest.

In both Europe and the United States no single event contributed more to popularizing the picture postcard than the series of World's Fairs and Expositions that were such landmark events during the latter half of the nineteenth century. The real beginnings of the picture postcard in France are generally thought to be the centennial 1889 exhibit in Paris, where the Figaro-produced postcards (known as "Libonis") of the Eiffel Tower could be purchased and mailed on the spot. Similarly, "the opening of the World's Columbian Exposition in Chicago on 1 May 1893 was the chosen event for the début of the first American picture postcards. In units of two at a time, the public could purchase ten different aspects of the Exposition from conveniently placed vending machines for the price of five cents a time" (CP, 17). But, and from now on I shall be concerned only with France, it is really the World's Fair of 1900 that inaugurates the ages of the postcard in France.

One can scarcely exaggerate the significance of the 1900 Universal Exposition in providing a catalyst for the development of an indigenous French postcard industry. Much has been written about this exposition and its extraordinary success and significance; what needs to be considered here is the significance of the link between this event and the mass production and dissemination of the pictorial postcard, especially as it represented Paris. What many historians of the postcard neglect to bring out is that the coupling of the popularization of the picture postcard and those spectacular events confirms not only the postcard's democratic vocation but also its less attractive penchant for propaganda and nationalistic self-promotion. And more so than in any other country, to promote the nation in France is to promote its capital, and vice versa. For it is impossible to speak of this exposition without taking account of a simple but crucial fact: beyond the numerous exhibits of exotic foreign and regional native cultures and artifacts, what people came to see—and they came by the millions (51 million visitors is the number now cited) from all parts of France and the world—was Paris itself. The chief display of the 1900 Expo was Paris, a Paris fully recovered from the three traumatic events that had blighted earlier fairs: the triple traumas of Haussmannization, the Siege of Paris and the Commune, and in a different way, the Dreyfus affair, which had seriously weakened France's self-aggrandizing claim to being a world-class fount of justice and human rights.

Visitors to the 1900 Expo were greeted at the main gate by an immense piece of kitsch statuary: a controversial statue called *La Parisienne,* whose ostentatiously modern dress broke with the tradition of allegorical female statuary: "The City of Paris welcoming its guests has been personified not by a Greek or Roman lady in classical drapery but by a Parisian woman dressed in the latest fashion."[35] Continuing this emphasis on Paris, the Exposition grounds boasted (in addition to the building representing contemporary Paris) a reconstituted medieval Paris, as though the Paris of Hugo's *Notre-Dame de Paris* had to be placed *en abyme* as a sort of foil for the new Paris that was being displayed and celebrated all around it. And finally there was the high point of the fair, the rue de Paris, extending from the Invalides bridge to the Alma bridge, a street representing the entertainments available in the city of light: "not a street of Paris, the metropolis of the arts, of Paris the great intellectual capital; but a street of a very special Paris, the Paris of artistic cabarets, of the latest chansonniers, of extravagant fantasies. It is, to sum it up in a phrase, Montmartre on the Cours-la-Reine."[36]

To celebrate Paris (as a woman, as a medieval wonder, as a place of popular entertainment) was to assert French national identity, to the exclusion of France's other cities, as well as to reaffirm its claim to being not just the capital of France but of the so-called civilized world. As Paul Grenehalgh points out, what distinguished the French exhibitions and perhaps especially the 1900 event was their nationalistic emphasis, in contrast with the more commercial character of the Anglo-American productions. And this emphasis on Frenchness was inseparable from, indeed conveyed by the emphasis on Paris: "The obsession with the civilizing aspects of 'Frenchness' led to a concentration of resources on events in Paris.... Paris was the show-piece which drained resources in order to tell the world what it was to be French, much to the annoyance of many other French cities and areas."[37] The potent link between the rise of the postcard industry and the promotion of the nation and its capital are expressed with enthusiasm by a contemporary journalist:

The triumph of the Post Card is once again the 1900 Exhibition. It was reproduced a thousand ways, embellished, overloaded with all the fantastic luxury of the most perfect bad taste: sites, types, unknown corners, overviews, costumes, perspectives, architecture, all topics, all points of view on the huge international exhibition were exhausted.

Even the lightwork was imitated by sewing star-shaped beads onto the images. Despite the infantile aspect of these illustrations destined to dazzle simple souls, there is something touching about these processes. It is France they celebrate, that they make known and loved.... For my part I love these multicolored paint-daubed squares of paper which naively radiate the childlike glory of the fatherland.[38]

The Postcarding of Paris

As many commentators have pointed out, throughout the nineteenth century, but especially during the latter half of the century, artists, writers, journalists, and photographers were seized with the obsession to submit the entire social body to exhaustive scrutiny and record. It was, in Philippe Hamon's apt phrase, the "age of the exposition": "a panoptic and democratic obsession with transparency, display, opening, bringing into the light and placing into circulation [*mise en lumière et en circulation*] installs itself."[39] As MacCannell observes, this ideal of transparency is the essence of modernization, which he defines as "the opening up and dramatization of every important social institution."[40] And nowhere was this obsessive desire to expose and inventory the real more active than in Paris, because, as Daniel Oster and Jean Goulemot observe, the city's very heterogeneity inspires taxonomies: "Diversity gives rise to inventories"; and further, "Paris is a city one numbers [*numère*] and enumerates [*enumère*]."[41] These inventories take the form of the famous *physiologies,* the equally famous *guides* (especially the *Paris-Guide* assembled for the 1867 World's Fair with contributions from the greatest contemporary writers), much of Honoré de Balzac's *Comédie humaine* and Émile Zola's *Rougon-Macquart,* Maxime Du Camp's multivolume *Paris,* and many, many more. In fact, as Hamon acutely observes, in the case of Paris the taxonomic urge does not operate on a completely inchoate referent, for Paris is "itself pre-articulated by power (the 'quartiers' or 'arrondissements', the streets 'aligned' and the monuments 'landmarked' by the administration)."[42] There are, notes Hamon, twenty volumes in Zola's *Rougon-Macquart* just as there are twenty *arrondissements* in Paris! What we have in the case of the postcarding of Paris is then a layering effect, grid upon grid.

Haussmannization enhanced this "pre-articulation" of the urban fabric by "segmenting" the city into increasingly discrete and socioeconomically homogeneous *quartiers* whose express function

it was to separate the classes, and whose perhaps unintended effect was to confine the working classes to isolated districts, cut off from the flow of urban life.[43] Haussmannization widened not only the gulf between the *beaux quartiers* and the teeming ghettoes of the dangerous classes but also, and this is of particular interest to me, the gap between the bourgeois spectator-*flâneur* and both the bourgeois women and the worker whose access to metropolitan life was severely limited: "It was the bourgeois who was more likely to be able to move from scene to scene; the worker whose lesser economic circumstances were more likely to confine him to a locale," writes Richard Sennett.[44] The ability to move from *quartier* to *quartier,* hence to adopt the all-seeing perspective of the taxonomist, was throughout much of the nineteenth century a privilege of class and gender, since as all agree there was no female equivalent to the *flâneur;* in Janet Wolff's apt phrase the "flâneuse" was "invisible," unthinkable.[45] Whatever the LL initials hide I would be most surprised to discover that any member of the LL team was a woman or a worker. The postcarding of Paris then participates in, indeed spectacularly carries forward into the twentieth century, the nineteenth-century representation of Paris as made up of ever more finely fragmented coequal visual units, and that representation is bound up with the marking of differences along class and gender lines. Yet, at the same time, it must be noted, some of these postcards also attest to the breakdown of these systems of segregation inherent in modernity: several highly popular series of postcards are devoted to a small group of women (often fallen aristocrats) who symbolize the coming of a new age of female urban mobility: the women coach drivers, the secular goddesses of *nouveau* Paris (fig. 1.5).

At the turn of the century the omnipresent view card is the chief perpetuator of the lightly controlled panoptic gaze, the positivist taxonomic imperative, the bourgeois apprehension of the real as composed of interchangeable microunits, as well as of course the democratic urge to expose to the sunlight. The ontology of the postcard is totalizing:

Nobody need fear that there is any spot on the earth which is not depicted on this wonderful oblong. The photographer has photographed everything between the poles.... The click of his shutter has been heard on every Alp and in every desert. He has hunted down every landscape and seascape on the globe. Every bird and every beast has been captured by the camera. It is impossible to gaze upon a ruin without finding a Picture Postcard of it at your elbow. Every pimple

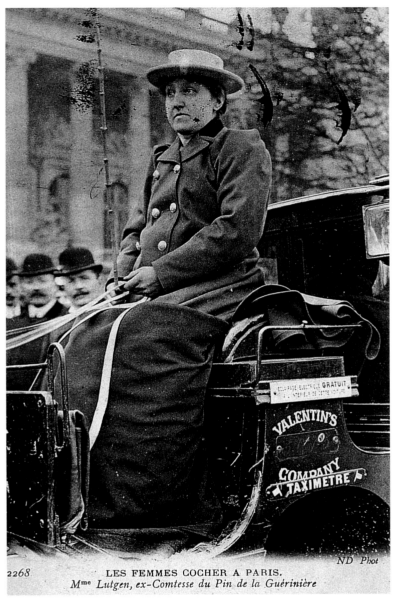

2268 LES FEMMES COCHER A PARIS.
M^me _Lutgen, ex-Comtesse du Pin de la Guérinière_

1.5. "Les Femmes Cochèr á Paris."

on the earth's skin has been photographed, and wherever the human eye roves or roams it detects the self-conscious air of the reproduced. The aspect of novelty has been filched from the visible world. The earth is eye-worn. (James Douglas, quoted in *PP*, 79)[46]

The postcarding of Paris was an immense enterprise: the chief series on Paris (Tout Paris, Gondry, ND, LL, FF, CM) produced, so far as I make out, something like 10,000 views of the city, and to this we must add many smaller more specialized series, such as those on the *petits métiers* or on sports. There are cards covering every aspect of Parisian life: its small crafts (ragpicker, umbrella salesman, dog shaver, mattress maker), its markets (Halles) and slaughterhouses (Villette), its bizarre characters (Bibi *la purée,* the shoe shiner; E. Guenon, the human telegraph; MacNorton, the human aquarium; G. Ménart, the rat chaser; M. Rémond, the walker on water in the Bois de Boulogne), its fires and floods (notably that of 1910), its strikes and demonstrations, on the one hand; its glitzy social events (the races, visiting royalty), beautifully manicured gardens, fine shops and department stores, and spectacular public monuments, on the other. In the most extensive series each number corresponds to a particular view, and major sites are photographed from every conceivable angle: the Madeleine is viewed frontally at close range, from midway down the Rue Royale, and from as far as the Place de la Concorde; each gargoyle on Notre-Dame's towers has its slot (figs. 1.6 and 1.7).[47]

Produced during what was clearly experienced by contemporaries as a transitional moment, the postcards record both the vanishing *vieux* Paris and the emerging *nouveau* Paris or Paris *moderne*.[48] And yet I would argue that despite the great diversity of *belle époque* Paris postcards, which defy easy generalizations, the LL series most accurately represents the dominant discourse on Paris produced by Paris in the first decade of the twentieth century, a discourse clearly inflected by a politics of class, civic, and national privilege. When subjected to close scrutiny, the series is in fact highly selective in its representation of the city. And this selectivity, or lack of exhaustiveness is typical of Paris postcards in general even to this day. The *arrondissements,* for example, are not all equally well represented. Gérard Neudin, in his authoritative guide, lists among the well-represented *arrondissements* the first, fifth, sixth, seventh, eighth, and ninth, which means that all the others, which include both the high-bourgeois sixteenth and seventeenth as well as the more working-class eighteenth and nineteenth—residential areas unlikely to be visited by tourists—are underrepresented.

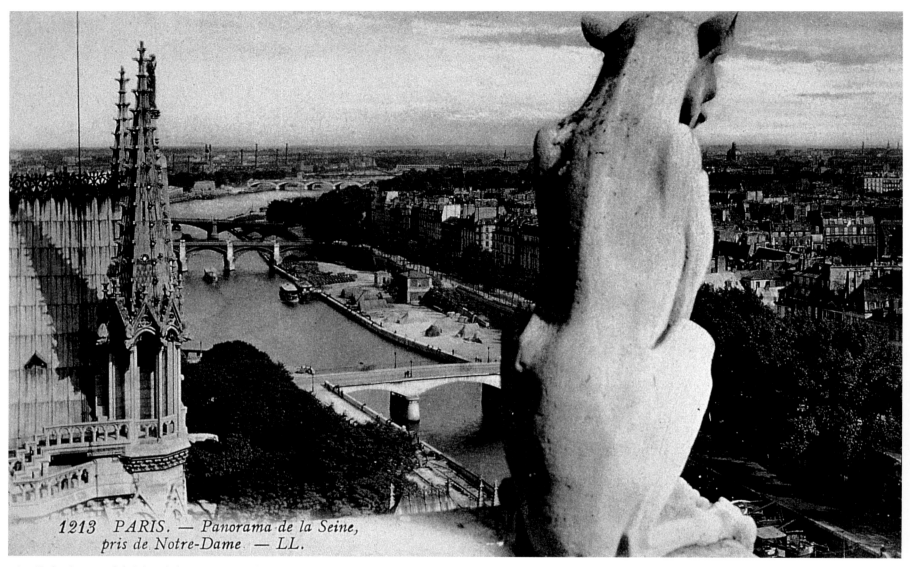

1.6. "Paris.—Panorama de la Seine pris de Notre-Dame.—LL."

The society privileged in the early postcards is the society of spectacle first identified by the situationists and brilliantly studied by T. J. Clark;[49] the vision produced by many of these cards is that of a prosperous city bustling with commercial and leisure activities, a remarkably beautiful city miraculously free of unsightly slums and disfiguring poverty, a place where people throng the broad avenues and boulevards, or are strangely absent from museum interiors, but a city where no one is ever caught working, except possibly plying some highly picturesque *petit métier,* such as making mattresses on the *quais* or selling birds. In short, the Paris of the 1900 postcard is a highly idealized Paris, the home of a triumphant middle class, and in this it is no different from its Edwardian counterparts, for, as Dûval notes, "it is difficult to find postcards showing views of the less salubrious areas in which the majority of people lived. Professional photographers tended to concentrate on the more aesthetic aspects of what was fashionable and picturesque rather than record the grimy drear of the back streets" (*CP,* 33).

Not surprisingly, given this decidedly bourgeois emphasis, the very center of LL's Paris has shifted away from the traditional center of the Île de la Cité. As against Notre-Dame, the ground zero of an earlier Parisian self-representation and panoramic totalization—the inaugural card in the series ratifies the shift to the west and the upper-class neighborhoods brought about by Haussmann; it represents l'Arc de Triomphe (fig. 1.8). An overwhelming number of cards represent the great sights of the right bank: the Arch, the Champs-Élysées, the Bois, the Madeleine, the Parc Monceau, the Opera both inside and out. For though LL is primarily a recorder of facades, certain cards record in great detail the interiors of such monuments as Notre-Dame, the Opéra, the Panthéon, and most uncannily, the Louvre and other museums (fig. 1.9).

If what fascinates in the colonies, as well as in the more exotic regions of France (notably the domestic Orient constituted by Brittany) and even picturesque parts of Paris, is the quaintness of dying traditional societies with their beautiful costumes, strange rituals, and other emblems of auratic cultures, what is conveyed by views of Paris 1900 is the thrill of modernization. The Paris of LL is not the Paris of Eugène Atget (the author of the eighty-card series, "Petits Métiers de Paris"); it is not the Paris of eerily deserted back streets and melancholic fountains. Rather, it is a Paris proud of its glorious past but enamored of the present. Everywhere are the icons of modernization: trains, buses, passenger cars, and through

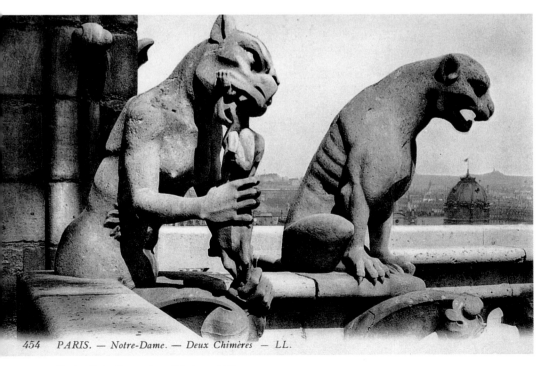

454 PARIS. — Notre-Dame. — Deux Chimères — LL.

1.7. "Paris.—Notre-Dame.—Deux Chimères.—LL."

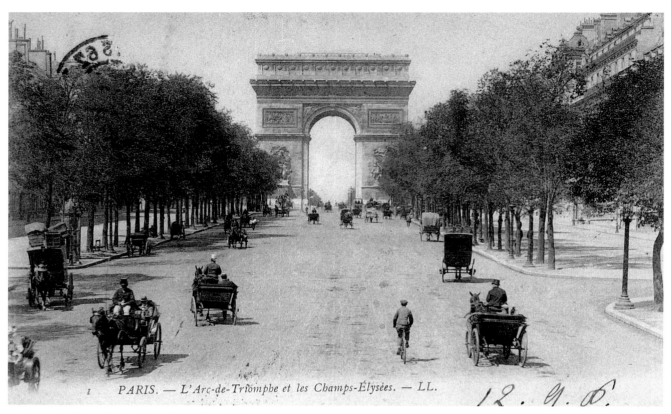

1.8. "Paris.—L'Arc-de-Triomphe et les Champs-Élysées.—LL."

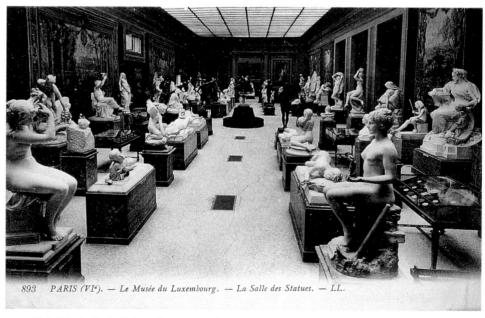

1.9. "Paris (VI).—Le Musée du Luxembourg.—La Salle des Statues.—LL."

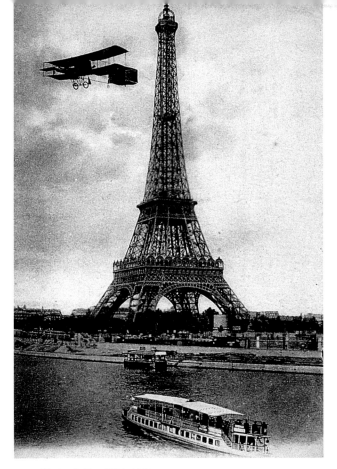

1.10. "Paris.—La Tour Eiffel—LL."

what appears to be the wonders of trick montage even planes flying incongruously low over the monuments of the past. It is not unusual in these resolutely modernist cards to find the emblems of progress piled one on top of the other: a flotilla of omnibuses parked near the metro entrance in front of a train station, a plane flying over the Eiffel Tower while a *péniche* sails by, and so on (fig. 1.10).

Perspective is crucial to the effect produced by these artfully constructed views. The camera is almost never positioned at ground level; rather, it hovers somewhere slightly above, so that the viewer dominates the scene. Major monuments often serve as vanishing points, which has the effect of diminishing their intrinsic interest—they are at best hazy vertical forms in the distance—while heightening the sense of rational urban planning (figs. 1.11 and 1.12). Symmetry further contributes to a reassuring sense of balance and harmony, even when, as is sometimes the case, all the people seem to be walking down one side of the avenue or street (fig. 1.12).

Here and there a detail of street life arrests one's glance in the manner of the Barthesian *punctum,* and the street scene is the universe of the *punctum:* a man checks his fly as he leaves a public urinal (fig. 1.13), a dapper walker lifts his cane in the air as he is about to cross the street, two coachmen chat during a traffic jam in the Bois (fig. 1.14), a man seated on a bench tips his hat to an invisible person beyond the borders of the card, a horse-drawn cart piled high with hay crosses a tram while a man—perhaps suffering from hay fever—passes by blowing his nose.

Above all, LL's Paris, more so than that of any of its competitors, is a Paris suffused with a warm and radiant light: in contrast with other series, which often go in for Monet-like variations on Paris in the rain, Paris in the snow, Paris at dusk, Paris by night, it is or at least it seems to be always high noon in LL's views of Paris. This euphoric luminosity is, of course, an effect produced by technical advances in the field of photographic reproduction, notably the process invented by one Tessié du Motay, known as *phototypie,* which enables the cheap reproduction of photographs with, in the words of one historian, their "values of shadow and light, going from deep black to pure white and including all the shades of grey."[50] But it is also a key element in LL's grammar of representation.

And this brings us to what is finally for me a central issue, since it is precisely what is almost always left unaccounted for in the totalizing analyses derived from Foucault: I refer to the extraordinary pleasure produced by viewing these cards, *plaisir de la carte.* Unquestionably that pleasure is complex, and in order to account for it we must turn away from Foucault and his analytic of the pleasure of power and toward Barthes, the professor of the power of pleasure. Part visual (these cards are very beautiful), part cognitive (these cards contain a great deal of information), the *plaisir de la carte* is in large part nostalgic. As Staff observes, there is something Proustian about early picture postcards: "Today, when an Edwardian picture postcard is held in the hand, time for the moment is captured; for the picture is not just a reproduction or copy such as can be seen in a book, but is an actual representation of that time, and is something belonging to those years" (*PP,* 71). This is a crucial insight: what we have here is not simply a representation of Paris, but a fragment of past Parisian life. The postcards we hold in our hands and file away in our albums are the same cards as those we can see represented on postcards of postcard displays (fig. 1.15); they create, however tenuously, some

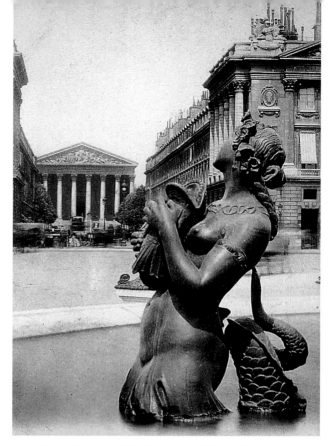

1.11. "Paris.—Perspective de la Rue Royale et l'Église de la Madeleine.—LL."

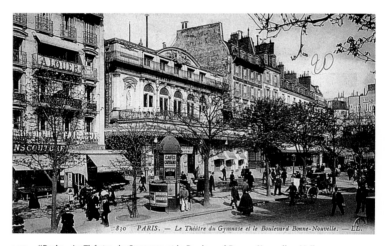

1.13. "Paris.—Le Théatre du Gymnase et le Boulevard Bonne-Nouvelle—LL."

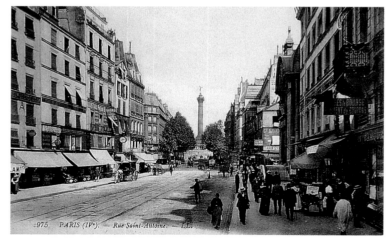

1.12. "Paris (IV).—Rue Saint Antoine.—LL."

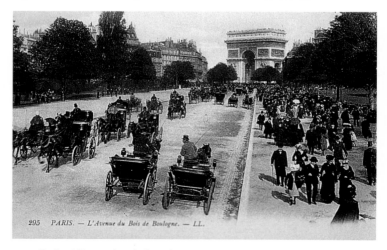

1.14. "Paris.—L'Avenue du Bois de Boulogne.—LL."

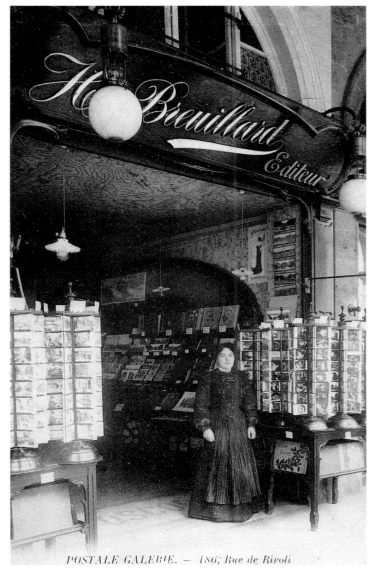

1.15. "Postal Galerie.—186 Rue de Rivoli."

sort of direct link between the viewer and the viewed. The complex and shifting reality that was Paris at the turn of the century is here reduced to a series of discrete units that can be easily manipulated and readily consumed.

Recto/Verso

So far I have proceeded largely as though the postcard were merely a minor mode of photography, but of course what constitutes the specificity and the fascination of the modern illustrated postcard is that it has, as we have noted, two sides, two faces, the pictorial and the scriptural. It is the perfectly reversible semiotic object, a virtual analogon of the sign. Just as the image face of the postcard provides visual representations of the street scenes of Paris 1900, the message side records the millions of exchanges between the men and women of that time, which often refer quite explicitly to the choice of image, for the sides are not sealed off from one another any more than are the signified and signifier. As one author puts it, the relationship between the two sides is "never gratuitous, even if it sometimes remains ambiguous."[51] It is in reading those communications, which range from laconic formulaic greetings to virtual letters in the crabbed microscopic handwriting the French call *pattes de fourmi,* that one is placed in the position of the voyeur, or better yet the eavesdropper on everyday life. If the pictorial side of the postcard has been replaced by TV and other visual media, the message side is the forerunner of the telephone. From the backs of these cards emerges a murmur of small voices speaking of minor aches and pains, long-awaited engagements, obscure family feuds; reporting on safe arrivals and unexpected delays; ordering goat cheese; acknowledging receipt of a bouquet of violets, a bonnet; in short, carrying on the millions of minute transactions, the grain of everyday life (figs. 1.16 and 1.17).[52]

Coda: Benjamin's Paris

When attempts are made to contextualize Benjamin's *Passagen-Werk,* and they are made repeatedly, the emphasis generally and properly falls on the complex intellectual and/or historical contexts of the project: Benjamin's variously influential interlocutors and readings, the events of February 1934 and 1936 (the Popular Front). What is surprisingly neglected is the physical context in which Benjamin worked on his magnum opus; in other words, what was the Paris of

the twenties but especially the thirties like?[53] More specifically: how did that Paris represent itself and to what extent does Benjamin's project participate in that distinctive urban consciousness?[54] Once again in order to grasp that metropolitan discourse I turn to the postcard.

After the golden age of the postcard came its decadence. The quality of the images declined, the craze for postcard collecting waned, and albums formerly displayed in the living room were relegated to the attic. The comparison between the sparkling, richly detailed view cards of the first decade of the century and the muddy sepia-colored view cards of the thirties provides striking and highly legible information about the shift in urban self-representation from the prewar period to the depression years. There is more going on here than a mere decline in the quality of reproduction; the discourse produced by these cards is shot through and through with a melancholic nostalgia that the future-Oriented World's Fair of 1937 and its multifarious glossy black-and-white postcards cannot offset. The representation of the chimera of Notre-Dame set against the Paris skyline—a topos of Paris photography from its origins to the present—attests to the passage from a euphoric diurnal to a dysphoric nocturnal regime of self-representation (figs. 1.18 and 1.19). But there is more: if we turn over the cards produced by the editor Yvon we find that they are part of a series called "Paris...en flânant."

Though the *flâneur* as such is a nineteenth-century type whose modern avatars are, according to Benjamin, the reporter, the sand-wichman,[55] his own reflections on the *flâneur* must be seen against the background of a Paris packaged as a series of *passéistes* tableaux arrayed before a regressive twentieth-century *flâneur*. Even as Benjamin is promoting the *flâneur* as artist of modernity, the mass media (for example, the postcard) is engaged in making *flânerie* synonymous with a rejection of modernity, a bittersweet quest for a fleeting past, a way of life about to be engulfed in apocalypse, the very same one that engulfed Benjamin. The next chapter in the *discourse of the metropolis* will be written by its new occupants, and notably by that paradigmatic hurried modern tourist, Hitler. Here, even the promiscuous postcard industry falters, and there are as yet in the immense and constantly expanding bank of Paris view cards (at least to my knowledge) no post-cards of the famous photographs of Hitler in front of the great monuments of Paris. But perhaps it's only a matter of time.

AND YET THERE ARE BUT POST CARDS, IT'S TERRIFYING.

—Jacques Derrida, *The Post Card*

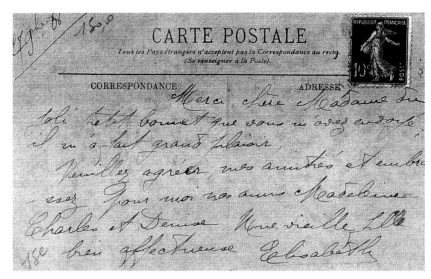

1.16. Handwritten message on a *carte postale*.

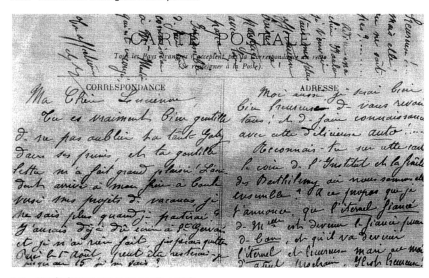

1.17. Handwritten message on a *carte postale*.

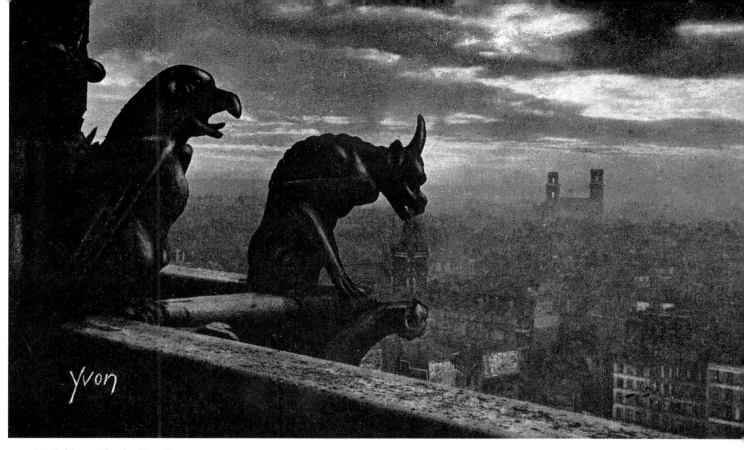

1.19. Detail of the west façade of Notre Dame.

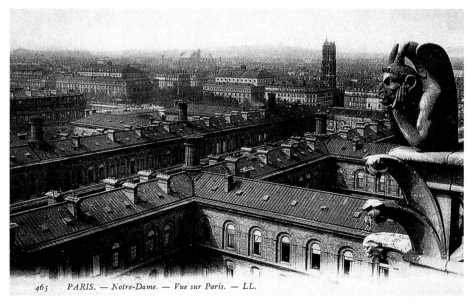

465 PARIS. — Notre-Dame. — Vue sur Paris. — LL.

1.18. "Paris.—Notre Dame—Vue sur Paris—LL."

..

POSTCARDS AND THE

..

INVENTION OF OLD AMSTERDAM

..

AROUND 1900

..

Nancy Stieber

Around 1900, most cities had been "postcarded," their major features committed to images on cardboard that could be sent through the mail. The postcarding of a city was an international phenomenon; publishers documented the city's physical features in similar fashion, whether in Lisbon, Buffalo, or Munich. Following in the wake of the topographical carte de visite and the stereocard popularized in the nineteenth century, by 1900 the postcard had become the chief mode for mass production of city images. Amsterdam was no exception to this process. The first Dutch topographical postcards were published on the occasion of the 1883 International Colonial Exhibition in Amsterdam. By 1901 more than a dozen postcard publishers were active in Amsterdam alone, and the flood of postcards in the Netherlands had become so great that the post office temporarily suspended all sales of illustrated cards in order to catch up with the backlog.[1]

The aim of this chapter is not to provide a general survey of fin-de-siècle postcards of Amsterdam, but rather to demonstrate some of the work they performed for local needs. I will argue that postcards, aside from their mundane and obvious uses, operated as visual expressions of attitudes toward the historical development of the city. Alongside other forms of popular visual culture such as view books, prints, and stereocards, postcards were harnessed to express attitudes toward the changing cityscape. But because of the opportunities they offered users literally to leave their marks on the cards and to assemble and reassemble them in narratives about the city, postcards provided a more personal and even intimate instrument. The example of Amsterdam described below is not atypical of the uses to which postcards were put in other cities, particularly those contending with the changes attendant on rapid urbanization around 1900.

From the 1880s to the 1920s, the period coinciding with the postcarding of Amsterdam, the cityscape underwent a rapid, continuous, and far-reaching renewal of its infrastructure, growing for the first time beyond its seventeenth-century boundaries. In those years, construction of the Central Station altered the city's famed riverfront skyline, a new ring of residential districts arose around the city, the harbor works were renovated, canals were filled to create wider transportation routes, and large-scale office buildings and department stores were introduced into the inner city. While parts of Amsterdam remained unaltered, modernization was nonetheless evident everywhere, if only by virtue of ubiquitous telephone lines and electric tram wires. Amsterdam in this period was a city learning how to master its growth. It introduced new controls for construction: a building ordinance in 1905; an aesthetic advisor appointed to the Department of Public Works in 1913; an architectural committee to review new building de-

signs on city land along with a Committee for Urban Beauty to prevent the loss of existing old buildings; and in 1917 a new, aesthetically motivated plan for the further extension of the city.

The rapid changes of the last quarter of the nineteenth century affected the daily experiences of the city's inhabitants, who viewed the shifts in the cityscape with ambivalence. On the one hand, familiar spaces were being altered; on the other hand, new spaces were being created. Given the widespread curiosity about, concern for, and celebration of the shifting urban landscape, the need arose to make those changes comprehensible by narrating them verbally and visually. A plethora of popular descriptions, guidebooks, histories, picture books, and series in newspapers and magazines followed the changes in the city closely in word and picture. The postcard offered an immediate and active way to participate in this documentation of urban change. The producers of the cards realized that there was a market for postcards aimed at the local population, whose familiarity with the city would enable them to read the images on the postcards with more precision than the tourist. For the tourist the card usually functioned as a metonymic device in which a landmark symbolized the entire city and through which evidence of a visit could be mailed, while cards purchased by Amsterdammers, as we shall see, could be interpreted with greater nuance and thus be used in more varied ways—one of those being to illustrate the historic development of the city.

Contending with Urban Change: The Postcarding of Amsterdam and Personal Geography

By 1900 a large array of topographical postcards of Amsterdam was available. German manufacturers dominated the earliest production of Dutch subjects, but soon a myriad of smaller and larger publishers in the Netherlands created local competition.[2] Some of these sent their photographs to Germany for production. Others set up printing workshops in the Netherlands.[3] Many images first produced for photograph albums were reissued as postcards (figs. 2.1 and 2.2). New photographs were also commissioned. One Dutch publisher began offering 75 postcard views of Amsterdam in June 1901, and by May 1902 was offering 190. It was not unusual for the same photograph to show up as a cabinet photo, a postcard, in a view book, or as an image in the illustrated press.[4] Publishers also used the same photo-

graphs repeatedly in their postcards, reissuing them with variations in cropping, offering colored or uncolored versions. Sometimes the same photograph moved from publisher to publisher. Together the proliferation of topographical postcards before the First World War constituted a vast collective achievement in representing the contemporary cityscape.

While postcard publishers had the tourist foremost in mind as the market for their topographical cards, a local audience also made use of the new illustrated cards much as it had come to use the previously introduced blank postal cards: as greeting cards for birthdays, get-well cards, and birth announcements; for making appointments, conveying congratulations, and sharing family news. In a period when as many as three mail deliveries a day allowed for a quick exchange of information, the postcard served daily communications as a precursor to the as yet less widespread telephone.

With the arrival of postcards, the local market for images of Amsterdam was served by the proliferation of neighborhood postcard publishers. A local shopkeeper would hire a photographer, often one attached to a company that printed postcards, to take shots of the neighborhood, send the photos to be produced as postcards, and then sell them from the shop to the people in the neighborhood, often with his or her own imprint.[5] Through their activities, nearly every street and alley in the city was photographed around 1900. While the number of cards representing the main sights of the city and the older districts far exceeded the number for the ordinary neighborhoods, the very fact that most Amsterdammers could count on mailing a postcard of their own street indicates the almost encyclopedic result of postcard manufacture around 1900.

Amsterdammers not infrequently selected cards because the image on the card conveyed the sender's relationship to the city. Messages on such cards might indicate that the street represented is where the sender lives. On a postcard showing the park around which a military band would parade on royal birthdays, a teacher writes to her pupil in 1901, "Now you see in which part of the city your teacher lives. It's so crowded there on the Queen's birthday" (fig. 2.3).[6] Four children, two brothers and two sisters from Amsterdam who had traveled to Friesland in 1912, send "the daughter of the station chief in Stavoren" a card of the street they live on after their return. Cards are used to remind the recipient of places in the city where experiences had been shared with the sender. A sister writes a faraway brother birthday greetings on a card showing a quay on the Amsterdam

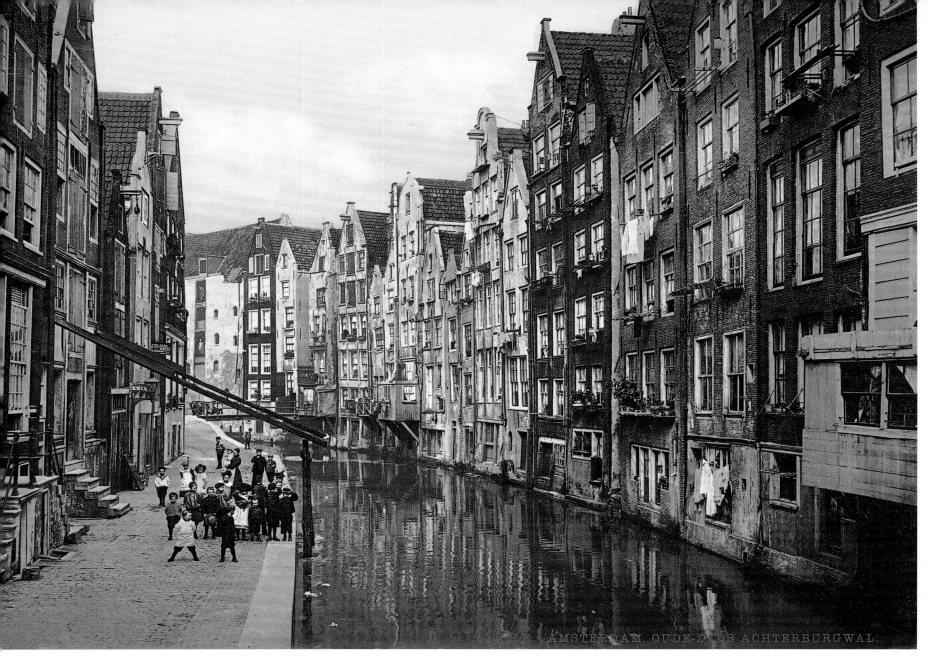

2.1. "Oudezijds Achterburgwal," ca. 1890.

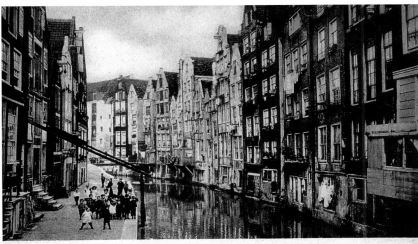

O.Z. Achterburgwal, Amsterdam.

2.2. "Oudezijds Achterburgwal," before 1905.

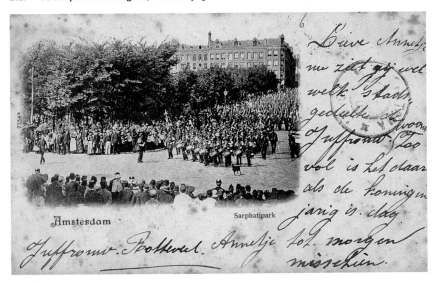

2.3. "Sarphatipark," mailed in 1901.

harbor, "Do you still remember that we walked here and you asked a hundred questions?" Another sister writes birthday greetings in 1899 to her sister with the reminder, "This is the park where we walked so often in the winter, but now it's green with leaves."

Such combinations of text and image construct a personal geography of the city, one that usually overlooks the landmark status of what is represented on the postcards in favor of a more intimate connection to location. These cards do not participate in the construction of the tourist stage; rather, the cards become an aid to documenting a private map of the city. A lover writes his girlfriend on a card of a windmill at the edge of the old city, "Can you still remember from where you saw this mill? Have a good look. I think there are still some pleasant memories connected to it." In such a case, even a well-known landmark becomes transformed into the personal token of a shared experience. On a card showing Amsterdam's crystal palace, a symbol of its modernity, an aunt tells her niece Nellie in 1900, "Because you are so sweet you may stay with auntie a few days and I'll let you see exactly what's on this card as large as life" (fig. 2.4). Here the image represents not a shared memory but the promise of a shared experience. Nellie's aunt makes no direct reference to the particular building or the bridge represented on the card, which were frequent subjects of Amsterdam postcards. Rather, the card becomes a means to convey the excitement of seeing the cityscape "as large as life," in reality, not simply as a representation. This contrast between the represented city and the city as experienced, often accentuated in these messages, was quite distinct from the tourist's use of the card as a warrant of having been on the spot. The postcard with the message about the traveler's experience provides the recipient only with an image and a sense of separation and distance. The Amsterdam cards cited above provide a palpable connection to the city's spaces, a sense of familiarity and belonging, of either memory or anticipation of sharing the place depicted on the postcard.

Most Amsterdam cards, however, were not mailed and not marked by messages. Many were purchased by collectors to construct a visualization of city for their own enjoyment. From their earliest publication, topographical postcards were immediately considered collectible. While the advent of technologies of mass production such as the carte de visite and the stereocard had already lowered the price of topographical images, the postcard was still cheaper.[7] Collecting images of the city's topography was now possible for the masses. In the Netherlands, following German and French leads, clubs were

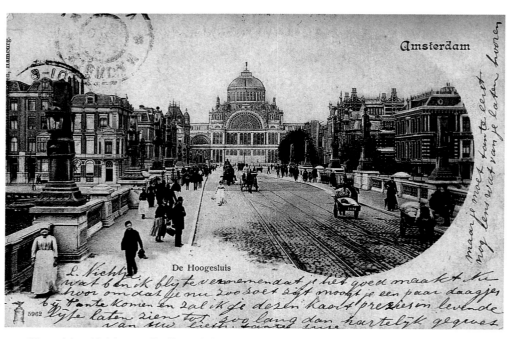

2.4. "Hoogesluis and Paleis voor Volksvlijt," mailed in 1900.

founded for collectors, instructing them on the proper construction of a collection, providing names of collectors in other countries, and establishing the protocols for communication among collectors.[8] Club magazines enjoined collectors to collect cards that had been postally used. While some collectors insisted that a stamp be placed on the picture side of the card, judging from the greater number of Amsterdam cards from the period before the First World War that were never mailed, many collectors simply wanted the unused and pristine card.

The club journals frequently claimed that "everyone, high or low, rich or poor" could afford to collect, and there is some evidence to corroborate that collecting was widespread throughout Dutch society.[9] But it is difficult to determine the age or class range of collectors other than from anecdotal sources. We can surmise that a collector frequently listed in the postcards journals, Mrs. J. G. M. de Bruijn-Brinkman, who lived in a mansion on one of elite canals in Amsterdam, summered at a chic address, and stamped postcards that she mailed to collectors with either address, was an upper-middle-class matron. It is notable how prevalent women are on the lists of collectors, some advertisements mentioning specifically that "ladies from respectable circles" are invited to exchange cards. A message in doggerel verse sent on a card to a child by a family member states, "This building, called the Amstel Hotel, cannot be left out of an album," leaving no doubt that children collected postcards.

Collectors often exchanged cards with others in foreign countries. The collectors' magazines not only provided lists of those who wanted to enter into an exchange, but gave collectors standard phrases in the major languages. Some insight into how Amsterdammers wished their city to be seen by foreigners, or perhaps the image of the city they believed foreigners desired to receive, can be gained from postcards sent to a pair of sisters in Havana between 1908 and 1910 by Eugénie Kruijt, a lady who lived on a respectable middle-class street in Amsterdam. The exchange of cards between Havana and Amsterdam was initiated by Mrs. Kruijt, who probably found the sisters' address in a collectors' magazine. Selecting one of the views considered typical of the city, on the first card she mailed them she writes in French, "Do you wish to exchange cards with the Netherlands?" (figs. 2.5 and 2.6). Her choices, at least in the thirty-four cards that have survived, were primarily located in the older sections of the city, but she also included seven depicting the new districts constructed in the previous decades (fig. 2.7). The cards, nearly half of which were produced by the German postcard publisher Dr. Trenkler, are all in color, with stamps placed on the pictorial side. Colorful and

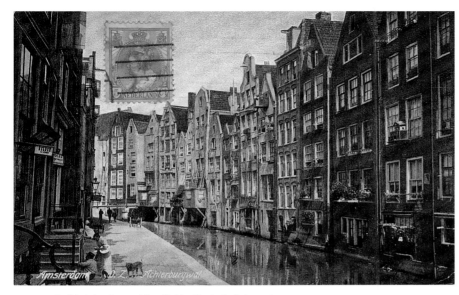

2.5. "Oudezijds Achterburgwal," mailed by Mrs. E. Kruijt in 1908.

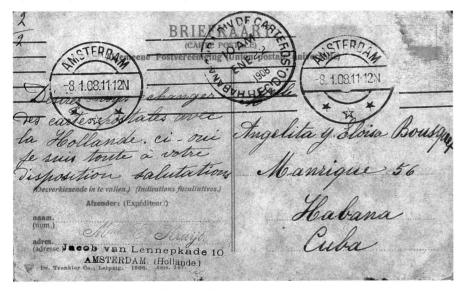

2.6. Handwritten note by Mrs. E. Kruijt (verso of fig. 2.5).

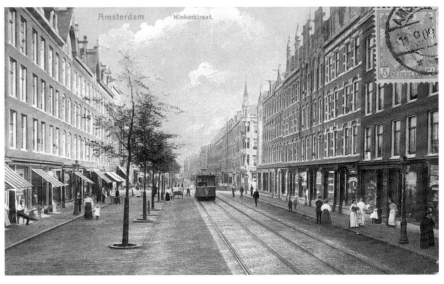

2.7. "Kinkerstraat," mailed by Mrs. E. Kruijt in 1909.

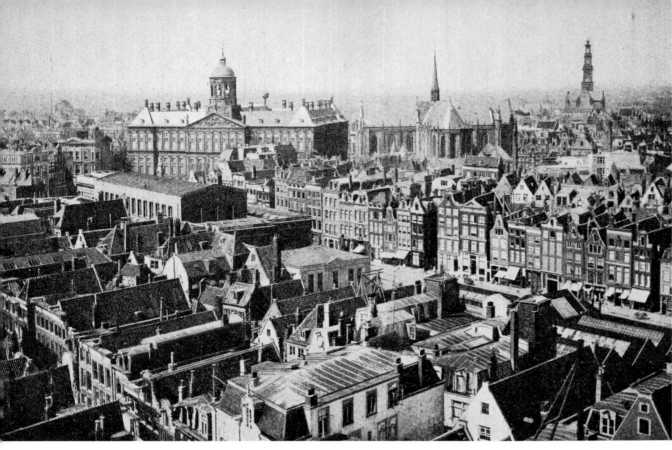

2.8. Photograph taken from the spire of the Oude Kerk.

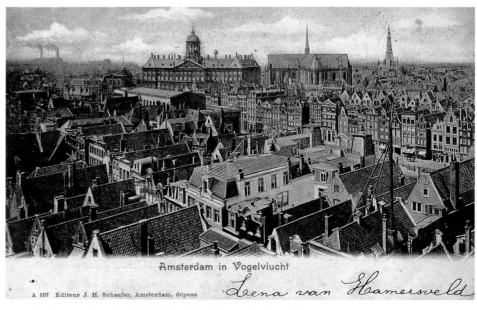

2.9. "Amsterdam in Vogelvlucht" (Bird's-Eye View of Amsterdam), mailed in 1901.

bright, these cards portray a modern, industrious city: bustling shopping streets, markets, busy thoroughfares, and major urban institutions. Twenty of the cards include an electric tram. While this sample is too small to draw more general conclusions, it is evident that this Amsterdammer was interested in portraying the city as a vibrant, contemporary metropolis and assumed her foreign colleagues wanted such cards. In 1918 the Cuban sisters received another fourteen cards of Amsterdam from a different Dutch collector. These were all published by Amsterdam companies in garish colors, and half depicted the recently constructed portions of the city. On the other hand, three cards sent abroad by Mrs. de Bruijn-Brinkman were of the most standard touristic postcard views: the Rijksmuseum, the Herengracht, and the Groenburgwal. Even this small sample of cards sent by Amsterdammers to others reveals that the choices made convey differing visions of the city.

But what of Amsterdammers collecting Amsterdam postcards? Of ten cards sent from Amsterdam to Hilversum between 1901 and 1904 to a young lady for her collection, eight are of frequently depicted views, such as the Dam and the Groenburgwal. Only one card has a message ("Here is a card for your collection"); the rest are simply signed. The fact that the friends and family chose standard views may be an indication that this collector was not particularly discriminating. The postcard magazines took collectors to task for failing to specialize. Postcard collecting, like stamp collecting, was meant to be a serious hobby from which one could learn. One senses a defensive posture against the commonly expressed reproach that postcard collecting was a temporary fad, a frivolous pastime.

Serious collecting of topographical images of Amsterdam had a long pedigree. The creation of so-called topographical atlases had reached its heyday in the eighteenth and nineteenth centuries, when Amsterdammers assembled vast collections, of prints, drawings, maps, and paintings of the city.[10] In contrast to the later postcard collectors, these were largely upper-middle-class, male members of the Amsterdam elite. In the nineteenth century, photographs began to take a modest place in their collections but postcards were not considered appropriate material. In 1904, however, one of the most distinguished of the modern collectors, D. C. Meijer, who played an important role in the formation of the local Amsterdam historical society, commented that the postcard was making it possible for everyone to afford to create an atlas of his or her city. The aim of a collector, he wrote, is to try to get as complete a picture as possible of the city. His advice about the methods for organizing collections

along systematic topographical categories, a taxonomy according to the city's morphology, was echoed in the advice dispensed to postcard collectors in the newsletters of collecting clubs.[11] We can be certain that there were collectors who specialized in collecting cards of Amsterdam, because the trade journals often earmarked newly published cards as appropriate for the Amsterdam collector.

Antiquarians and historians had long touted the topographical atlas as a means to understand the development of a city by comparing subsequent maps and bird's-eye views or by examining views of the same location depicted at different times. As Amsterdam's pace of growth and change quickened over the nineteenth century, the desire to chart changes visually increased. Maps indicating the city's development over time were published. Books and newspaper series described with painstaking detail the way various sites in the city had been altered. Picture books compared contrasting views of the same location "then and now." Postcards were also harnessed to carry out the task of documenting change.

When the popular author and raconteur Justus van Maurik climbed to the top of the Oude Kerk in 1901, he commented on the contrasting view he remembered from his first climb up the spire forty years before (fig. 2.8). Then he could see the edge of the city with meadows stretching in the distance, but now the outlying fields he had observed were no longer visible; in all directions they had been replaced by the "new city."[12] Van Maurik uses the view from the tower to construct a contrasting nostalgic vision of what has disappeared congruent with his stories of the picturesque and quirky street figures who were then dying out. While he takes telephone wires that stretched across the city like a spider's web as a sign that Amsterdam has become a *wereldstad*, literally a "world city" or cosmopolitan metropolis, the awareness of all that has changed since his childhood, awakened by the altered view from the tower, inspires him to write an account of how things were in Amsterdam's recent past, what has disappeared, and what has changed. Van Maurik's vision demonstrates how the visualization of the city had become implicated in perceiving its history.

Postcard images of the city similarly activated a range of attitudes toward the past and the city's development. The photograph of the view from the Oude Kerk that illustrated Van Maurik's account of his trip up the tower is paralleled almost precisely by a J. H. Schaefer postcard that was repeatedly published in different versions (fig. 2.9).

Both photograph and postcard create a skyline marked by major monuments representing historic Amsterdam: the old city hall, the Nieuwe Kerk, and the Westerkerk—anchors in the sea of continuous urban construction that extends as far as the eye can see. Panoramas taken from the roof of the Central Station created modern counterparts to the seventeenth-century skylines ("profielen"), the paintings and prints whose totalizing views had promoted the majesty of the city during its golden age.[13] Modern panoramic postcards permitted a minute comparison of the cityscape from one period to the other.

These images, then, responded to and interpreted change in the city. Postcards became an aid to those familiarly acquainted with the city in charting the shifting cityscape and visualizing the city's unfolding history. While less obviously intimate than the use of postcards by individuals to illustrate the sites in the city with which they identified, this application of postcards also contributed to the construction of a personal geography of the city by illustrating the experience of change. Postcard collections, no less than other forms of popular culture, expressed Amsterdammers' anxieties and hopes about the urban environment. However, postcards permitted the democratization of an activity that had previously been restricted to the elite because of cost. Their accessibility compared to old prints and their standardized size made them easy to manipulate in a collection.

Certain postcards of Amsterdam provided thoroughgoing documentation of changes in the city as they happened. When major new buildings were erected, they were immediately celebrated through incorporation into the canon of postcards that featured individual buildings. On the back of a postcard depicting the Hirsch store (1912; fig. 2.10), the writer notes its recent construction, showing off the addition to the neighborhood to someone who no longer lives in Amsterdam. Of a new bridge built across the Amstel River in 1903, a trade publication writes, "The Amsterdammers in particular will certainly place this card in their collection."[14]

In 1903, with the demolition of the old Exchange building (1845), the construction of the new Exchange, designed by architect H. P. Berlage, constituted a long-anticipated event in the modernization of Amsterdam. The major postcard publishers brought out cards of the new Exchange, focusing on its monumental presence on the main entry route into the city from the Central Station to the Dam.

An Amsterdam publisher produced a set of cards depicting the old Exchange shortly before its demolition. This, as trade journals explained, was a series that would particularly appeal to the members of the stock exchange, who had walked the old building for many years, but also to collectors, for whom the cards would later represent a piece of Amsterdam history.[15] Yet another firm brought out a card of the building in ruins. A pair of postcards was issued contrasting the simultaneous disappearance of both the old Exchange and horse-drawn trams with the rise of the new Exchange and electric trams. The cards included the conceit of a farewell message to the old and a welcome message to the new, as if they were personalities departing from and joining the urban community (fig. 2.11).[16] Here postcards served the local population's fascination with following the changes taking place in the city. Intended for local consumption by those who would appreciate the satirical verses in Dutch, these cards also imply a shared and collective experience of change.

When in 1906 the Exchange experienced construction problems that created a public scandal, a joking card with puns showing the buildings with cracks was immediately issued.[17] Postcards, then, reported topical changes in the city and documented what was disappearing, so that the city's historical line of development could be felt and seen. Like the more intimate messages about shared walks, these cards assumed a familiarity with the city's spaces by a public that knew the city "as large as life." These cards represent a self-conscious attempt on the part of the publishers to illustrate urban history and their assumption that a market existed for postcards that responded to the local community's identification with the city.

The use of postcards to track changes in the city is illustrated by a beautifully executed scrapbook compiled by an Amsterdammer, J. A. Jochems, who was born in 1836.[18] When he began the scrapbook in 1911, he had witnessed the dramatic alterations in the cityscape of the previous fifty years. His scrapbook represents an obsessive effort to capture those changes. Using photographs, newspaper articles, and postcards (fig. 2.12), he unrelentingly documents the demolition of churches, schools, shops, houses, bridges, and towers. He notes all scales of change, from the replacement of a historic gate to the destruction of a neighborhood through urban renewal. He documents the filling of canals to create wider streets in the city and the dismantling of Amsterdam's main square, the Dam. In Jochems's account, the city is exposed to a continuous erosion of the familiar. His vision of Amsterdam is restricted to what has been "lost," offering "last

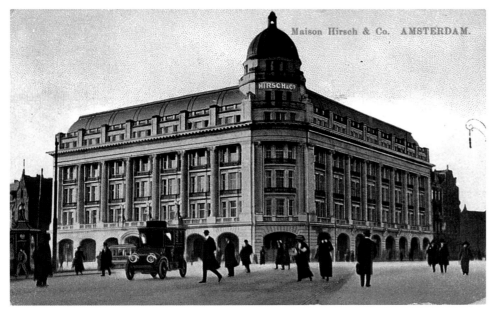

2.10. "Maison Hirsch and Co.," mailed in 1914.

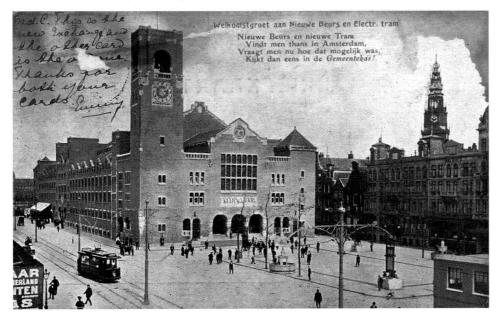

2.11. "Welkomstgroet aan Nieuwe Beurs en Electr. Tram" (Welcome Greeting to the New Exchange and Electric Tram), mailed in 1904.

glimpses" and "views we will never see again." While he occasionally permits a view of the restoration of historic buildings to appear in his collection, he rarely shows the resulting cityscape after the demolitions he documents. He records the demolitions required to build the Hirsch store, but never shows the completed building, only the temporary structure that housed the store during construction and that itself subsequently disappeared. "Disappearing Amsterdam" is his theme; the building and the streetscape as they existed before remain his central focus.

Jochems draws on clippings from newspapers and magazines, particularly from series with titles like Old Amsterdam, Disappearing Amsterdam, or Bygone Amsterdam (Amsterdam van Vroeger), the last being the title he gives his own scrapbook. He augments the clippings with handwritten reports and with a variety of visual aids drawn from numerous sources, including postcards. Here Jochems treats the postcards as transparent documentation of the city's state, evidentially equivalent to the photographs and reproductions of drawings and prints that he also draws upon. Jochems pastes in the postcard of the old Exchange with the horse tram described above (fig. 2.12), leaving out its pendant, the view of the new Exchange with the electric tram (fig. 2.11). He humorlessly corrects the stated age of the building on the satirical verse printed on the card. He writes the dates of the building's construction and demolition on the card, as he does on other photographs, as if to acknowledge the building's birth and death.[19] Other postcards serve as illustrations of cityscapes no longer "alive": the buildings pulled down to create the Hirsch store in the Leidseplein (fig. 2.13), and those demolished during the renewal of the Dam.

For Jochems the postcard became a piece of historical evidence, a ready-made illustration, presumed to be an objective recording of the past. But it also served Jochem's involvement with the city and its spaces. Although he refers to himself only once in the scrapbook, the devotion with which he charts the city's changes conveys his identification with Amsterdam. This idiosyncratic selection of materials, never intended for publication, demonstrates the way that postcards could contribute to the construction of a personal geography and history of the city. While parallel to an ongoing public discourse about the city's changes conducted in the press, Jochem's version reveals an individual privately expressing his distress about the disappearance of the city he has known.

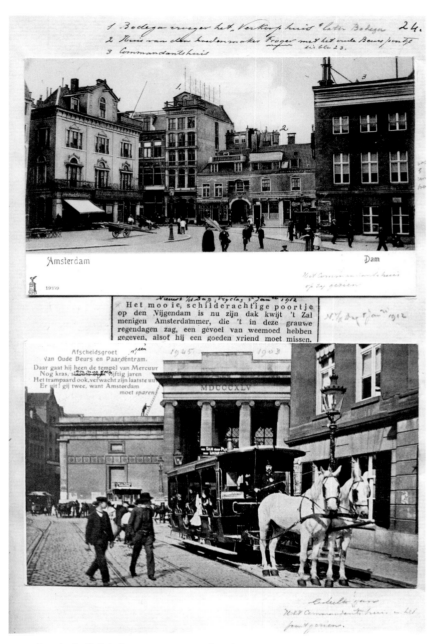

2.12. Scrapbook of J. A. Jochems, 1911–18, p. 24. Note the postcard with "Farewell greetings" to the Old Exchange Building and Horse Tram.

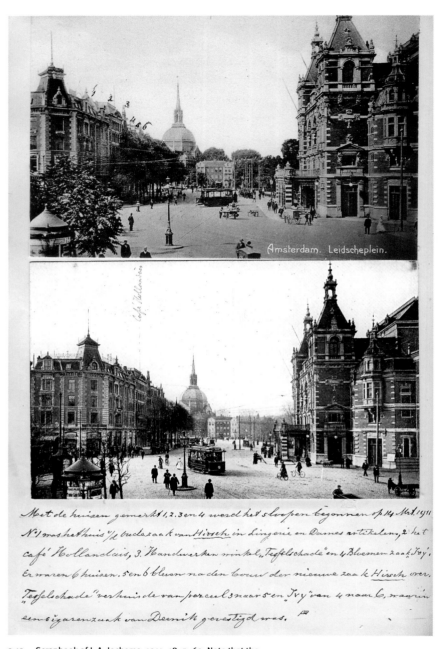

2.13. Scrapbook of J. A. Jochems, 1911–18, p. 62. Note that the buildings that were demolished for construction of the Hirsch building are marked with numbers corresponding to the commentary below.

The Invention of Old Amsterdam

On the binding of the marbled cover of his scrapbook, Jochems had the title "Bygone Amsterdam" inscribed in gold letters. The primary image that emerges from his representation of the city is one of erasure. Other Amsterdammers witnessing the same dramatic changes in the city focused instead on celebrating the new.

When Amsterdam welcomed foreign visitors to the 1883 International Colonial Exhibition, city officials and other members of the Amsterdam elite wished to present the city as a *wereldstad*, a cosmopolitan metropolis. This position was somewhat premature, as the economic revival of Amsterdam was only just underway. Souvenir view books published in 1883 emphasize the new sights in the city over the old in an attempt to demonstrate Amsterdam's up-to-dateness. We see the Palace of Industry (1864), the Aquarium (1882), and the not-yet-completed Rijksmuseum (1885), all built within the previous twenty-five years. These are often accompanied by a few images representing the historic nature of the city through general views of the canals and selected older buildings such as the medieval Sint Antoniespoort, the sixteenth-century Montelbaanstoren, or the 1648 Town Hall. This simultaneous celebration of old and new in the city, on the one hand presenting Amsterdam as a world city and on the other fascinated with what remained from the past, typifies collections of Amsterdam images from the last quarter of the nineteenth century.

Topographical postcards of Amsterdam around 1900 similarly conflate old and new in the city. They present a proud vision of the city's modernity: its gasworks (fig. 2.14), new department stores, and railroad station. They focus on monumental symbols of the city's attempt to imitate cosmopolitan Parisian allure: the Amstel Hotel, the Palace of Industry, and new bridges over the Amstel. Many cards feature the electric tram as an emblem of modernity. Yet this is a carefully staged version of the modern city, showing highly selective views. Absent are factories, abattoirs, and other forms of new industrial infrastructure. There is relatively little representation of the expansion at the edge of the city, although the construction of new residential districts was a constant at this time.[20] Two cards that unusually reveal the city under construction, exposing the boundary between a new district and the open landscape being consumed by its extension, actually have as their subject the largest drawbridge in the country at the time. The harbor, on the other hand, its "forest

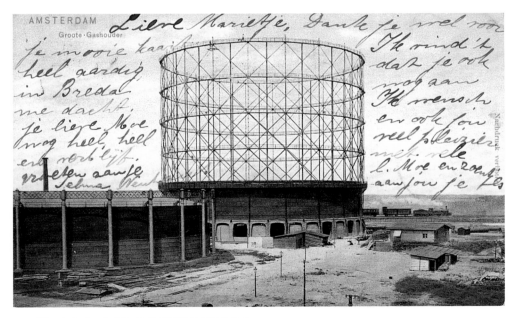

2.14. "Groote Gashouder" (Large Gas Tank), mailed in 1905.

of masts" traditionally associated with the city's historic wealth and importance, is frequently depicted in postcards, though without emphasis on the new large-scale harbor works.

There is a predominance of cards showing the oldest districts of the city, the medieval core and the concentric set of seventeenth-century canals. This is undoubtedly in large part because of the tourist market for such cards. But the selection of images also participates in a recent development in the verbal and visual representation of the city that defined canonic views of a constructed "Old Amsterdam." Instead of the previous focus on the primary monuments of the city, as in the topographical tradition established in the seventeenth century, images of Amsterdam published in histories, guidebooks, and souvenirs began increasingly to include general typifying overviews of the main canals and compositions in which the major old monuments were depicted romantically. The view of the Zuiderkerk from the Groenburgwal and the Oudezijds Achterburgwal became favored subjects. Certain buildings, such as the Munt Tower, the Montelbaans Tower, and Sint Antoniespoort, were selected from the many remaining buildings from previous centuries as indicators of the old city.[21]

"Old Amsterdam" became the designation for a vision of the city intended to convey what was identified as its characteristic beauty. Perception of that beauty had grown in direct proportion to the degree to which it was being threatened by the city's growth as its nineteenth-century rise in fortune was accompanied by the widening of streets, the filling of canals, and the demolition of canalside rowhouses for large new buildings answering the administrative and commercial needs of modern urban life. As the unaesthetic results of these changes in the cityscape become apparent, the topographical representation of the city shifted its focus to include general views of canals and other corners of the city deemed evocative of an Amsterdam untouched by change. The view of the Oudezijds Achterburgwal (figs. 2.1 and 2.5), for example, became one of the most frequently photographed points in the city. This picturesque representation of Amsterdam was firmly established by the time that postcards begin to be mass-produced. While many postcards focused on individual buildings, a large number provided generic views of the cityscape intended to convey its characteristic beauty. A commentator in a Dutch postcard collectors' magazine asked in what other country were the postcards more interesting than those of the Netherlands—where else in the world were such beautiful old cities to be found?[22]

Postcards around 1900 thus contributed to the construction of Old Amsterdam as a beautiful encounter with the past. As with the postcard construction of modern Amsterdam, in the postcard construction of Old Amsterdam selectivity is evident. Less frequently included were some of the areas of the city that today would be considered most picturesque: the depressed working-class areas of the Jordaan, the squalid Jewish Quarter, the Eastern and Western Islands, or the Entrepotdok. To the extent that some of these areas were depicted in postcards, they displayed street life rather than the built environment, following the urban stereotypes, or "physiognomies," developed in the nineteenth century. Postcard series from the first decade of the twentieth century entitled Snapshots from the Street Life of Amsterdam (Momentopname van de Amsterdamsche Straatleven) or Working-Class Life in Amsterdam (Volksleven Amsterdam) focused on tableaux of peddlers, tradesmen, and even prostitutes (captioned "Dark Amsterdam"). Other series concentrated on groups easily recognized and associated with the city: orphans from the municipal and religious orphanages who wore familiar costumes, firemen, and policemen in their uniforms.

Postcards mediated between two visions: "Old Amsterdam" and "Amsterdam as Cosmopolitan Metropolis." The staid and tranquil historicized view of the city was engendered in reaction to Amsterdam's new self-definition as modern city, industrious and bustling. An article announcing the publication in 1903 of a moonlit panorama postcard of the city expresses this duality. It explains how on the postcard one sees the city laid out as viewed from the Central Station. The image removes us from "the bustle of the metropolis" and shows the restful, atmospheric effect of the moonlight, which makes Amsterdam appear tranquilly before us, yet also expresses the busy life of the city through the thousands of lights in the streets and houses.[23]

The attempt to reconcile old and new in the city becomes most apparent in the cards that included multiple images. By including a collection of images, these cards were intended to convey a complete representation of the city, miniature topographical atlases so to speak. The choices of subject matter included are revealing. One series by J. H. Schaefer continually contrasted a major new building, such as the 1885 Rijksmuseum or the 1898 Post Office, with a site that had come to be identified with Old Amsterdam such as the view down the Groenburgwal. The card depicting the new Exchange was issued in 1898 immediately after the long anticipated design for the building was revealed. Here the desire to indicate the new in Amsterdam is

so strong that the image is taken directly from the drawing released in March 1898, five years before actual construction of the building, so that the south facade and tower depicted differ from what was eventually built (fig. 2.15).[24]

From 1903, Schaefer began publishing cards with multiple images on a black background. In one of these an overview of the city combines with fragmented views to suggest a synthesis of past and present. The composition of the card is anchored at the bottom by a cartouche with the skyline of Amsterdam taken from the Central Station in emulation of the traditional printed skylines of the city. Above float twelve images, with the 1898 Post Office given pride of place in the top center, surrounded by an equal mix of Amsterdam old and new (fig. 2.16).[25] One postcard literally represents a collection: it depicts sixteen postcards scattered around the arms of the city (fig. 2.17). Old Amsterdam is represented by the Montelbaanstoren and Munt Tower at the upper left and lower right corners. In between are placed major new buildings such as the Central Station and Concertgebouw.

These postcards showed Amsterdam fragmented in bits and pieces. But the mix of old and new in the tiny photographs was attempting to create a comprehensible wholeness through the kaleidoscope of images. While such assemblages contrast with the traditional panoramic views that provided a totalizing and unified overview of the city, these compilations offered a manageable framing of the contradictions within the city. The multiple image postcards mediated old and new by placing these bits of the city in equivalent frames, fulfilling a desire to create a comprehensible wholeness out of the experience of change. They posit a city perceived in continuous transition.

Some postcard publishers, however, chose to specialize in a purely nostalgic view of Amsterdam that represented the city as if all movement and change were foreign to it. The partnership Brouwer and De Veer published such cards between 1910 and 1912.[26] Their particular painterly style is immediately recognizable (fig. 2.18). Of the hundred cards they published together, just over half depict the oldest part of the city, the district to the east of the Damrak.[27] Only one depicts a view outside the seventeenth-century boundaries of the city: the Rijksmuseum. To create a romanticized vision of the city, their nostalgic choice of concentrating on the oldest section of Amsterdam is further enhanced by a graphic restriction to blue and sepia, which washes all views with a harmonious consistency and obscures the contrasts and variety of the active city. Instead, a vision emerges of Amsterdam as if seen through the mists of time.

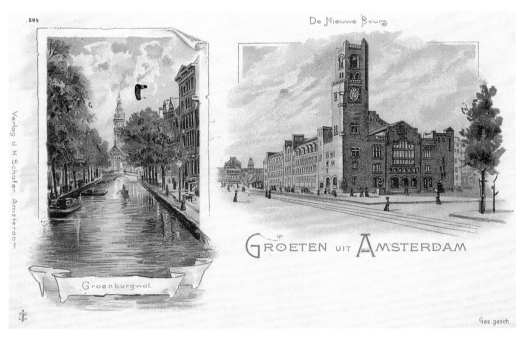

2.15. "Groeten uit Amsterdam" (Greetings from Amsterdam).

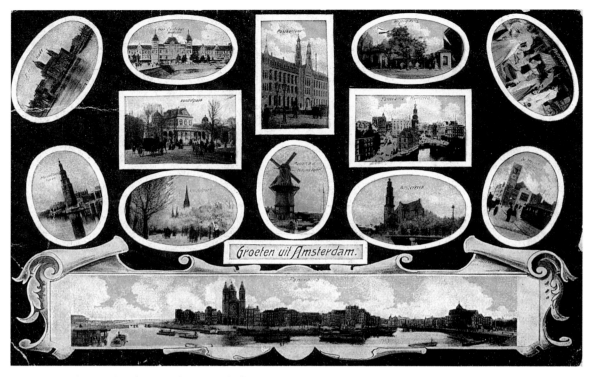

2.16. "Groeten uit Amsterdam" (Greetings from Amsterdam).

A number of Brouwer and De Veer's postcards match compositions previously published by the artist L. R. W. Wenckebach, whose pen-and-ink drawings of Amsterdam had appeared from 1898 to 1907 in the Sunday edition of a local newspaper (figs. 2.19 and 2.20).[28] Wenckebach limited his drawings to Amsterdam within its seventeenth-century boundaries. When, in 1907, one hundred of his views were published in a book distributed free to subscribers to the newspaper, nearly half were of the oldest district. The book frankly proclaims its intentions in its title, *Oud Amsterdam* (Old Amsterdam).[29] Few of the views depict the major monuments; Wenckebach focuses primarily on quaint corners of the city, on canals, streets, and alleys with older houses intact. Although he was drawing the contemporary city, his images consistently avoid references to its modernity. He eliminated the advertisements then covering buildings; no trams and no telephone wires appear in his drawings. He was, in fact, occasionally inspired by the compositions of earlier postcards, which served as models for his drawings, although he would eliminate from them street signage and other signs of modern life to conform to his nostalgic aesthetic.[30]

2.17. "Groet uit Amsterdam" (Greetings from Amsterdam).

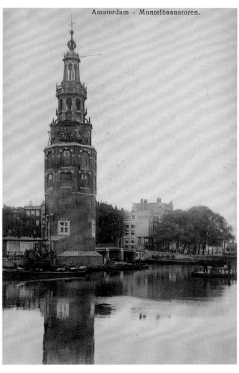

2.18. "Amsterdam—Montelbaanstoren."

2.20. L. W. R. Wenckebach, *Het Oude Beurspleintje*, scrapbook of J. A. Jochems, 1911–18, p. 26.

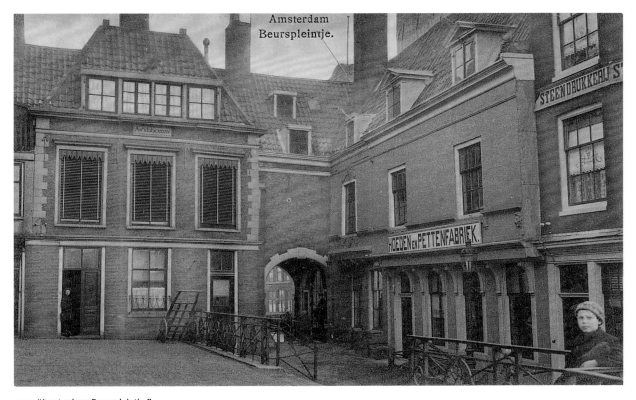

2.19. "Amsterdam: Beurspleintje."

While a number of Brouwer and De Veer's cards correspond to Wenckebach's compositions, an even larger number portray the same subjects that attracted him. In both cases, a still, harmonious Amsterdam emerges as if unscathed by modernity. Even when Brouwer and De Veer produce a postcard of Berlage's new Exchange, it is seamlessly incorporated into the older cityscape. Both Wenckebach and the two partners allowed Amsterdammers to imagine the contemporary city as if it still occupied a past, but a vision of the past that was constructed in the present and only in existence there. Unlike Jochems's documentary use of postcards as presumably objective evidence of past reality, the cards of Brouwer and De Veer shaped a current experience of the city that occurred only through their representations.

With the increasing perception of aesthetic qualities in the older built environment, the issue of the relation between old and new in the city became actual. Many architects, urban designers, historians, artists, and politicians had come to revile the filling of canals and demolition of the urban fabric for the sake of transportation corridors. To prevent the further destruction of the historic core of the city, they began to organize and develop methods to deal with the built remnants of the past given the modern demands placed on them. After 1900, campaigns successfully prevented the filling of canals and creation of streets that would have cut through the major concentric canals. Nonetheless, individual owners of buildings, no matter how old the construction, were free to change and modernize them. In 1911 a municipal committee was organized to review proposed changes to such buildings.

The Committee on Urban Beauty (Commissie voor het Stadsschoon), consisting of representatives of local architectural, artistic, and historical societies, could only give advice. It worked through persuasion and example, not by virtue of any governmental mandate, although it was given the opportunity, through the cooperation of the Amsterdam building inspector, to review all requests to demolish or remodel buildings in the older portions of the city.[31] The committee consciously rejected a nostalgic perspective in favor of a modern, professional attitude that the architectural forms of the past should be appreciated for their aesthetic qualities, characteristic of the city, and that whenever the demands of modern living could be accommodated, efforts should be made to preserve

those qualities. Their aim was to preserve buildings with artistic value (*kunstwaarde*) or influence on the cityscape.[32] However, the committee did not oppose modern design and was against the erection of historical imitations. Its policy was not to make a museum of the city, not to contribute to making "Old Amsterdam" a spectacle. Its main campaign was to prevent the wrecking of Amsterdam's characteristic beauty at the hands of those they considered aesthetically incompetent, that is, the contractors and developers whose architectural qualifications and judgment they questioned. The committee represented professional expertise banded together to defeat the philistine approach to urban design on the part of commercial interests.

The stated aims of the committee were threefold: to prevent the unnecessary loss of urban beauty; where loss was necessary, to attempt to maintain or restore urban beauty; and to encourage new construction that would fit in the context of the existing cityscape. The committee began its work first by reviewing proposed changes to existing historic buildings, giving design advice, and attempting to dissuade owners from demolishing their property; and second by documenting buildings whose demolition or alteration they could not prevent—in the committee's words, "to retain the image of the lost beauty" through photographic documentation.[33] The assistant to the committee, L. H. Bours, began to compile photographs of the buildings in the historic core of the city, with an emphasis on those slated for destruction. The committee used its photographic archive to provide comparative views of buildings before and after their renovation, intending to educate builders and property owners on good and poor methods of designing in a historic context.

In 1915 the committee decided to expand the impact of its photographic documentation by issuing a packet of twenty postcards.[34] The publication of the postcards was announced in the press and in all the major architectural journals. The committee explained that it had examined which Amsterdam buildings and cityscapes had been produced as postcards and found that many of the subjects were not particularly important and many were poorly executed, poorly printed, or garishly colored.[35] Their purpose in producing their own postcards was to increase public awareness of Amsterdam's characteristic beauty and to allow everyone interested in the beauty of the city to acquire a collection of well-executed postcards. As the commentator in one of the architectural periodicals put it, the cards were meant to popularize architectural beauty and would certainly

2.21. "Amsterdam, Roomolenstraat 11," 1917.

make many aware of much beauty that had previously been carelessly passed by.[36] The committee was acknowledging both the well-established power of postcards to convey a sense of the city and the widespread practice of collecting Amsterdam images; they wished to use the postcards to persuade the public of their own vision.

Their vision of Old Amsterdam was considerably different from the prevailing one seen in postcards (fig. 2.21). With the exception of a few views of the interior of the 1648 Town Hall, their postcards show few buildings with landmark status.[37] However, their photographs are not in the genre of picturesque cityscapes in the mode of Brouwer and De Veer. They are documentation of specific examples of architectural quality rather than evocations of romantic atmosphere. The photographs are clinical in their unsentimental, perspectively correct focus on architecture, with the precise location in the city carefully noted in the caption in modern sans serif letters. Their purpose was pedagogical: to teach the public appreciation of urban beauty, not by offering an imaginary passage to the past but through modern aesthetic analysis. Here, then, another construction of the city's history prevailed, one that insistently viewed the continuous existence of the built environment into the present without the nostalgic evocation of the past.

Amsterdammers walking their city in the years around 1900 could not help but be confronted by the colossal changes in the cityscape. As one commentator noted in 1916, Amsterdam was no more.[38] Within memory its inhabitants had experienced the loss of familiar sights; it was as if the city were disintegrating and re-forming before their eyes. For some, postcards became a way to reinforce their identification with the city by mediating their own experiences of its spaces. For others, postcards provided documentation of change in the city as it happened. And for still others, an Old Amsterdam created in postcards in which all signs of modernity had been erased from the contemporary city satisfied a desire to restore harmony to their disrupted urban experience. For all of these Amsterdammers, postcards provided pictorial assurance of the continued character of the city despite its continuous transformation. The postcarding of Amsterdam played no small role in providing visual means for the city's inhabitants to contend with its changes and find an aesthetic reconciliation between old and new.

CORRESPONDENCE HERE:

REAL PHOTO POSTCARDS AND

THE SNAPSHOT AESTHETIC

Rachel Snow

Beginning in the 1880s, photographic cameras, which had previously been expensive and cumbersome and required extensive knowledge of technical chemical processes, became more mobile, more automated, and relatively inexpensive. Kodak led the way in making photographic technology more accessible by manufacturing such user-friendly cameras as the Brownie, which was introduced in 1900 and cost as little as one dollar. During this time various kinds of novelty cameras also appeared, including the first postcard camera, the 3A Folding Pocket Kodak, which was introduced in 1903. This camera used postcard-sized negatives that, once exposed, could be printed onto paper formatted with a postcard back.[1] Real photo postcards were made by four different groups: large businesses, which solicited and purchased negatives from local and traveling photographers; commercial portrait photographers; itinerant photographers traveling door to door and working at places of recreation; and untrained amateur snapshooters who wanted to make their own photographic postcards to keep or send to family and friends. This last group was the only one to make real photo postcards for personal pleasure rather than for profit. Amateurs with the proper equipment could develop their own photographic postcards, or they could send their exposures to commercial establishments that would do it for them.

Until recently, little scholarly attention has been paid to postcards. However, with the growth of fields like media and visual studies and a new emphasis on vernacular objects in traditional fields like history and art history, postcards are finally starting to get the critical attention they deserve.[2] Real photo postcards are also becoming a subject of critical interest.[3] Several comprehensive exhibits and publications on them have laid an invaluable foundation for this and other future studies.[4] This first wave of real photo postcard scholarship has left in its wake numerous handsomely illustrated books, mostly of various private collections.[5] However, the essays accompanying these books have not provided enough critical analyses of the formal, social, historical, and political importance of real photo postcards, nor considered their unique place within photographic history. Regrettably, many of these exhibits and publications also lack any kind of well-articulated methodology that might be used as a model for others who seek to better understand real photo postcards.[6] For this reason, the present essay abandons the general survey–style approach previously used by many scholars, in the hope of gaining specificity through a close examination of a few representative examples of real photo postcards selected from several thousands viewed during years of research.[7] My analysis of these examples reveals, among other things, that some real photo postcards cling to

earlier nineteenth-century uses and conceptions of photography, while others clearly reflect new and different kinds of attitudes toward both photography and life in an increasingly image-driven and commercial society.

The relation of real photo postcards to nineteenth-century traditions is manifested in two ways. First, some snapshooters and nearly all professional photographers depended on long-standing tropes from studio portraiture. Second, the design of real photo postcards stressed the tangible nature of photographs as three-dimensional objects that can be handled. Most nineteenth-century uses of photograxephy stress touch and materiality in concert with optical realism. Tactility played such an important role in early photography because what seems so real and so present in the image is, in fact, never just that. Time has marched on, and the people and things pictured will inevitably have been changed by time's passage. One might say that such stress on materiality, objecthood, and touch is an attempt to help the photograph's optical realism do what it seems as if it should do naturally on its own, that is, to anchor the photo in time, as something that will stop or at least slow the inevitable march of time forward.

Real photo postcards, like all postcards, relate to twentieth-century traditions through their use as a mode of brief and ephemeral communication. Postcards were one significant part of a culture increasingly inundated with images that often had a very short shelf life, meaning that they would appear suddenly, communicate quickly, and often leave people's consciousness as soon as they disappeared from the cultural space. One might think of advertising photographs and snapshots as quintessential images of this kind. Many real photo postcards follow this model in their ubiquity and adoption of a casual snapshot aesthetic.[8] Instead of taking nineteenth-century photographic practices as a model, some real photo postcards were closer in use and tone to an era in which photography itself became available to a mass market and images increasingly became a part of all economic and cultural walks of life. This new direction was signaled by a preference for individualized images, even if that meant giving up the "perfection" and "polish" of studio-made portraits to embrace the spontaneity and informality of a snapshot aesthetic.

Real photo postcards came into being during a flowering of American consumer culture from 1900 to 1920, a time defined by the mass production of inexpensive standardized goods, including new, more affordable, and user-friendly cameras. During this time, upwardly mobile middle- and working-class Americans enjoyed their newly found ability to buy various symbols and accessories of material success, or at least to create the outward appearance of material well-being. These consumers also sought out ways to assert their individuality in a culture where obvious class distinctions were becoming less apparent through visual appearances alone.[9] They wanted products that were inexpensive but also allowed them to feel like they were distinguished, somehow different from other consumers who, just like them, could also purchase the same mass-produced symbolic accoutrements of wealth. Photography was perfectly suited to this new American consumer because it was relatively affordable and, although the means of taking pictures (cameras) were standardized, the end product it produced (photographs) was capable of being individualized. Increased access to photographic technology at least opened up the possibility for innovation in relation to both form and content, something that up until this point largely had been determined by commercial studio photographers. Kodak capitalized on the public's desire for individuation and wealth by launching advertising campaigns that linked their new cameras to the ideals of ownership, individuality, and self-determination.[10]

Such ideals may be clearly seen, for example, in an advertisement from their "Kodak as you go" campaign of 1910, in which a fashionable woman in a fur coat leans out from the driver's seat of a new car with her camera to snap a photograph (fig. 3.1). Because the viewer cannot see what the woman found important and interesting enough to stop and photograph, the fashionable woman herself, along with her car and camera, become the viewer's sole focus. This choice of composition is an indication that Kodak was selling not just cameras, but also a particular image, an idea about who uses their product, namely fashionable, independent types who have time for leisurely drives, not to mention the money for fur coats, cameras, and cars. In addition to aligning their product with material wealth, Kodak also imbues their product with abstract values and ideals, like self-determination, individuality, and independence. This is most clearly expressed by their emphatic use of the word "you," which appears in different forms no less than eleven times in the brief text, which reads: "Wherever the purr of your motor lures you, wherever the call of the road leads you, there you will find pictures, untaken pictures that invite your Kodak—intimate pictures of people and places that you and your friends can enjoy again and again as you thumb the leaves of your Kodak album. And you can take them." Kodak users are described as adventurers and discoverers, not just

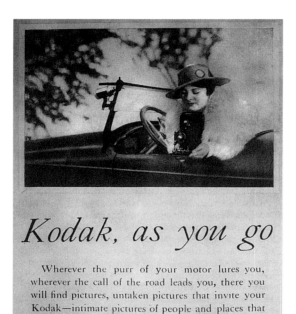

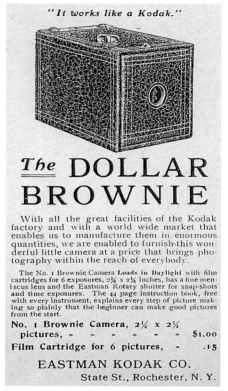

3.1. "Kodak as You Go," advertisement, 1910.

3.2. "The Dollar Brownie," Kodak advertisement, 1907.

of places, but of photographs, and not just any photographs, but their very own. Buying a Kodak will allow you to take "intimate pictures" that you, *and only you,* could make. In this respect, they are characterized as not only photographs, but reflections of their maker's identity. Most importantly, amateur photography is characterized as a means to such individualization. This is also made explicit by an essay on real photo postcards in a Kodak publication from 1914 that explains, "A post card bearing a picture printed from a negative made by the sender is doubly welcome, for it has the individuality of companionship—a personal touch that is lacking in the cards we buy."[11]

Despite linking their product to a privileged lifestyle, most of the cameras Kodak sold to the general public were in fact relatively inexpensive. The affordability and accessibility of their cameras was emphasized in other ad campaigns, like those for the Brownie camera, which could also be used to make real photo postcards. In a plain and decidedly more practical-looking advertisement from 1907, mass manufacture and accessibility are stressed instead of the individuality and wealth featured in the 1910 advertisement (fig. 3.2). The image focuses on the product alone and says nothing about a privileged lifestyle. Similarly, the text is factual and underscores the idea of accessibility. A comparison of these two advertisements reveals that Kodak was clearly negotiating a fine line between promoting their cameras as an accessible and democratic technology and showing their cameras to be a symbolic accoutrement to a prestigious and luxurious lifestyle. It is hardly surprising in light of this discussion that many real photo postcards made by amateurs feature the photographer's prized material possessions, such as homes and cars, and show activities associated with wealth and privilege, such as travel. It is also highly significant that this advertisement suggests sharing one's own photographs with family and friends, thus making snapshots a means for display; in other words, a means of conspicuous consumption.

Kodak also promoted their cameras (and amateur photography in general) by publishing various kinds of instructional materials, including a magazine entitled *Kodakery*. Portraiture was such an important aspect of amateur photography that from October of 1914 to March of 1915 the magazine included essays in monthly installments on the subject, most of which simply translate the techniques of studio portraiture into the popular realm, although there are a few points at which a more informal approach is also encouraged.[12] A similarly mixed message is advanced in Kodak's "how to" manuals, including *At Home with the Kodak* (1910). This booklet offers examples of "good" amateur photographs, many of which emulate studio

techniques, including a portrait of a woman in formal dress seated in a chair in a sparse studio-like setting (fig. 3.3). Like the subjects of studio portraits, she faces forward and looks in the direction of (but not directly at) the photographer. Such examples in no way push the photographer's or sitter's creative boundaries of self-expression, nor do they particularly highlight anyone's individuality. However, at other points in the *At Home with the Kodak* manual the amateur is encouraged to circumvent the studio aesthetic and take more natural and spontaneous-looking photographs. In this and other Kodak publications, snapshot images are closely associated with the privacy of home and family, or as the author describes them, "little intimate pictures that can be secured in no other way."[13] The manual also instructs: "Nine hundred and ninety-nine children out of every thousand are naturally graceful and will pose themselves far better than you can.... The tactful Kodaker can coax his little subjects into the proper place for the exposure, and then wait till the proper moment arrives."[14] The photograph accompanying this passage is captioned "An Unposed Pose" and effectively illustrates a mix of snapshot casualness in the young girl's pose and expression with a more formal studio quality in the lighting, the sparse setting, and the fact that the taking of the picture was planned as an occasion unto itself (fig. 3.4).

Such publicity material actively defined snapshot photography by linking it to specific social values and ideals. Kodak did not just teach the masses the technical nuances of operating their new cameras; they also told amateurs what and how to photograph. Kodak never instructed amateurs just to shoot entirely off the cuff without any regard for composition and other formal considerations like framing, exposure, pose, and lighting. Rather, these manuals cultivated what might be called a controlled snapshot effect. In other words, they advocated making photographs that were as aesthetically pleasing as studio photographs, but with the spontaneity, naturalness, and intimacy associated with snapshot photography. Considering the conflicting messages of their various advertising campaigns and promotional how-to material, it becomes clear that Kodak could not settle on just one strategy to define and promote snapshot photography. Simultaneously, they aligned their cameras socially with both accessibility and privilege, and aesthetically with both a casual snapshot aesthetic and the traditional formulas of studio photography.

This dual influence of new (snapshot) and traditional (studio) models can be seen in a comparison of two amateur-made real photo postcards representing both ends of the spectrum. Predetermined studio conventions prevail in a real photo postcard from 1908 showing a little girl identified as Lillian in the text on the front of the card (fig. 3.5). Her forward-facing pose and placement on a chair, with one hand resting on the nearby table, are tropes seen in studio portraiture. It is just another day at home, but the little girl wears a fancy lace dress and has her hair done up as though she were going to be photographed in a more formal studio setting. The planned formality of her portrait becomes all the more apparent when compared to a simple and spontaneous image on a different real photo postcard, which shows a man holding a baby identified on the verso as Alma Prager (fig. 3.6). Unlike Lillian in her portrait, the baby is not specially dressed for this photograph, nor is she seen in a corner of a home that has been turned into a makeshift studio. She is outdoors and simply held up in front of the camera as the photograph is snapped. Adding to the feeling of spontaneity and casualness is the rather haphazard and abrupt framing of the scene, which includes only the slightest glimpse of the man's profile and the ashy tip of the cigar in his mouth, in contrast to the highly composed and symmetrical nature of Lillian's portrait. The casualness and spontaneity evident in Alma Prager's portrait indicate just how far some real photo postcards had moved away from traditional studio portraiture. Amateur real photo postcards like Alma's portrait openly embrace a distinctly new snapshot aesthetic and, as such, demonstrate a new conception of photography as a recreational activity, something fun and spontaneous, and a common occurrence that can take place anywhere at anytime.

We have seen how Kodak promised individualization in their advertisements, and users of their products often did end up with individualized photographs, just not in the ways they probably hoped for or expected. The individualism of their images is largely due to the random accidents and mistakes that are part and parcel of amateur snapshot photography. This is true, for example, of an amateur-made real photo postcard of a group of people in which a haze envelops the entire photograph, making it difficult to see any of the subjects or their surroundings clearly (fig. 3.7). A female subject in the back is forced to peer out from behind the hat of a woman in front of her, and none of the children look at the camera operator except the girl sitting in the man's lap, who rubs her eye and makes a disgruntled face precisely at the moment of exposure. Indeed there is something almost humorous about the flaws so openly on display here. This ill-fated photograph was even printed on the postcard upside down. Yet, despite so many flaws, a snapshot photograph like this one is, in many ways, more interesting than most studio portraits, for what it lacks in professional

3.3. Example of a formal portrait from *At Home with the Kodak* (1910). Kodak encouraged amateurs to mimic studio tropes such as those seen here.

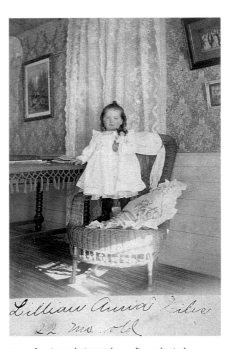

3.5. Amateur photographers often adopted tropes from studio photography, as in the case of this real photo postcard of Lillian Niles.

3.6. Some amateur photographers valued spontaneity and casualness, as in the case of this real photo postcard of Alma Prager.

3.4. "An Unposed Pose," from *At Home with the Kodak* (1910). Kodak encouraged amateur photographers to let subjects pose themselves for a more natural-looking portrait.

3.7. Although flawed, this amateur real photo postcard is in many ways more interesting than the planned perfection of similar studio group portraits.

polish, it makes up with a charm and intimacy that studio photographers are so rarely able to capture when following their professional conventions. Such aesthetic differences between studio and snapshot photography may also be seen as an effect of the divergent expectations that the public had of each type of photography. Studio portraits were produced under the auspices of a business transaction, the goal of which was usually to produce a very serious and dignified likeness for generations to come. While many people would visit the photographer's studio more than once in their lives, it was still considered a special occasion by most, and certainly not as common an occurrence as taking snapshot photographs. Snapshots, while still expected to preserve and document, are usually taken directly within the flow of life. While many are not entirely spontaneous, they are almost never as carefully planned as studio portraits.

Another direct comparison of a studio-made real photo postcard (fig. 3.8) with one made by an amateur (fig. 3.9) reveals important differences between the two modes of production. In the studio photograph a woman in formal dress rigidly poses in front of fancy props and a standardized backdrop that most assuredly appeared in countless other portraits taken at this studio. Conversely, the woman in the amateur-made real photo postcard is dressed casually and is seen at home in an environment familiar to her and unique to this particular woman's photograph. The woman in the studio portrait assumes a formal and studied pose, typical of many studio portraits, and averts her gaze from the camera. There is a sense of ease, spontaneity, and self-determination in the amateur real photo postcard that is entirely absent in the photograph of the woman in the studio portrait. Comparatively, the pose of the woman on the porch appears rather "unladylike" for its time, as she stares back at the camera, spreads her legs apart slightly, and raises her arms. She takes up far more space and inhabits it far more comfortably than the woman in the studio photograph. These significant differences in pose show the subjects of amateur-made real photo postcards had a more obvious hand in defining themselves in the resulting image, and thus had the opportunity to circumvent (if even in small and subtle ways) various kinds of stereotypical representations. This degree of control over how one is represented in a photographic portrait was unprecedented and was brought in many instances about because the sitter or someone close to him or her was taking the photograph.

The historical development of amateur photography might well be divided into three basic and gradually overlapping phases, with each increasingly reflective of the public's desire for individualized

3.8. Formal studio portrait on real photo postcard.

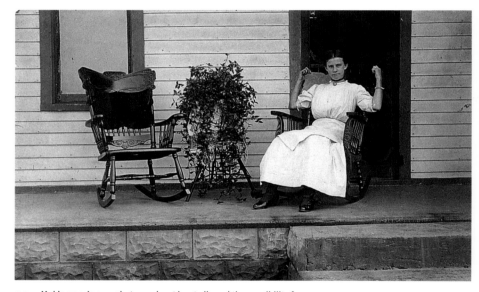

3.9. Making one's own photographs at least allowed the possibility for more control over the final product, as evidenced by this amateur made real photo postcard showing a woman casually posed on her porch.

3.10. Novel studio backdrops and props encouraged sitters to pose more casually than in traditional studio settings, as in this studio real photo postcard made at Coney Island, 1910.

3.11. The snapshot aesthetic sometimes influenced studio portraits, as seen in this more casual portrait of a woman smiling and adjusting her glove.

representations: the first being simple access to buying photographs of oneself, friends and family from commercial and itinerant photographers; the second being the introduction of user-friendly and inexpensive technologies that allowed people to take their own pictures, though such pictures were often strictly modeled after those images made in phase one by commercial practitioners; and the third and final phase in which many users of such technologies gradually began to break from the convention of phase one, a process that is still not complete (and may never be).

The emergence of real photo postcards at a time of shifting and hybridized photographic practices is indicated by the fact not only that some amateur real photo postcard photographers mimicked studio tropes, but that many studio and itinerant photographers showed the influence of a new, more casual snapshot aesthetic. Some studio photographers began to market their traditional product by emphasizing the same values that helped make snapshot photography so popular. This tactic is seen, for example, in a 1914 advertisement for a Pennsylvania studio photographer, J. C. Slear, which reads, "Individuality. A photograph to be effective as a likeness should show more than a momentary expression. It should show the individuality of the sitter. Our personal attention assures this." Slear takes a similar approach to Kodak in his appeal to the public's desire for individualization, but he also rejects an important hallmark of snapshot photography, namely, spontaneity and momentary expression.[15] Thus, he promotes his product as having the best qualities of *both* snapshot and studio photography.

The infiltration of the snapshot aesthetic into the studio can also be seen in the use of backdrops that encouraged more casual, spontaneous, playful, and self-determined poses. A typical example is a group portrait taken at Coney Island that shows the subjects posed on a prop that looks like the back of a trolley car (fig. 3.10). Sometimes the influence of snapshot photography is more subtle, as in the case of a studio-made real photo postcard that shows a full-length portrait of a woman in three-quarters profile who smiles as she looks away from the camera and down at her black leather gloves, which she appears to be adjusting (fig. 3.11). These are minor but telling changes from what could have easily been a typical studio photograph had she simply looked up, placed her hands at her side, and not smiled—in other words, if she had posed like the woman in the formal studio portrait discussed earlier in this essay (fig. 3.8). As it is, this portrait indicates how, even in the most traditional studio

settings, the influence of the snapshot aesthetic was beginning to be seen in the adoption of more casual poses that appear to be a collaboration between the sitter and photographer, if not chosen entirely by the subjects themselves. These examples of casualness in the studio, while certainly not rare, were still the exception to the rule. Most portrait studios retained a traditional formal approach to portraiture and considered such portraits their specialized niche, as well as their best chance for survival in a new era of do-it-yourself snapshot photography.

Perhaps what most distinguishes one real photo postcard from the next, whether amateur or studio-made, is the inclusion of text. This is true in the case of Lillian's portrait (fig. 3.5). The text on the front of the postcard reads, "Lillian Anna Niles at twenty-two months" and on the verso, "Dear Sister, This is our little darling, blue eyes, light hair and rosy cheeks. Hope you all are well: often read your names in the paper. We all are well. I am doing my work alone now. Love to all. Mrs. N." Even though her words remain somewhat opaque to anyone viewing this postcard almost a hundred years after its making, some parts of her text, and certainly the motivation behind taking such a photograph, are very familiar and express the same desire found in many family snapshots today: namely, the desire to create a tangible, individualized, potentially long-lasting, and highly realistic record of a loved one. Although text may be one of the most effective ways to reflect the unique personalities involved in the posing and making of any given real photo postcard, as this example shows, textual additions often leave the viewer with many questions. Yet, despite these questions, text still offers the viewer a more intimate glimpse into the nature and tone of those involved in the postcard exchange, which is to say that textual additions may individualize without simultaneously clarifying.

Then, as now, people could and often did write on the back of many other kinds of photographs that were not specifically designed to be written upon (including, for example, studio-made cabinet cards and snapshots not printed with postcard backs). The texts accompanying such images are usually simple factual notations intended to identify the sitter or event for those who might not be familiar with the subject matter, or perhaps to prompt the memory of the photographer or other viewers who knew a sitter or experienced the events pictured. Such captions might be as simple as "Jack age 5" or "A day at the beach." The text one finds on real photo postcards that have not been posted in the mail is often similar to the text found on other types of photographs. In general, these brief captions do not elaborate on the subject of the photograph, its significance, or what occurred before, during, or after the moment pictured. Presumably any need for extensive textual explanation or narration would either have been mitigated for those with access to the photograph by familiarity with the people and things pictured or provided at the moment of viewing by someone who could offer such information orally.[16]

The text on real photo postcards that were actually posted is very different from that on the types of photographs discussed above, because it is predicated on the expectation of a response, on the likelihood that the receiver of the postcard will eventually send some kind of written reply and that the cards will form part of an ongoing, present-tense, and specific dialogue. Communication on these cards is largely carried out through brief conversational familiarities and conventions that do not require reply, such as "Having fun," "Hope all is well," "Wish you were here," "We are all well." However, it is not uncommon to find questions that do require a reply, such as "When will you be coming to visit us again?" or "How is father?" As noted, one would very rarely find such open-ended commentary on the backs of other kinds of photographs. Like the text on all postcards, that on posted real photo postcards was a direct and specific communication from the sender to the receiver and was, of course, written with a specific individual in mind. The interactive nature of postcards is further underscored by the many occasions where senders either thank their friends and families for postcards they have received or admonish them for not responding in kind.

The existence of many unsent real photo postcards raises the obvious question as to why one would make (or buy) a real photo postcard and not use it as such. We can only assume that for many the act of taking or sitting for the photograph—the production of the image itself—was as important as using the photo postcard as a form of textual communication. It is also quite possible that many people simply opted for the postcard format on a whim, not knowing whether they would eventually send their photographs through the mail but wanting, nonetheless, to have that option. Ultimately, there was little reason not to have a photograph developed as a real photo postcard, since those not sent through the mail could still be used in the same ways as a traditional photograph (left loose, placed in an album, hung on the wall, etc.). While the existence of such cards is important to note, in order to understand what makes all postcards,

including real photo postcards, unique, we must turn our attention to the implications of a design that, at the very least, invites the user to include text and send a photograph through the mail.

If we know we are holding a real photo postcard and not just a snapshot, our immediate impulse after glancing at the image is to turn the card around and read the other side. This act transforms our awareness of the photograph as an image into an awareness of the photograph as an *image-object*. In other words, when any kind of postcard, in this case a real photo postcard, is actually used as a postcard, it is activated as a three-dimensional object in a way that most other photographs of the early twentieth century and almost all of the later twentieth century were not. One could make a strong case that throughout its history, photography has moved increasingly toward dematerialized, less tangible forms (although even now the process remains far from complete and is thus more a speculation than a historical reality, even though it is often discussed as such). While a general trend toward dematerialization seems clear, one must not forget important fits and starts on this path, those moments and instances in which photographic objecthood and materiality are and have been reasserted. The unique design and diverging uses of the real photo postcard are exactly such an instance. The real photo postcard provides an opportunity to study an early example of how photography came to be at a crossroads between new and old practices, and, more specifically, how photographs possess dual identities as both image-objects and a means of quick and often ephemeral communication. Some people used real photo postcards to communicate in ways characteristic of this trend toward dematerialization and in ways that foreshadow the ease and spontaneity with which many people use digitalized photographic images today. But many used real photo postcards in ways that emphasized the photograph as an object.

Within the history of photography, the experience of tactility was first emphasized by the small clasped cases used to house daguerreotypes. These display cases closely associate the photographic image with three-dimensional objects apprehended through touch. The materiality of the daguerreotype is more conspicuous than that of a loose-paper photograph, if for no other reason than that the viewer was forced to manipulate a case in order to open it and see the image. Loose-paper photographs require no such manipulation, and digital images (unless printed out) actually prevent it altogether. Real photo postcards with text messages

reassert the materiality of the photograph by encouraging viewers to treat them as three-dimensional objects of touch. The daguerreotype was not the only form in which the materiality of the photograph was asserted in the nineteenth century. It was not uncommon, for example, to find photographs framed with a swatch of clothing or lock of hair from the person in the image. Photographs were also incorporated into personal jewelry, such as brooches, lockets, and watches.[17] Again, these practices are telling examples of the public's desire to associate the photographic image with touch, a desire that over time has waxed and waned. Of course, digitalization is the closest that photography has come to being a purely visual medium, with images stored in memory cards and viewed on computer screens or similar electronic devices. Yet, even in the midst of the digital revolution, there now seems to be a growing nostalgia for the photograph as a paper object; hence the growing popularity of printers designed just for this purpose. As of yet, the public refuses to completely surrender the photograph as a material object. Real photo postcards, especially those that incorporate text, should be thought of as a continuation of these nineteenth-century traditions: they embody the same desire for the material image-object.

The various appearances and uses of real photo postcards are indicative of the position they occupied as a medium that overlapped two different historical moments and showed technological and aesthetic tendencies of both (although usually not in the same card). Some were made in keeping with typical nineteenth-century collecting and memorializing practices, and others show new and innovative uses in regard to circulation and textual emendation of photographs. An example of the former is the practice of carefully arranging real photo postcards into albums. This activity has precedents in the history of photography, including nineteenth-century traditions of arranging cartes-de-visite, cabinet cards, albumen prints, tintype portraits, and many other types of photographs, including snapshots, into albums. The making of such albums requires decisions about the placement and sequencing of postcards, and, as such, it should be seen as a way in which individuals were able to personalize their postcard collections. Postcard albums ranged from deluxe leather volumes to far more humble and common clothbound books with paper pages that had slots in which to insert postcards, as in the example of a two-page spread from an album compiled by Dessie Voyles (fig. 3.12). The inside cover of this album is signed twice by the

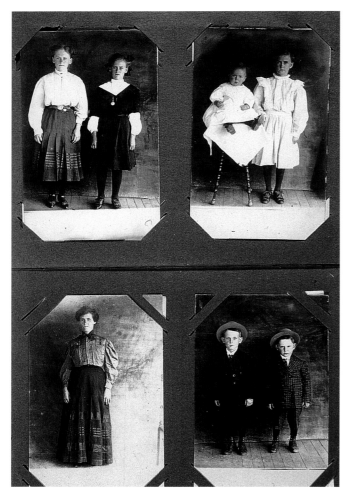

3.12. Two-page spread from a typical real photo postcard
album, compiled by Dessie Voyles, 1909.

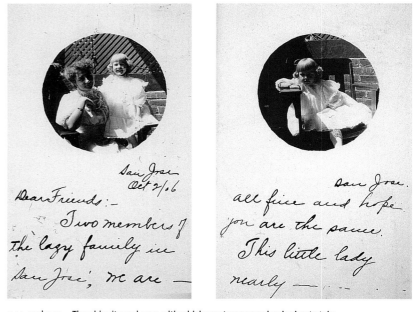

3.14. and 3.15 The ubiquity and ease with which amateurs were beginning to take
snapshots is demonstrated by these two real photo postcards from an incomplete series of cards in
the author's collection that show a little girl and her mother playfully posing for the
camera in San José, California, in 1906

3.13. Making one's own photographs also allowed greater invention
in terms of subject matter, as in this unique, although somewhat puzzling,
amateur real photo postcard of a cow, sent from a grandmother to her
grandson.

compiler, first as Dessie Voyles and later, presumably after marriage, as Dessie Sawyer. The album is dated January 23, 1909, yet the dual signatures suggest that a significant passage of time occurred during its making and that the album was an ongoing project that required time and a prolonged commitment on the part of its maker. Putting these cards, which might otherwise be easily lost or destroyed, into a book indicates a desire to keep them safe in one location and to have them ready for easy, repeated viewing. The time and care put into the making of this album is not obviously reflected in the simple and inexpensive materials used to make it. However, it still demonstrates a conscious effort to preserve a personal history in the form of images. In so doing, Dessie Sawyer gave the ephemeral novelty of real photo postcards a kind of formal permanence. Not surprisingly, most of the cards in her album (and the many other albums like it) are portraits of friends and family. This album shows that at least some people expected real photo postcards (whether studio- or amateur-made) to preserve the likeness of a loved one for oneself and for future generations.

This interest in collecting real photo postcards for purposes of remembrance and preservation does not run through the genre as a whole. The material permanence of the photograph is of little consequence to some real photo postcard users. In such cases, the ease and casualness demonstrated by the photographer and sender are very similar to what we can observe in many amateurs using digital photography today. The casualness of real photo postcards is also demonstrated by the tone of the text found on some cards, like that on the verso of a real photo postcard of a cow, which reads: "Dear Honey Boy, Do you know whose picture this is? Hope you are feeling better and having a good time. Lovingly, Grandma" (fig. 3.13). The written communication on many real photo postcards, including this one and Lillian's portrait, is often quick, informal, and makes reference to events and people that only the sender and receiver, and perhaps those close to them, would completely understand. In this case, one is left wondering why this particular cow is so special as to merit the taking of a photograph. The casual tone of this text and the rather light and silly subject matter of the photograph indicate that it was probably not intended as a serious or long-lasting record to be passed down for posterity. The newfound levity, ease, and frequency of taking photographs are also evident in a series of cards sent from San José, California to Aurora, Oregon on October 2, 1906,

one showing a little girl and her mother and the other just the little girl (figs. 3.14 and 3.15). The text begins on one card, is continued on the other, and was presumably finished on other cards now separated from these two. The text demonstrates once again how real photo postcards were often conversational in tone and part of an ongoing dialogue. The serial nature of these cards also indicates that the photographer had no problem with casually snapping numerous photographs in a whimsical manner and that the subject matter of photographs was treated far less preciously in the era of snapshot photography than in the days when having one's photograph taken was an event unto itself.

In attending to the similarities and differences between studio and amateur real photo postcards and examining specific examples of each, my aim has been not only to develop an analysis that takes up the specificity of real photo postcards' aesthetics and textual messages, but also to describe their position in one of the most important shifts in the history of photography. Immediately after its introduction to the public, photography was a relatively specialized and expensive niche activity, or a craft practiced purely for commercial gain. However, after the introduction of inexpensive cameras like the Brownie, and slightly later during the era of the real photo postcard, photography became a medium readily available to and taken up by a mass amateur audience as a means of self-expression, individualization and conspicuous consumption. Access to studios and the ability to consume photographs only constituted one phase in photography's development as a mass medium, a process that was not truly completed until most people could make their own photographs and tell their own stories. Real photo postcards played a short-lived but integral role in this early phase of photography's democratization.

Real photo postcards are overwhelming in number, frequently banal and unartful in their appearance, and, with the lapse of time, the often private significance of these cards can be difficult to decipher, all of which makes them a problematic subject for scholarly study. Rather than viewing the unique characteristics of real photo postcards as a liability, or avoiding questions concerning how we are to deal with these kinds of photographs, we might see the format's particular attributes as a useful entry point into a critical analysis of the genre. This essay, though brief, is an attempt to begin to show why this genre is worthy of historical and critical study, and how one might go about such a study given the complications described above.

..

POSTCARDS TO THE FRONT:

..

JOHN HEARTFIELD, GEORGE GROSZ,

..

AND THE BIRTH OF

..

AVANT-GARDE PHOTOMONTAGE

..

Andrés Mario Zervigón

Toward the end of 1916, as Europe's Great War grew unimaginably barbaric, the young German poet and future publisher Wieland Herzfelde received a package while serving at the western front. Like those accepted by other soldiers, his parcel should have contained the food and mementos that families customarily sent male relatives to keep Germany's fighting youth in good spirits. Herzfelde's box certainly bore the signs of familial tenderness. "I enjoyed very much the graceful manner with which the field address was written and the care with which everything was packed," he later recalled.[1] But despite such markers of affection, Herzfelde could not l have expected anything from parents who had long since died. Moreover, the spirits he needed sustained were ones of a thoroughly antiwar commitment. What he opened was in fact a parcel sent by his good friend George Grosz, a somewhat misanthropic painter who had begun sending a series of parcels to the front in order to annoy soldiers—or encourage like-minded friends—with a vaguely antimilitarist assortment of gifts.[2] Herzfelde's parcel, for example, "contained two starched shirt-fronts, one white and one with a floral pattern; a pair of black sleeve protectors; a dainty shoe horn; a set of assorted samples of tea, whose individual handwritten labels claimed that the teas would inspire 'Patience,' 'Sweet Dreams,' 'Respect for Authority,' and 'Loyalty to the Royal Family.' Haphazardly glued to a cardboard were advertisements for hernia belts, fraternal song books, and fortified dog food, labels from schnapps and wine bottles, photos from illustrated papers— all clipped at will and assembled absurdly."[3] What Grosz conveyed within this package was not just a near-absurdist regurgitation of his country's wartime commercial kitsch, but the sense that a great gap now lay between the patriotic image these items cultivated and the true conditions of frontline combat they helped to obscure. Herzfelde quickly perceived this message, noting "the great pleasure" he took "in the irony with which [Grosz] had selected the gifts."[4]

As the early twentieth century's advancing technology blew apart a seemingly limitless supply of human flesh on the First World War's extended fronts, Germany's government and private commercial culture had fed its constituents with visions of heroic death and national pride.[5] Grosz's parcel, complete with assorted bourgeois knickknacks and its splayed-out collage of advertisements, thrust those visions back to the front, where, in an uncomfortable incongruity, they seemed a subversively ironic statement.[6] Indeed, the gaps and fissures lying between the arbitrarily cut and glued advertisements alone operated as a metaphor for the great disjunction between the country's general understanding of its war

and the soldier's traumatic experience of it. Grosz's care package therefore offered space for a critique of the combat within the very gaps his package as a whole recreated. Soon, he and Herzfelde's older brother, the advertising artist named John Heartfield,[7] would use this same ironically critical strategy on postcards that they mailed without the protective shield of a parcel box. On these small pieces of correspondence sent to the front, "photograph clippings had been assembled such that they said in pictures what would have been censored had it been said in words."[8] Grosz and Heartfield had learned that the gaps that the painter had cultivated in his care packages could also be used between assemblages of photos where formal cleavages could speak even more than the loquacious photos themselves. It would be this knowledge that not only enabled the men to communicate censorable messages in a period of coerced consent, but also led them toward a critical photomontage process with which they would digest the subsequent Weimar period's social chaos. Their technique of photomontage subsequently came to dominate modernism's historical avant-garde, and particularly the Berlin Dada movement, in which both men would play important roles.

Discussing Heartfield's and Grosz's subversive wartime postcards, however, is necessarily a speculative affair because none of these early works have survived. Equally vexing are the hazy anecdotes surrounding the "discovery," as it were, of this new avant-garde technique. Heartfield, for example, reported in a 1966 East German radio interview that postcards had unquestionably played a fundamental role in what he described as the "invention" of photomontage. "In Moscow I told [Sergei] Tret'iakov about earlier works, which I made along with other people, and which led me to the path to the invention of photomontage—if you want to call it that. Those works were postcards which we soldiers—[or] not only I…[but above all] soldiers—[often] made to get their messages to relatives back home covertly, so to speak. They were glued postcards."[9] Though offered in the characteristically halting speech of Heartfield's late age, this account seems clear enough when considered against his brother Wieland's words.[10] But the older Heartfield exercises a curious need to precede this explanation with a note in which he says that he offered it first to Sergei Tret'iakov, the Russian avant-garde author whom the artist had befriended in 1931. Tret'iakov, in fact, played a singularly important role in promoting this postcard explanation well beyond the level of anecdote. In his 1936 monograph on Heartfield, for example,

the first book to be published on the artist, Tret'iakov pointedly begins the body of his analysis with a short quotation taken from a larger talk that Heartfield had delivered before Moscow's Polytechnic Institute in 1931. And it was in this portion of the public lecture that Heartfield specifically described, perhaps through Tret'iakov's assistance, the role postcards played in photomontage's beginning.

The censor in the war years did not permit anti-imperialist ideas to be expressed, particularly in written form. The soldiers at the front grasped for all possible tricks to report their life in the trenches to dependents back home who were often still anesthetized by chauvinist ideas. One had to point out the yawning chasm between life on the front and the life of the bourgeois freeloaders. The soldiers used among other things the following means: they glued together photographs and various magazine clippings, etc., [thereby contrasting] for example, heroes who had fallen for the homeland with some pictures from magazines illustrating the life of the capitalist parasites. Two–three sharp, striking words amplified the thought. Nothing further. That was the beginning![11]

Already central to this account is the notion that homemade postcards could visually communicate the glaring inequalities of Germany's war experience yet pass censors who were looking almost exclusively for forbidden text. But regarding this argument as a whole, Wieland Herzfelde would later write: "Some of our friends, among them Tret'iakov, created out of that story the legend that the anonymous masses had thus invented photomontage. The truth is that many of those who received the aforementioned cards took pleasure in them and attempted to make something similar. That encouraged Heartfield to develop out of what was originally a politically inflammatory pastime a conscious technique."[12] Herzfelde may describe this traffic in postcards as part "inflammatory pastime" and part legend in the making, yet he admits that it ultimately encouraged a "conscious technique" that was to become avant-garde photomontage.

As these cases of hesitation and possible coaching imply, postcards alone may not have served as the singular impulse toward critical montage. Brigid Doherty, for example, has analyzed the broader cultural context of World War I that may have led to critical montage. And while postcards figure prominently in her account, so do the Liebesgaben, or care packages, that were often sent to the front as well. In fact, she points out that these packages occasionally contained the prized *Klebehefte*, handmade books of colorfully montaged newspaper clippings compiled by women volunteers for

the pleasure of the country's troops.[13] These may have been partly the satirical butt of Grosz's montaged cardboard, the treat awaiting Wieland Herzfelde as he opened his own care package in 1916. Sherwin Simmons has also reviewed the cultural context of this time and has found that prewar advertising too was a foundational influence on the origins of avant-garde photomontage, an argument made all the more compelling by Heartfield's prewar training in the field and Grosz's use of advertising clippings on Wieland's cardboard.[14]

But as Eckhard Siepmann has pointed out, a feature of wartime postal correspondence may have served as the all-important catalyst to transform these phenomena into critical photomontage:

The principle of photomontage is as old as the photograph itself, and the principle of collage, the incorporation of multiple realities—or photo fragments—into the handmade picture assembly, was in the air during those years. And at this time, montage and collage were already surfacing as a fragmentation of reality in the postcard industry, in advertising, in journalism, and also in the visual language of the French and Italian avant-garde (Cubism and Futurism). For Grosz and Heartfield, however, this visual fragmentation came at a particularly decisive moment. For them, the montaged visual space became the appropriate answer to what the war and—beside this—daily existence in the big city had done to atomize the apparitional experience of a coherent life and world. But the legend entwining itself around their discovery of collage as a separate artistic procedure already suggests this subsequent development; once Heartfield and Grosz saw collage as an answer to their shattered times, it emerged as a means by which one could express social contrasts through postal correspondence between the front and the homeland, expressions which in a verbal form would have fallen victim to the censor. The step from Cubism and Futurism forward, therefore, is one where a stress on the disparity of single elements becomes the emulation of social disparities, social contrasts.[15]

Montage may have been in the air as a cultural tendency awaiting its critical deployment at just the right moment. And that moment may have come when formal disparities could suddenly be made to reveal social ones. Yet, as Siepmann suggests, the postcard itself served as that uniquely important vehicle for this tendency's realization, a colorful surface that marks the threshold of this moment

in a uniquely visible way. He sees the postcard as that one medium whose capacity for subversive exchange encouraged users to appropriate and juxtapose images so that they might communicate what could not be said in words. It was therefore in the postcard specifically where public and personal visions of war could be contrasted in a forum lying at the very limits of open declaration.

In this last sense, Heartfield's and Grosz's choice of postcards as their preferred vehicle of dissent was not a choice at all but rather an act of last resort. However, if one reviews the history of postcards in Germany, their turn to these small missives was also quite clearly a logical act. Since the Franco-Prussian War, private printing firms in Germany had begun using postcards as an important surface on which to print uplifting militarist images. Central European postal historians have suggested that the picture postcard was devised during this mid-nineteenth-century conflict specifically to penetrate Germany's domestic spaces with a newly minted martial iconography.[16] The format then quickly gained popularity. The picture postcard's increasingly affordable printing process and its low mailing costs made these colorful pieces of correspondence almost as popular as the letters and blank postcards that had filled Europe's mailboxes. But it would soon be the card's size, that of the average photograph, that made it the ideal surface on which to print photographic images, particularly after the inventions of the carte de visite (1853) and halftone printing (1880).[17] Shortly after this second date, Germany had become Europe's greatest manufacturer and sender of picture postcards.[18] George Grosz maintained a particularly strong fascination with these products because, by the time he was a boy, their rapid production and light subject matter had made them the venue for popular culture's most inventive photographic images.[19] His archive in Berlin teems with examples he collected both before and during the war.[20] In these cards, flying fantasies of modern technology (fig. 4.1) or the drunken stupor experienced by gaggles of beer-drinking buddies (fig. 4.2) are composed from assorted photographic fragments to create eye-catching fantasies. Such compositions inspired Grosz's drawn and painted work of the time, particularly in their oddly Futuristic orientation toward dynamically disjunctive spaces and image fragments (fig. 4.3).[21]

Heartfield was also engaged with photographic postcards from early in his career. In his training as an advertiser, he was taught what Prussia's military had long learned, that these small missives were a particularly convenient and effective way to disseminate publicity to large numbers of people at the sender's expense, something that had

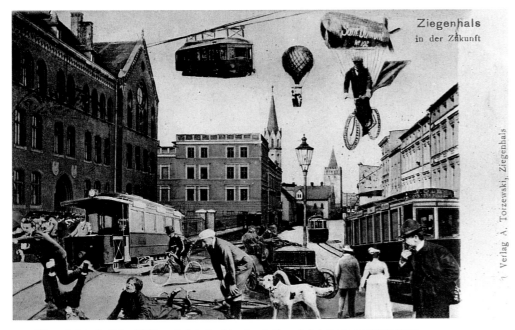

4.1. "Ziegenhals in der Zukunft" (Ziegenhals in the Future), n.d., Ziegenhals is the name of the village.

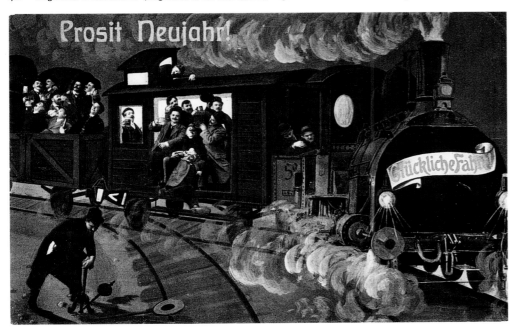

4.2. "Prosit Neujahr!" (Cheers, New Years!), n.d.

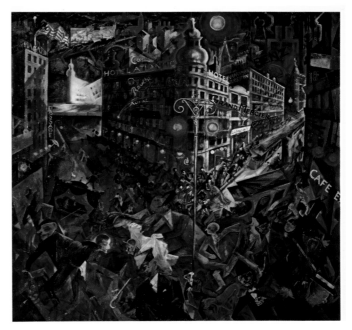

4.3. George Grosz, Metropolis, 1916–17.

become a general practice before the war. Dresden's Odol mouthwash firm, for example, famously created a series of photomontaged postcards between 1901 and 1903 that became canonical by 1913, the year Heartfield matriculated in Germany's only advertising degree program.[22] These works adhered images of the company's distinctively shaped bottle to photographs of incongruously vast city squares, creating a perpetual shift of meaning between the small bottle, which seemed suddenly monumental, and the town square, which became a singular advertising opportunity (figs. 4.4 and 4.5).[23] What such cards stressed, both in Grosz's collection and in Heartfield's advertising orbit, was a creative incongruity between the visual terms they employed and the spaces they implied. Grosz's collected *Prosit Neujahr!* card, for example, features photo fragments of drinking men adhered to a painted train, thereby combining the photorealistic with the clearly animated, a compositional conceit suggesting through its disjunction the men's hazy stupor and drunken misdirection. Similarly, *Ziegenhals in der Zukunft* (Ziegenhals in the Future) assembles an impossible array of flying, walking, and wailing figures in a city square, each proposing an entirely different space through its scale and placement. The resulting formal and spatial gaps create a series of disjunctions that read as a distant or fantastic future. The

Odol postcards reduce such eye-catching ruptures to two basic but ill-fitting terms, creating with the bottle and its new space of exhibition a similarly antirealist assembly of photorealist parts.

Because of their ubiquity, inventiveness, suitability to photography, and semiprivate nature, picture postcards remained an ideal medium for war propaganda. It was likely on account of these characteristics that Heartfield and Grosz found themselves sending these small pieces of correspondence to communicate their subversive discontent. Indeed, each day of the First World War saw on average 9.9 million pieces of mail sent from Germans to the front and 6.8 million pieces posted in return. Well over half of this total were postcards, and a good many of these sported photomontaged images, which had become a highly popular novelty at the time.[24] Heartfield and Grosz's missives would have been the few within this enormous count and therefore easily overlooked by the censor's weary eyes.[25] But the men's images would have also been fundamentally different from those constituting the montaged norm.[26] Germany's imperial government, after all, was desperately trying to maintain enthusiasm for its conflict by claiming that the country's armed forces were fighting a winnable war of defense. Visions of true frontline conditions might threaten to dispirit a home population that remained woefully unaware of the war's gruesome extremes.[27] By necessity, therefore, the front and homeland had to be envisioned in these photomontages as a seamless entity, victoriously bound in the same conflict and suffering the same conditions.

Photomontaged cards meeting postal approval correspondingly eschewed the distances and differences between domestic and frontline spaces. A mother shown instructing her son in the cult of Prussian militarism (fig. 4.6), for example, does so in the context of Christmas, when the father's fighting can be cast as the work of "peace." "Christmas, at home and in the field," confirms the card's caption in the upper-right corner, articulating a relationship of shared — though melancholy—festivity between these montaged scenes. Germans, this composition assures, maintained such complete martial unity that their various ceremonies could be exchanged and enjoyed equally despite the ill-fitting context in which they might take place: a domestic Christmas could be legitimately celebrated at the front, while youthful military prancing seemed suitable for the family living room.

In order to affirm such messages, postcards like these studiously avoided the jarring thematic and compositional disjunctions that so excited Heartfield and Grosz in the prewar commercial postcards

4.4. Odol mouthwash postcard, 1901.

4.5. Odol mouthwash postcard, 1903.

that they collected. The Christmas piece, for instance, goes to great airbrushed and compositional lengths to unify the two experiences visually. The line formed by the mother's and son's arms is duplicated by the two solders' abutting elbows above it. Similarly, the boy's flag is mirrored in the father's shotgun, while the glow from the Christmas tree is repeated in the godlike luminosity surrounding the relaxed soldiers. The feminine partner to this card (fig. 4.7) makes an analogous repetition of vertical forms defined by the Christmas tree candles, the helmet spike, and the curious gift sausage held proudly aloft. In both images, the only things separating these tightly woven photo-fragments are the abstractions of geography and longing, the very distances these cards seek to thematize and ameliorate.

Photomontaged propaganda postcards in Germany had developed this synthetic approach to disparate photographic fragments even before the war began. In fact, the Prussian royal house itself pioneered this smoothing technique when it issued an endless series of cards in 1913 to mark the Kaiser's twenty-fifth jubilee.[28] These compositions featured heroic photographic portraits of the monarch montaged in front of a view of his palace or the Prussian landscape. One particularly sophisticated photomontage composes the Kaiser's visage from an array of images showing the country at work and in the process of military preparation (fig. 4.8). The Kaiser, such a montage suggests, was the very embodiment of Germany's industrial and military prowess, the unifying figure in whom Germany's great diversity cohered with effortless and productive ease.

Once the war had begun and battle entered the popular imagination, these cards could display a fairytale landscape of

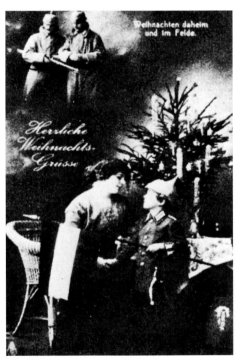

4.6. "Weihnachten daheim und im Felde; Herzliche Weinachts-Grüsse" (Christmas at home and in the field; Merry Christmas), ca. 1916.

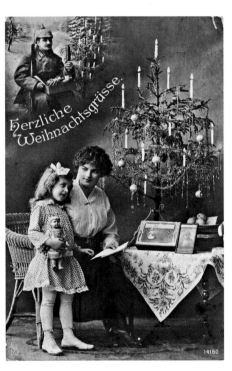

4.7. *Herzliche Weinachtsgrüsse* (Merry Christmas), ca. 1916

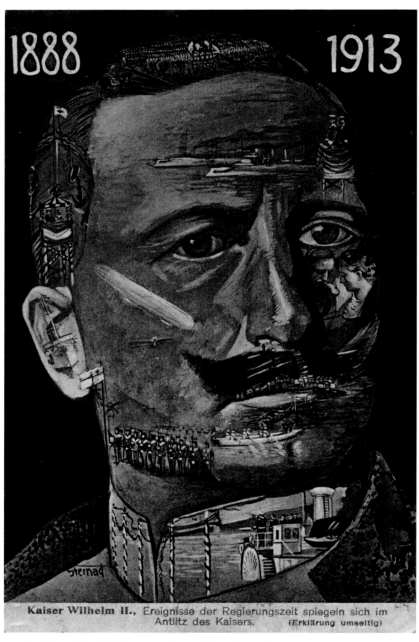

1888 **1913**

Kaiser Wilhelm II., Ereignisse der Regierungszeit spiegeln sich im Antlitz des Kaisers. (Erklärung umseitig)

4.8. E. Bieber, *Kaiser Wilhelm II,* postcard, 1913. The caption reads, "Events occurring over the time of rule mirror themselves in the face of the Kaiser."

montaged soldiers overseen by a galaxy of royal family members, as in *In Memory of My Period of Service* (fig. 4.9). Such a composition avoided the messiness of war while it naturalized the military's hierarchy into a product of the cosmos. On another card (fig. 4.10), photomontage could recreate the bombing of London by convincingly affixing spaceship-like zeppelins over the British capital's darkened cityscape.[29] All these images were meant to cohere both thematically and spatially, surprising viewers not with the unbelievability and disparity we have come to associate with photomontage but with a realism that belied their obvious origin in disparate fragments.

Heartfield's surviving work from this time demonstrates that he maintained a near-singular focus in undoing this heavily constructed and falsely homogenized vision of war. Handmade postcards spoofing this vision would soon follow. But first, in what can best be described as photo-juxtapositions, dating to 1917, he contrasted official images of the conflict with those illicitly snapped at the front (fig. 4.11). The idea, he later explained, was to use photography's perceived realism to undermine the omnipresent images that showed the war as sanitary and heroic. Approved "photos of the war," he argued, "were being used to support the policy to persevere when the war had long since been settled on the Marne and the German army had already been beaten."[30] As an example of this procedure, he cited a work he finally published seven years later: "In the 1924 yearbook of the Malik Press [*A Place for the Worker*] there are two photos under each other that show very well what I have said up to now about work with photographs.... Above is a picture about a general from the command, how he is buried...with all that pomp. Then second, how the poor front soldier was buried in the place where grenades tore him apart, with lime thrown over him. Yeah, the picture is in there, with a striking, good caption. So here are two juxtapositions above and below."[31]

Here was a manner not only of confronting Germany's false representation of its war, but of highlighting the obscene disconnection between—in this case—an officially approved image of death and another that few citizens would ever see. Indeed, photographs such as the one showing a general's burial were part of an elaborate propaganda apparatus that Germany's government and armed forces established shortly after the onset of the war. The most important component of this setup was an intentionally complex web of censorship offices spun by overlapping regional and military authorities, which together forced the country's illustrated magazines and postcard manufacturers to self-control what they reproduced. To fill the gap created by this restraining of the press, the War Press Office offered

4.9.　Photomontage: soldiers, their commanders, the Kaiser, and landscape, ca. 1917.
From the collection of Hannah Höch.

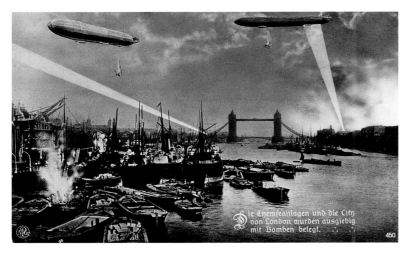

4.10.　"Die Themseanlagen und die City von London wurden ausgiebig mit Bomben
belegt..." (The Thames installations and the city of London were substantially covered with
bombs...). Wartime postcard.

4.11.　John Heartfield (attributed), juxtaposition, 1917. The captions read:
"How a general who died behind the front is buried" and "How proletarians massacred
at the front were dumped."

a limited supply of photographs and photo opportunities that essentially became the only "safe" images that these private outlets could reproduce. The country's thirst for war photographs, therefore, was satiated by authorities who specifically sought to hide the war's unprecedented barbarism.[32] The loquacious camera had essentially become one of the period's most significant tools of silence. Had any commercial organization at the time published the amateur photograph that Heartfield used in the above photo-juxtaposition, its print license would have been revoked and the individual responsible could have even faced jail time.[33]

On account of this purposefully incomplete representation, a vast disjunction arose between the war that citizens saw at home and the conflict that soldiers experienced at the front. Erich Marie Remarque wrote plaintively of this perceptual gap in his 1929 novel *All Quiet on the Western Front*. His soldier protagonist Paul visits home:

I imagined leave would be different from this. Indeed, it was different a year ago. It is I of course that has changed in the interval. There lies a gulf between that time and today. At that time I still knew nothing about the war, we had been only in quiet sectors. But now I see that I have been crushed without knowing it. I find I do not belong here [Paul's hometown] any more, it is a foreign world. Some of these people ask questions, some ask no questions, but one can see that they are quite confident they know all about it [the war]; they often say so with their air of comprehension, so there is no point in discussing it. They make up a picture of it for themselves.[34]

According to Remarque's postwar reflections, not only had Germany's civilian population been woefully underinformed of the conflict's horrific extremes, but these citizens had simply invented a picture to augment an official one they instinctively knew was incomplete. Indeed, the war's approved photomontaged postcards demonstrated how this could be done, literally instructing citizens on how to use available photographs to construct their personal vision of the war. Heartfield designed his photo-juxtapositions specifically to dismantle or forestall such visions and instruction. They would have marked the yawning gulf between the fantasy world Paul finds at home and the slaughter to which he must soon return.

The photo-juxtaposition Heartfield cites as an example of his early work makes such disjunction a singular focus. Its captions, for example, read, "How a general who died behind the front was buried," and continue, "How proletarians massacred at the front were dumped." Not only are the war's burdens unequally shared, the entire composition declares, but this inequality has been veiled from public view by the more appealing pomp of high-rank mourning. Visually, the juxtaposition amplifies this disparity by comparing rows of rigidly upright soldiers lining the final passage of the general to horizontal piles of soldiers' corpses being collected for mass burial. Even the tight circle of officers carrying the general's coffin becomes a shocking mess of bodies in the photograph underneath. Where the first image shows a coffin surrounded by mourners, the second shows soldiers at work, surrounded by death. This unfolding of an implied narrative thereby inverts the thematic arrangement of the official photograph. Disparity, reversal, and inversion complement the themes of silence and unveiling through the composition as a whole.

This sort of confrontation finds an even greater extreme in the artist's 1917 juxtaposition "This Is What a Hero's Death Looks Like" (fig. 4.12). These words, lying at the composition's center, suggest the kind of martyrdom that was praised by Prussia's military apparatus and that was correspondingly depicted in numerous postcards throughout the war (fig. 4.13).[35] But in Heartfield's juxtaposition, such idealized heroism is suppressed by two amateur frontline photos, rendering officially glorified death a mere point of textual implication. Moreover, the artist's two appropriated images use the horror of torn and decaying corpses to mark with flesh the distance between this vision of corporeal defeat and the implied heroism of a soldier's death. His placement of the photographs guides this marking, offering an overview above and the detail below, a contrast of mass death with individual passing, armies of corpses with the singular "hero's" expiration.

Such contrasts offered a quick and efficient way to unveil the underside of war, exposing a great distance between the combat's reality and its official representation. But Heartfield could have never published such compositions on a mass scale or sent them through the post; the risk of being censored or arrested was simply too great. There remained, however, another option he could call on to achieve this antiwar subversion. Rather than contrast Germany's propaganda with the war's suppressed reality, he could literally disassemble the government's misleading visions until the resulting disjunction might alone reference this gap between fiction and actuality. It would be this last strategy, finally, that led him and Grosz to produce photomontaged postcards parodying the government's approved postal visions of wholeness.

The montaged postcards and broadsheets these artists made just after the war show how they likely re-sorted the official visual terms of combat—specifically as found in propaganda postcards—in order to transform compositional and thematic unity into a shocking disorder. The postcards Grosz made in 1920 (figs. 4.14 and 4.15) and 1922 (figs. 4.16 and 4.17), for instance, capitalize on the gaps of meaning produced by mismatched appropriated fragments and thereby encourage a satirical inference that, as an equivalently oppositional antiwar statement, could never be straightforwardly articulated during the conflict itself.

Significantly, however, Grosz's and Heartfield's photomontaged postcards would have sought not just to unveil the difference between war propaganda and the combat's lived experience, but also to pull and stretch photographic meaning until it no longer signified with the fixity that propaganda demands. In lieu of surviving examples, Grosz's 1920 *The Imperial Family in Changing Times,* made within the context of Berlin's politically engaged Dada movement, serves as a good illustration (fig. 4.15). Here the artist appropriated a lithographed photorealist postcard glorifying the Kaiser's family (fig. 4.14). To this card he pasted photo-portraits of the Weimar Republic's first government and various participants in what would be called the Kapp putsch (1920) over faces of the underlying royal family members. By comparing the three groups this way, Grosz implied that Germany's first republic had not broken with the imperial past but simply represented its continuity. A historical note is in order here. The war's impending loss had actually seen the Kaiser introduce full parliamentary democracy one month before his government's collapse, October 1918. But this gesture seemed insufficient and arrived far too late. One month later, on November 8, 1918, U-boat sailors refused to embark on a final suicide mission to break Britain's crushing naval blockade, and with the resulting mutiny, Germany found itself in total revolution. Fearing for his life, the Kaiser abdicated and fled to Holland. At this point the Spartacist League, whose members had earlier split from the German Social Democratic Party (SPD), declared a new communist government in Berlin. In response, the majority Social Democrats declared a parliamentary government of their own that was to build upon the Kaiser's final democratic reforms. Deeply embittered by the war, Heartfield and Grosz threw their support behind the Spartacist revolution and sought to deploy their art for its cause. But in December 1918, the majority socialists, under the leadership of Friedrich Ebert, formed an alliance with the remaining hierarchy of the armed forces and soon crushed

the revolution violently. Heartfield and Grosz were driven apoplectic over this state of affairs, as were the Spartacists, who formed themselves into the German Communist Party (KPD) by January 1, 1919. For the next year and a half the country was continually rocked by uprisings from the Left and the Right, most notoriously in the proto-fascist Kapp putsch, which attempted to install a military dictatorship.

Grosz's montaged postcard comments on this state of affairs by suggesting that Germany's first government behaved no differently than its recently expired imperial predecessor, and more menacingly, that Friedrich Ebert's ruling cabinet sympathized with the right-wing attempt at its own overthrow.[36] And much as the artist's earlier postcards likely scattered glorifying image fragments into a satirical composition, so too did Grosz use both regimes' own propaganda to imply what might have otherwise been libelous to utter even in the freer environment of early 1920. In the altered card, the SPD majority government's attempt to convey authority fails once registered against the imperial pomposity its members ostensibly sought to reject. A factor making this piece by Grosz such a powerful critique is that both the original and remotivated significations, conveyed by the snipped heads, are equally discernible. In fact, Grosz increases the dissonance between these significations by placing his male heads atop all the given figures, regardless of gender. From the gaps, viewers might infer the meaning that the cut surface inadequately provides. And it is significantly the source material of photographic propaganda that has been made to imply a meaning diametrically opposite to what the images' original patrons intended. Transforming montage from a demonstration of thematic unity to one of radical disjunction not only exposed the difference between the postwar regime's democratic image and its imperious—even barbarous—behavior, but it also demonstrated that photography could not be relied upon to produce secure meaning. Berlin's Dada movement, therefore, continued doing what Grosz and Heartfield had started during the war, undermining falsely coherent visions of Germany by re-sorting these pictures' components and subverting their photographic power.

But there is an additional component of this montage that gives its antipropagandistic and photographic subversion yet more power: its expansion upon Grosz and Heartfield's original strategy of intervening in the relationships bound by postal correspondence. It was, after all, specifically by working within the format of a

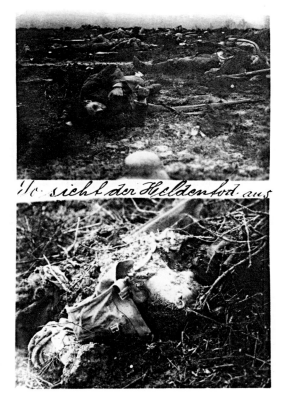

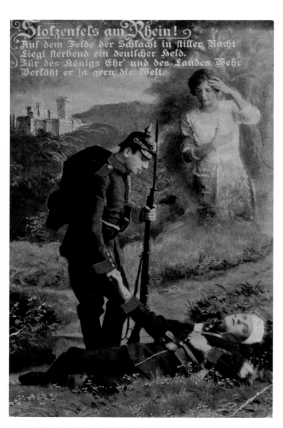

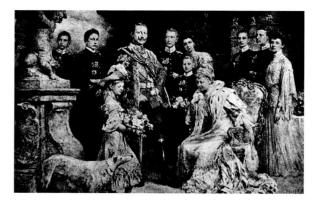

4.12. John Heartfield, "So sieht der Heldentod aus"
(This is what a hero's death looks like), 1917.

4.13. "Stolzenfels am Rhein!" (Proud Rock on the Rhein!),
ca. 1916.

4.14. Original lithographic postcard forming basis of George Grosz's
montage in fig. 4.15.

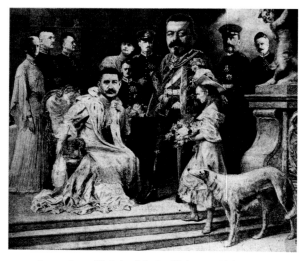

4.15. George Grosz, *Die kaiserliche Familie im Wandel der Zeiten*
(The Imperial Family in Changing Times), 1920. The image's
reversal results from the offset printing process.

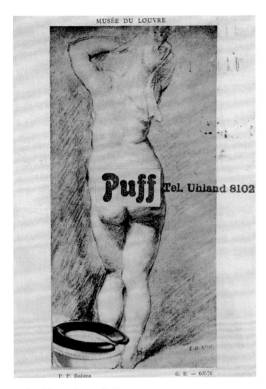

4.16. George Grosz, *Puff*, 1922.

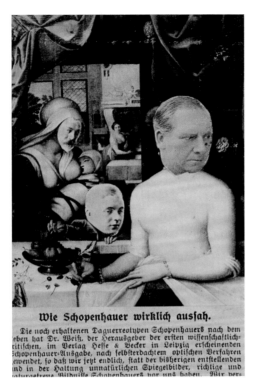

4.17. George Grosz, *Wie Schopenhauer wirklich aussah* (What Schopenhauer Really Looked Like), 1922.

postcard that Grosz felt *The Imperial Family in Changing Times* could make its greatest intervention visually, even if this item reached its audience through the pages of an illustrated magazine. Precisely because postcards were otherwise associated with intensely private correspondence, his critique could gain greater impact. Because picture postcards were normally exchanged between family members or close personal friends, the images they displayed seemed to receive the natural endorsement of the person who sent them. Germany's infinitely complex network of wartime postcard exchange, therefore, ultimately functioned as a system of consent operating on the most intimate and, hence, effective point of viewer engagement possible. The postcards that Grosz and Heartfield sent to the front and those that Grosz later altered for mass-circulation publications intervened at what could be seen as the most personal level of an image's power. This would be the level at which Berlin's Dada movement devised many of its other photomontages as well. *Who Is the Most Beautiful?* (fig. 4.18), made in 1919, for example, shows how Heartfield and Grosz adopted the similarly intimate conceit of an illustrated fan as the platform for their critique. Grosz specifically had in mind a late nineteenth-century bourgeois *accoutrement* on which well-heeled women added images of their family, friends, and admirers for coy display. An important monograph illustrating such knickknacks figured prominently in Grosz's book collection (fig. 4.19).[37]

In the men's photomontaged alternative, the adhered figures are not subjects of affection but rather targets of deep satirical critique. Appearing on the cover of the Dada magazine *Everyone His Own Football,* the photomontage attacked Weimar's socialist government by comparing its members' strutting poses to those of beauty pageant contestants.[38] Their images haphazardly transported into such a context, Germany's Weimar leaders seemed to have their value assessed by physical appearance rather than by political or military accomplishment, an act that unveiled the visual shallowness of their propaganda program. Conveying this critique as well, through the conceit of coy feminine disclosure, is the fan itself, which produces the sense that its origin lies in the realm of earnest and intimate desires, the site of unbridled authenticity and truth. *Who Is the Most Beautiful?* therefore, speaks at the level of an intimate tease as its visual and formal dislocations illustrate the difference between these figures' political stature and their unpopular reception in early Weimar.

But so too was this spoofing a clear product of Grosz and Heartfield's wartime postcards, items that similarly undermined and satirized—at an intimate level—the falsely tight and ordered world that

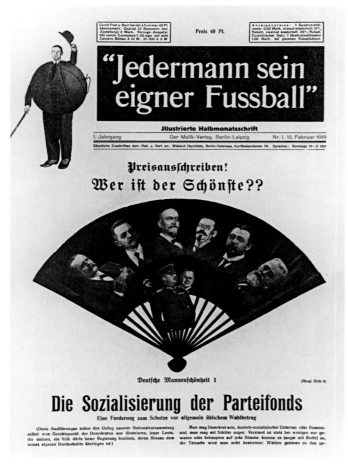

4.18. George Grosz and John Heartfield, *Who Is the Most Beautiful?*

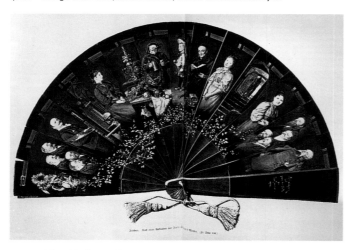

4.19. Eduard Grützner, *Fan,* 1892.

official postcards had seamlessly constructed. And as the 1922 post-card *What Schopenhauer Really Looked Like* (fig. 4.17) demonstrates, Grosz would continue to use this small format to experiment with the disorientation that oddly arranged photographic fragments might stimulate, particularly when their different realities or given contexts collide rather than adhere.

Grosz and Heartfield were not the only members of Dada to appropriate a critical photomontage formula from this realm of personal communication during the war. Hannah Höch later confirmed a similar origin for the montage that she and fellow Berlin Dadaist Raoul Hausmann practiced:

Actually, we borrowed the idea from a trick of the official photogra-phers of the Prussian army regiments. They used to have elaborate oleolithographed mounts, representing a group of uniformed men with a barracks or a landscape in the background, but with the faces cut out; in these mounts, the photographers then inserted photographic portraits of the faces of their customers, generally coloring them later by hand [fig. 4.9]. But the aesthetic purpose, if any, of this very primi-tive kind of photomontage was to idealize reality, whereas the Dada photomenteur set out to give something entirely unreal all the appear-ances of something real that had actually been photographed.[39]

This official mount she was describing was almost surely a postcard framed and hung for semipublic display. A similar cabinet card, already mentioned above, rests in Höch's archive and carries her handwritten annotation "the beginning of photomontage."[40] But unlike the montaged postcards that were designed to be sent to the front rather than from it, these images formed a direct bond between the intimate and the official, in this case transforming the personal endorsement of postal exchange into the actual photographic presence of the person who otherwise made that same endorsement, the soldier. Ultimately hanging in a living room or resting in a photo album, this picture would unite vastly divergent spheres of experiences and thereby domesticate a larger social and military continuity through photography's visual coherence.[41]

In describing Dada's alternative to this official montage practice, Höch also points to the movement's larger goals. She states specifically, for example, that whereas these acceptable montaged postcards idealized reality, Dada sought to "give something entirely unreal all the appearances of something real." Her explanation is instructive, though it may initially seem counterintuitive; wartime montages, after all, also seem to give something false the appearance of reality. But a look at her *Cut with a Kitchen Knife Through the Last*

Great Weimar Beer-Belly Cultural Epoch of Germany (1919–20; figs. 4.20 and 4.21) reveals an essential distinction in what Dada and the former Wilhelmine authorities understood reality to be. Compared to the montaged postcards she cites as an inspiration, Höch takes a diametrically opposite approach to representing soldiers and generals next to their Kaiser, as seen in her composition's upper right-hand corner. Whereas during the war the soldiers appear to occupy a stage set (fig. 4.9), above which hover the emperor and other high authorities, in Höch's work those soldiers and generals swirl around Wilhelm's body, interrupting the very consistency of his face. An incongruous top hat rests on his head, betraying the bourgeois core wrapped under the emperor's military drag. Locked wrestlers symbolize his hypermasculinity as they replace his signature mustache. A dancing General Paul von Hindenburg seems to lure his leader through a disastrous war. A *Stahlhelm* soldier salutes from above while generals, clerics, and financial leaders at the opposite side offer their strange praise. Meanwhile, a machine gun points at the ruler's head. Here was something visually unbelievable that, by Dada's reckoning, offered the truth behind appearance, the gaps, fissures, and overlaps that had genuinely corresponded to the Kaiser's fractured world and photography's lost seamlessness. These were also the truths that wartime propaganda had specifically sought to suppress through its smooth and unbelievable surface. Indeed, while the jubilee postcard had depicted the ruler as an effortless composite of the country's many parts (fig. 4.8), in Höch's work of disjunction those parts jump like popcorn from the broken confines of his visage.

In early 1920, when Höch completed her monumental photomontage, there existed a new, though limited, freedom that allowed Dada's members to communicate in pictures what had been risky to articulate during the war years. But the movement used this liberty to reflect on more than the years spanning 1914 to 1918. With photomontage, they not only undid smooth wartime visions but also reflected and encouraged what they saw as Weimar's chaotic and imminent demise. It is for this reason that the technique that Heartfield, Grosz, Höch, and others adopted during the war now became absolutely central to Berlin Dada's project: to confront Weimar's conservative bourgeois face with the reality of a traumatized and fragmented contemporaneity. And once again postcards, now of the playfully disjunctive variety, took an important role in influencing the movement.

Just as Grosz and Heartfield had earlier sought to readdress the way in which their contemporary actuality was being represented, so too did Dada demand an absolute commitment to the here and now in its art. As Wieland Herzfelde described this charge in his introductory essay to the 1920 First Great International Dada Fair catalogue, "The Dadaists acknowledge as their sole program the obligation to make what is happening here and now—temporally as well as spatially—the content of their pictures, which is why they do not consider *A Thousand and One Nights* or 'Views of Indochina' but rather the illustrated newspaper and the editorials of the press as the source of their production."[42] In this period following the war's disastrous conclusion and Weimar's difficult formation, Dada would concentrate solely on the phenomena marking this transformation. To do so, the movement would appropriate popular press images and editorials in order to reflect a chaos that a genteel and distant *Views of Indochina* could not. Berlin Dada's new art would laud a tattered contemporaneity, the kind of reality its members had consistently labored to reveal during the war, when official images sought otherwise. As the group's 1918 manifesto declared: "The highest art will be that which in its conscious content presents the thousandfold problem of the day, the art which has been visibly shattered by the explosions of the last week, which is forever trying to collect its limbs after yesterday's crash. The best and most extraordinary artists will be those who every hour snatch the tatters of their bodies out of the frenzied cataract of life, who, with bleeding hands and hearts, hold fast to the intelligence of their time."[43] With words equating a bedraggled epoch to bodies that had been shredded on the war's front and in the subsequent 1918 Revolution, Dada called for an art of radical simultaneity and disjunction that would, as Herzfelde explained, "proceed from the requirement to further the disfiguration of the contemporary world, which already finds itself in a state of disintegration, of metamorphosis."[44] Dada's photomontage, in other words, would use a technique of the radical non sequitur both to reflect and to encourage its society's chaotic deterioration. And it would do so by deploying the photomontage techniques pioneered by the postcards that had originally inspired them, missives such as *Ziegenhals in the Future* (fig. 4.1). In this image, the apparently seamless and objective photographic medium had been cloven apart, forced to join the ranks of painting, drawing, and written text as a form of representation that could not contain reality in neatly structured packages of representation.

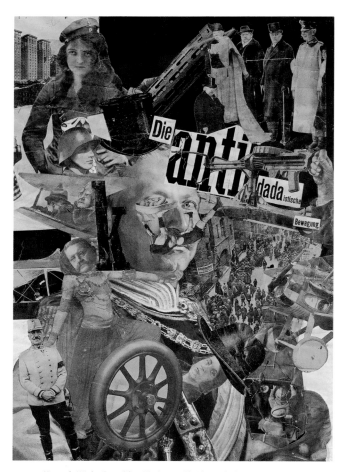

4.20. Hannah Höch, *Cut with a Kitchen Knife Through the Last Great Weimar Beer-Belly Cultural Epoch of Germany*, 1919–20 (detail)

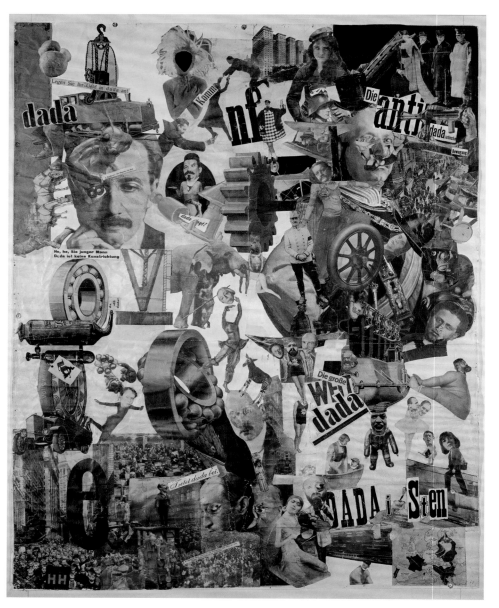

4.21. Hannah Höch, *Cut with a Kitchen Knife Through the Last Great Weimar Beer-Belly Cultural Epoch of Germany*, 1919–20.

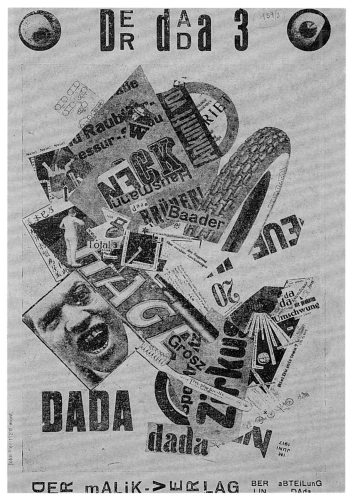

4.22. John Heartfield, *The Tire Travels Around the World*, 1920.

In Dada's update of a disjointed prewar commercial photo-montage technique, photography's very insecurity was made to mirror the dissolving epoch. The medium, in other words, had become metarepresentational, able to reflect its contemporary reality through its very instability, its dismantling into a form without structure. Photomontages such as John Heartfield's *The Tire Travels Around the World* (1920) (fig. 4.22) or those he collaboratively assembled with Grosz such as *Sunny Land* (1919) and *Dada-Merika* (1919) specifically pair photographs from illustrated periodicals with text that seems to reflect the political anarchy of the country's divergent editorial writers. In such work, both the written text and the photograph are subject to shifting and wildly subjective—even evacuated—meaning. *The Tire,* for instance, features the screaming mouth of fellow Dadaist Raoul Hausmann, a floating toothbrush, and a tire careening from the background toward an array of commercial and political propaganda, thereby showing that the photographic image and text had both become equally subjective and therefore—at this moment of social disintegration—reflective of a radical discontinuity. Many of these photomontages were printed in the movement's periodicals and exhibited in the First Great International Dada Fair of June–August 1920. But their origin ultimately lay in the more private exchange of postal correspondence. In fact, the presence of Hausmann's screaming face in *The Tire* and similar appearances of Dada's members in the movement's many other photomontages demonstrate that the re-performance of Weimar's perceived disintegration would carry the intimate signature that had declared a postcard's personal relevance. Postcards sent to the front were now personal confirmations of social decay, exhibited on a mass scale.

AMBIVALENT UTOPIA: FRANZ

MARC AND ELSE LASKER-SCHÜLER'S

PRIMITIVIST POSTCARDS

Kimberly A. Smith

Historians of modern art have long recognized that German Expressionism gained much of its force and clarity from its artists' fascination with the so-called primitive. Yet only recently has Expressionism's appeal to archaic and exotic sources been subjected to critical scrutiny, in an effort to situate its primitivism both historically and ideologically.[1] However, the historical significance of primitivism in the work of Franz Marc, one of the era's most significant painters and the cofounder, with Wassily Kandinsky, of the Blaue Reiter, remains largely unexplored. To be sure, Marc's desire to transcend the material world by devoting his art to capturing the pure primitive forces that he believed animals embodied is discussed in virtually every account of his work.[2] Yet this perspective brings our understanding of his work only so far. Certainly Marc, like so many of his central European contemporaries, longed to disentangle himself from what he saw as an overly materialistic and positivist society, and he turned to animals as a means of facilitating that escape. But how might Marc's perspective be located within the context of early twentieth-century Germany? What were the ideological ramifications of Marc's fascination with the animal world and its connotations of primitive fierceness and freedom? In other words, it is not enough to accept Marc at his word and view his art as a romantically inspired representation of idyllic metaphors for spiritual freedom; we need to assess Marc's evocation of the primitive critically, as an act born of historically specific circumstances.

To build upon, and move beyond, the commonplaces of Marc literature, perhaps a shift in focus is necessary. I would like to turn from the large-scale oil paintings for which Marc is best known to a series of small postcards he made in 1913 and 1914 for his friend, the Expressionist poet Else Lasker-Schüler. Marc and Lasker-Schüler first met in December of 1912, prompted by an introductory letter sent by Lasker-Schüler, which was followed by a postcard from Marc, on which he painted a tower of lustrous blue horses (fig. 5.1). For the next year or so, the two new friends generated a rich epistolary exchange in which Marc produced lovely small-scale animal paintings on postcards and Lasker-Schüler responded with postcards and letters, at times ornamented with her own drawings. Marc's postcards, made for Lasker-Schüler, offer an opportunity to reframe his commitment to representing animals in the context of an ongoing dialogue with his friend, characterized for both poet and artist by a typically Expressionist disenchantment with modernity and a search for primitive utopian alternatives.

The correspondence between Marc and Lasker-Schüler is briefly mentioned in much of the literature on both figures, yet few attempts have been made to analyze these postcards as culturally meaningful objects. The most extensive commentary has been written by Peter-Klaus Schuster, in which he states that the postcards "show Marc's work…to be a vision of a spiritualized, paradisal existence to which the human individual feels a nostalgic sense of belonging."[3] Schuster proposes that the paradise envisioned in these images is the rural retreat of Sindelsdorf, where Marc lived with his wife Maria.[4] Marc's postcards do indeed articulate a primordial fantasy that both accords with Marc's long-held love of animals and integrates the poetic concerns of Lasker-Schüler. Yet I will argue that it is not Sindelsdorf that is imagined by the postcards but Thebes, the archaic fantasy world invented by Lasker-Schüler. In this fictional space, Lasker-Schüler took on the poetic identity of Prince Jussuf, the Arabic name of the Old Testament's Joseph, in an ancient Egyptian paradise. Schuster also suggests that this utopian idyll, because of its spiritual primitivism, stood as a direct reproach to the materialist values of Wilhelmine Germany. I will explore the genuinely radical details of this utopian vision below, particularly as it concerns the enunciation of alternative identities. Yet if we view the postcards as fundamentally intertextual objects, as I think we must, then we can recognize that they mediate, and are mediated by, contemporary beliefs about Egypt and animals as sites of primitive purity. The postcards' transgressive potential must be situated within the cultural complexities of a utopia that relied on colonialist representations of the primitive for its identity. Located at the interstices of these primitivist discourses, the postcards mark off a utopian space of exotic alterity that not only contradicts but confirms the dominant culture of contemporary Wilhelmine Germany.

When he began exchanging postcards with Lasker-Schüler, Marc entered a Theban world that already had begun to take shape in Lasker-Schüler's private correspondence of 1910 and in her novel *Mein Herz* (My Heart).[5] In this alternate, fictional realm, Lasker-Schüler began to call herself Jussuf, Prince of Thebes, a persona that reappears in a book of essays entitled *Gesichte* (Visions/Faces) in 1913, and the novel *Der Prinz von Theben* (The Prince of Thebes) in 1914. Marc knew of Lasker-Schüler's work before they met, and first introduced himself to her in writing as the Blue Rider, a title drawn from the *Blaue Reiter Almanac,* which he had recently edited with Kandinsky. Adopting the guise of the Blue Rider represented a gesture

of openness on Marc's part to enter into Lasker-Schüler's poetic, avant-garde world filled with alternate identities. From the beginning of their correspondence, then, Marc's missives willingly participated in the articulation of Lasker-Schüler's mythical Thebes, so that Thebes began to be realized in the moments where production and reception overlapped. Both Lasker-Schüler and Marc made pictures, though Lasker-Schüler was and is best known for her writings. Lasker-Schüler's drawings in her letters and postcards are instructive and contribute to the construction of the postcards' Thebes, but her text really does most of this work. In contrast, Marc's written messages are brief, while his images give visual form to Thebes in a playful and sustained way. Marc used his postcards to unfold a place in which Jussuf's stories might occur, a verdant, richly hued landscape populated by equally vivid creatures (fig. 5.2). Various beasts are positioned in delicate arrangements, usually with the cards oriented vertically. The animals are rendered in india ink, watercolor, and gouache, and a few of the images also use collage in addition to traditional media. In the postcards, Marc creates a shimmering world sparkling with vitality, thus animating the imaginary realm of Thebes that is their subject.

And Thebes is most certainly what is shown in these images. In certain instances, this is immediately apparent simply from the titles Marc gives to his pictures, such as *Prince Jussuf's Lemon Horse and Fiery Ox, From Prince Jussuf's Hunting Grounds, The War Horse of Prince Jussuf, Image from Jussuf's Times of Peace,* and *From the Ancient Royal City of Thebes.* Even when the title does not explicitly indicate the connection to Lasker-Schüler's construction of ancient Egypt, the postcards note the Theban context pictorially or textually. In certain instances, Marc's message to Lasker-Schüler directly indicates the animals' role in the kingdom of Thebes, as in "this is the brood mare of the blue horses, from the Prince of Thebes' stud farm" (20 March 1913), or "this is the war horse of Prince Jussuf—fearful!" (1913). It is not just the titles and text, however, that invite us to see these as Theban scenes. For example, in Marc's first postcard to Lasker-Schüler, *The Tower of Blue Horses,* the horse in the foreground bears a half moon and star on his neck, and again above his front legs. Lasker-Schüler used the same glyph in her portraits of herself as Prince Jussuf, suggesting that the horses stand metaphorically for the prince, or mark them as belonging to the state of Thebes. In either case, we are meant to remember that we are looking at a Theban landscape,

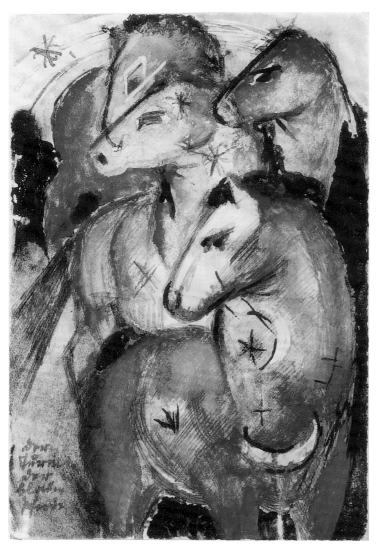

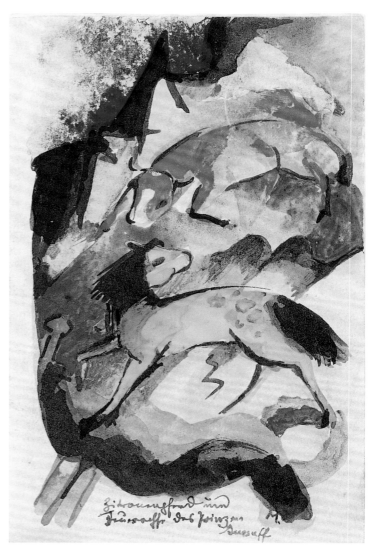

5.1. Franz Marc, *Tower of Blue Horses*, 1913, postcard to Else Lasker-Schüler.

5.2. Franz Marc, *Prince Jussuf's Lemon Horse and Fiery Ox*, 1913, postcard to Else Lasker-Schüler.

the poetic creation of Lasker-Schüler's imagination, to whose rituals and spaces Marc has begun to contribute as well. And in response to *The Tower of Blue Horses,* Lasker-Schüler wrote in reply: "How beautiful is the card. I have always wanted my white horses in my favorite color [blue]. The crescent moons are wonderfully artistic; they are Egyptian crown prince daggers in the skin of whinnying legends. How can I thank you!"[6] Thus the Theban state, which had initially been Lasker-Schüler's own creation, becomes Marc's project as well, as he populates its imaginary lands with a menagerie of jewel-colored beasts.

Marc's fascination with animals, which he began painting almost exclusively as early as 1907, derived from the desire to access authentic experience that also lies behind Lasker-Schüler's interest in ancient Thebes. Both poet and artist felt that the modern world suffered from a formulaic and inauthentic culture that needed to be revivified through passion and intensity. As Karl Webb notes, Marc and Lasker-Schüler both searched "for a renewed sense of innocence and purity which they felt had been lost in the profane and inhuman world around them," and both advocated "a return to the primordial forces of life, to a type of vitalism."[7] Marc and Lasker-Schüler's mutual desire to produce a spiritually resonant art, prompted by dissatisfaction with the culture of modern industrialized Germany, was typical of the Expressionist generation. Indeed, it is this yearning for an antimodern metaphysical truth that, paradoxically, defines so much of German modernism. For Marc, animals became his key signifiers of the spiritual, emblems of a more authentic and natural form of existence and freed from the constraints of civilized logic. In German culture, animals represented a mode of knowing the world marked by instinct and irrationality, a view that had developed from the ideas of the French *philosophe* Jean-Jacques Rousseau.[8] For Marc, then, animals could stand as expressions of a pure artistic ideal that for him was not only modern but morally imperative: "I see no more appropriate means of the *animalization* of art, as I'd like to call it, than the image of the animal. That's why this is what I'm aiming at."[9]

Ideals of organicism and instinct are expressed in Marc's postcards to Lasker-Schüler not only thematically, through the depiction of animals in landscape settings, but formally as well. For Marc, the freedom and spontaneity of the animal world became the template for instinctual aesthetic decisions, a way of bypassing the outdated conventions of mimetic representation. Although his Theban scenes reveal skillful, controlled attention to the spatial demands of the small postcard, the lambent quality of watercolors,

and the integration of formal interrelationships, they also cultivate an air of unrestrained spontaneity. For example, in *Prince Jussuf's Lemon Horse and Fiery Ox,* Marc fully takes advantage of the range of densities that working in watercolor can offer; fields fluctuate from nearly transparent to deeply pigmented, creating a flow of undulating surfaces. The formal effect is that of breathing bodies or swelling waves, lending the images a rhythmic vivacity. When Marc began sending his friend exquisite images of instinctual beasts painted in a languid, organic style, Lasker-Schüler welcomed the introduction of these animals to her poetic Thebes as appropriate signs of an antimodern integration with the natural world.

Marc searched for symbols of a more "natural" purity not only in the animal world but, like so many other Expressionist artists and writers of the era, in the art of ancient and non-Western cultures. He viewed these as more primitive, untainted by the materialist values of modern Germany, and, therefore, as sources of both aesthetic and spiritual renewal. He often visited the Museum of Ethnography in Munich, for example, and had a small collection of ethnographic objects.[10] In this effort to locate antimodern visual forms, Marc embraced Egypt as a source of artistic inspiration even before he entered Lasker-Schüler's well-developed fantasy of Thebes in 1912. He and Kandinsky had included Egyptian shadow puppets in their *Blaue Reiter Almanac,* objects that Marc must have known represented for Kandinsky "the concept that art may be brought to life by the 'divine fire' of the creator."[11] In addition, Marc described his admiration of Egyptian art's spirituality in an essay of 1911/12: "I can paint a picture of the deer.... I can, however, also want to paint a picture of what the deer feels. What an infinitely finer sense must a painter have to paint that! The Egyptians have done it."[12] In some cases, Marc's work contains specific references to Egyptian examples that were recognized by contemporary audiences. In 1911, for example, a reviewer of Marc's exhibition at the Galerie Thannhauser in Munich wrote: "Pieces like *Team of Donkeys* and the *Monkey Frieze* are fascinating in and of themselves. But the themes already belong to the art of the ancient Egyptians, and if Herr Marc takes them up again, then that only shows what a strong retrospective trait is inherent in this 'most recent' painting" (fig. 5.3).[13] Indeed, Klaus Lankheit has identified the precise source for *Team of Donkeys* as an Egyptian relief from around 2700 B.C.E. located in the Rijksmuseum in Leiden, confirming the contemporary reviewer's intuitive recognition of Egyptian art as the inspiration for Marc's formal strategies (fig. 5.4).[14]

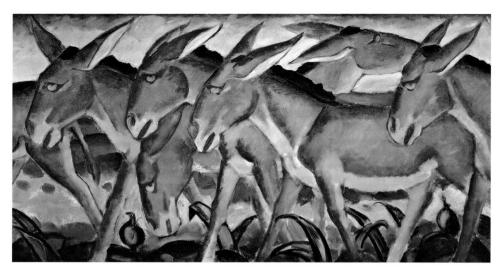

5.3. Franz Marc, *Donkey Frieze*, 1911.

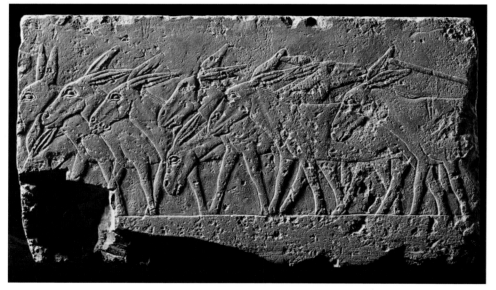

5.4. *Donkey Relief*, Egyptian, ca. 2700–2600 BCE.

References to the example of Egyptian art can be recognized in Marc's Theban postcards as well. In *Tower of Blue Horses,* the first postcard he painted for Lasker-Schüler, the heads of the horses are shown in profile, as they are in *Donkey Frieze* and its Egyptian model in Leiden. The oblong shapes of the blue horses' heads overlap each other in a shallow space, creating a rhythmic procession of similar forms, again mirroring the composition of the Egyptian frieze. In *Tower of Blue Horses,* the figures are arranged vertically rather than horizontally as in the Egyptian space, and the two bodies of the lowest horses appear foreshortened. Yet the visual thrust of the image clearly lies in the even repetition of the horses' profiled, overlapping heads, creating a contained sense of steady motion. This focus on the profiles of animals, learned from Egyptian art, can be seen in other postcards as well: in the snarling faces of the two panthers in *The Three Panthers of King Jussuf* (fig. 5.5), the blue horse in *Drinking Trough on Rubin Mountain* (fig. 5.6), the magenta deer in *From Prince Jussuf's Hunting Grounds* (fig. 5.7), and others. Emphasis is continually placed on the simplest attributes of the animals, those that can be perceived in profile or frontally, so that Marc's postcards are marked by a clarity of form that also characterizes ancient Egyptian images.

In addition to their profile views and overlapping forms, the postcards seem to call on the example of Egyptian images in their use of highly saturated hues assigned to clearly delineated forms. Egyptian wall painting utilizes undiluted colors applied to carefully outlined shapes, but Egyptian jewelry may offer an equally instructive comparison to the postcards. Lasker-Schüler once thanked Marc for his pictures by writing: "Glorious cards—I have laid them all in a jewelry box...I *cannot* thank you more!"[15] For Lasker-Schüler, the postcards shone like precious gems, and, given Marc's interest in Egyptian culture, we may ask whether they emulate the example of Egyptian jewelry in particular. For example, in *The Three Panthers of King Jussuf,* the shapes of the animals are outlined in black and filled with brilliant shades of yellow and purple, a configuration that resembles the glossy surfaces of differently colored semiprecious stones separated by fine filigree. A similar constellation of carefully segmented shapes in distinct colors can be seen in *From Prince Jussuf's Hunting Grounds.* In both of these examples, the similarities to ancient jewelry are also encouraged by the collapsing of figure and ground into a single plane of interlocking forms, like the cloissonistic compositions of Egyptian metalwork. In the postcards, the "background" shapes, filled with hues of burnt orange, deep violet, and forest green, vie with those of the "foreground" creatures, dissolving any clear sense of recessed space.

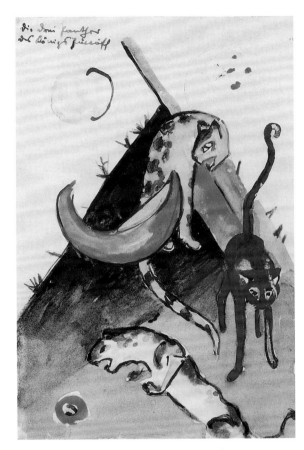

5.5. Franz Marc, *The Three Panthers of King Jussuf,* 1913, postcard to Else Lasker-Schüler.

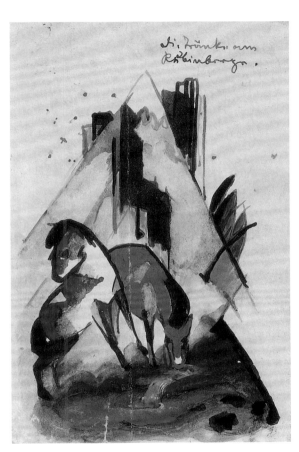

5.6. Franz Marc, *Drinking Trough on Rubin Mountain,* 1913, postcard to Else Lasker-Schüler.

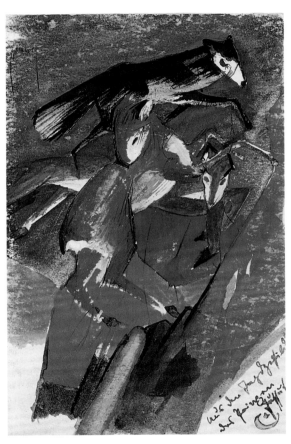

5.7. Franz Marc, *From Prince Jussuf's Hunting Grounds,* 1913, postcard to Else Lasker-Schüler

Lasker-Schüler responded to Marc's postcards with genuine gratitude and pleasure. Moreover, her replies indicate that she viewed the cards, or more specifically their animals, as precious presents to Jussuf and, by extension, to the kingdom of Thebes. In one postcard to Marc she declares: "The city of Thebes is delighted by the antelope and I, the Emperor, am extremely moved."[16] In another, she writes, "you are the one who creates pure [*lauter*] holy animals that now live in my groves. For the small calf, a sweet fat little animal, I have had an extra stall built from gold. Thus I glorify your animals."[17] At times, Lasker-Schüler even incorporates these creatures into the iconography of Thebes. For example, when Marc sent Lasker-Schüler a postcard depicting a large elephant (fig. 5.8), Lasker-Schüler responded as Jussuf: "Oh, you dear brothers, the elephant card will be printed on the flag of my city. How can I thank you!!"[18] Thus, Marc sent postcard pictures of lively creatures painted in an Egyptian style to Lasker-Schüler, with titles indicating their place in Jussuf's kingdom, and Lasker-Schüler responded by declaring the prince's satisfaction with Marc's animate gifts. By these means the dialogue develops, one in which Marc's images of animal silhouettes set within a shimmering, colored landscape instantiate, through content and form, the ancient Thebes of Lasker-Schüler's imagination. And Lasker-Schüler, as their primary beholder, confirms their role in enunciating this Egyptian fantasy by incorporating them into the iconography of Thebes and accepting them as gifts to the prince. The movement of sender to receiver and back to sender again revolves throughout 1913, repeatedly actualizing the exotic vision of Thebes through this cyclical process of exchange.

The ancient Egyptian site of Thebes appealed to Lasker-Schüler not only because of its antimodern qualities, as discussed earlier, but also because this primitivist utopia allowed her to dramatically extend her socially given identity. With Thebes, and as Jussuf, Lasker-Schüler formed a space free of the modern bourgeois conventions against which she had long strained. Lasker-Schüler made that contrast strikingly clear by adopting the persona of Jussuf not only in the fictive Egyptian kingdom of her texts, including the postcards to Marc, but by dressing as Jussuf in the contemporary world of Berlin. Her friend Gottfried Benn recounted the effect that such "performances" created: "She had jet-black hair, cropped short, which was still extremely unusual in those days.... Neither then nor later was it possible to walk across the street in her company without the whole world coming to a halt and looking at her: eccentrically full skirts or trousers,

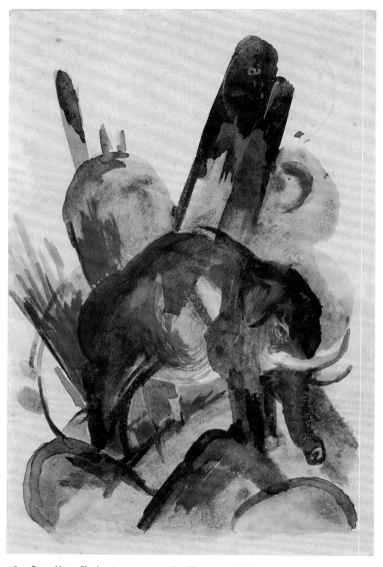

5.8. Franz Marc, *Elephant*, 1913, postcard to Else Lasker-Schüler.

improbable upper garments; neck and wrists festooned with showy, fake jewelry; chains and earrings; pinchbeck rings on her fingers."[19] Several scholars have noted how Lasker-Schüler's fluid appropriation of the Jussuf character, and her willingness to erode the distinctions between her real and fictional selves, functioned as a genuinely radical challenge to normative definitions of selfhood. Perhaps most obviously, the role of Jussuf allowed Lasker-Schüler to adopt a male persona and, therefore, to diverge from accepted notions of a stably bipolar femininity and masculinity. Antje Lindenmeyer, for example, analyzes both those staged public events in which Lasker-Schüler read from her writings, as well as the less systematic appearances on the streets of Berlin, where she also wore the costume of Jussuf. For Lindenmeyer, both acts conform to the notion of performance as theorized by Judith Butler and, thus, offered possibilities to perform gender transgressively.[20] Similarly, Katrina Sieg argues that the role-playing and cross-dressing involved in Lasker-Schüler's Jussuf character explicitly disentangled desire from strictly heterosexual or homosexual positions; thus, "the fluidity of her desire challenged the stable roles and hierarchies of gender and sexuality."[21]

Just as significantly, Jussuf also offered Lasker-Schüler a way to claim her Jewish heritage without adhering to the modes of Jewish subjecthood available to her in Germany at the time. The years before World War I were a time of intense cultural debate about Jewish identity within German society. During the nineteenth century, many German Jews had participated, to some degree, in the complex processes of assimilation, embracing German traditions and culture and becoming increasingly secularized members of a highly educated middle class. Theodor Herzl's Zionist movement, inaugurated by the first Zionist Congress in 1897, challenged this liberal assimilationist paradigm and was prompted in part by the realization that liberalism had not eliminated anti-Semitism in central Europe. Herzl argued against assimilation and for a renewed sense of a separate Jewish identity, famously proposing that a homeland be created for Jews in Palestine. Herzl's political Zionism, with its call for a Jewish nation, coexisted with cultural Zionism, represented by figures like Martin Buber who sought to foster a Jewish sense of self that depended not on German values but on that which was unique and essential to the Jewish character. Yet many Jews rejected Zionist ideas, seeing them as a threat to their sense of themselves as Germans, which they continued to value highly.[22] The details of this heated public conversation about the nature of individual and communal Jewish identity are too complicated to discuss in depth here. What can be said, however, is

that the question of what it meant to be Jewish became far more urgent than it had been during the liberal years of quiet assimilation. Some Jews continued to believe that they would some day be integrated within German culture, but their hopes now ran up against an increasingly visible and separatist notion of Jewish identity.

Lasker-Schüler rejected the assimilationist approach of her parents' generation and made her Jewishness a central part of her literary work. By adopting the persona of Jussuf, Lasker-Schüler strategically enacted a version of Jewish subjectivity closely allied with ancient Egypt. The link between Jewish identity and the East already had a long history within European intellectual culture. Jan Assmann has written about the "Moses/Egypt discourse," a project of cultural memory that he traces from the eighteenth to the twentieth centuries, in which Egypt is seen not as the amoral antithesis of monotheistic Israel but as its foundation. Within this evolving discourse, Moses is believed to have been an Egyptian, who carried certain aspects of Egyptian law and religion, particularly the monotheistic beliefs of Akhenaton, to the Hebrews.[23] By the early twentieth century, non-Jewish Germans customarily associated Jewish Germans with Egypt, and the "Orient" more generally.[24] Cultural Zionism claimed this heritage in order to foster a uniquely Jewish subjectivity, calling for Jews to renew their ties to the Holy Land and celebrate this connection between modern Jewish identity and an ancient Middle East.[25]

By giving voice to a Jewish identity rooted in Egypt, Lasker-Schüler incorporated select aspects of cultural Zionism into her work, yet it would be reductive to describe Lasker-Schüler's writing as Zionist, in part because Zionism itself was a complicated movement. Moreover, Lasker-Schüler created a personal mythology that deviated from the cultural or political Zionisms of her time by creatively articulating a unique and fluid sense of Jewish identity. Here, it is crucial to recognize how Lasker-Schüler's construction of Jussuf depended on shifting sets of characteristics that promoted a deliberate sense of play and self-consciously avoided any static notion of selfhood. Although this variability can be seen in much of her writing, for our purposes it is instructive to see Lasker-Schüler working this strategy into her earliest correspondence with Marc. In her first letter to the artist in 1912, Lasker-Schüler suggested that they meet in person, and introduced herself as "Jussuf, the Prince of Thebes." This initial message was followed in the coming weeks by a letter in which Lasker-Schüler denied ever writing the first letter, but again identified

herself as Jussuf, and finally a third letter that explained the trajectory of her self-created royal background: "I *am* from Galiläa, then went to Baghdad, then came to Thebes. *Thus* everything is explained."[26]

The adoption of an alternate identity is one of the hallmarks of Lasker-Schüler's work, as is the radical vacillation between different, often conflicting, viewpoints. Remember also that Lasker-Schüler drew portraits of herself as the prince and staged public readings at which she assumed his appearance by combining an elaborately ornamented body and carefully inscrutable speech. Lasker-Schüler purposefully blurred the line between her real and fabricated identities, even wearing the costume of Jussuf during the course of her daily activities. It is this mobile conception of the subject, in conjunction with the obvious artifice of Jussuf's appearance, that disallows her Oriental Jew from being dehistoricized as a timeless essential truth. As Katrina Sieg notes: "Rather than locking a Semitic identity into racial exoticism, her Oriental costume marked that identity as fictional, as fantasy. Her Jussuf, a savage Jew [*Wildjude*], remained unaligned with any organized faction in the Jewish community."[27]

This notion of the *Wildjude* occupies a strategic role in Lasker-Schüler's endeavor to articulate an alternative model of Jewish identity. She often used the term *Wildjude* in her personal and public writing, including her correspondence with Marc. In one instance, for example, after thanking Marc for another of his painted creatures ("I tell you, my Blue Rider, the new splendid horse is a wild, shaggy fellow. I have kissed him on the mouth. Too many gifts!"), she signs the postcard, "your wild Jew Jussuf."[28] Lasker-Schüler's appropriation of Jussuf as the sign of her Jewish character also contributes to the construction of the savage Jew, since Joseph predated Moses's establishment of Judaic law. Donna Heizer suggests that the wild Jew "is a poetic metaphor for her longing to return to an ancient, original Jewish culture.... This 'wildness'... is supposed to be an inherently Oriental quality characterized by passion, bravery, and the ability to produce great art."[29] Lasker-Schüler's concept of the *Wildjude* as an emblem of ancient strength, and source of alternative identity, was supported as well by her use of a fabricated *Ursprache,* or archaic language. In her 1913 publication *Hebrew Ballads,* for example, Lasker-Schüler writes certain poems and stories in her idiosyncratic and nonsensical version of ancient Hebrew: "Abba ta Marjam / Abba min Salihï / Gad mâra aleijâ / Assâma andir."[30] Nina Berman, who

has analyzed Lasker-Schüler's project within the context of German Orientalism, explains: "'Wild' implies rebelliousness, resistance and youthful strength. Together the prefixes '*ur*' and '*wild*'—in the context of the dominant German-Christian society—impart a self-conscious position of alterity. *Ursprache* and *Wildjudentum* stand metaphorically for the enterprise of newly determining Jewish self-understanding in Germany."[31]

Marc's animals signify an archaic truth crucial to the enactment of Lasker-Schüler's Theban idea. By picturing Lasker-Schüler's Thebes as a richly hued realm filled with equally colorful beasts, Marc's postcards may be seen as participating in her vision of an alternative Jewish identity marked by passion and instinct. The natural fierceness suggested by Marc's animals mapped well onto the poet's conception of the savage Jew (*Wildjude),* with its connotations of impassioned, instinctual behavior. The question of Jewish identity may have had personal relevance for Marc, and the model of the savage Jew may also have appealed to him as a way of thinking through his own complicated religious origins. Although Marc considered becoming a Protestant minister when he was young, his patrilineal heritage was originally Jewish. His great-grandfather was Jewish, and the family name, Marc, was that of an old Jewish family from Arolsen.[32] In a culture in which one's Jewish background was often considered relevant even if the family had converted generations before, it is certainly possible that the deeply introspective Marc may have sought a way to integrate his past with his present, to reconcile his Jewish ancestry with a modernist practice that he viewed very much as a spiritual enterprise.[33] After all, Marc and Lasker-Schüler met after she saw his woodcut based on her poem entitled "Versöhnung," which literally translates as "reconciliation" but is also the German word for Yom Kippur, so issues of Jewish identity were present from the beginning of their artistic friendship.[34] And Marc's animals figure that conception of Jewish selfhood born of ancient Egyptian culture, which, as envisioned by Lasker-Schüler, provided a utopian antidote to the politically fraught question of Jewishness in modern German culture.

These two signs of the primitive—animals and ancient Egypt—set into motion a circuit of ideas relating to purity, naturalness, passion, and spirituality. Yet I would like to argue that, as with other contemporary deployments of the primitive, both Marc and Lasker-Schüler's turn to archaic themes belies the very authenticity to which they aspire. In other words, while both embraced Thebes and its beasts as sources of an untainted truth—and thus as the means by which a radical Jewish and, more generally, modern culture might be

articulated—the idea of ancient Egypt and its animal kingdom was apprehended only through its cultural representations. Mediated by contemporary expressions of the primitive, Marc and Lasker-Schüler's Thebes may be recognized as part of a larger Orientalist discourse operative in Germany during the early years of the twentieth century. The extent to which Lasker-Schüler's writing participates in Orientalist notions has been studied, notably by Berman and Heizer, but Marc's animal paintings have never seemed to lend themselves to similar readings. I suggest that the entry of the postcards into the cultural construction of Thebes should call our attention to how these precious, jewel-like animals may also depend on and contribute to a German mythologizing of the Orient. In doing so, the transgressive aspects of the postcards discussed above are met by the pull of Orientalist projections. The postcards, I suggest, offered an especially appropriate space to negotiate this tension between radical utopia and conservative ideology.

Orientalism depends, as Edward Said first demonstrated, on colonial fantasies projected onto the material circumstances of the regions under their control.[35] Said has claimed that Germany exhibited only a scholarly relation to the Orient, rather than an Orientalism tied to nationalist bids for power, because of its belated interest in military colonialism. However, others have persuasively argued for a more inclusive notion of Orientalism in Germany. Berman, for example, has studied forms of Orientalism that "are not dependent on the presence of a colonial or an administering bureaucracy" yet "nevertheless display structural and functional similarities to the Orientalist representations generated by the culture of colonial powers."[36] As a way of understanding—or misunderstanding—other cultures, Orientalist discourse has been bound not solely to the dynamics of political and military colonial control but also to what has been called the "imperialist imagination." Germany may not have begun its colonial enterprises as early as France and Britain, or amassed similarly large holdings, but scientific expeditions, literary representations, and other cultural methods of appropriation established a tradition of Orientalism that informed German ideologies about the Orient, including Egypt.[37] For example, Richard Lepsius's three-year archaeological expedition to Egypt in 1842–45 contributed substantially to the emerging discipline of Egyptology and was financed by Kaiser Friedrich Wilhelm IV. Lepsius apparently viewed his research as benignly philological, yet his scientific

victories, while not based on military might, exhibited the claims of mastery and nationalism that also marked more overtly colonial exploits.[38] The Kaiser recommended Lepsius to Egypt's ruler, Muhammad Ali, who allowed Lepsius to excavate wherever necessary and to export what he found to Germany. Around fifteen thousand objects were eventually shipped back to Germany to become part of the state's museum collections. Thus, Lepsius's expedition resulted in the literal plundering of Egypt's cultural treasures, exhibited in the Egyptian Museum in Berlin nominally under scientific auspices, but clearly also as testaments to Prussian power. Made possible by these German archaeological expeditions, the many exhibitions on view at the Egyptian Museum in Berlin, to which Lasker-Schüler certainly had access, were therefore examples of what we might call "nonoccupational imperialism."[39]

As part of Germany's imperialist imagination, Egypt figured prominently in an Orientalist discourse that extended beyond the exhibitions at the museum. For example, the pictorial and textual records of Lepsius's expedition were published in a lavish twelve-volume set that made the details of his findings available to the public. Moreover, during the nineteenth century, although philological interest in Egypt began to wane in academic circles, among the general public, familiarity and interest in ancient Egypt's aesthetic achievements only increased.[40] Lepsius's student Georg Ebers published several popular novels and accounts of Egypt, including *Uarda: Roman aus dem alten Aegypten* (1876) and *Aegypten in Bild und Wort* (1878).[41] By the early twentieth century, Egyptian art and architecture, as represented in exhibitions, books, novels, and images, became objects of fascination for a German public well versed in the pleasures of cultural colonialism.

We must recognize, then, that Lasker-Schüler's understanding of Egyptian culture and history necessarily relied on contemporary Orientalist representations of ancient Egypt as consumable Other. In fact, Lasker-Schüler first conceived of her poetic Thebes during a visit to the popular Egyptian exhibition at Berlin's Lunapark, where villages and people were displayed as anthropological artifacts to be viewed by German visitors, and she spoke of the Egyptian exhibition several times in her letters.[42] Her vision of Egypt was thus highly mediated, and, in choosing Thebes as a site of utopian projection, Lasker-Schüler participated in the exoticizing discourse of Germany's imperialist imagination. Thus, although Thebes offered a means by which Lasker-Schüler could envision radically alternative Jewish and gendered

identities, its rhetorical importance lay simultaneously in its ability to conjure Orientalist fantasies linked to colonial projects, producing a tension between ideologically progressive and conservative politics.

Marc's Theban creatures are no less mediated than Lasker-Schüler's Egypt, and also bear the traces of Germany's Orientalist discourse. Although Marc's animals are intended to signify naturalness, they are products of social practice and beliefs about exotic animals. The images themselves hint at the animals' cultural origins since virtually all of the postcards represent domesticated, tamed, or enclosed beasts. If Marc and Lasker-Schüler were interested in animals as sources of the wild purity and instinct that both thought was missing from modern culture, we might expect Marc to have depicted creatures whose natural habitat situated them far from the spaces of civilization. Yet instead we find horses marked by Jussuf's signature crescent moon and taken from his stud farm, trained attendant dogs, and a sacred calf that, Marc writes, "was found sleeping in the palace gardens on the day King Jussuf ascended the throne."[43] In one postcard, a small black fox and two boldly painted deer actually reside in Jussuf's hunting grounds, according to Marc's title (fig. 5.7). Even the spotted cats on another card, which appear to snarl fiercely as they crawl across the page, turn out not to be wild beasts but imperial possessions, "the three panthers of King Jussuf" (fig. 5.5). Together, the postcards present Jussuf's animals as individual components of an imperial collection, a menagerie of objects compiled for the pleasure of the king. We are gazing at animals captured in a controlled space, an environment more like a zoo than a jungle.

This sense of capture is enhanced by the postcards' prismatic quality, compared earlier to the interlocking shapes of Egyptian jewelry. Arranged on the surface of the card like precise pieces of a multihued puzzle, the animals are confined by their own dark contours as well as by their fixed positions within a carefully wrought scheme. Moreover, certain formal elements highlight the artificiality of this environment. In several of the postcards, Marc combines collage with watercolor, affixing metallic strips of paper to the surface in compositionally unexpected locations, as in *Three Animals on Blue Mountain*. The silver paper appears as a material intrusion, bluntly calling attention to the constructedness of the scene. In addition, the ringed forms that often appear in the upper right corners of the pictures semantically represent the sun or moon. But this circular shape is actually made by the indentation of the postmark on the obverse side of the card. It is the result of human ordering and systemization, and once the viewer recognizes the orb's true origin, it is difficult to ignore this ghostly reminder of the administrative network in which the postcard takes part. This *Poststempel* moon again urges us to see the landscape, and the animals in it, as a scene that owes as much to the ordering forces of the social realm as to the instinctual demands of a natural kingdom.

These formal gestures speak to the artificial logic that underpins these pictures, suggesting the simulated space of a menagerie or zoo rather than the space of the wild. This synthetic principle is again connoted by the curious, angular mounds that rise out of the background in several of the postcards, including *The Three Panthers of King Jussuf, Drinking Trough on Rubin Mountain,* and *Elephant*. The edges of these projections are too jagged and precise to represent natural topography. These are unusual, crystalline forms, not unlike the Expressionist structures designed by Bruno Taut and Paul Scheerbart. Yet these obviously constructed shapes also correspond to the forms found in the modern German zoo, specifically the type founded by the influential entrepreneur Carl Hagenbeck. When Marc created his postcards, the zoological world was in the midst of the "Hagenbeck revolution," a fundamental transformation in exhibiting animals initiated by Hagenbeck's Animal Park, located in the Hamburg suburb of Stellingen. Hagenbeck had years of experience capturing and selling animals and exhibiting them in traveling shows along with people, a practice also represented by the Lunapark displays of which Lasker-Schüler was so fond. By 1902, Hagenbeck had begun construction on his Animal Park, which would provide an influential new model for zoological gardens across Germany and, ultimately, Europe and the United States as well. Hagenbeck's zoo did away with the cages of typical zoos and replaced them with panoramic settings in which animals seemed to roam freely, thanks to hidden enclosures built into the landscape. To suggest the terrain of their original habitats, Hagenbeck had large stone formations constructed that provided rocky terrain for the animals and a dramatic backdrop to the animals' activities for the visitors to the zoo (fig. 5.9).[44]

Hagenbeck's zoo opened in 1907 and was a resounding success with the German public, though his new techniques were not as universally acclaimed by zoo professionals. In Munich, however, city officials embraced Hagenbeck's use of sculpted mountains and invisible enclosures as a model for their own civic project, the new Munich zoological garden. Construction had already begun by 1910, when an article in *Münchner Neueste Nachrichten* reported that the ambitious new zoo would have "a scholarly, educational, and

aesthetic effect by connecting animals in a characteristic way with the surrounding landscape.... In accordance with the Hagenbeck style of parks, by doing this, the animals appear to be really free to move."[45] The zoo opened in 1911, providing Marc and the other citizens of Munich with a new zoo experience based on the illusion of freedom within panoramic settings in which large, carefully crafted stone cliffs provided the sensation of a rugged, hilly terrain for the animals.

This may offer us a way to understand the jagged, mountainous protrusions that appear in several of Marc's postcards, structured forms that are cut too cleanly to be mistaken for natural topography. Emerging from the distance like craggy pyramids and crystal columns, these masses resemble Hagenbeck's carved precipices, indicating again the possibility that Marc's animals must be understood as creatures of the zoo rather than of the wild. In fact, we know that Marc's depictions of animals were sometimes based on his visits to German zoological parks. Many of Marc's earliest studies "from nature" occurred not in nature but in the Berlin Zoo, where he created drawings of elephants, bears, lions, and flamingos that would inform his future work. He frequently visited the Zoological Collections of Munich as well, and as early as 1907 had contributed lithographs to a children's book entitled *The Zoo.*[46] Marc's anatomical renderings, oil paintings, and watercolor postcards are the products, then, of a highly mediated encounter with animals through their cultural representation in the zoo. Yet these experiences paradoxically formed the basis for an artistic practice that presented animals as the source of a purely natural truth uncorrupted by social concerns.

As products of Marc's encounter with the modern zoo, the postcards make their own contribution to the Orientalist discourse already at work in Lasker-Schüler's construction of ancient Thebes. The late nineteenth- and early twentieth-century zoo presented itself as an apolitical scientific undertaking intended to enhance human understanding of the natural world. The Berlin Zoo, for example, was organized according to strict taxonomic categories, which, through their systematic organization, would act as a research tool for scientists and an educational tool for visitors, instructing them on the attributes and range of animal species.[47] Yet this positivist pursuit of scientific knowledge represents a particular understanding of progress fundamentally in keeping with the ethos of acquisition and investigation that also underlay colonialist ventures during the nineteenth century. As Eric Baratay and Elisabeth Hardouin-Fugier write, "This argument of scientific utility was accepted...because, in its strict pursuit of knowledge and rationality, it theorized and justified

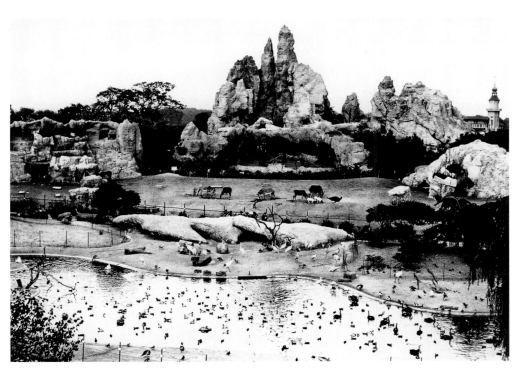

5.9. Hagenbeck's Animal Park, main panorama, Stellingen, mid-1920s.

their ambition to make an inventory of the world, to appropriate it. Zoological gardens were considered to be both showcases for and instruments of this domination, at once symbolic and practical."[48] Moreover, many zoo collections existed and grew because of the colonizing expansionist policies of Europe's nations as they built their empires. The entertainment and edification provided to visitors of German zoos in particular depended on the violence of Germany's own colonial activities, and the capturing of animals for zoological collections represented one aspect of a diverse and often brutal set of colonial practices.[49]

The spaces of the German zoo, in addition to its animals, make reference to the expansive colonial ambitions that frame its displays. For example, an eclectic variety of international architectural styles can be found at the Berlin Zoo, including the Elephant Pagoda, made to resemble a Hindu temple, and the Ostrich House, constructed in the manner of an Egyptian temple (figs. 5.10 and 5.11).[50] Zoos seemed to collect exotic buildings as avidly as they did exotic animals, so that these structures also indicate the German colonialist premises of the zoo, which see other cultures' traditions as existing primarily to be consumed by an acquisitive nation. In addition, as Patrick Wirtz notes, "At zoos, visitors could see ostriches, lions and elephants inhabiting Chinese pagodas, Hindu temples and Near Eastern mosques. Foreign, representing both immigrants and conquered colonial peoples, expressed in this presentation manner, meant inferior through its association with animals."[51] The spaces of the zoo, then, further strengthen the notion that the zoo functioned as an Orientalist phenomenon, tied profoundly to the imperialist agendas—both occupational and nonoccupational—that were the lifeblood of Orientalist discourses. Both the buildings and the animals represented Germany's colonial power and became sites onto which German visitors could project their fantasy of a vast and undifferentiated Orient that was packaged and controlled in the space of the zoo.

Marc would have seen the Egyptian-style ostrich house during his first visit to the Berlin Zoo in 1907, encouraging him to make a connection between the zoo's animals and Egyptian culture that was later explored in his postcards for Lasker-Schüler. And Lasker-Schüler's own drawings of Thebes bear a remarkable similarity to the zoo's elephant house, designed to resemble a Hindu temple, suggesting that this structure offered Lasker-Schüler an accessible model of exotic architecture as she attempted to give visual form

to her Egyptian kingdom (fig. 5.12). Lasker-Schüler's adoption of the Hindu-style elephant house, rather than the Egyptian-style ostrich house, is telling, since it is entirely in keeping with the Orientalist predilection for disregarding the specificity of other cultures and thus fixing them conceptually in an atemporal and primitive realm. Lasker-Schüler fashioned a generalized image of a primitivist Egypt that did not correspond to any particular place but was rather the imaginative result of various exotic tropes available in German popular culture. Her Theban world incorporates elements not only from representations of Egypt and Africa, but also from Arabic, Persian, Greek, and Indian culture. According to Nina Berman: "This removal of barriers and the blurring of linguistic and cultural differences among specific cultures of North Africa and Asia produces a blending of these countries and cultures into a fictive realm. Through this homogenization, one of the previously mentioned representational strategies which Edward Said identifies as a characteristic of Orientalist texts, the individuality and specific history of single cultural areas is abolished."[52]

Marc and Lasker-Schüler's postcards, then, represent two seemingly incommensurable positions: one is radically resistant to normative notions of secure power and stable subjectivity, while the other benefits precisely from those precepts of dominance and privileged identity exercised by colonialist agendas. Orientalist fantasies of a subjugated "primitive" culture mediate the postcards' representation of Thebes and its animals. In this way they participate in the most ideologically conservative and even oppressive paradigms of German culture. Yet, as we saw at the outset of this essay, the postcards may also be regarded as a genuinely transgressive place where the boundaries between male and female are breached; wild lands create a space for an alternative Jewish identity; and the self in general is understood to be performative and fragmentary rather than natural or whole. The physicality of the postcards themselves seems to reiterate this disjunction. The restless motion of the postcard offers its own transgressive possibilities. For example, we may interpret the transient, mobile qualities of the postcard, which wins its space through small, fragmentary gestures rather than broad proclamations, as analogous to the fractured fluidity of Jussuf's identity. Together the postcards sustain a kind of radical openness, in their conversational rhythm and unenveloped display, which recognizes the extent to which identities emerge from continually shifting relationships and are thus always provisional. In this kind of identificatory site, the assertion of a secure and mastering subject is implausible and even absurd. The single postcard on its own lends itself no more readily

5.11. Elephant House, Berlin Zoo, ca. 1873.

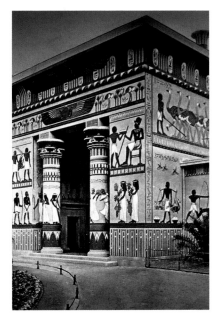

5.10. Ostrich House, Berlin Zoo, ca. 1901.

5.12. Else Lasker-Schüler, letter to Franz Marc, 1912.

than multiples to the maintenance of firm boundaries. This is, after all, why the postcard as a genre has received so little attention from historians of art. It is, in some respects, inherently liminal and fits uneasily into the desire for aesthetic uniqueness and its fetishization of the precious object.

On the other hand, as with most marginal products, attempts have certainly been made to recuperate the postcard in the interests of a dominant culture. Lasker-Schüler herself reluctantly participated in this process when she sold Marc's postcards in 1919 to Germany's Nationalgalerie in a moment of financial distress. From her jewelry box they had traveled, after Marc's death on the front in 1916, to her apartment wall, and finally to the Nationalgalerie, where they were promptly exhibited as a collection in the museum's new building, previously the home of the German prince. Here the fissured discontinuity of the postcards was replaced with systematic order, as the exhibition presented the postcards as a unified body of work. The director of the Nationalgalerie, Ludwig Justi, emphasized this understanding of the postcards as aesthetically complete in his accompanying essay: "The *whole* is a delightful poem, combining a loving observation of Nature with a free play of form" (emphasis added).[53] In addition, the exhibition suppressed the postcards' multivalency, derived from their diverse textual and visual tasks, so that only Marc's watercolor renderings remained to be seen. Lasker-Schüler noted this indignantly in a letter to Justi: "I have *no right* to sell the pictures, because they were addressed to my son as well as to me…. And now my boy is not even paid the basic courtesy of leaving the *writing* in place, [of being able to see] that these incomparable cards were drawn for his mother…. I want to buy the pictures back."[54] Yet no matter how insistently the postcards' visual component was privileged (presumably each postcard was framed and hung, or laid face-up in display cases) and the verso concealed, the hidden text would always haunt the image. While the museum may have conferred on the postcards, individually and as a group, the presence of the work of art, that same autonomy would always be subverted by the postcards' submerged history, producing an ambivalent vacillation between immediacy and contingency.

Because the postcard wavers between fragmentation and wholeness, the former offering a potentially disruptive or critical strategy and the latter promising the regressive myth of absoluteness, it seems an entirely appropriate field for Marc and Lasker-Schüler's joint project, which is itself defined by a similar ambivalence. Together the two Expressionists turned to postcards as a means of articulating a shared utopian vision, one that held out the possibility of radically alternative and fluid identifications, that was simultaneously spoken from the perspective of the colonizer. Yet in adopting the personas of Jussuf and Ruben, these voices imagined themselves also as emerging from the space of ancient Egypt and embodying the colonized subject itself. These two modes cohabit and collide in the postcards, creating an unstable meeting of incompatible positions that, nevertheless, need each other for this particular utopia to be enunciated. Perhaps the postcards could be thought of, then, as what Homi Bhabha has called the "colonial signifier," by which he means literature produced by colonizers writing from conquered territories. Bhabha describes the nonsense that develops in such texts, in which cultural dominance and colonial otherness become "incommensurable levels of living and meaning." He continues, "The colonial signifier—neither one nor other—is, however, an act of ambivalent signification, literally splitting the difference between the binary oppositions or polarities through which we think cultural difference."[55]

Although Lasker-Schüler and Marc do not paint or write from Egypt itself, they project themselves wishfully into its space, and I would suggest that we may profitably turn to Bhabha's description of a colonial signifier that produces "an undecidability between contraries or oppositions" as a means of conceptualizing the utopian project represented by Marc and Lasker-Schüler's Theban postcards. They too both suffer and prosper from the colonial fantasy that makes many of their basic assumptions even conceivable. The Orientalist allure of exotic lands to which the postcards give expression marks them clearly as products of Germany's ideologically conservative culture. And yet, from this same place, gender and ethnic identities are adventurously challenged, upended, and celebrated as fragmented and fluid. The postcards themselves restage this meeting of opposites, as they are simultaneously disparate, fleeting objects and precious aesthetic charms. If there is a kind of utopia achieved, at least discursively, in the postcards, it is perhaps precisely because of this in-betweenness, this irresolvable ambivalence. "What is articulated in the enunciation of the colonial present—in-between the lines—is a splitting of the discourse of cultural governmentality at the moment of its enunciation of authority."[56] Just as Lasker-Schüler and Marc's postcards speak from the place of colonial privilege and aesthetic authority, they simultaneously fragment and usurp that privilege, making nonsense of it, suggesting the possibility of different values, incompatible sites, and other identities.

COLONIAL COLLECTING:

FRENCH WOMEN AND ALGERIAN

CARTES POSTALES

Rebecca J. DeRoo

Between the turn of the century and World War I, postcards became mass media of communication and collectible objects for the first time in French history.[1] A significant portion of the millions of postcards produced yearly in France displayed Algerian tourist sites and ethnic types. During the 1980s, postcolonial scholarship set out to unmask the colonial agenda in these postcards by linking seemingly nonpolitical Orientalist iconography to the French colonial project. Malek Alloula's *The Colonial Harem,* the best known of these revisionist texts, provides an important interpretation of the images, yet also demonstrates the shortcomings of an approach that focuses solely on Orientalist imagery.[2] Alloula reproduces postcards of subjects such as belly dancers and harem women (typical Orientalist iconography) and arranges the images into a narrative so that the models are progressively unveiled.[3] Using metaphors of penetration and possession, he compares the unveiling of the women with the French colonial conquest of Algeria. By rearranging the cards in his book, however, Alloula fails to consider what personal arrangements of the images might have meant for those who collected them. Furthermore, he overgeneralizes the metaphor of sexual conquest and overly delimits both the audience for the cards and their meanings: penetration and possession imply that the viewers and collectors were heterosexual males. Rather than reduce the postcards to a monolithic masculine colonial imperative, as anti-Orientalist readings tend to do, we must investigate how the images functioned differently depending on the context of their use. This essay seeks to uncover the layers of meaning the cards acquired as "views" and "types," as they were produced by the government-aided tourist industry and displayed by French *collectionneuses*.

ND Studio's Colonial Algeria

Colonial postcards had complex origins, which were emblematic of the complex motivations for their production and obscured by the cards' cross-continental travel. Since 1840, the French presence in the colony had relied on capitalist involvement in tourism. By the turn of the century, the French government was funding Neurdein Frères (ND) photographic studio, one of the largest French postcard producers. The government used ND images for travel guides and historic records because tourism expanded the colonial infrastructure and postcard publicity stimulated private investment. ND covered Algeria extensively, with the number of Algerian images second only to their representations of France, and many of these images continued to be reproduced thereafter in various formats. For example, *La France*

Africaine: Le Tourisme et l'hivernage en Algérie-Tunisie, published by the Compagnie Générale Transatlantique cruise line, and *Le Tourisme en Algérie,* published by the French government, reproduced ND images similar to those used as postcard scenes.[4] Like other Paris studios, ND studios sent photographers to the colonies to take pictures.[5] ND processed and edited the images in Paris, and then marketed them to businesses in Algeria. Because the postcards were bought, sold, and postmarked in Algeria, the role the French company took in their production was suppressed; the cards were understood by the French to originate from the colony and to reflect the sensibilities of the local population.

Neurdein Frères' 1905 catalogue divides the postcards into two main categories: "views" of major cities and "types and costumes" of Algerian people.[6] Though records do not indicate how many copies of each image were printed, the catalogue lists 1,320 views and 201 types. This division between views and types also resembles the breakdown of cards in ND travel souvenir books, which typically begin with panoramic overviews of the city, move in closer to see the sites, and end with a picture of a smiling young woman. Souvenir books focus on one city, but postcards from various cities demonstrate the number of different ways that Algeria was represented. Their expressions of colonialism are idiosyncratic and sometimes contradictory, yet underlying themes emerge. As the following examples are intended to suggest, the cards express the separation of and difference between Europeans and Algerians in terms that were immediately legible to nineteenth-century Europeans: the organization of urban space and racial categories based on physiognomies. These frameworks were used to represent French control over and displacement of the Algerian population and to justify the French presence in Algeria.

Two views of Algiers can be compared to show the implicit contrast in the series between the rational force of modern France and the unknowability of "native quarters." "ALGER.—Le Boulevard de la République" (fig. 6.1) shows the Immeuble Lescat, the site of municipal administration in the capital city of the colony. All the details demonstrate civic order: geometrically aligned streets, evenly spaced lampposts, and a mounted police officer on patrol represent not literal governing, but rather symbolic control of the colony. The Immeuble Lescat on the right is a monument to the imperial dominance and "civilizing" force of France. The classical, permanent style of the building transplanted from France exhibits no influences

from indigenous architecture or adaptation to Algerian ways of life, but it demonstrates that the French have imported their culture with them.[7] Such images of the European quarter promise the tourist modern transportation, luxury hotels, and leisurely activities—all in safe and familiar places offering the comforts of home.

Compared with this modern French administration, "ALGER.— Une Rue de la Casbah" (fig. 6.2) emphasizes that the Ottoman Turkish reign in Algeria belonged to a past era. The card depicts a street in the Casbah, the main indigenous neighborhood, and presents Algerian ways of life as primitive, mysterious, and disordered. A boy and his donkey climb the sloped terraces that lead to the palace. The jumble of dilapidated buildings with plaster cracking off the walls emphasizes the Casbah's outdatedness compared with the modern streetcar and shops on the Boulevard de la République, where the rational ordering of urban life is readily apprehended. The labyrinthine streets, barred windows, and closed shutters in the Casbah create an ambiance of mysteriousness and impenetrability, one that corresponds to guidebooks' emphasis on its unknowability: "The Casbah…still has the same mysterious atmosphere. It still resembles the Moorish women whose veils only allow their eyes to be seen. There are still the same low doors that seem to never open." *La France Africaine: Le Tourisme et l'hivernage* compares the disorganized Casbah and the orderly city streets of the French quarter: "the Casbah, in which houses are jammed one on top of another, guides the eye toward the European city with [its] marvelous gardens, vast, bright boulevards humming with activity, and stylish apartments."[8]

City views of French administration, commercial centers, and leisure activities reinforce a comfortable separation between the civilized metropole and the indigenous population. They are the only postcards that depict Europeans as well as indigenous Algerians; however, they portray Europeans as the majority, and the groups do not interact. The cultural divide is instantly visible: Europeans mill around the Boulevard de la République while a single Algerian crosses the street. In the Casbah, the boy is busy with his own "primitive" activities, safely apart from European life. Although space does not permit me to discuss rural views, these, too, tended to promote the superiority of the colonizer's use of the land. Images of Tebessa, for example, depict Roman ruins to allude to a history of a Western, Christian presence in North Africa. These contrast with contemporary scenes of tents and Arab markets that are intended to suggest a more primitive and inconsequential occupation of the land.

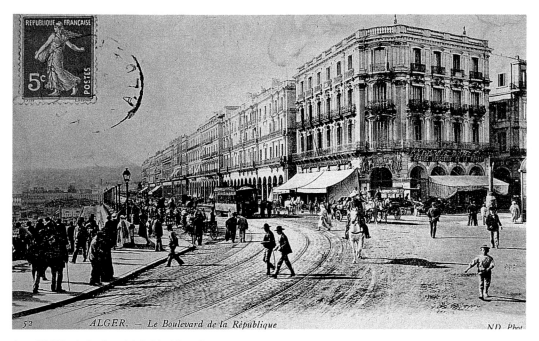

6.1. "ALGER.—Le Boulevard de la République."

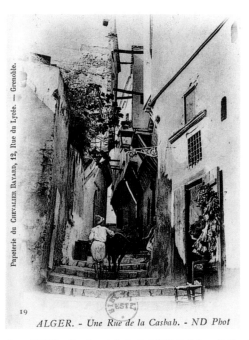

6.2. "ALGER.—Une Rue de la Casbah," Bibliothèque Nationale, Paris.

In contrast to the views, which can be sorted according to two utterly opposed manners of life within the city and on the Algerian land, the types exclusively depict Algerians.[9] Captions that classify the subjects according to work and race recall late nineteenth-century ethnographic practices that themselves developed from mid-century physiognomy.[10] While physiognomy used physical features as a guide to individual character and class, the ND ethnic type categories take individual subjects and their clothing to represent traits of an entire race. This labeling by work and ethnicity erases social interaction, turning Algerian society into an ahistorical series of categories served up for novelty and local color. Indeed, it is the pseudoethnographic style of the Algerian postcards that allows for depictions of the unusual, taboo, and erotic, as the following examples demonstrate.

"Un Arracheur de Dents" (fig. 6.3) is a typical work scene. Like most of the ND work images of men, it presents what might appear to be an uninterrupted view of the bizarre or curious customs of Algerian culture. The tooth-puller conducts business as his client sits in the street; standing over him, a barefoot onlooker (perhaps his assistant) takes in the activity. Such images emphasize the "primitiveness" of the indigenous culture; a plier-like tool and bowl of water are his only apparatus. Because the subjects go about business uninterrupted,

the postcard seems to provide a privileged, "authentic" view. Yet here, as in all the ND postcards of Algerians, the background and surrounding situation are actually unclear. By close cropping, the Algerian subjects are isolated from any social or geographic context that would account for their actions or that could problematize French presence at the scene. In dramatic contrast to the views of Algeria that anchor Europeans at sites with city labels and monuments, the types have neither city names nor recognizable landmarks.

While work scenes predominantly depict men actively living out cultural traditions (however decontextualized), the ethnic types almost always portray women and present them as the bearers of the culture. The young women wearing "regional costumes" supposedly embody a particular ethnic group. They are more obviously posed, as if welcoming the viewer's presence. Men in work scenes look dirty and poor, but because the women are young, partially undressed, and posed in neutral settings, the erotics of the image can often dominate.

In images of women in studio interiors or in courtyards, eroticism is inflected by pronounced differences in racial representation. In "Mauresques" (Moorish Women; fig. 6.4), for example, the

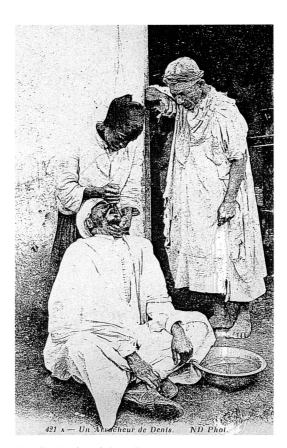

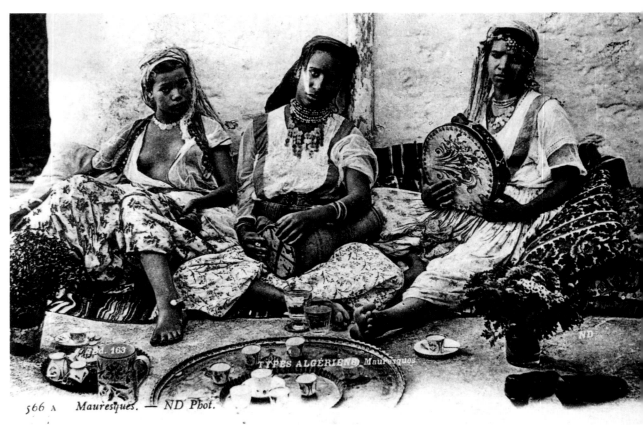

6.3. "Un Arracheur de Dents."

6.4. "Mauresques."

women seem to look out, inviting us with their tambourines and tea ceremony to join in or watch their activities. Though all are labeled "Mauresques," the dark women are more fully clothed, sit relatively upright, and gaze at the viewer with blank expressions. The light-skinned woman raises her eyebrows, suggestively glances at the viewer, and reclines with her legs spread apart and shirt drawn back to reveal her breasts. Whereas this woman, physically closer to European conceptions of beauty, can offer herself for sexual exhibition, the dark-skinned women are too "other", seeming to lack both the physical traits and the sense of self required for self-eroticization.

The walls of the courtyard, like the Muslim veil, delineate women's private space; images like this invite us to vicariously transgress the limits of normal access to such spaces.[11] In doing so, the postcards violate private, cultural, and religious boundaries, breaching both the practice of the veil and the taboo against representation in Islam. Yet trespassing into women's space does not appear to be a transgression in these images; if they are capable of interaction, the women do not resist but offer themselves.

When situated in souvenir books, images of Algeria typically moved from city views to smiling young women, as illustrated by the sequence of images in the above account. City views were closer to actual tourist experiences, but the unreal harem scenes were set up to show what tourists never saw. The postcard form itself and the ethnographic labels that accompanied them emphasized authenticity and concealed the staging of the scenes. The images promised the tourist a colony that was alluringly different and, by constructing a reassuringly French framework, attempted to foreclose the possibility that their picture of colonial difference would prove unsettling.

Circulation and Collection

In contrast to their arrangement in souvenir books, when these images were actually used and collected in postcard form, they were often placed in other sequences, categories, and situations that altered their colonial content. Moreover, when postcards were exchanged through the mail, the images were linked with the tourist's text. What do such practices tell us about how the cards were understood through the activities of tourism and exchange?

As tourists, both men and women bought ND cards at kiosks, *tabacs,* and newsstands located near the sites pictured on the cards and exchanged the cards with members of either the same or the opposite sex. By purchasing a card and writing a message on the back of the image, a French tourist marked or commemorated his or her presence at that place. The sender also asserted his or her position as someone with the money and leisure time to travel.

The small message space was intended for simple greetings. And because the postcard was not private, it was used for general communication. Postcard messages from Algeria were generally abbreviated because the cards could be sent for five centimes instead of ten when they contained only a greeting and closing. Messages may have also been brief because they were traded through exchange societies and sent to collectors not personally known to the sender. When a sender was not familiar with a collector, collectors' journals suggested limiting comments to polite remarks and salutations. One postcard collector's guide suggests covertly conveying romantic sentiments by specially positioning the stamp on the postcard. Though it is impossible to know how often this was done, the article suggests that postcards could be used to communicate ideas and sentiments beyond those written in the message.[12]

In some ways, a lack of commentary may be most revealing. An absence of descriptive messages characterizes images of *Mauresques,* Ouled Naïls belly dancers, and the harem. Postcards showing seminude women often have no message, stamps, or post-mark, suggesting that either they were never sent and instead were kept by the purchaser or that they were sent in an envelope. None of the messages that I have seen on such cards comment on the images; most contain only brief salutations. For example, a postcard of a *jeune Mauresque* exposing her breasts is signed "Bonjour lointain," with a signature on the front and back of the image (figs. 6.5 and 6.6). Despite such acts of possession, the sender of the harem picture could not, for obvious reasons, be understood to be saying, "I was here, I saw this." Even though it is difficult to determine what hidden message, if any, was conveyed, the striking congruence between explicit sexual imagery and lack of message suggests that in this instance the image, and its possession through a signature, became the exclusive content of the communication.

A similar silence surrounds images of Algerian women in guidebooks. For example, *La France Africaine* shows an ND image of a "Mauresque d'Alger."[13] The woman is unveiled, but clothed, wearing abundant jewelry. The *Guide Joanne* lists cafes with Ouled Naïls belly dancers (who were widely rumored to be prostitutes) but does not describe them; indeed, one travel account calls an Algerian

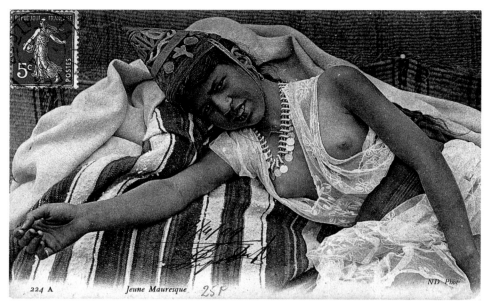

6.5. "Jeune Mauresque."

6.6. Verso of "Jeune Mauresque" (fig. 6.5).

woman's dance "indescribable."[14] It is the pictures that promise most about what would be found in Algeria. Images of women smoking and exhibiting their bodies were not discussed, presumably because such overt references to sexuality were inappropriate in a guidebook, but perhaps also because, paradoxically, texts actually adhered more to the actual sights a tourist might encounter—tourists would never see Muslim women exposed as they are in these pictures.

Thus, to understand postcard images in relation to tourism and colonialism, we have to attend to places where textual and pictorial representations diverge, to the discrepancies between the postcard image and the postcard message or the guidebook's pictures and text—to what can be shown but not described. Although it was considered bad taste to send a woman collector a card with French women posing provocatively or exposing themselves, the ND images of Algerian women were acceptable because it was another culture that appeared to be transgressing French mores. Thus, while French writing conventions made harems unaddressable in tourist texts, and Muslim practices made the locales off bounds for tourist visits, the image on the card introduced eroticism into social exchange.

Collectors were also a significant part of the postcard market. Although there were male collectors, postcard collecting was often represented as a feminine activity, and the ND cards I have discussed were printed after the practice of postcard collecting by women had become established. Thus, the cards must have been produced to some extent with a female audience in mind. In fact, many of the cards previously described were addressed to Mademoiselle. We need to consider the meaning of the cards in light of this gendered spectatorship of the images, particularly since these were exceptional images for a female audience, affording opportunities for personal expression not available elsewhere.

Women frequently kept postcards in albums, but today it is extremely difficult to locate an intact collection: most images have been separated for sale or reclassification in archives.[15] Though women's magazines and collectors' journals have a promotional intent and do not necessarily represent what a range of women may have done and thought, they do give access to the responses to and the uses of postcards by their readers.

Postcard collecting provided women both opportunities to engage in social exchanges with gentleman callers and to display their creativity. *La Femme chez elle* (1900) describes: "Recently a veritable commerce of polite remarks and courtesies between young men and women has been established due to postcards … for a well brought

up young lady…[postcard collecting] provides thousands of ways of demonstrating her tact and savoir-faire."[16] Thus, postcards allowed women the opportunity to display publicly their taste, education, and individuality, and provided a means of negotiating between social custom and personal desire.

While collectors' journals insisted that organizing a collection through the flexible form afforded by the photo album was a matter of personal taste, they also suggested possible arrangements for both type and view cards. *La Gazette Cartophile,* a journal for women collectors, recommended a geographic arrangement of view cards, by country, department, city, monument, and site, so that the organization would reconstruct a trip city by city.[17] The *Gazette* also suggested arranging "types and costumes" cards by region and ethnic features, as if they were a "scientific" survey of the ethnic population.[18] The journals gave more guidance for sequencing views by region, but rarely mentioned how to arrange ethnic types, suggesting that the organization of types was more ambiguous and leaving more room for the *collectionneuse* to impose her own order on the cards.

Sources suggest that when arranged for private use, collections had more fluid functions than these documentary and didactic objectives. A woman author who was nostalgic about a trip described how postcards reawakened her memories: "I wouldn't know how to gaze at these wonders without a feeling of personal satisfaction… I have, before my eyes, the same valley and the [image]…is so well reproduced that a whole legion of memories awakens within me." An author from *La Famille* explained how a woman asked traveling friends to send her cards regularly. With images and messages from friends: "It is no longer an ordinary album of photographs, it is also [an album] of memories."[19] Messages and images might recall personal memories or be used for imaginary travel: "Leafing through an album, is almost taking a trip; even better, it's taking a trip during which one would only see that which is worth seeing."[20] For women whose movement was restricted, postcards allowed them to vicariously explore distant places within the private space of their homes.

The contradictory views of North Africa in ND postcards are repeated in stories of the "Orient" in popular women's magazines. Both express ambivalence toward Algeria for the female viewer. Though articles specifically on Algeria were seldom published in women's magazines, representations of the Middle Eastern "Orient"

were popular. Like postcards, the stories in women's magazines could be used to travel imaginatively to different places, to identify with the depicted characters, and to safely live out exotic fantasies.

In *Femina* magazine's article "Femmes du désert," Mme Jean Pomerol describes her study of religious sects, race, and women in the Sahara.[21] A photograph depicts the author in her salon at home in Paris, surrounded by souvenirs from her travel, reflecting her creativity and understanding of language and customs. Pomerol herself represents authority, education, and taste—ideas also aimed at *collectionneuses*. The article conveys a curiosity about women around the world, perhaps similar to that expressed by women who collected type postcards. The text also reflects the racial hierarchies present in postcards: Pomerol describes blacks in terms of slavery and praises Arabs as the most beautiful race because their skin is closest to a European complexion.

Pomerol suggests a fascination with beauty rituals: "[The woman in the Sahara] has long, long periods of leisure….She uses them to adorn herself. And what adornment!… Flowing draperies, attached by an abundance of barbarous jewelry…. Henna on her hands, which become a mahogany color…. Makeup on her cheeks, applied without any intention of imitating nature…. Muslin veils trailing on the ground."[22] The article seems to encourage French women to try exotic beauty rituals as their own private escape, but then, as to reaffirm the superiority of the colonizer, adds that these women can only bathe once a week because of water shortages. Though the images may provide women an outlet for an erotic fascination, the fascination remains tempered with ambivalence.

In the ND postcards, as in the Pomerol article, Algerian women are presented to French women as both dirty and exotic—in ways that may seem contradictory but that can also work in tandem. In the article, elaborately dressed and bejeweled *danseuses* posed atop a camel wear costumes like those of the women in the Mauresques postcards. At the same time, images of women preparing couscous outdoors resemble gritty ND scenes of people working in the streets. This attitude of simultaneous attraction to and repulsion from the subjects, seen earlier in the view and type postcards, allows the women to experience both identification and distance.

Collecting postcards of Algerian women, including harem scenes, was a rare socially sanctioned occasion for women to view and display images of other women in exhibitionist and sexually provocative poses. The public explanation for this license was that

women took interest in the details of cultural difference and in the foreign costumes in the images. Yet collection practices also suggest that French women identified with the erotic sexuality that Algerian women represented. This identification could have taken a variety of forms for women collectors, such as assuming an exotic identity and participating in Oriental "mystery." Through these possibilities for identification, women could use postcards within the boundaries of social convention as a way to actively imagine and desire sexuality.

The contradictory representation of colonial subjects in the postcards allowed women to mobilize a tactical identification. At times in their collections, women seem to have played off the racial and economic differences of the models, expressing their sense of the racial superiority of whiteness and bourgeois elitism toward menial labor. Yet women could also "forget" race and class: while the cards codified and marketed racial and economic others, they simultaneously allowed a complicated but productive identification by gender. For French *bourgeoises,* enjoying advantages of class and race, Algerian women exemplified the free expression of erotic sexuality. French women may have used images of the harem (ironically, a notoriously unfree site) to rewrite sexual domination at home; at the same time, however, their means for self-expression fit within the patterns enforcing colonial domination abroad.

The ND postcard images reflected the interests of the commercial tourism industry and the French colonial government and appealed to viewers because they reinforced bourgeois attitudes about race, work, and gender. The silence around the images in guidebooks and in the personal messages written on the cards, however, indicates viewer ambivalence about the images and evoked other interpretations of them. French women's exchange and collection of the postcards demonstrate that they accepted colonial depictions, including racial hierarchies, degraded labor, and eroticized feminine stereotypes. Yet by reordering, recategorizing, and displaying the cards in collections, these women found in the images possibilities that exceed those imagined by the colonial and commercial industries that produced them. Thus, the colonial postcards did not merely reinscribe accepted hierarchies; they were also used to displace and expand definitions of bourgeois femininity.

..

PRESENTING PEOPLE: THE

..

POLITICS OF PICTURE POSTCARDS

..

OF PALESTINE/ISRAEL

..

Annelies Moors

During the first decades of the twentieth century, picture postcards were by far the most popular source of visual imagery of Palestine and its population available. Half a century earlier, improvements in the means of transportation had already made travel to the Middle East less expensive, quicker, and more convenient. Following the first Cook's Tour of Palestine, organized in 1869 just after the completion of the Suez Canal, the number of visitors to Palestine started to grow rapidly. The demand for pictures further increased when technological developments made it possible to reproduce photographic images cheaply and on a larger scale. By the turn of the century, picture postcards, usually produced in Germany, had become widely available. These postcards were sold not only in Palestine itself but also directly to the European and American markets and were avidly collected.

Although other visual media have overtaken the position once held by picture postcards, large numbers of postcards continue to be produced. Commonly seen as a trivial commodity, they are nonetheless implicated in the field of politics. Postcards with images of people inevitably generate particular kinds of knowledge about and sensibilities toward those depicted, especially in settings such as Palestine/Israel where the struggle over territory and contestations of national belonging have been so intense. In this chapter I analyze how four sets of picture postcards construct and present the population of Palestine/Israel at very different historical moments: early twentieth-century commercial postcards, Zionist postcards from the 1920s and 1930s, Israeli commercial postcards from the 1970s and 1980s, and Maha Saca's Palestinian postcards from the 1990s.

This analysis privileges the discursive density of sets of picture postcards over the polysemic nature of individual pictures.[1] It has often been argued that photography, because of its claims to transparency and immediacy and its professed documentary status, is a technology of mapping, surveillance and control par excellence. Such a perspective is, however, too one-dimensional when dealing with these postcards.[2] Not only those in power, but also subaltern groups have made use of photography's indexical qualities and its status as evidence to engage in ideological struggles through the production of an alternative visual imagery. Depending on the positionality of producers, "making visible" may also work to undermine established ways of seeing. Both the early Zionist postcards and those produced by Maha Saca (albeit in very different ways) aim at producing and presenting alternative styles of representation.

The sets of picture postcards I discuss here were mainly produced for an international public. Whereas commercial postcard

producers aim at providing their clients with those images they think will be attractive to them, more politically motivated producers use visual means to convey an ideological message to the public. Still, the boundaries between the two are often blurred. Commercial producers and their publics are influenced by hegemonic ways of seeing that have a strong political edge, while politically motivated producers also need to take the expectations of their targeted audiences into account. Turning to individual postcards and their audiences, while it is true that particular images may be read in multiple and even divergent ways, the ways in which images are structured, both visually and through captions and accompanying texts, propose certain "preferred readings," impose constraints on alternative readings, and, hence, circumscribe interpretative agency.[3] Still, postcard producers, in an attempt to attract as large a clientele as possible, may themselves actively include a variety of discourses. Moreover, such closures are never absolute; captions may strongly direct audiences toward particular preferred readings, but they are never able to capture everything present in a photograph.[4]

The first set of postcards of Palestine, dating from the early twentieth century, was based on a paradox. While the preconditions for producing such cards were closely connected with major political and economic developments affecting the Middle East, the imagery on these cards conveyed a message underlining the lack of change in Palestine. Quite a number of postcards sold in the first decades of this century reproduced images photographed thirty or forty years earlier. Yet, with Palestine represented as a "living museum," this was not deemed problematic.

Biblical connotations were central to forging the link between the present-day population and a distant past. While the definition of Palestine as the Holy Land has a long history, early nineteenth-century developments in scientific thinking brought about a novel style of representation. Positivist modes of thought created a widely felt need to prove the truth of Christianity with reference to a concrete, observable reality, and photography was seen as the ideal medium to provide such eyewitness evidence.[5] With the growth of international tourism, commercial photographers made avid use of the popularity of biblical imagery too.

In the nineteenth and early twentieth centuries, many travelers to Palestine had religious motivations, and travel guides, such as the Baedekers, recommended the Bible as the best source of information for those visiting the Holy Land. "The Bible supplies us with the best

and most accurate information regarding Palestine, extending back to a very remote period and should be carefully consulted at every place of importance as he proceeds on his journey."[6] It did not take long for photographers to turn such notions into commercial profit. By the 1860s, commercial photographers had already started to create scenes from the Old and New Testaments on photographs, stereoscopic views, and lantern slides, producing the visual images that travelers were looking for. Travel guides even started to provide advice about where the highest-quality products could be obtained. According to Baedeker, the best photographs were "those of the American Colony in Jerusalem and Bonfils of Beirut, and the coloured photographs of the Photoglob of Zurich."[7] La Maison Bonfils, established in Beirut by Félix and Lydia Bonfils in 1867 and later managed by their son Adrien and his successor, A. Guiragossian, was one of the most successful photographic firms aiming at the tourist market. Most of the illustrations found on postcards attributed to Photoglob Zurich, were, in fact, made from Bonfils' images. The American Colony Photo Department, started in the late 1890s, was one of the commercial activities of the American Colony, a religious group in Jerusalem started by pilgrims from the United States and Sweden. By the turn of the century, when it had become possible to reproduce images cheaply and en masse on picture postcards or as illustrations printed in magazines and books, these images reached an increasingly large public. In 1922 the American Colony opened stores in New York, making its large collection of images of the Holy Land directly available to the North American market. Until the end of the British Mandate, the American Colony was one of the most successful and diversified commercial photographic studios in Palestine.[8]

Picture postcards with biblical connotations included highly constructed as well as more natural-looking on-location scenes. Images based on early photographs consisted of settings for which models had obviously posed. The figures on a postcard titled "Nazareth. Carpenter's Shop" from the series Homelife in the Near East were, for instance, clearly so arranged as to represent the Holy Family (fig. 7.1). Some of the early Bonfils photographs that were to circulate widely on picture postcards were also evidently staged. On a card captioned "Field of Boaz," people pose so as to visualize the Old Testament parable from the Book of Ruth, in which Boaz, a rich and prominent man from Bethlehem, meets the poor and widowed Moabitess Ruth harvesting on his land (fig. 7.2).

With advances in photographic technology, a different style of representation developed and images of peasants and Bedouin in more naturalistic settings became possible. Good examples are

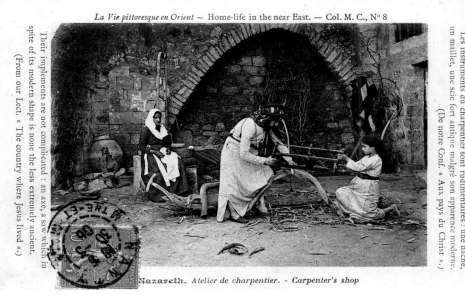

Their implements are not complicated : an axe, a saw which in spite of its modern shape is none the less extremely ancient. (From our Lect. « The country where Jesus lived ».)

Les instruments du charpentier sont rudimentaires : une hache, un maillet, une scie fort antique malgré son apparence moderne. (De notre Conf. « Aux pays du Christ ».)

Nazareth. *Atelier de charpentier. - Carpenter's shop*

7.1. "Atelier de charpentier.—Carpenter's shop," mailed 1906.

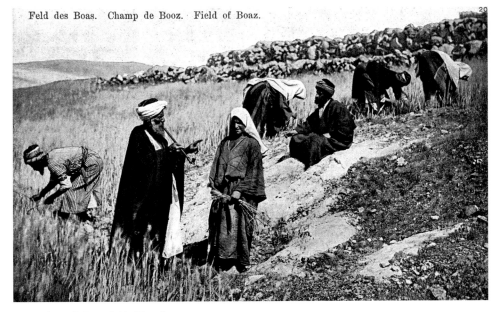

Feld des Boas. Champ de Booz. Field of Boaz.

7.2. "Champ de Booz. Field of Boaz."

the later Bonfils pictures and the series produced by the photographic department of the American Colony in Jerusalem, which depict the work of peasants and Bedouin. While they may be interpreted as scenes from daily life, they were in fact constructed in such a way as to leave out all traces of change, with some also framed as biblical allegories through captions, such as "Virgin's Fountain. Nazareth," "The Water Carriers" (Joshua 9:21), "Women at the Mill" (Matthew 24:41), or "Measuring Wheat" (Luke 6:38) (fig. 7.3). Adrien Bonfils, who reused many of his father's prints, retitled some of them as biblical illustrations. For instance, "Druze Peasants from Mt. Carmel at Mealtime" became "Actual Types Who Resemble the Twelve Eating at the Last Supper with the Savior."[9] Images of shepherd life were used to illustrate the twenty-third psalm (fig. 7.4), and images of fishermen at the Sea of Galilee "toiling with their nets" were also very popular.[10]

The notion that the living image of persons and events from the Bible was to be found in everyday sights was built on the assumption that the appearance and customs of the present-day inhabitants of Palestine had not changed. The lead of "Village Life in the Holy Land," a major early article about Palestine in the widely read popular scientific magazine *National Geographic,* summarizes its contents as "A description of the life of the present-day inhabitants of Palestine, showing how, in many cases, their customs are the same as in Bible times."[11] Captions and text on picture postcards made the same point. The accompanying text of the "Carpenter's Shop" postcard not only referred to Palestine as the Holy Land but described the carpenter's implements as "not complicated: an axe, a saw which in spite of its modern shape is none the less extremely ancient." And when "Measuring Wheat" was used as an illustration in *National Geographic,* it was accompanied by the following text: "This is one of the scenes of the threshing floor, as primitive to-day as it was in the Biblical period 2000 years ago. It helps us to understand the phrase, 'good measure, pressed down, and shaken together, and running over.' Luke vi: 38."[12]

The overall effect of this denial of coevalness and the spatialization of time was to distance the viewer from those depicted.[13] These postcards are thus good examples of an Orientalist discourse. The population of Palestine was depicted as living not only in another place, but in another time, an earlier historical epoch, that the viewers had long left behind. Still, it is worth recalling that such a biblical style of representation had different implications in the nineteenth and early twentieth century than in the later twentieth century. Since

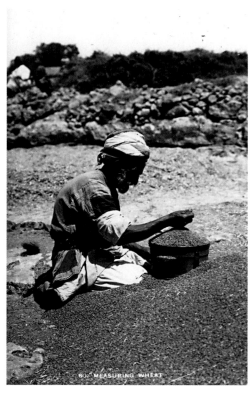

7.3. "Measuring Wheat."

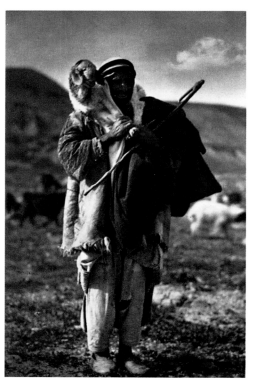

7.4. "Palestine—Native Shepherd Carrying a Lamb."

the 1830s, artists who did biblical paintings had debated the link between the contemporary population of Palestine and the early Christians. Biblical figures had previously been depicted as European or classical in appearance, but now a new style of biblical painting turned to the actual Palestinian-Arab population of the Holy Land (or, more generally, the Arab world) and their material culture as sources of inspiration. Some, however, saw the "Islamization" or "Arabization" of sacred figures as dangerous in its focus on appearance rather than substance, on costume rather than spirit.[14] Similarly, biblical archaeologists in the 1920s considered the distant past as part of European history, but kept the present population at a distance, as it were, viewing the Muslim presence as a degeneration from the past.[15] Representing the population of Palestine as similar in appearance and lifestyle to the early Christians can conceivably work against such distanciation. In the later part of the twentieth century, however, debates about who could represent the early Christians no longer had such a potentially critical edge; by then the main effect of displacing Palestinian-Arabs to the biblical past was indeed to produce difference and distance.[16]

With the increased concern of science with human variation, scientific classifications of the population of Palestine were made according to loosely defined types, which were seen as ranked in a hierarchical order. Because photography seemed the medium par excellence for mapping people in terms of their external appearance, photographers began to represent different categories of the population as "types," that is, to construct individuals as abstractions, anonymous exemplars of a specific group, often specified in the caption as such; references to time, place, and geographic specificity were left out of the picture.[17]

Photographers everywhere turned subaltern people into types, but there was a particular geography of types.[18] In Palestine people were mainly represented as mildly exotic "Oriental" types, often differentiated through the use of particular styles of dress (veils and robes). Major lines of demarcation were religion and habitat, as is evident in captions such as "Mohammedan Women" (fig. 7.5), "Jewish Woman of Jerusalem," "Bethlehem Woman" (fig. 7.6), and "Jerusalem—Bed[o]uin Women" (fig. 7.7). The caption "Christian Women" is not often found. However, there are a large number of cards of "Women from Nazareth" and especially "Bethlehem Women," names that carry heavy Christian connotations. The Bonfils catalogues, for instance, had a separate section of "types, scénes et costumes de Palestine et de Syrie" with hundreds of entries such

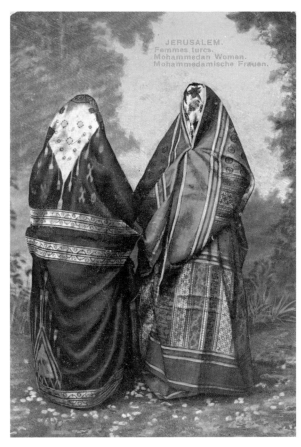

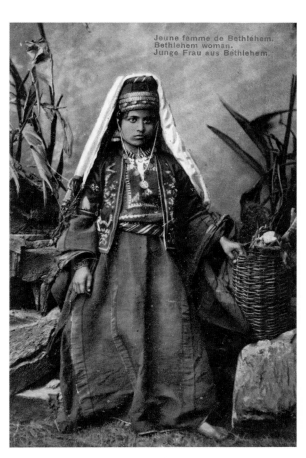

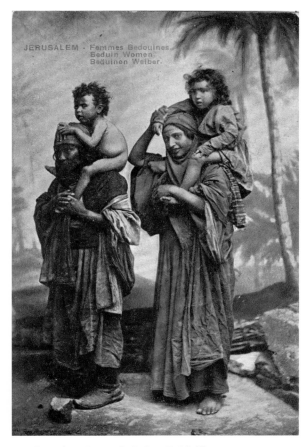

7.5. "Jerusalem. Femmes turcs. Mohammedan Women. Mohammedamische Frauen."

7.6. "Jeune femme de Bethléhem. Bethlehem woman. Junge Frau aus Bethlehem."

7.7. "Jerusalem—Femmes Bedouines. Beduin Women. Beduinen Weiber."

as "type de femme Bedouin" and "type Juif à Jérusalem."[19] Such typologies rapidly gained widespread currency and were to remain influential among the general public—for instance, in travel books and *National Geographic*—long after they had become discredited in academic circles. Those depicted were not only removed from the present and delegated to another, earlier time, but they were placed within an internal evolutionary hierarchy, the first stage of which, in the Holy Land, was biblical time.

Still, it is much harder to represent "types" in photographs than it is in drawing. In drawings, one can combine elements from different images, but even rigorously staged photographs always exude the power of contingency. Photographers themselves did not take the division of the population into types on the basis of appearance very seriously. Using the very same models to represent different categories of the population, they constructed types through attributes and attire, or simply through captions, rather than through physiognomy.[20] The ways in which producers struggled with the (lack of) typicality is well expressed in the text accompanying a photograph produced by the American Colony titled "Woman Spinning Wool" and reproduced in *National Geographic* and as a picture postcard (fig. 7.8): "This woman belongs to a class like that of the people of Jericho, neither Bedouin nor peasant, but a compound of both. Her costume, like her blood, is a mixture, her dress is Bedouin in character but her headdress is similar to that worn by the peasant women."[21]

Images of Jews on turn-of-the-century picture postcards were often quite similar to those of other sections of the Palestinian population; like them, they were represented as anonymous and decontextualized mildly exotic types, the postcard publishers using captions on the postcard to identify their religion.[22] The main exceptions were elderly Jewish men. In a depiction invoking Christian anti-Semitic notions, they were often shown as "Wandering Jews," who were seen as condemned to drift homeless for their refusal to accept Christianity (fig. 7.9). Such postcards of Jews sitting on their luggage are similar to representations of the "Wandering Jew" in Western art, a theme that was seen as illustrating the truthfulness of scriptural prophecies and thus of Christianity.[23]

The development of the Zionist movement in Palestine brought about a radical break with earlier postcard imagery. Jewish visual self-representation had previously reflected east European Jewry and the Diaspora culture, but starting in the 1920s and 1930s, as a new and modern Jewish culture arose, the image of the pioneer became dominant. The creation of a Jewish postcard industry, including

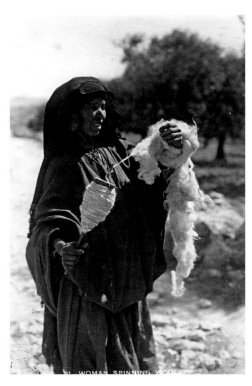

7.8. "Woman Spinning Wool."

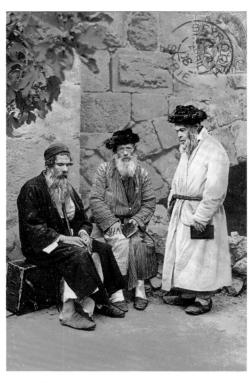

7.9. "Juifs de Jérusalem—Jews of Jerusalem," mailed 1908.

printing and publishing, was part and parcel of the Zionist project, and Zionist postcards, often depicting pioneers, began to be printed and disseminated in Palestine itself. By the early 1920s, the Jewish National Fund and the Foundation Fund had established their own photographic departments, which produced and disseminated pictures showing the Jewish redemption of the land.[24] Commercial postcard producers also became involved in this new style of representing Jews. Palphot (Palestine Photo Rotation Company), founded in 1934 by Jewish immigrants from Germany, produced a series titled We Build up Palestine, for example, which Zionist organizations used in their *aliya,* or immigration campaigns.[25]

Central in the imagery of the new Jewish pioneers was involvement in physical labor to underline their dedication to the project of redeeming the land; individual postcards had captions such as "Joy in Work" (fig. 7.10), "Jewish Farmer," "The Gardener," "Jewish Shepherd in Galilee" (fig. 7.11) and "Chalutzim [Pioneer] Building Road" (fig. 7.12). From an interview with the owners of Palphot, it is evident that these early pioneers were seen as too-good-to-be-true models. "All those famous postcards showing muscular men building Jewish cities in the desert and robust maidens merrily harvesting fruit in the *kibbutz* orchards certainly did their part in promoting to world Jewry, if in a rather romantic way, the idea of Jewish independence."[26] Especially during the first decades of the century, many Jewish settlers, coming from Russia, were influenced by various strands of socialism and its style of representation. Involvement in productive labor, particularly agriculture, was seen as crucial to building up a "normal" Jewish society, in contrast to the "unproductive" Diaspora communities. The emphasis on physical work also tied in with the concept of "Hebrew labor," by which only Jewish labor was to be employed on Jewish land, the net effect of which was the exclusion of the Palestinian Arab population. These postcards present self-confident young people whose energy and commitment to change is highlighted through visual means, such as the angle from which the picture is taken and the sharp contrast between light and dark. These are modern youth with a vision. In the case of Jewish immigrant women, their modernity is further highlighted with reference to gender equality, visually expressed through their style of dress, such as wearing shorts; their comportment; and the activities they engage in.[27]

Such images were constructed not only as an alternative to the Diaspora culture, but in contrast to the very different styles of visual representation of the local Palestinian Arab population. As mentioned above, when Arab labor was depicted, traces of modernity were often purposely omitted; their way of working was defined as traditional and their tools as simple and primitive. The involvement of the Zionist pioneers in agricultural and other developmental activities such as building roads, however, was constructed as a project executed by self-confident youth who used modern machinery and were able to show the fruits of their labor. Through such contrasts the Zionist myth of "making the desert bloom" was reproduced and the notion "we build up Palestine" visually constructed. This is not to say that biblical connotations were absent. The point is, however, that the new Jewish immigrants were seen not as representing living exemplars of the biblical past, but as consciously and actively (re)creating biblical links as part of a new culture.

Such dichotomies become acutely visible when we juxtapose postcards addressing the same theme, such as "Jewish Shepherd in Galilea" (fig. 7.11) and "Palestine. Native Shepherd Carrying a Lamb" (fig. 7.4). As mentioned above, the latter can be seen as referring to the Good Shepherd, who "lays down his life for the sheep." Yet, in contrast to the "Jewish shepherd," who, overlooking the land and his flock, with his arm resting over an open book, represents the ideal pioneer image of the intellectual worker, directed towards the future, the "native shepherd," in his tattered clothing, also appears poor and primitive, a relic of the past.

The third set of postcards to be analyzed consists of Israeli commercial postcards. After 1948, when the state of Israel was created, Israeli postcard producers came to dominate the market, with Palphot holding a particularly strong position. As in the early twentieth century, these postcard producers provided the imagery tourists were looking for, but the motivations of those visiting Israel had become more varied. Religious considerations were still often a major impetus, but views of Israel as a pioneering and modern nation, part of the Western world, were also becoming popular. The result was a bifurcation in the ways in which Jewish Israelis and Palestinian Arabs were represented on picture postcards. Whereas there are strong continuities between Israeli depictions of Palestinian Arabs and the earlier Orientalist imagery of the inhabitants of the "Holy Land," representations of Jewish Israelis trace their genealogy to the Zionist postcards of the 1920s and 1930s.

There are indeed striking similarities between modern Israeli postcards and the earlier imagery of young and energetic kibbutzniks working in the fields or building roads. Some refer to the popular

7.10. "Joy in Work (Kvutzah Schiller)."

7.11. "Jewish Shepherd in Galilee."

7.12. "Chalutzim Building Road."

7.13. "The Pioneer Fighting Youth

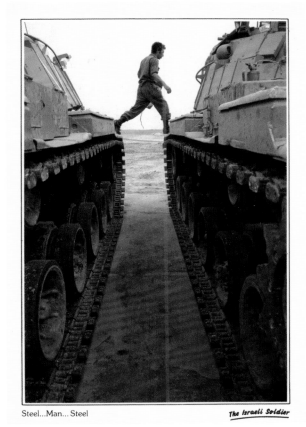

Steel...Man... Steel

The Israeli Soldier

7.14. "Steel...Man... Steel."

notion of the *Sabra,* an Israeli term for Jews born in Palestine, from *sabr,* the Arabic name for the cactus fruit. The metaphor behind the term is both visually and textually expressed on a postcard of two women paratroopers with cactus fruit prominently present in the foreground. The text on the card's reverse reads: "The renowned Israeli sabra cactus, symbol of the Israeli temperament, prickly on the outside, sweet on the inside."

If in the earlier years after the founding of the state of Israel images of the humanist (socialist) pioneer abounded, after the 1967 war the notion of the "tough Jew" gained a stronger presence. According to the owners of Palphot, their all-time best-selling postcard was probably "the one showing the troops at the Western Wall during the Six Day War." They estimate that about ten thousand copies sold very rapidly.[28] These cards often fuse the military and the religious. A postcard of an armed soldier praying, titled "Jerusalem. Soldier by the Western Wall" and with the accompanying text "For Zion's sake, I will not hold my peace and for Jerusalem's sake I will not rest (Isaiah 61)," refers to the historical and religious claims of the Jewish nation (represented by an armed soldier) to Jerusalem. A similar message is conveyed by a card of armed soldiers marching in front of the old Jerusalem walls, the reverse of which reads, "Jerusalem route march. Annual pilgrimage to Jerusalem. Background the citadel (David's tower)." Or, from Palphot's Beautiful Israel series, a card of soldiers on a tank in silhouette, which on the front reads, "...to guard thee in all thy ways..." (Psalms 91:1) and on the back, "Behold he that keepeth Israel shall neither slumber nor sleep" (Psalms 121:4). More generally, pictures of soldiers were widely available in the 1980s, with one postcard series actually titled The Israeli Soldier. Pictures in this series often focus on the human side of the military, such as the pioneer-soldier working the land ("The Pioneer Fighting Youth Battle—for Crops," depicting a soldier in front of a harvesting machine; fig. 7.13), the human face of the military ("Brothers in Arms," "The Sleeping Soldier," "Basic Training Is Over, No More Wiping the Smile Off Our Faces...," and "Sorority of Fighters," the latter two cards representing women soldiers), and the good army ("Securing Peace on the Lebanese Border"). But the series also includes cards referring to the military-masculinity nexus ("Steel...Man...Steel," a card of a soldier stepping from one tank onto another; fig. 7.14).

Whereas the pioneer image of the 1920s and 1930s was part of an oppositional discourse rejecting European anti-Semitic imagery as well as the Diaspora culture, the imagery of Jewish Israelis on Israeli postcards from the 1970s and 1980s is part of a hegemonic discourse

that by and large converged with Western imagery depicting Israelis both as modern, productive, and civilized and as descendants of the ancient Hebrews, entitled, as victims of the Holocaust, to live in and revitalize the Holy Land. In contrast to the early Zionist imagery, their Jewishness is taken for granted and no longer explicitly referred to in the captions. Moreover, ultra-Orthodox or Hasidic Jews, such as the inhabitants of the Mea Shearim quarter in Jerusalem, can also be found on Israeli postcards. If in the 1920s and 1930s the notion of the pioneer was developed in contrast to the Diaspora Jewry, in the 1980s Mea Shearim and its inhabitants came to be depicted as the Jewish picturesque.

Israeli postcards of Palestinian Arabs, in contrast, are far more similar to the early twentieth-century postcards. Although more naturalistic photographs replaced studio portraits, they were still often highly constructed and accompanied by props no different than those in nineteenth-century photography. As before, Bedouin are prominently present, and images of elderly men smoking water pipes and women carrying earthen water jugs or baking bread can easily be found. The presence of Bedouin on tourist postcards as the most exotic group available has, however, a particular saliency in post-1948 Israel. Presented as "nomads," they are easily conceived of as less rooted in and worthy of the land than the Israelis. Furthermore, while references to the biblical past are still common, it has become Israel's Jewish past and historical grounding which the captions tend to underline. Peasants harvesting grain, for instance, are accompanied by a text stating "Herodion. Arab villagers harvesting near King Herod's fortress built in 42 B.C."

The dichotomy between Jewish Israelis as modern, active, and essentially part of the Western world and Palestinian Arabs as traditional and primitive, part of the East, takes on a particular moral undertone in the case of images of women. In later postcards, Jewish Israeli women are no longer depicted in a mildly exotic style, as Jewish women on early twentieth-century postcards had been, but as engaged in some leisurely activity, such as sunbathing, or in somewhat unusual activities and occupations, for instance, as kibbutzniks, policewomen, soldiers, or paratroopers, often wearing some sort of uniform that downplays gender difference. In that respect they are quite similar to the pioneer women in the twenties and thirties wearing shorts or uniforms and actively working together with their male counterparts. This does not mean that gender is irrelevant, nor does it do away with conventional notions of femininity. The captions of postcards in the series The Israeli Soldier, mentioned

above, speak to this point, with images of male soldiers accompanied by texts such as "Steel…Man-Steel" and those of female soldiers with "Basic Training Is Over, No More Wiping the Smile Off Our Faces."

Comparing the representations of Jewish-Israeli women with those of Palestinian Arab women brings various contrasts to the fore, especially in postcards that juxtapose both. While images of Israeli women in "traditional dress" are conspicuously absent, Palestinian Arab women are almost always depicted in long, colorful dresses, wearing a considerable amount of jewelry (especially in the case of those designated as Bedouin), accompanied by objects such as water jugs, and placed in a setting of deserts, camels, and tents.[29] Combinations of these elements present them first and foremost as exotic; there is, in fact, a postcard series called Exotica. This, however, is not the whole story. For while some of these women are depicted in a pose that is intended to be attractive to the viewer, in other cases that is not the main thrust of the image. Postcards of street or market scenes quite often have at their center Arab women carrying loads on their heads, while other cards depict them as carrying large loads of firewood with captions such as "Fuel for Thought—Arab Women Collecting Wood." Whereas in some cases such work is aestheticized, especially when women are depicted carrying earthenware water jugs, some of these representations of women at work also create associations with poverty, drudgery, dirt, and backwardness. Textual expressions referring to the static and timeless nature of Arab society work in similar ways, such as in the case of a postcard that says on the front, "As in Biblical Times," and on the reverse, "A Bedouin (Nomad) woman tends her flock of sheep near her home—as in days gone by." Another card, captioned "Women's Lib.," functions in a violently ironic mode to highlight Arab women's gender subordination. In short, whether Jewish Israeli women are depicted in a context of recreation and relaxation, able to refrain from the drudgery of work, or in professions that in many settings were and are still seen as a male prerogative, Palestinian Arab women are represented as subordinated to their own men and victims of their own society.

In response to the widespread availability of such imagery, Palestinian organizations and individuals have become engaged in the production of picture postcards with a particular political edge. The last group of postcards analyzed here, those of Maha Saca from Beit Jala on the West Bank, are exemplary insofar as she features Palestinian women wearing lavishly embroidered dresses. Having been collecting traditional Palestinian dresses and artifacts since the 1980s, in the early 1990s Saca began to depict these on picture postcards

and posters in order to reach a wider public, both Palestinian and foreign. Her aim was to inform that public about Palestinian cultural heritage and, especially in the case of foreigners, to convince them of the historical presence of the Palestinian people.[30] Saca strongly emphasizes that these dresses form material proof, beyond the proof given by songs and stories, of the existence of a Palestinian cultural heritage. Different parts of historical Palestine had their own styles of modeling and embroidery, and dresses in these styles can be considered as evidence of a former Palestinian presence in each and every one of these locales. As Saca expresses it, "This was not a land without a people, or only a desert. These dresses are a document of our historical presence and our heritage."

By collecting dresses from different areas and disseminating their images on picture postcards, Maha Saca reclaims, as it were, these areas as territory belonging to the Palestinian nation. Yet for material culture to work as an argument for territorial claims, the "nationality" of these cultural products needs to be securely anchored. In fact, the "mislabeling" of such dresses as "Israeli traditional dress" has been an important impetus for her to engage in her collecting and postcard project. To underline that the dresses on her postcards are part of a Palestinian heritage, all these cards have "Palestinian" inserted in their captions, and in a few cases the strong visual symbol of the Palestinian flag is added. A postcard captioned "Palestinians in traditional dresses, eating Palestinian traditional food 'Falafel and Humos' at Ifteim's restaurant, established 1950, Bethlehem 'originally from Jaffa'" brings it all together (fig. 7.15). It not only highlights the Jaffa origins of the restaurant and links Palestinians to their traditional dresses and food, but, through the small Palestinian flag stuck in the falafel, it also reclaims falafel as a Palestinian food. Compare this with a Palphot postcard of a falafel sandwich with an Israeli flag stuck in it and on the front the text "Falafel—Israel's National Snack."

Through choices of camera angle, shot size, lens, focus, lighting, and composition, most of Maha Saca's postcards present the dresses in all their colorful details. By taking advantage of photographic techniques, her postcards create maximum clarity, transparency, and visibility. These lavishly embroidered dresses are different both from the simpler embroidered dresses peasant women still wear in some parts of Palestine and from the modernized versions urban middle-class women may wear on special occasions. Thus, presenting these dresses, self-consciously staging them on postcards, is in itself a truly theatrical performance.

This theater is very much like heritage theater, with the museum-like quality of the dresses enhanced by the historical settings in which they are presented, such as the Church of the Nativity in Bethlehem, Hisham's palace in Jericho, the Damascus Gate in Jerusalem, and the palace of Sulaiman Jasser in Bethlehem. These images also include many other icons of Palestinian heritage, such as earthenware water jugs, wicker baskets, stone hand mills, Bedouin-style coffee pots, and hand-woven rugs. The postcards that depict women inside a Palestinian house include as many elements of Palestinian heritage as possible.

A different set of postcards presents the coastal cities in Israel with the women often posing in front of an old Palestinian house. On a card depicting five women (one of them holding an earthenware water jug) in a park in Jaffa, the high-rise buildings of Tel Aviv are clearly visible in the background (fig. 7.16). The political message comes through in the caption on the back: "Palestinian Women Near Jaffa in the Traditional Costumes of Majdel, Safiriyyah, Beit-Dajan, Yabnah and Yazour." These are all Palestinian villages depopulated and destroyed in 1948 when the state of Israel was founded. Such images and captions refer to the ubiquitous unity-in-diversity theme, which highlights differences in style and color of the dresses and their particular locations of origin, while defining the women as part of one Palestinian nation. Diversity is constructed by means of styles of dress; the women wearing these dresses are each others' equivalents. Such a way of presenting women in costume is very different from that on the postcards from the turn of the century, when the women themselves were labeled in terms of religious and ethnic differences.

There are other tensions between the women-bodies and the dresses. Whereas the dresses stand for a rural tradition, the women wearing these dresses are not older peasant women, but women who present themselves as modern, urban, and civilized, using fashionable makeup and wearing modern shoes.[31] They do not show concern with keeping their hair well covered, but use head coverings playfully to underline their attractiveness. In short, while these embroidered dresses represent a Palestinian rural tradition, they are worn by women who express, through their body language, makeup, and hairstyles, middle-class urban modernity rather than the ways of living and the activities of a rural past.

This becomes visible through the presence of "other women" on these postcards. One example, a postcard of a Palestinian woman in colorfully embroidered dress, is particularly interesting because it

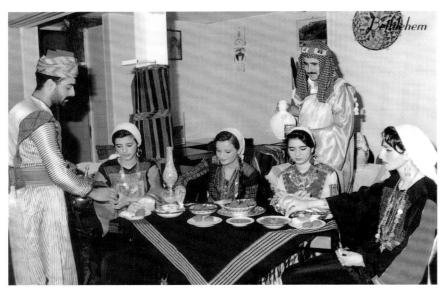

7.15. "Palestinians in traditional dresses, eating Palestinian traditional food 'Falafel and Humos' at Ifteim's restaurant, established 1950, Bethlehem 'originally from Jaffa'" (prepared and produced by Maha Saca).

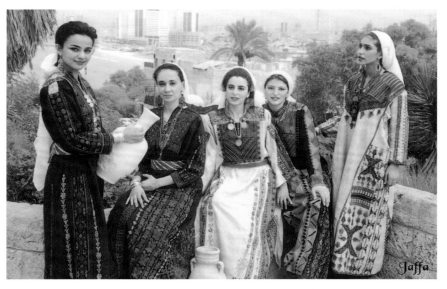

7.16. "Palestinian women near Jaffa in the traditionalcostumes of Majdel, Safiriyyah, Beit-Dajan, Yabnah and Yazour" (prepared and produced by Maha Saca).

includes an old photograph of a woman wearing the same headdress the model is wearing (fig. 7.17). The inclusion of this photograph on the postcard works as a strong and convincing argument to produce the authenticity of the model's outfit and to underline its historicity. Yet, at the same time, the different ways in which the model and the woman in the old photograph present themselves creates a discontinuity between the past and the present. Whereas the latter looks straight ahead in a serious and restrained manner, appears not to be wearing makeup, and has her coin headdress completely covered with her veil, the former smiles at the camera, wears both eye makeup and lipstick, and has her veil draped in such a way as to show off the coins on her headdress.

The women depicted on Maha Saca's postcards also appear far removed from certain types of menial women's work. The ways in which they hold the (obviously never used) earthenware water jugs substitutes earthenware as a prop or an ornament for earthenware as a means for carrying water. A postcard depicting six women in their embroidered dresses at the Damascus Gate in Jerusalem brings this point to the fore (fig. 7.18). There are striking contrasts between the women posing and the women who are incidentally present, part of the scenery, as it were. For instance, virtually all of the latter have their hair fully covered. More important for the issue of representing labor, there is also a strong contrast between how the one peasant woman (wearing an embroidered dress) carries a load of what are probably vegetables or fruits on her head, wrapped up in a plastic bag inside a bright turquoise plastic shopping bag, and how one of the models presents (rather than carries) a wicker basket in front of her.

Maha Saca is outspoken about her choice of women who model these dresses. While it is mainly elderly rural women who still wear embroidered dresses, Saca did not consider it expedient to depict these women on her postcards because that would have made it too easy for a Western audience to link Palestinian heritage with poverty and backwardness. As she says, "I choose beautiful girls to present these beautiful dresses, to show the culture of Palestine. We do not need to show backwardness, such as women baking bread in the taboun, the West has already done that." In other words, to counteract the effects of cards such as "Women's Lib.," she employs a style of representation that connects embroidered dresses—material evidence of a long-standing Palestinian presence in Palestine—with a middle-class urban modernity that the models embody in their style of presentation.

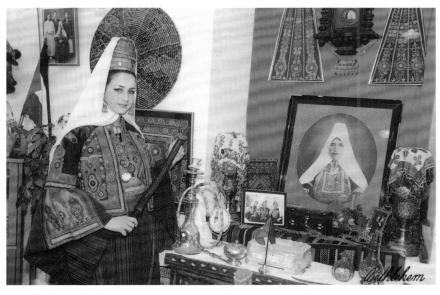

7.17. "Bethlehem 'Thob' between the past and present" (prepared and produced by Maha Saca).

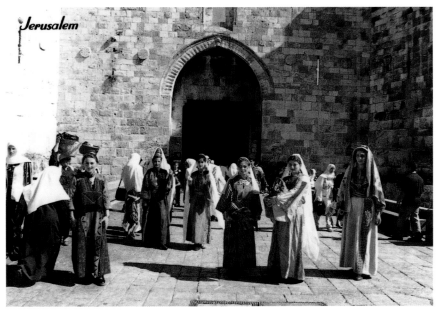

7.18. "Palestinian women in their Jerusalem traditional costumes: 'We shall stay as the everlasting Walls of Jerusalem'" (prepared and produced by Maha Saca).

This essay indicates how politics and postcard production intersect. The early twentieth-century postcards of the inhabitants of Palestine, Arabs as well as Jews, were framed through an Orientalist discourse that produced otherness and distanciation. In the case of Palestine, such a discourse took first of all the form of "biblical allegories," while "evolutionary typologies," based on geography or religion, were also common. The impact of political developments—the transformation of most of historical Palestine into the State of Israel—is evidenced by the development of Zionist postcard production. As Said argues, with the development of the Zionist movement, the Semitic myth bifurcated: "One Semite went the way of Orientalism, the other, the Arab, was forced to go the way of the Oriental."[32] Thus, images of Palestinian Arabs on Israeli postcards continue to be quite similar to early twentieth-century Orientalist postcards, whereas images of Jewish Israelis can be traced back to Zionist postcards of the 1920s and 1930s that broke with earlier Orientalist and anti-Semitic depictions of Jews. It has required more recent Palestinian postcard producers, such as Maha Saca, to develop an alternative Palestinian imagery.

It is not only ideologically motivated postcard producers that are involved in cultural politics. Mainstream commercial postcard production also has a political edge. Aiming to provide their clients with those images they think will be attractive to them, their work by and large reproduces commonly held stereotypes. Yet the imagery they produce is not necessarily homogeneous and may well include elements from different discourses. Commercial postcard producers who produce mainly for an international public of tourists and visitors have to take into account that the exotic is one element these visitors look for. No category is quite as exotic as that of Palestinian Arabs, especially the Bedouin. While it is true that various means are employed to marginalize their presence, such as through the denial of coevalness, it is hard to deny that the very presence of "Arabs" on Israeli picture postcards can have a critical edge in and of itself. There is an inherent tension between the presence of Palestinian Arabs on these postcards and the notion of Israel as an exclusively Jewish state, which is reflected in the old Zionist slogan "A land without a people for a people without a land." In a similar vein, for those in the know, the postcard discussed above of two women pioneers with *sabra,* the cactus fruit featured prominently in the foreground, contains a memory trace of the now largely displaced Palestinians, who often used *sabr* to mark the borders of their land. Even when Palestinians are physically absent, they may, therefore, be present nonetheless.

EXHIBITING

THE MUSEUM

David Prochaska

DEPARTMENT OF HISTORY

UNIVERSITY OF ILLINOIS

1 December 2000

Dr. George R. Ellis, Director

Honolulu Academy of Arts

900 S. Beretania Street

Honolulu, Hawai'i 96814

Dear Dr. Ellis:

Following up on our recent telephone conversation, I am enclosing the formal exhibition proposal with illustrations for the traveling exhibition Hawai'i: Postcards of Exoticism, Exoticism of Postcards, which I am curating. After opening in spring 2001, the exhibit will be available for loan early in 2002. Designed for four small rooms or gallery areas, the exhibit does not require extensive space. A 125-page paperback exhibition catalogue consisting of an introductory and critical essay by myself plus reproductions of the cards and a checklist will accompany the exhibit. Currently I am developing an interactive, Web-based CD-ROM version of the exhibition that visitors will be able to view on computer monitors placed at several locations in the exhibition galleries. I hope you will consider adding the exhibit to your exhibition schedule for the Honolulu Academy of Arts.

Although the attached proposal describes the exhibit in detail, I would like to underscore a number of points here. Whereas museum exhibitions of Hawaiiana mostly emphasize the past over the present, and chiefs over commoners, this exhibition takes a revisionist approach. Hawai'i is not generally considered a settler colony in popular American

discourse; Hawaiian picture postcards, produced primarily for tourist consumption, are not generally viewed as exoticist imagery produced in a colonial situation. By putting on view such exoticist images of Hawai'i, by demonstrating the formal photographic practices used in constructing Hawai'i as exotic, and by showing implicitly how they are analogous to colonial and postcolonial practices elsewhere, this exhibition contends that terms and categories such as colonial, postcolonial, internal colonialism, and settler colonialism are in fact applicable to Hawai'i. The exhibition stages these issues through formal museological and visual practices, which in turn grow out of current critical and art-historical theory.

Although trafficking between "high" and "low" art is a sine qua non of twentieth-century art and art history, such quintessentially popular genres as picture postcards are rarely, if ever, displayed in art museums. Through careful selection of a wide number of striking images, this exhibition does just that. As such, the exhibition adds a strong voice to the ongoing colloquy concerning the porous nature of "high" and "low" art. It does so through the presentation of a distinctive, readily identifiable genre of objects—postcards—that aims to elicit the reaction "why didn't someone think of this before?"

The exhibit is innovative not only in regard to the objects it displays but in the way it displays them. Instead of implicitly representing an identifiable art-historical approach, as most exhibitions do, this exhibit problematizes contemporary currents in art history and critical theory by explicitly staging them for the museumgoer. Just as the now middle-aged "new art history" challenged the hegemony of the art object per se (and its associated discourses of artist, oeuvre, career, and connoisseurship) and broadened the scope of art history to encompass the contexts in which art objects are produced and circulated (audience, reception), so too does the exhibit embody such newer approaches by explicitly presenting the three-part nexus of production, image, and reception in the first three exhibition rooms. To further underscore the contingent nature of art-historical interpretations, the fourth room self-reflexively stages the exhibition in the form of a museum within the museum. As you are well aware, such underlying display practices are themselves innovative and by no means common in museology.

At the same time, the postcards on display are intrinsically interesting both in formal aesthetic terms and as documents (in the late nineteenth- and early twentieth-century sense of the term). Not simply picture postcards of Hawai'i, the cards selected for display exemplify the construction of Hawai'i as exotic. The formal photographic practices seen here thus echo analogous practices—more often textual than visual— discussed extensively in postcolonial studies, and often in terms of Orientalism. Therefore, the cultural work that this exhibition of exoticist Hawaiian postcards performs is twofold: first, to expand the discussion of Orientalism to exoticism more generally, and second, to shift the usual register of debate from the textual to the visual.[1] Additionally, such visual images perform the political work of questioning the status of Hawai'i vis-à-vis the continental United States—is it a state or colony? A colony or postcolony?[2]

The attached exhibit proposal develops these and other points in a discussion organized around the postcard images themselves. Taken together with the proposal, these remarks will, I hope, convey to you a sufficiently detailed picture of the exhibition so that you will be able to consider it for the Honolulu Academy of Arts. If you have any questions, or if I can supply any additional information, please do not hesitate to contact me.

Sincerely yours,
David Prochaska
Associate Professor

Hawai'i: Postcards of Exoticism, Exoticism of Postcards

CONTENTS

INTRODUCTION

This exhibition scrutinizes the colonialist construction of Hawai'i as exotic exemplified in picture postcards and related images.[3] In staging the construction of exoticist Hawaiian postcard images in a museum space, the exhibition draws extensively on contemporary discussions concerning representation, art and artifact, the gaze, and high and low art.[4]

Colonial and postcolonial terms and categories are not generally applied to Hawai'i in systematic, analytically rigorous ways, although Hawai'i is commonly glossed as "exotic" in popular discourse. Rather than critically interrogate such exoticizing moves, however, most studies and museum exhibitions are content to reproduce exoticist terms and categories. In Hawai'i and elsewhere, museum exhibitions emphasize the past over the present, chiefs (*ali'i*) over commoners (*maka'ainana*), and royal lifestyle over the material culture of the Hawaiians.[5] Often encountered in written texts on Hawai'i, such uncritical use of exoticist categories is even more prevalent in works concerning visual culture. Thus, studies of Hawaiian photography—and non-Western photography generally—consist primarily of surveys and monographs on individual photographers.[6] Similarly, studies of Hawaiian postcards, and postcards more generally, consist overwhelmingly of coffee-table compilations often fueled by imperialist nostalgia.[7] Even after the "new art history," very few theoretically informed studies of Hawaiian and other non-Western photographies exist.[8]

This exhibition exemplifies newer critical approaches in its organization and installation. The exhibition is divided into four rooms or areas that focus on the following four themes: postcard production, imagery, and reception, and construction of the exhibition.[9] Within each gallery area the visitor's gaze is directed to a number of focal points. Using as an organizing principle the nexus of production, imagery, and reception, the exhibition moves away from a focus on images per se to demonstrate visually the ways exoticist postcard imagery is constructed.[10] A further innovative feature is the fourth gallery area—laid out as a museum within the museum—which constitutes a metacommentary on the exhibition the visitor has just seen. Such an installation recalls and extends such influential museum shows as Art/Artifact and especially Mining the Museum.[11]

The design and layout of the accompanying exhibition catalogue mimics the "look" of an early twentieth-century postcard album. The catalogue essay is organized visually. In other words, the

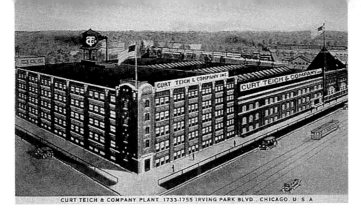

8.1. "The Largest Post Card Factory in the World."

text is driven by reproductions of postcards and other images so that the images become the "text." Thus, the written text amplifies and complements the images rather than vice versa.

ROOM 1: PRODUCTION

The overall space of this installation area creates the interior of a postcard publishing plant, with vertical panels separating the printing presses from the retouching studio. Large-scale photomurals picture such a plant in cutaway sections. A photo blowup depicts a press printing postcards, and ambient printing press noises recorded on a tape loop are audible to visitors standing directly beneath an overhead speaker. For the retouching studio, stools, drafting tables, brushes, and paints are used. A photo blowup of retouchers at work clearly shows that primarily women performed this work.

Fig. 8.1 "The Largest Post Card Factory in the World" (Teich postcard, A91552, 1922. Courtesy of the Lake County (IL) Museum, Curt Teich Postcard Archives).

This advertising postcard for Teich Company was "used by salesmen to let customers know when to expect a sales call."[12]

1.1 A Job Folder

Job folders from the Teich Company, one of the largest U.S. postcard publishers, document the creation of Hawaiian postcards step by step from the initial order through photo retouching and blue monochrome proof to final color postcard. The contents of two job folders arranged on the wall and in a glass case along with descriptive labels show stages of production of two postcards.[13]

Fig. 8.2: "The Naniloa Hotel, Hilo's Garden Hotel," original black and white photograph (courtesy of the Lake County (IL) Museum, Curt Teich Postcard Archives).

The job folder for "The Naniloa Hotel, Hilo's Garden Hotel" includes the order form, an internal company telegram, plus various artwork. The order form informs us that Teich postcard 0B-H920 was ordered May 27, 1940, by the Naniloa Hotel in Hilo in an initial run of 6,500 cards. The order form includes the following directions to the retouching department: "Block out the upper background, and bring the trees in the foreground a little clearer, as well as the hotel itself: also the lava formation in the immediate foreground on the water's edge." The following day, May 28, 1940, the advertising-sales division sent an in-house telegram conveying Curt Teich Jr.'s personal recommendations for the card production: "Mr. Teich, Jr. suggests that we center the hotel on the card in cropping the photograph to post card proportion. As to the treatment of the background, Mr. Teich, Jr. believes that we should sort of fade out the background into the distance by just reproducing it as one solid mass of flat green lawn against which the trees surrounding the hotel will stand out.... With respect to the colors on [the] card...Mr. Teich, Jr. wants us to draw on the coloring we have used in producing cards for Hawaii in the past."[14]

Fig. 8.3: "The Naniloa Hotel, Hilo's Garden Hotel," blue monochrome proof (courtesy of the Lake County (IL) Museum, Curt Teich Postcard Archives).

Next a retouched photo was produced, followed by a blue monochrome press proof with all the requested changes including the caption on the bottom. In this version the upper background of the original photo has been blocked out, leaving a flat, undifferentiated background behind the hotel. A press proof was then produced, followed by the final color postcard, to which a range of lavender hills had been added in the background behind the hotel as well as blue sky and yellow-tinged clouds.

1.2 A Geographical Index

Geographical indexes from the Teich Company served primarily as the photographer-salesperson's order book in Hawai'i. They list the retailer ordering the cards, the cards ordered, the number ordered, the date, and whether the card was reprinted. Sample pages from geographical indexes combined with the postcards referred to map cities and towns, such as Honolulu and Hilo, where the retailers were located.[15]

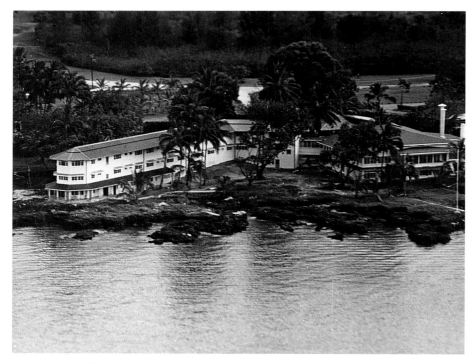

8.2. "The Naniloa Hotel, Hilo's Garden Hotel," original black-and-white photograph.

8.3. "The Naniloa Hotel, Hilo's Garden Hotel," blue monochrome proof.

"Honolulu Tom Boy, Honolulu, T.H." (Teich color postcard, ca. 1905. Courtesy of the Lake County (IL) Museum, Curt Teich Postcard Archives).

The page from the geographical indexes that includes "Honolulu Tom Boy" is the fifth of thirty-four pages for Honolulu. The geographical index tells us that Weinberg, another postcard publisher, placed the order, and that "Honolulu Tom Boy" was one of twelve cards ordered. The index also gives the card number, A9200, which falls within a numbering schema used by Teich in the first decade of the twentieth century.

1.3 A Postcard Catalogue of Colonial Hawai'i

This focal point consists of sample pages of a computerized checklist of Hawaiian postcards produced by the Teich Archives along with the cards indexed. For other postcard publishers, the only way to reconstruct all the postcards produced is by searching in public collections and among private collectors, an extremely time-consuming, painstaking, and hit-or-miss process. For Teich Hawaiian postcards, however, we have copies for all 1,582.[16]

"Royal Hawaiian Hotel, Waikiki, T. H." (Teich color postcard 2B-H892, 1942).

This card appears on the seventh of sixty-four pages of a computer list of all 1,582 Hawai'i cards produced by Teich. For each card the Teich production number is given (here 2B-H892), the major and minor subject is identified (hotels), the location is specified (e.g., Waikiki or Hawaii), and a computer record number is assigned (102225).

1.4 Altered Images

Comparing the same or a slightly altered photograph in different contexts provides telling clues about the way that postcards helped to construct Hawai'i as "exotic." In the late nineteenth and early twentieth centuries, when photographers were typically considered artisans rather than artists, with the result that their work was rarely copyrighted, photographs were frequently purchased, retouched, and reissued as postcards. Certain alterations were more common than others, such as elimination of ethnic details, in keeping with the tendency to render Hawai'i "exotic."

Fig. 8.4: J. J. Williams color photo (signed color photograph "Williams Honolulu." Courtesy of the Lake County (IL) Museum, Curt Teich Postcard Archives).

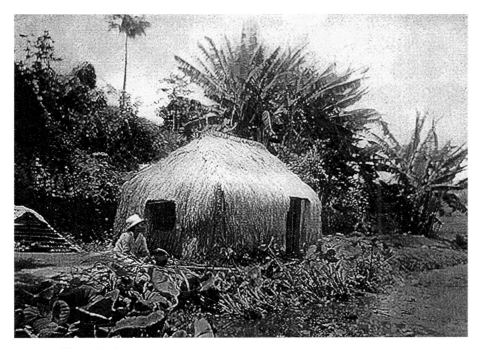

8.4. J. J. Williams color photo

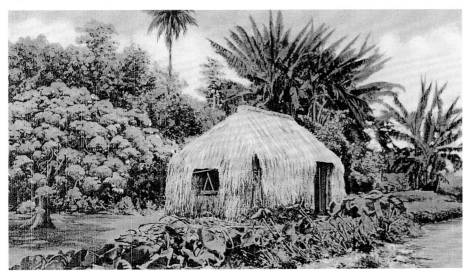

8.5. "Old Hawaiian Grass Hut."

On the back of the Williams photograph, the structure is referred to as a "chicken coop."[17]

Fig. 8.5: "Old Hawaiian Grass Hut" (Teich color postcard 6A-H475, 1936. Courtesy of the Lake County (IL) Museum, Curt Teich Postcard Archives).

Teich changed the "chicken coop" to a "grass hut," according to Teich production order no. 60001, dated March 27, 1936. The card was produced for the Patten Co., which was based in Honolulu and which also supplied Williams's original photograph. Significantly, the Teich order also includes the following instructions for retouching and airbrushing: "Eliminate figure of man, also pig pen in background. Suggest that you put in a Poinciana tree in place of the pig pen and move the grass shack a little further over towards the right." (Fig. 8.5)

1.5 Individuals and Generic Types

In conformity with older visual genres, postcards usually caption people as representative of generic types rather than as named individuals. Sometimes, however, researchers can recover the identity of these "generic" individuals, as is the case here.[18]

Fig. 8.6: "Hula Maids" (postcard, Visual Collections, Bishop Museum, Honolulu. Courtesy of the Bishop Museum).

Bishop Museum staff have been able to identify the Kodak Hula Show performers in this card. From left to right: "'Tiny' Akeo, unknown, David—, Hannah Atwood, Ruby Notley, Ida, Naone, Helen Alama, Tootsie Notley, Helen Smith, Smabo Auna. Little girl is Fran Xavier."[19]

ROOM 2: IMAGERY

The second exhibition room is the single largest installation space, but it should not be so large as to overshadow the others. The centerpiece of this area is a darkened room within a room in which slides of postcards are continuously projected on the walls.

2.1 Postcarding the World

During the so-called golden age (*l'âge d'or*) of picture postcards, from 1900 to 1920, the sheer number and diversity of postcards produced suggest a more or less conscious attempt to create a comprehensive archive or visual encyclopedia of the world. To convey the sensation of this "postcarding" of the world, of this image saturation, the visitor enters a darkened hexagonal room on whose walls six slide projectors continuously screen sets of postcard images from Hawai'i reflecting

8.7.　"Aloha Hawaiian Islands," cover, Teich color postcard booklet, 1935.

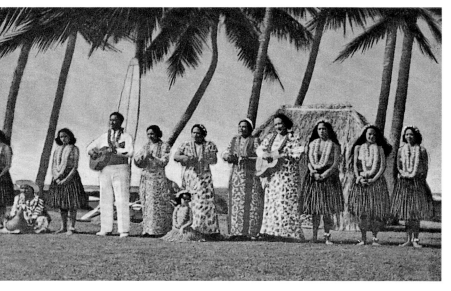

8.6.　"Hula Maids."

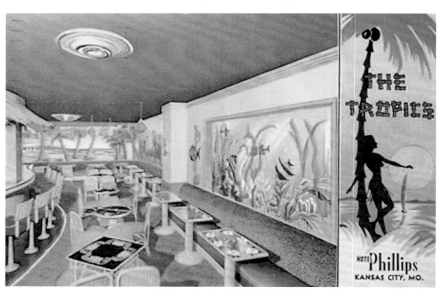

8.8.　"The Tropics, Hotel Phillips, Kansas City, Mo."

different genres (views, scenes, and types), locales (Waikiki, Diamond Head, Oahu, the "neighbor islands"), and themes (hotels and tourists, surfing and beachboys, Hawaiian chant and ukelele, boat day and cruise liners).

"Surf Riding, Honolulu, T. H." (Teich color postcard, ca. 1905).

"A Native Feast or Luau, Honolulu" (Teich color postcard, 30T, ca. 1904).

"Moana Hotel, Waikiki, Honolulu" (Teich color postcard, 96T, ca. 1913).

The original caption for this card reads: "The Moana Hotel was built in 1895, and is surrounded by lovely palms and tropical foliage, on the beach of Waikiki near Honolulu. It is the exclusive hotel of Honolulu and the home of the many wealthy visitors to the Islands. Moonlight bathing, parties, dances, and concerts are nightly features of life at the Moana. A beautiful pier extends far into the ocean from the hotel and from its deck can be witnessed the wonderful aquatic sports which occur at all hours on Waikiki Beach."

Hawaiian woman with leis (color postcard, from Brown, *Hawaii Recalls*, 105).

Fig. 8.7: "Aloha Hawaiian Islands" (cover, Teich color postcard booklet, 1935. Courtesy of the Lake County (IL) Museum, Curt Teich Postcard Archives).

The saturated colors of this postcard booklet cover, which could be dubbed "tropical lurid," are a fitting introduction to the highly stylized views found inside.

"Pa'u Rider" (Teich color postcard, ca. 1905).

The original caption of this card reads: "Hawaiian girls all wear a divided skirt or pa'u when riding. The side saddle is practically unknown in Hawaii. The pa'u or skirt is made so that when the rider advances along the road it streams out, forming a picturesque sight. The Hawaiians, both men and women, are experts on horseback and some of the champion cowboys of the world live in Hawaii."

2.2 Continental U.S. Postcard Producers

Arrangements on surrounding walls or rectangular kiosks in the middle of the room explore additional aspects of postcard imagery in greater detail. Postcards not of Hawai'i but of the mainland that draw on comparable exoticist tropes—the "tropics," the "South Seas"—underscore the use of similar pictorial strategies in different places to produce similar exoticist effects.

Fig. 8.8: "The Tropics, Hotel Phillips, Kansas City. Mo." (color postcard, reproduced in Barry Zaid, *Wish You Were Here: A Tour of America's Great Hotels During the Golden Age of the Picture Post Card* [New York: Crown Publishers, 1990], p. 89).

It is a long way in reality to the ocean from the Hotel Philips, but not in this exoticist fantasy. It is not certain that this is a Teich card, but it most likely is.

2.3 Local Hawaiian Postcard Producers

Besides being produced by continental American firms, postcards were made locally in Hawai'i by both *haole* (whites), and ethnic Asian photographers. Often local photographers catered to specific local communities and ethnic groups, and produced a range of photographs from postcards to wedding album photos. Different ethnic Asian photographers—for example, On Char, Morito Koga, and Tai Sing Loo—catered to different ethnic Asian communities, such as the Japanese, Chinese, or Filipinos.[20] Some postcards were produced or hand tinted in Japan.[21] Yet there was considerable contact in this cultural contact zone. Asian photographers learned photography from whites, and some were employed in white photography studios. White photographers—for example, J. J. Williams and Ray Jerome Baker—catered as well to Asian communities.[22]

Fig. 8.9: "Japanese Grass House, Hilo, Hawaii. Cane in Blossom, Wainaku" (color postcard, mailed 1909. Courtesy of the Bishop Museum).[23]

2.4 Tropes

To say "Hawai'i" is to say stereotypes, tropes. Although exoticist stereotypes are reproduced over and over, and although by definition stereotypes appear unchanging, they do have a history—they come and go—and they vary over time. Displays here show repetitiveness as well as variation by juxtaposing postcards alongside other images ranging from the so-called contact period to the present. For example, hula in Hawai'i has a much more complex history than is apparent from its stereotyped representation on picture postcards. Postcards of hula girls can be juxtaposed with images drawn from historical and anthropological works. At the same time, the extent of the hula stereo-

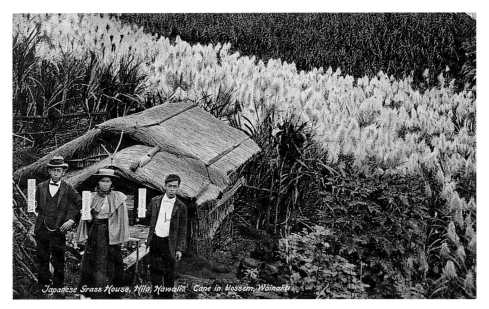

8.9. "Japanese Grass House, Hilo, Hawaii. Cane in Blossom, Wainaku," mailed 1909.

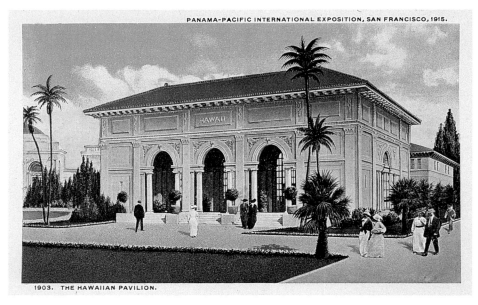

8.10. "Panama-Pacific International Exposition, San Francisco, 1915: 1903. The Hawaiian Pavilion," 1915.

type can be conveyed by displaying hula girls in other visual media—travel posters, movie stills, Hawaiian shirts, Matson liner placemats, and sheet music covers. A second trope illustrated here is leis and lei sellers.

"Flower Girls, Honolulu" (Teich color postcard, 76T, ca. 1904).

John Webber, *A Girl of Atooi, Sandwich Islands* (1778) (private collection, Honolulu). Webber (1752–98) was the official artist on Captain James Cook's third voyage, 1776–80. Head and neck leis made of feathers as depicted here were popular with Hawaiian royalty.[24]

Herb Kawainui Kane, *Lei Sellers* (collection of the Chart House, Inc.).[25]

2.5 Other Genres

Hawaiian postcard images exemplify more genres than can be displayed in this exhibition. Two additional ones included here are postcards of national expositions and humorous postcards employing gigantism. Hawaiian pavilions at national expositions, such as the 1915 Panama-Pacific International Exposition in San Francisco, represent aspects of Hawai'i that were represented in turn on postcards.[26] Included, moreover, are several artifacts that recreate the space of such expositions. Humorous postcards popular especially between 1905 and 1915 utilized gigantism as a pictorial conceit, such as depicting pineapples bigger than people.[27]

Fig. 8.10: "Panama-Pacific International Exposition, San Francisco 1915: 1903. The Hawaiian Pavilion" (Teich color postcard, R54279, 1915. Courtesy of the Lake County (IL) Museum, Curt Teich Postcard Archives).

ROOM 3: RECEPTION

The overall space creates the interior of an early twentieth-century American upper-middle-class sitting or drawing room. A large photomural of such an interior on the wall and various objects and furnishings suggest the range of exoticist visual culture common at the time. An easy chair, table, and postcard album ready for viewing dominate the scene. Also included are a stereoscope and stereographs, exoticist Hawaiian sheet music on the piano, and an exoticist memento from the 1915 Panama-Pacific exposition on a coffee table. Through a ceiling speaker over the piano viewers can hear a continuous tape of nineteenth- and early twentieth-century exoticist classical compositions (Rimsky-Korsakov, Saint-Saëns).

Fig. 8.11: On the Beach at Waikiki, or the Golden Hula (1915. Courtesy of the Bishop Museum).[28]

"On the Beach at Waikiki" was a *hapa-haole* song that led to a fad for Hawaiian music in 1915 on the mainland. *Hapa-haole* song style is based on ragtime rhythms and harmonies.

3.1 Postcard Messages

This focal point displays postcard messages. A message written by a sender on a postcard appropriates the card from the producer; mailing it puts it into circulation between a sender and a sendee. Levels of appropriation range widely: no message, a signature over the image, an "X" marking the hotel room where the tourist stayed, a lengthy message, "all-over" cards (i.e., cards written "all over"), and postcard sequences in which the message carries over from one card to another to form a continuous narrative. One of the most striking characteristics of messages is how often they have nothing to do with the postcard image. All too frequently cards express casual racism towards the people and places depicted.

Fig. 8.12: "Japanese Grass House, Hilo, Hawaii. Cane in Blossom, Wainaku" (color postcard, verso, mailed 1909. Courtesy of the Bishop Museum).

This is the verso, or message side, of the postcard in figure 8.9 above. The message reads: "To Master J. Ross McConkey, Honolulu: 'Hello Brother, how are you enjoying yourself? I know what you enjoy are the Moving Pictures, don't you. How is Tom & the girls? Give them my love & keep some for my little doctor. With love from your friend Agnes.'" The postcard message on the back has nothing to do with the image on the front.

3.2 Postcard Albums

The preferred way of organizing and preserving postcards in the early twentieth century was in an album. The different kinds of cards collected and juxtapositions of themes and genres provide valuable insights into the ways in which a contemporary audience viewed and appropriated postcards. Here albums placed under glass are opened at appropriate pages.

Fig. 8.13: Bryan family postcard album, p. 6 (ca. 1920s. Courtesy of the Bishop Museum).

The handwritten text for the photo on the left reads: "Leis. When you come to us across the world of waters, /We're a lei a-waiting just for you; / Pansies from a little cottage garden, / Violets still glist'ning with the dew; / Tokens true are they of our Aloha— / Emblems of a welcome from our heart; / If you'll wear one for a while, joy will walk

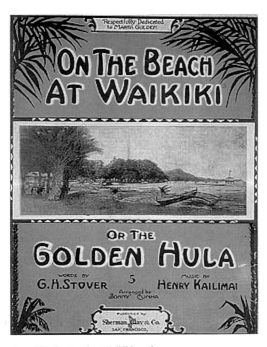

8.11. "On the Beach at Waikiki, or the Golden Hula," 1915.

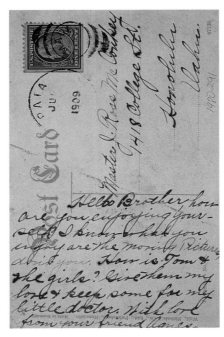

8.12. "Japanese Grass House, Hilo, Hawaii. Cane in Blossom, Wainaku," verso, mailed 1909.

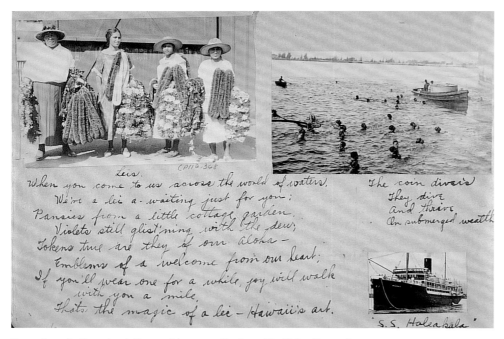

8.13. Bryan family postcard album, p. 6 (ca. 1920s. Courtesy of the Bishop Museum)

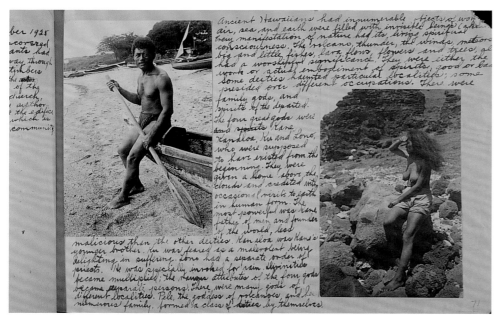

8.14. Bryan family postcard album, p. 71 (ca. 1920s. Courtesy of the Bishop Museum)

/ with you a mile, / That's the magic of a lei—Hawaiian art." The text under the upper right photo reads: "The coin divers / They dive / and thrive / On submerged wealth."

Fig. 8.14: Bryan family postcard album, p. 71 (ca. 1920s. Courtesy of the Bishop Museum).

The handwritten text reads: "Ancient Hawaiians had innumerable objects of worship…air, sea, and earth were filled with invisible beings…. Every manifestation of nature had its living spiritual consciousness. The volcano, thunder, the winds, meteors, big and little fishes, lava flows, flowers and trees, all had a worshipful significance. They were either the work or actual embodiment of spirits, good or bad. Some deities haunted particular localities; some presided over different occupations. There were family gods, and spirits of the departed. The four great gods were Kane, Kanaloa, Ku and Lono, who were supposed to have existed from the beginning. They were given a home above the clouds and credited with occasional visits to earth in human form. The most powerful was Kane, father of men and founder of the world, less malicious than the other deities. Kanaloa was Kane's younger brother. Ku was feared as a malevolent being delighting in suffering. Lono had a separate order of priests. He was especially invoked for rain. Divinities became multiplied; the various attributes of the four gods became separate persons. There were many gods of different localities. Pele, the goddess of volcanoes, and her numerous family, formed a class of deities by themselves."

3.3 Same Image, Different Contexts

Tracking the same photograph in different publications—with different titles and different explanatory text—provides telling clues regarding intended audience and reception. Here the same photograph circulates in different publications and formats, including postcards, but the contexts in which they circulate are different, so that the audience responds differently.[29]

Fig. 8.15: Roy Jerome Baker, "Hawaiian woman washing clothes in stream near Paia, Maui, 1912" (reproduced in Baker, *Hawaiian Yesterdays*, p. 20. Courtesy of Mutual Publishing).

With details concerning place and date, this image conveys to the viewer a sense of a straightforward documentary photograph.

Fig. 8.16: "Hawaiian Wash Day" (Baker Photo postcard reproduced in Blackburn, *Hawaiiana*, p. 64. Courtesy of Mark Blackburn).

Here the same photo as in figure 8.15 was first produced as a postcard by Baker. Now it is reprinted in a book of Hawaiian knickknacks and collectibles for sale in Hilo and is captioned "Real Photo Card by Baker. Mauna Kea Galleries, Hilo, Hawai'i. $20–30." The documentary photograph in figure 8.15 has been transformed into the commodity in figure 8.16 with an exchange value of twenty to thirty dollars.

3.4 Postcards and Tourism

Connections between postcards and tourism are displayed here. For many Hawai'i is synonymous with tourism. Retail stores, such as the Hawaii and South Seas Curio company, sold postcards along with other tourist items as souvenirs of Hawai'i. To advertise their cruise ships, Matson Lines used not only postcards but also murals, menu mats, calendars, tourist brochures, baggage labels, and ticket envelopes.

Fig. 8.17: Advertising postcard, Hawaii and South Seas Curio Co. (mailed ca. 1914. Courtesy of the Bishop Museum).

"225. The Island Curio Co. Honolulu, Hawaiian Islands. Oldest, largest and most complete curio store" (advertising postcard, Hawaii and South Seas Curio Co.).

ROOM 4: CONSTRUCTING "HAWAI'I: POSTCARDS OF EXOTICISM, EXOTICISM OF POSTCARDS"

The final installation space consists of a museum within the museum. Life-size photo blowups on the walls depict museum staff "behind the scenes" preparing the exhibition that the visitor has just seen. The fourth room thus serves as a coda to or commentary on the first three rooms.[30] By self-reflexively staging the exhibition the museum visitor has just viewed, the room stresses the contingent nature of the art historical perspective and museological practices that inform the exhibition.[31] Thus, the exhibition presents multiple perspectives on Hawaiian postcards with the aim of letting museum visitors make up their own minds.

4.1 What We Don't Know

The contingent nature of the exhibition is emphasized through visual displays of what we know and what we do not know. What is striking about postcards is not how much but how little we know. Generally, all we have are the cards themselves. What we do not know—the names of most postcard photographers, the dates of production, the number produced, the cards in a series that are missing—is suggested here through a series of blank photographs on the wall, each bearing the name of a photographer of whom we lack a portrait.

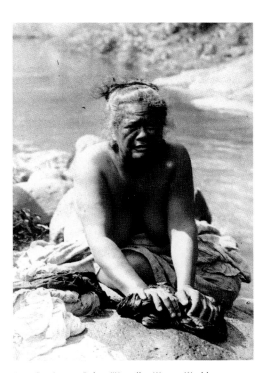

8.15. Roy Jerome Baker, "Hawaiian Woman Washing Clothes in Stream near Paia, Maui, 1912."

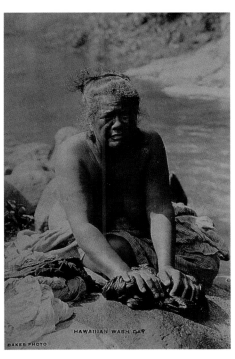

8.16. "Hawaiian Wash Day."

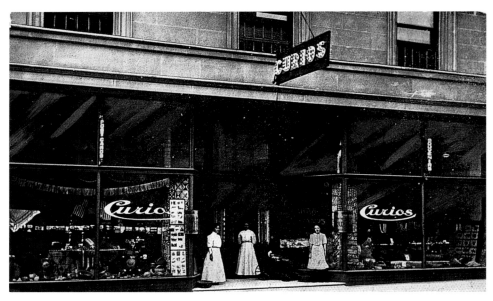

8.17. Advertising postcard, Hawaii and South Seas Curio Co., mailed ca. 1914.

8.18. "Hawaiian Grass House."

Fig. 8.18: "Hawaiian Grass House" (postcard. Courtesy of the Bishop Museum).

Here we do not know the individuals pictured, the location, the date, the name of the photographer, or the publisher—nothing except the postcard itself. What we do not know—the absences—far outweighs what we do know—the presences. With few exceptions, we lack archival information for postcards concerning both photographers and postcard publishers. Not the name of the photographer—who was generally considered an artisan rather than artist—but the name of the publisher more often appears on the card. When postcard stocks were sold, it was not uncommon for the new owner to reissue the old cards under his (the publishers were generally male) name. People and subjects generally absent in extant Hawaiian postcards include ethnic groups (Filipino, Chinese, Samoan), women, the majority of occupations, and the built environment broadly construed.[32]

4.2 Deltiology and Deltiologists

What we do know about postcards is pictured here: dealers' business cards, postcard exposition posters, recent book republications of old postcards, and sample pages from price guides. These materials clearly suggest the extent to which the study of postcards (deltiology) is driven not by art historians and museum professionals but by amateur and professional deltiologists and collectors.

Fig. 8.19: "Mark Blackburn is the owner of Mauna Kea Galleries in Hilo, Hawai'i" (inside back cover, Blackburn, *Hawaiiana*. Courtesy of Mark Blackburn).

Museum and archival collections of postcards have often been formed more by accident than design. In contrast, avid antiquarians engage in deltiology. Deltiology is thus connected to the history and psychology of collecting. Old postcards are sold by dealers at flea markets and expositions. Journals and compilations of particular genres are published. Price guides are regularly updated. In the last two decades, prices have increased significantly and a boomlet of book compilations of old postcards has occurred. Part of this is due to nostalgia for the past, in part it constitutes one variety of imperialist nostalgia.[33]

4.3 But Is It Art?

Since postcards are not generally considered art, they are not usually displayed in museums. Different postcards elicit different responses to the question "But is it art?" some of which are staged here. For those inclined to view postcards as art, certain kinds of postcard images can be emphasized. On the other hand, many contemporaries considered

postcards and other photos as straightforward factual documents, a perspective on the visual record also presented here.[34] Thus, this exhibition, influenced by the traffic between "high" and "low" culture in twentieth-century art, expands the more common art-historical emphasis on images per se to encompass their production and reception as well.

"Hawaiian woman with lauhala for mat weaving, Pukoo, Molokai" (Baker Photo, 1912. Reproduced in Baker, *Hawaiian Yesterdays,* p. 17).

This documentary-style photo was issued by Baker as a postcard. Baker seems to have approached photography generally from a documentary perspective. For example, he was in the habit of making an annual photographic inventory of downtown Honolulu, usually on January 2, to "photograph new buildings and other sights that caught his eye."[35] In 1941 he published *Honolulu Then and Now,* subtitled *A Photographic Record of Progress in the City of Honolulu.*

8.19. "Mark Blackburn is the owner of Mauna Kea Galleries in Hilo, Hawai'i."

Fig. 8.20: Capitol Building (former Iolani Palace) (Teich color postcard mailed 1934. Courtesy of the Lake County (IL) Museum, Curt Teich Postcard Archives).

This is an example of a so-called linen card produced by the Teich Company. The style, in which cards were embossed with a linen-like finish, was popular from the 1930s through the 1950s. Typically air-brushed by hand in pastel colors, these highly stylized, "picture-perfect" simulated linen cards stand at the opposite extreme from more empirically straightforward, yet still stylized, documentary images such as figure 8.19. "To me there was something magical about those linen cards," writes one aficionado. The subjects "seemed so perfect. And those skies! The most gorgeous robin's-egg blues gently fading into pale peach tinged with just a blush of coral, a few wisps of fluffy white clouds floating overhead.... There were no telephone poles or wires scarring the skies. Flowers and trees were always in full bloom, and shadows, if any, were a rich and lovely lavender.... This was a world even better than reality."[36] In this card, 'Iolani Palace, former home of Hawaiian monarchs, has been airbrushed, and its history, too: 'Iolani Palace was seized by Americans when they overthrew the Hawaiian monarchy in 1893.

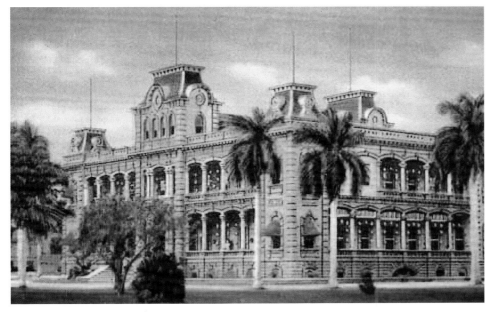

8.20. Capitol Building (former Iolani Palace), mailed 1934.

Guestbook

After viewing the various perspectives on postcards presented here, the museum visitor is invited to record his or her comments on the exhibition in a notebook at the exit.

Outward and Visible

Signs: Postcards and the

Art-Historical Canon

Ellen Handy

Postcards—so evocative and delightful in themselves, so often seen as representing the encounters between actual or armchair travelers and a "real" world of nature, geography, human difference—may yet be more significant when followed into the realms of fine-art reproduction. These physically modest bits of card stock bearing photomechanical reproductions of famous artworks are emblems of cultural authority, though we seldom acknowledge their significance. Envisioning an encounter with the canon of great art, we might picture a scholar visiting the canvases in richly wrought frames on palatial walls of a great museum, or a student earnestly leafing through the illustrated pages of Janson's, Gardner's, or even Stokstad's massive survey textbooks in a dusky university library.[1] But might we not instead imagine a child, a senior citizen, or a busy parent on a break from home responsibilities, strolling past the dazzling arrays of a museum shop and perusing the postcard reproductions of works of art displayed there for sale? If we choose to concentrate upon scholars, rather than members of the general public, addressing the canon, are they pacing through the Louvre in Jamesian reverie, pulling open and closing the file drawers of a university slide library, at their computers surfing image databases on the Web, or perhaps sprawling on the floor of a study with the contents of a shoebox crammed with decades of accumulated museum postcards? Hal Foster's pronouncement that "today the canon appears less a barricade to storm than a ruin to pick through" might be refigured so that the ruin becomes a mountain of material to be recycled, from which protrude corners of scraps bearing images: museum postcard photographic reproductions.[2]

This fanciful image has serious intent. If we cannot envision and describe what it is to encounter a concept so foundational to art history as the canon, we will not be able to argue its status and significance effectively. Postcards, humble though they may seem, are clues and tools of power in this pursuit. Think of them as the outward and visible signs of the operations of canon formation in the museum. A comprehensive history of museum art-reproduction retailing does not yet exist, instructive though it would be, and the present essay does not seek to supply this need.[3] But by scrutinizing the displays of the museum's virtual recreation of itself for sale, by exploring the place where self-image and defined canon meet commerce and where viewer experience becomes active participation through an economic nexus, in short, by perusing the postcard racks in a museum shop, we may have found a royal road to the institution's slumbering unconscious and a key to the operations of canon formation in art history.

As keepers of the great majority of nonarchitectural works that comprise the canon of art history, museums sort, evaluate, and prioritize their own holdings through sometimes difficult choices about which works in the museum's collection are to be reproduced and sold in postcard format. Year by year, we can observe them negotiating art history's central structure, the canon, in their presentation of their collections through postcards. Art-reproduction postcards are unacknowledged legislators of the discipline of art history, an unexamined alphabet by means of which the language of art history is expressed. The basis of these choices is the values, preferences, and quirks of canon formation, highlighted by the process of reproduction. Fragile, much contested, and problematic, the canon is not in fact an abstraction or a theoretical construct. It is concrete, thoroughly reified, and available for sale in the museum shops of the world. Jordana Mendelson and David Prochaska point out in their introduction to this volume that postcards form a constitutive part of the way in which the business of art history is negotiated on a daily basis. What happens, then, if the reproductive postcard, and not its subject, enters the foreground of our attention?

During the last decade or two, changing directions in the discipline of the history of art have opened the possibility of such a study. For generations a typically hierarchical and stubbornly nonreflexive realm of study, art history is now leavened by cultural studies and has begun to permit consideration of previously unacceptable objects of study that enter its discourse with parity with, or occasionally dominance over, the works of the established canons. Photography has played a subtle and central role in this process, and increasingly we come to see reproductive photography as important to this process. Adding another layer of complexity was fine-art photography's rise to complete acceptance as a valid medium in art institutions and markets, a rise that was paralleled by a new critical preoccupation with the medium's mimetic and reproductive properties.

Much of the impulse toward this reshaping of art-historical subject matter derives from the impact of various strains of postmodern criticism and theory. Yet these normally tend toward the elaboration of positions around ideas rather than the scrutiny of the individual object as *Ding an sich*. Discussion of images in reproduction, which emanate from these starting points, more generally address the outcomes of image reproduction in relation to originals rather than exploring the specific case of museum reproduction postcards. Material culture approaches, on the other hand, typically privilege more tangible and autonomous objects than

art-reproduction postcards, which thus remain relatively unexplored, perched between one extreme and the other. But as the discipline of art history reshapes itself like Proteus, new topics, new questions and new perspectives emerge, making an unlikely subject like fine-art-reproduction postcards suddenly legitimate.

James Elkins, whose scholarly interests are perhaps broader than those of any other art historian working today, boldly surveyed new terrain while sedulously avoiding the problem of art-reproduction photography in his article "Art History and Images That Are Not Art." He comments that informational images "engage the central issues of art history such as periods, styles, meanings, the history of ideas, concepts of criticism and changes in society;…can present more complex questions of representation, convention, medium, production, interpretation, and reception than much of fine art; and finally,…far from being inexpressive, they are fully expressive, and capable of as great and nuanced a range of meaning as a work of fine art."[4] Working more from within the traditions of the field and as a historiographer, Dan Karlholm has accused art historians of harboring an "ambiguous and unresolved relationship with their own reproductive images," a problem he has made a considerable contribution toward resolving through thoughtful historical analysis of masterworks reproduced in textbooks.[5] Both these authors represent a new openness to consideration of images not previously discussed within the discipline.

Turning to consider museum reproduction postcards, we may pause to ask what they will tell us if we question them. Do these literal exemplars of the abstraction of the canon prove to be mute, inglorious stones or eloquent oracles? What do postcards of museum works say about art history? Are they important in their own right? What experiences do they offer? When did it become possible if not wholly typical to discuss this in art history? How do these images empower people through the development of personal relationships to the idea of artworks, art history, and the canon? In what ways do reproductions of canonical museum artworks function as signs and intermediaries?

Barbara Savedoff has argued that in art history books, text comes to illustrate the reproductions rather than vice versa, and speaks as well of the ways in which "our experience with reproductions so overshadows our firsthand experiences of art."[6] Can postcards illustrate visitors' often overwhelming museum experiences? Do art-reproduction postcards play a significant role in visitors' organiza-

tion of their perceptions and experiences from chaotic overstimulation into coherent and meaningful wholes? These issues could certainly be addressed through sociological analysis, market research, and the like, but others may also be explored through the lenses of art history or of the memoir. Using the decidedly unscholarly but sometimes re-velatory tool of personal anecdote, I will sketch below some possible answers to these questions.

Until recent times, the discipline of art history tended to privilege the study of what can be owned over what cannot—the history of objects over ideas, certainly, but more particularly the history of works of art over their usage, and indeed over their dissemination through photomechanical reproduction. Coincidentally, the founding works of the discipline of art history, and (significantly later) the great seminal texts about artworks and reproduction, were all written at primitive stages in the development of the craft and technology of image reproduction. If for no other reason than the recent explosion of superb image-reproduction techniques (including tri-tone printing and numerous refinements of digital photography and printing), it is important to reopen these questions now. Art history was born to languish in Plato's cave (the art-history slide-lecture room), just as it has inevitably come to be bedeviled by a postmodern Baudrillard-cum-Disney-World of unlimited simulacra.[7] Yet the increasing success of image-reproductive technologies also works to bring such emulations within spitting distance of their originals. Perhaps this progress can serve to legitimate an open discussion of the place that museum postcards (the most user-friendly of all art reproductions) hold in the conduct of the discipline and the formation of its practitioners. Tracking historiographic shifts in art history requires exploration of all possible data, and art-reproduction postcards are texts to be read as much as are the illustrations to early German art history textbooks so fruitfully discussed by Karlholm.

As more and more of the works constituting our canon are called to the Olympian heights of the great public collections, art history moves its focus from what you can own to what you can visit, exchanging simple market imperatives for touristical ones. Postcards, emblems of tourism par excellence, become more than symbolic objects at this juncture, and, appropriately, may even become subjects of museum reproduction themselves, or media for contemporary fine-art practice. Two methodological shifts in the practice of art history coincide with this trend: the new vogue for subjectivities in critical/

historical analyses, and the increasing importance of institutional rather than biographical or object-based histories of art. Through these approaches, the language of the postcard reproduction is easily read if we chose to recognize it, and the power of a postcard canon is readily understood if we dare to speak its name.

Though arguably the world's greatest storehouse of celebrated and valuable fine-art treasures, the Metropolitan Museum of Art is also a glorious trove of ephemera, fragments, everyday objects, and unlikely relics. One might indeed argue that it is precisely the combination of these two aspects that distinguishes a truly great museum. Among the less generally known collections at the Met is the Jefferson R. Burdick Collection of printed ephemera, the life's work of a purely, indeed fanatically, dedicated collector of more modest means than the collectors whose objects form the chief adornments of the museum's collections, like J. P. Morgan, Walter Annenberg, Jack and Belle Linsky, and others.[8] Among its vast array of highly demotic items, the Burdick Collection includes a substantial and far-ranging postcard collection. One tiny item within that collection is an outstanding emblem of the much, much greater institutional whole (fig. 9.1). A commercially produced postcard from about 1900, it depicts a portion of the museum's own Fifth Avenue facade. The handwritten message inscribed by an almost anonymous sender reads: "Interested in art? This is full of nice things." The journey from original to reproduction, from tourist experience to fine art, from subject to object and back again, reflected in the presence of this card in the Met's permanent collection offers a dense little nugget of metaphoric association. How fitting it was, therefore, when a Met museum shop merchandising scout selected this postcard from the Burdick collection for reproduction and sale! How postmodern is the concept of a museum shop reproduction postcard of a postcard!

Like a piece of conceptual art *avant la lettre,* or perhaps of proleptic mail art, the original postcard expresses the importance of a museum reproduction through its return to the heart of the collection and thus its translation to fine-art status.[9] The paradox of the initial humbleness of the image and card is triumphantly redeemed in its current circumstances. This is a very different case than, for instance, that of a postcard of the renowned Rembrandt painting *Aristotle Contemplating the Bust of Homer* (1653). Acquired by the museum in 1961, it occupies the comfortable role of a celebrated masterpiece acknowledged by reproduction for the benefit of its adoring fans. This painting is one of the sights to see at the Met, and its postcard surrogate documents that experience concisely for the benefit of

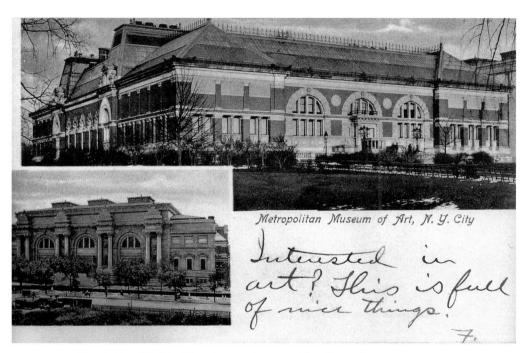

9.1. "Interested in Art? This Is Full of Nice Things," present-day postcard from Metropolitan Museum of Art shop reproducing a turn-of-the-century postcard.

visitors who require an *aide-mémoire* or a simulacrum to take home following their visit. The grandeur and complexity of the original is dutifully, if incommensurately, expressed in the petite scale of the postcard, yet the postcard itself has a certain iconic grandeur, holding its own among the many others for sale in the museum shop racks. Some of the striking impact of the actual painting is echoed in its diminished surrogate. One never chooses, after all, between the two as alternatives: the postcard fulfills purposes that the original is incapable of addressing. It is portable, consumable, exchangeable, and, from the point of view of the museum visitor, more permanent, since it may be consulted at will.

Three dissimilar critical models suggest themselves for a consideration of the role of the museum reproduction postcard in canon formation and in art history: Walter Benjamin's seminal yet problematic meditations upon the work of art in the age of mechanical reproduction, but also his essay "Unpacking My Library"; André Malraux's ideas about "le musée imaginaire" or "museum without walls"; and John Dewey's treatise on the transactional nature of art, *Art as Experience.* On the face of it, these models seem to have little in common. Yet upon careful examination with reference to museum reproduction postcards, they can be found to approach a valuable common ground.

Benjamin's prescient skepticism and poignant anxiety about the destruction of what he called the aura of artworks seem to presume that the works in question are paintings being flattened into the colorless, scaleless, textureless form of the early twentieth century's inferior reproductive imaging techniques. He succinctly asserts that "even the most perfect reproduction of a work of art is lacking in one element: its presence in time and space, its unique existence at the place where it happens to be."[10] Like that of most writers on image reproduction to date, the argument seems to have been based primarily on the case of art reproduction in published books without regard to the specific qualities and uses of museum postcards as objects. Yet it could be argued that such cards could in fact be taken as the most logical case study of what he means, for, on the one hand, these works strike directly at the idea that the unique, mystical, and inherent properties of a work are dependent on one's experience of it in person, and on the other hand, they present the viewer with a surrogate for removal from the museum. Benjamin is the great skeptic and prophet speaking against the debasement and commodification of masterpieces through their ceaseless reproduction. Yet one of his

points concerns photography's role in facilitating a cultural shift from the cult value of artworks to their exhibition value. Perhaps we might consider an individual's ownership and use of postcard reproductions of museum artworks as constituting a personal and partial return to the intimacy of emotional power of cult value. In each of the critical models considered here, we must ask, how in this system does one participate in experiencing art through reproductions: by turning the pages, sorting, purchasing, exchanging, commenting upon, or "curating" images?

Benjamin's tenderness toward printed books as multiples, as opposed to printed reproductions of works of visual art, is equally emphatic. His sense that a printed book may retain its preciousness, its unique status and delightful qualities, despite existing in more than solely one unique instance, is everywhere apparent in "Unpacking My Library."[11] The contrast is stark: works of visual art are threatened by the existence of multiples, which compromise their aura; works of literary art marvelously enter the intimate spheres of individual, sensitive collectors who delight in the intimacy of their experience with these works at home. Why is text treated differently from image? Would Benjamin have thought differently about images in replication if he could have learned of today's superb reproductive imaging techniques? The almost unrelenting gritty or foggy grayness and muddled midrange tones of monochrome fine-art reproduction of his day are shocking to eyes accustomed to today's increasingly sophisticated simulacra. In the case of photographic reproduction of fine art, it is already regularly true that reproductions are or can be more beautiful, lucid, eloquent, and richer in tone and detail than the originals from which they are made, an interesting problem to address. As Elkins' pioneering work on non-art images indirectly suggests, histories of fine-art-reproductive technology and practice, and the histories of their economic basis need to be written. The fundamental question derived from Benjamin's inconsistent attitudes toward differing forms of multiplicity among works of art and arguments would be, what is authentic and what is surrogate in relation to art, art history, and the canon? Can a postcard of a work in fact support and extend its aura rather than devalue it through its inferiority as a surrogate for the real thing?

André Malraux's ideas about the relation of reproduction to originals, and of museum objects to reproductions, are compactly encapsulated in an oft-reproduced portrait photograph taken about 1950 from *Paris Match* by Maurice Jarnoux. Square in format, it was taken at a stark angle from above a spacious office. Virtually every inch of the room's carpet is paved with photographic reproductions of works of art that sweep from the foreground toward the elegantly suited figure of Malraux, who leans on a grand piano while contemplating a photograph, not visible to our view. A spindly potted plant languishes beside the curtained window, suggesting that the reproductions and highly finished products of civilization like Malraux thrive at the expense of nature in this rarefied chamber. The rhythms of framing within the pages of reproductions syncopate and extend sideways across the frame of the image, and Malraux stands at the only point of interruption in the rows of pictures, himself thus neatly slotted into his system.

Malraux's famed proposition that photographic reproduction allows culture to transcend the bonds of time and place to allow a virtual museum (or, as it is usually rendered in English, the museum without walls) was first articulated in an essay of that name in 1953.[12] Malraux's central insight, that "photography imparts a family likeness to objects that have actually but slight affinity....Each, in short, has practically lost what was specific to it—but their common style is by so much the gainer," was for him the statement of a progressive, humanistic position.[13] Yet recently this notion has taken considerable criticism, particularly at the hands of Douglas Crimp, who is convinced that the existence of photography, particularly in its postmodern manifestations, suffices to erode traditional humanistic positions and museum institutions alike.[14] Crimp's polemical scorn for Malraux's now quaintly unfashionable views has been thoughtfully questioned by Andrew E. Hershberger, who carefully distinguishes between Crimp's rhetorical flourishes and Malraux's original positions, concluding that Crimp has used Malraux as something of a straw man in constructing his interpretation of photography's place in the museum in postmodern culture. As Hershberger has it, "Malraux's theory of photography suggests that the distinction between the real and the imaginary is not as interesting as their integration."[15]

As the portrait of Malraux plainly shows, his museum without walls was to take the form of a book, and his sequence of reproductions is organized as page layouts and spreads. His essay announces that "an earlier generation thrived on Michelangelo; now we give photographs of lesser masters, likewise of folk paintings and arts hitherto ignored: in fact, everything that comes into line with

what we call a style is now being photographed."[16] But this imaginary construction of the world's art in some ways more closely resembles a museum postcard collection, available for new juxtapositions and resequencing to produce new insights at will. Unbound, portable, available to all (unlike a scholar's expensive, reproduction-ready 8 x 10 photographs from archives), the postcards afford new possibilities, and while Malraux did not mention an imaginary museum of postcard reproductions, we may borrow and apply his formulation to that end. But is a shoebox collection of museum reproduction postcards more like the prints spread on Malraux's office floor or like the books in Benjamin's library?

In Malraux's scenario, the art-historical principle of style is central, and we may infer that his understanding of the audience's relation to the reproduced artworks is that of students and scholars perusing illustrated texts, perhaps in the university, perhaps at home. While Benjamin could allow the viewer/consumer pleasure and freedom only amidst the volumes of his library, Malraux welcomes them to the experience of perusers of books. The perspective is very different, but the emphasis upon printed volumes remains. Suddenly, it is acceptable, indeed desirable, for a viewer to have a relationship to art via reproductions, but these reproductions have been preselected and orchestrated by a professional for the consumption of the viewer in pursuit of understanding of style. Malraux, like Benjamin, offers relatively little encouragement to the patient museum postcard collector who curates her own experience by selecting postcards to bring home from the museum, who organizes images by any of many possible systems, rather than solely by style. The importance of the image/text relationship in Malraux's system is absolute, for after the creation of formal and stylistic linkages, the volume of photographs' biggest task is to present identifying or even critical texts about images. The question Malraux's view raises for us now is what can be owned and what cannot, in relation to art, art history, and the canon. "To collect photographs is to collect the world," as Susan Sontag tersely noted; Malraux's sense that we each can own our own museums through books of reproductions in fact leads inevitably to a more fundamental demand, that we can assemble and sequence our own image collections, imagine our own museums in the images of our own dreams and desires.[17]

The model for such radically reconfigured audience participation and viewer autonomy in the face of the world's art can be found in the writings of the philosopher of pragmatism John Dewey.

He irrefragably has the distinction of being the single most effective aesthetician in terms of theorizing art sufficiently and inclusively enough to admit performance art, conceptual art, mail art, and other such boundary-testing new genres of art on a level playing field with their traditional predecessors such as painting and sculpture.[18] This occurs through his unprecedented requirement that artist, artwork, and viewer all be recognized as central to the nature of art because art is to be understood as transaction, rather than essence or object. His work emphasizes direct, literal experience as the cornerstone of art, and privileges activity and vitality as principles: "Art denotes a practice of doing or making…. Every art does something with some physical material, the body or something outside the body, with or without the use of intervening tools, and with a view to production of something visible, audible, or tangible."[19] He links this to the qualities he previously identified as significant in experience: "art, in its form, unties the very same relation of doing and undergoing, outgoing and incoming energy, that makes an experience to be an experience."[20] His emphasis on experience rather than product is dramatic, as it opens art to being seen as transactional process involving viewers rather than solely as the product or deposit of the actions of an artist.

Developing this idea further, he calls art language, which "exists only when it is listened to as well as spoken. The hearer is an indispensable partner. The work of art is complete only as it works in the experience of others than the one who created it."[21] The power of Dewey's formulation is his insistence upon the active and defining role of the spectator in art. "Nothing enters experience bald and unaccompanied, whether it be a seemingly formless happening, a theme intellectually systematized, or an object elaborated with every loving care of united thought and emotion."[22] And "every experience is constituted by interaction between 'subject' and 'object,' between a self and its world…. In an experience, things and events belonging to the world, physical and social, are transformed through the human context they enter, while the live creature is changed and developed through its intercourse with things previously external to it."[23] Perhaps this is the idea Benjamin was pursuing when he wrote of his book collection: "Every passion borders on the chaotic, but the collector's passion borders on the chaos of memories…. The chance, the fate, that suffuse the past before my eyes are conspicuously present in the accustomed confusion of these books."[24]

Dewey's claim that art *is* experience—that of the artist and of the audience, linked in a triangular relation, the third pole of which is the work itself, opens new possibilities for consideration of reproductions of art works. By shifting the terms of debate from the object (or occasionally the artist) to the viewer and the relations between the viewer and the artist, Dewey unwittingly opens the door to accepting postcard reproductions as elements of the entire process of experience regarding works of art. The intensity and specific nature of the viewer's experience with the postcard reproductions is unlikely to be as vivid as that in the face of the original work, and it will assuredly be different in many ways in nature, but it exists, and may have its own integrity, meaning, and value. Dewey's system allows us to ask, what can you "experience" and how do you do so in relation to art, art history, and the canon? Once the viewer's experience is privileged, that viewer has the freedom to direct and participate in experiences that fall outside the boundaries of prior accounts of art and its meanings. Dewey's radical redefinition of art mandates the use of individual testimony in terms of viewer's experiences and thus even legitimizes an anecdotal approach to the questions under discussion. With his sanction, then, it makes sense to look for the coincidence of museum postcards with individual formative art-historical experiences in exploring their importance. But do museum reproduction postcards play a recognizable role in shaping the people who shape the history of art?

Art doesn't generate art history, people do. How, then, do art historians become art historians? Can museum postcard reproductions play a role in this process? Do postcards commemorate not just conventional experiences in travel tourism but also cultural adventures and art-historical concept formation? An autobiographical vignette may serve well here. When I was growing up in Buffalo, New York, in the 1960s, my early childhood included only one significant museum experience. Buffalo is a place where it is almost always winter, which is not easy for an energetic child in need of amusement. My parents often took us to the Albright-Knox Art Gallery on winter Sunday afternoons, and among my earliest memories is that of being pushed in a stroller through its serene galleries, with brilliant sunshine reflected from substantial snowdrifts piled outside the large picture windows and bouncing around the marble galleries. The gliding motion of the stroller made paintings appear to succeed each other as if passing on a conveyor belt. The color-field painting

for which the Albright's collection is distinguished is an acquired taste, and one that I didn't acquire then. But one work made an indelible impression over many winter visits: Andy Warhol's *100 Cans* (*Beef Noodle,* 1962). Possibly the lucid mimetic familiarity of image (for was I not also pushed down the canned-goods aisle in a shopping cart at the supermarket?) was responsible, possibly its vivid colors and repetitive graphic composition. Either way, this painting was a strong favorite of mine, in preference by far to "prettier" Post-Impressionist works or more entertaining and participatory works like Lucas Samaras's *Mirrored Room* (1966). Once out of the stroller, at an age when kids may be briefly subdued through bribery, I was sometimes promised a postcard to take home if I behaved unobtrusively for the duration of the visit. When the time came to redeem the pledge, my selection was inevitable: *100 Cans.*

That experience, of seeing an artwork, developing a relationship with it based in part on external experiences of my own, and selecting a simulacrum as a souvenir or *aide-mémoire* or fetish or totem—that experience is the experience of one way that we internalize and process our encounters with great art and bring them home. We cannot meaningfully leave our experiences with artworks in the museums, since we cannot ourselves lodge there permanently. The art-reproduction postcard is the point of connection between our experiences *in situ* and elsewhere, between a moment and its memory. The postcard serves as a kind of ambassador from one realm to the other. I do not believe that I am alone among followers of the art-historical trade in having begun an engagement with art mediated by postcard surrogates, or in having made a lifelong practice of postcard image collection.[25] So indeed, art historians are Deweyan live creatures who are "changed and developed through…intercourse with things previously external" to them.[26] Our passions for works of art are expressed in the public realm. For, as Benjamin noted, "ownership is the most intimate relationship that one can have to objects. Not that they come alive in him; it is he who lives in them."[27]

One iconic postcard of a Warhol alone is not sufficient to establish a relationship between museum postcards and art-historical formation, however. By the early 1970s, my museum visiting expanded to a much wider sphere during family visits to New York City, during each of which I lobbied incessantly for museum visits, principally to the Museum of Modern Art and the Metropolitan Museum of Art. Each visit followed a formulaic pattern that required my escape from the less museum-mad group of my family to probe specific galleries systematically, moving quickly until struck by individual works

demanding more protracted communion. After each sweep through an area or gallery, I'd repair to the museum shop to scout postcard reproductions of the works I'd chosen, or that seemed to have chosen me. Then I'd select a new section or gallery to reconnoiter. By 1976, I visited the National Gallery in Washington for the first time, and found its varied collections, wide-open spaces, and extensive offerings of postcards (presumably tax-subsidized, because of their bargain prices) singularly well adapted for my purposes.

Once home with the trove of postcards, I would study them again and again, recreating the experiences I had in the museum and planning personally significant routes and sequences for visiting the works again in the future, as well as engaging in deep and aimless reverie. I'd spread out the postcards in rows on the counterpane, as if trying to hold onto and remember dreams by going over them again upon waking, and then hang them in grid patterns on the wall above my bed, recurating these exhibitions often.[28] The organization of postcards might depend upon the moment's favorites, which could be either greater or lesser works, might represent a budding Wölfflinian stylistic analysis, or might be more decorative in intent.[29] The mixture of public and private experience, the importance of ordering, the intensity of the connection with the original through the vehicle of the reproduction were all well served by the hand-sized postcard format of these images. They had intimacy and authority in equal measure, and they afforded a vital resource in pursuing a relationship with art.

These early art and postcard experiences took place in a vacuum of ignorance owing to my lack of acquaintance with the existence of the discipline of art history, of the museum professions, and of discursive text about images. My astonishment upon discovering art history as a freshman in college was equaled only by my alacrity in declaring a major. Yet it was already becoming clear to me that the postcards weren't allowed a respectable place in this formalized arena of art study, and I began to feel they were suitable as dormitory decoration but somehow embarrassing to discuss in relation to what took place in the classroom. Though certainly not a budding ironic postmodern Baudrillardian viewer privileging the simulacrum above its referent, I remained strongly drawn to the work of art in its postcard reproduction. My graduate study of art history at Princeton began in 1980, a historical moment fraught with the tensions of imminent change to a long-static system. Unbeknownst to me, at least, the department then perpetuated a training that was increasingly outmoded in the view of the wider world, with highly traditional connoisseurship-based art-historical practice slightly leavened by Panofskian interpretative strategies,[30] just beginning to confront the new imperatives of the social histories of art.[31]

A standard rhetorical figure in the speech of my fellow graduate students was a defensive, longing invocation of "the Object," always as something to be saved from the callous handling of intellectual historians, to be preserved at the expense of too-elaborate arguments and critiques. Always in the singular, always with the definite article, this object remained a glorious abstraction. The sense of art history's need to protest and cherish concrete masterpieces from unspecified depredations consorted aptly with the presence of a large contingent of students in the department who were specializing in the Renaissance. Convinced of the centrality of their subject, they were naturally interested and invested in the notion of the canon, as opposed to the modern art history students, still then an eccentric minority undreaming of the imminent rise of their specialty to its present impressive, hegemonic place within the discipline. In this company, as a student of the history of photography, interested in how a new medium defines its own canon and enters that of fine art in general, and also as someone interested in nonstatus things like postcards, I found it hard to fathom or even articulate the absolute disjunction of value between masterpieces and humble reproductions, ostensibly mere handmaidens of art history, which were erected by those votaries of the Object. Yet my postcard accumulation continued as fellowships funded travel abroad to other museums and other museum shops.

Although it wasn't yet fully apparent to me then, the time had come for free play between categories, for arguments about originality and reproduction, for different kinds of art-historical questioning that might begin to allow space for the museum reproduction postcard to assume a meaningful place in the conversation. Rosalind Krauss's seminal article "The Originality of the Avant-Garde" first appeared in 1981, and its use of Benjamin's argument as a starting point for asking new questions emphasized that "authenticity empties out as a notion as one approaches those mediums which are inherently multiple."[32] But what happens to multiplicity as a notion when one approaches reproduction per se? How do we find and return significance to individual reproductions that exist in uncounted thousands of virtually identical examples? Does the Benjamin-Krauss line of inquiry open up new possibilities for considering fine-art postcard reproduction itself, or only for considering how avant-garde art practice responds

to such reproduction? Wherein lies the authenticity of which Krauss speaks? Dewey and a postcard-collecting museum visitor might locate it differently than Krauss presumes; Malraux certainly defined it in different terms. A full discussion of the range of artists' use of fine-art reproduction in their own work is beyond the scope of the present essay, but a select few examples may prove illuminating.

Krauss's example of Sherrie Levine and Crimp's of Louise Lawler are brilliant choices in their respective contexts, but other artists are of interest as well. Joseph Cornell's museum boxes of the 1930 and '40s and various meditations upon the art-historical past, such as his *Medici Prince* and *Medici Princess* boxes, reflect on how artworks preserve powerful images from distant moments of cultural history like proverbial flies in amber—but by including repeated reproductions of those images, Cornell introduced a new, idiosyncratic, quasi-curatorial element to his artistic practice.[33] Cornell's use of the images, some of which may well have been, or have been derived from, museum postcard reproduction, are not unlike the kind of personal and idiosyncratic image uses that I've posited as typical for collectors of museum reproduction postcards who are not in fact artists themselves.

Mass culture and high art meet on a level playing field in Joseph Cornell's work. His box constructions repurpose both reproductions of mass-culture images of movie stars and high-cultural referents like reproductions of portraits of various Medici, combining them with other disparate objects in a kind of idiosyncratic mini-kunstkammer/microcosm of art, nature, and history, courtesy of Surrealism. Cornell's reiteration of canonical masterpiece images in his boxes may or may not employ actual museum postcards—it would require a conservator to ascertain this for sure. But if modernism cannibalized the canon for its own ends and postmodernism picks through the canon's ruin, as Foster told us, then a lyrical artist of the early twentieth century like Cornell, who owned and reimagined the great art of the past via its reproductions, allowed for the transmutation of the canon into new forms. The reproductive postcard liberates the image to new life in the artist's hands. Cornell's reproductive images are recirculated, and possess a recharged aura, just as his works literally create his own *musée imaginaire,* and his process of creation is like a diagrammatic recapitulation of Dewey's precepts.

While Cornell created his own "museums," other artists concerned themselves more directly with storming the citadel of the canon by penetrating great museums' collections with examples of

their work. In the 1960s and '70s, the peculiarly hegemonic power of the Museum of Modern Art was at its height, particularly as regards a medium like photography. MoMA's now-legendary curator of photography, John Szarkowski, presided in nearly imperial magnificence, inventing and shaping artists' careers with his every purchasing and exhibition choice. The medium's unique practices and rituals, such as regular curatorial reviews of artists' unsolicited portfolios, the relative ease of acquisition of works by younger as well as established photographers because of the typically small-scale and low-market value of these multiples, and the frequency of photographers making gifts of their work to institutions and individuals (for the same reasons), all created a special climate that happened to coincide with the rise of movements like Fluxus and mail art.[34]

Among the most curious instances of an artist of this period responding to such a mixture of circumstances is that of Bill Dane,[35] who over an extended period of time sent hundreds of his quirky photographic postcards to Szarkowski and thereby entered the MoMA collection. Each postcard is technically an original photographic print, but by virtue of their casual imagery, their travel through the postal system bearing stamps, addresses, and inscriptions, they come to function as if they were reproductions of Dane's work rather than the works themselves. Additionally, his pleasingly banal imagery critically foregrounds the proposition that photography itself makes museum-style reproductions of all the matter of the real world. This suggestive confusion of original and reproduction, reality and image, is essential to the success of the work, and is dependent upon Dane's choice of the postcard format.

The exuberance and spontaneity of Dane's practice and the extensive representation of his work in the authoritative MoMA collection represent a simpler case of the same problem addressed by conceptual artist Dove Bradshaw, who also found an inspired way to achieve participation in a great museum collection via a postcard strategy.[36] Bradshaw makes much of her work in relation to society, sometimes in relation to the museum. In 1976, during a blockbuster exhibition at the Met, she visited the museum and decided to recontextualize a piece of it as an artistic statement. She did this by "claiming," as she put it, an ordinary fire hose in a corridor. Reasoning that since all the other artworks in the museum had wall labels, her newly proclaimed one should also, she brought a homemade caption ("Dove Bradshaw, *Fire Hose,* 1976, brass, paint, canvas") to the museum and installed it. One day while visiting the museum, she noticed that her wall text was still up, though this time balanced on

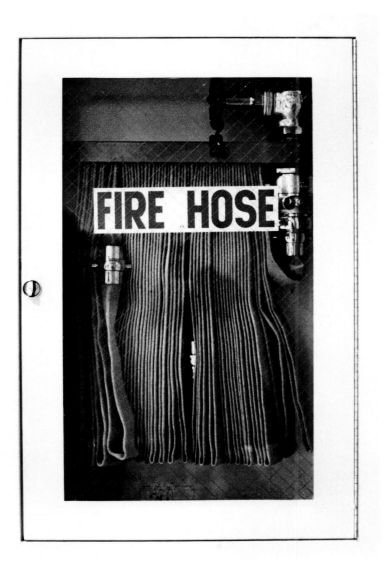

9.2. Dove Bradshaw, *Fire Hose*, 1978.

top of the hose inside the case; someone in the museum had become complicit. This emboldened her to take the next step—to make a postcard of her work. In 1978 Bradshaw carefully arranged to have "her" fire hose photographed, had her own postcards printed, and surreptitiously slipped a stack of them into the racks of the museum shop. They sold well; she replenished them as needed.[37]

Still, however, she and not the museum had produced the postcards of her work. She sought to rectify the situation, therefore, while working with the museum's Department of Photographs on another matter some years later. A lengthy practical and theoretical debate ensued. The photography department could not acquire a sculpture, but they did agree to produce an official postcard of the work; in doing so, they conferred the museum's imprimatur on the utilitarian, commonplace object that Bradshaw had earlier singled out. To make the postcard, however, museum regulations stipulated that the photography department first had to own a photograph of the fire hose from which the postcard could be reproduced. In 1989, therefore, Bradshaw sold the original print used to make her unofficial postcard to a collector for $1,000 with the understanding that it would be donated to the museum (fig. 9.2). The museum then created the card, the text of which stated that it reproduced a photograph of the fire hose, rather than the found or "claimed" sculpture itself. Another challenge arose, however, for the policy of the museum shop was that explanatory texts for museum cards were limited to approximately the length of a haiku, a challenging restriction in this complex circumstance. I was then serving as a young assistant to Maria Morris Hambourg, the curator of photographs, and it fell to my lot to meet with Bradshaw and to explain her intricate and unusual project to museum staff in the merchandising department, the editorial office, the copy photography studio, and the registrar's office. These formidable tasks were eclipsed by the challenge of summarizing a complex art project that had already continued for more than a decade and was not readily summarizable.

The design of the original postcard created by Bradshaw effectively mimicked that of other Met postcards of the period; the caption simply read:

Dove Bradshaw, American, 1949–
Fire Extinguisher, 1976
Brass, paint, canvas
The Metropolitan Museum of Art.

For the official postcard, I drafted a new caption:

Fire Extinguisher, 1976
Dove Bradshaw, American, b. 1949
Gelatin silver print, 6 x 7/8" x 4 11/16"
THE METROPOLITAN MUSEUM OF ART
Gift of Mr. and Mrs. Robert E. Klein, 1989 1989.1095
In 1976, the conceptual artist Dove Bradshaw "claimed" a fire hose in the Metropolitan Museum of Art by posting a label next to it that identified it as her work. Next, she had the fire hose photographed, produced postcards of her piece, and smuggled them into the Museum's store, where they sold briskly. This postcard reproduces the photograph *Fire Hose* now in the Museum's collection.
Printed in the U.S.A.
01-7482 © 1990 MMA [38]

The museum finally issued their postcard in 1992, and it sold even better than her earlier "guerilla" card (figs. 9.3 and 9.4). [39] When sculptor Carl Andre heard the story about Bradshaw's piece, he suggested that she make a small book about it. She produced a book slightly larger than postcard size in an edition of ten bound with clips that could be added to as the project continued to develop. [40] Later, Bradshaw retitled her piece *Performance,* explaining that if there were a fire, the extinguisher would go into effect, and also accounting for its use during periodic fire-safety inspections. [41] The most recent development in this continuing saga occurred in 2006, when Dada collector Rosalind Jacobs purchased an updated label from Bradshaw for $15,000 with the aim of officially donating Bradshaw's retitled 1976 sculpture to the Metropolitan—or would it be more accurate to say, back to the Metropolitan, since they technically "owned" it in the first place? [42] The newly expanded label reads as follows:

Dove Bradshaw
American, b. 1949
Performance
Brass, paint, canvas, reinforced glass
1976
Calling it a *claimed object,* Dove Bradshaw in 1976 quietly affixed her label next to it, this fire hose. In 1978 the artist made a guerilla postcard of her work and placed it in the museum postcard racks. She purchased two. In 1980 the museum acquired the original photograph used for that card. In 1992 the museum issued an official postcard telling its history. The card sold out. In contrast to an *objet trouvé,* the fire hose is integrated into the art context. It exemplifies one of

the major shifts in art since the 1960s—refocused attention from the object and picture plane to the site itself. A second distinction from the *objet trouvé* is the fact of the hose's potential function. Both the City's Fire Department and the Metropolitan Museum's Fire Department who inspect the hose regularly assure all concerned that in the case of its need this label would not in any way be a deterrent— thus the title *Performance.*
Purchase: Rosalind Jacobs, 2006
In honor of Melvin Jacobs [43]

If the Metropolitan formally accepts the donation, will they then issue an updated and revised postcard for the museum shop? [44] Regardless of these iterations, Bradshaw is a highly astute artist whose project displays understanding of exactly the significance of the postcard in relation to the museum, just as Cornell and Dane did in their quite different ways. Her project is admirably heroic in its originality, persistence, continuation over time, and insistence upon the centrality of postcard imagery in establishing the parameters of art and the authority of a museum's canon. Here is an artist who understands deeply the canon-making power of the postcard selection in the museum shop, and who has used it well to her own artistic ends!

Postcards as things invite dialogue; they are fodder for correspondence, we can literally inscribe them with meanings and transmit them. Much of their compellingly dialogic quality is premised upon that single characteristic. Yet even when we do not inscribe our sentiments upon their alluring blank expanses in ink and drop each rectangle into the mail, they invite us to project our own thoughts and associations into the space and body of great artworks, and thus— humble simulacra though they themselves are—they powerfully evoke the intensity of our experiences with the originals they represent, with those masterpieces that, we feel, not only speak to us, but call out to us to speak to and of them. My shoeboxes of postcards are largely undisturbed and uninscribed and never sent, but they are open to dialogue nonetheless. It is a dialogue between me and myself, me and the originals, me and the artists, me and the museum, me and art. The openness of these museum postcards to such use is concrete evidence of their generous nature, an openness that is also a screen upon which to project one's thoughts, feelings, passions, and questions.

I have argued that addressing the role of art-reproduction postcards in museums is an express route to the heart of understanding the key questions of canon formation and deformation

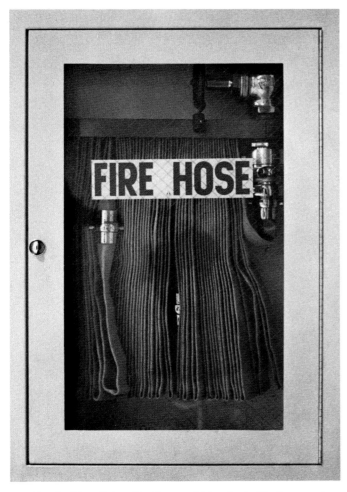

9.3. Dove Bradshaw, Metropolitan Museum of Art postcard of *Fire Hose,* 1970s, printed 1978 (recto).

in art history in general. I have indicated along the way in making that argument that these humble but valiant little images have their own charm, pleasures, and hold on the imagination of the art historian, and I have suggested that my own responses to and experiences with postcards are probably more typical than eccentric, however unusual my discussion of them may be. Museum fine-art-reproduction postcards are photographically derived images, and it is by now a critical commonplace that photography's presence in the world significantly interrupts existing hierarchies and questions the assumptions and the myths about the ways canons, elites, fine arts, art history, and especially museums function. Photography is a medium that pushes limits and tests issues in museum thinking and museum culture so readily that when it is pressed into service in the museum for reproduction, the fascinating irony results that those postcards can be defined as constituting new revisions of the traditional canon of fine art itself.

What, then, does this tell us about canons? Don't we find in human culture and history a broad array of touchstones, points of continuity, and spontaneous recognitions of the extraordinary or splendid? And don't these factor into the identification of exemplary works that come to form a canon? Some of the benign aspect of the

Dove Bradshaw, American, 1949-
Fire Extinguisher, 1976
Brass, paint, canvas
THE METROPOLITAN MUSEUM OF ART

Printed in U.S.A.

1898.1081

9.4. Dove Bradshaw, Metropolitan Museum of Art postcard of *Fire Hose,* 1970s, printed 1978 (verso of fig. 9.3).

idea of the canon lies in our patient willingness to use it well, to unmake, remake, and expand it from generation to generation—and clearly today we are privileged to live in a time when both Rembrandt's *Aristotle Contemplating the Bust of Homer* and Dove Bradshaw's *Fire Hose* may comfortably claim places in a freely contested and acknowledged provisional canon of art history. Extending Sontag's dictum about collecting photographs, we might extrapolate that to collect museum postcards is to own the canon, which one then may control through one's own selection, organization, and use. If one collects these postcards in the right spirit, it might be said that one indeed becomes a transactional instrument of the canon oneself.

Museum reproduction postcards are certainly eloquent oracles if we consult them attentively. As museums study their shop balance sheets and adjust their merchandising plans, as period styles and individual artists rise and fall in critical fortunes and popular estimation, we see changing arrays of collection reproductions via postcards. Yet there is a certain indexical relation between a museum's self-presentation of its collection and its canon, and it remains for historians of the future to consider whether we may gather a sense of the larger art-historical canon identification of the early twenty-first century better by consulting museum postcard reproduction choices, art-history textbook illustrations, or *Art Bulletin* articles.

Museum postcards are anchors of individual experience free of the dogmas of art history, independent of external direction, and under autonomous individual control as the original works they represent can seldom be, and then are so only for the few individuals fortunate enough to possess such works personally. The power of the postcard is not compromised by its humble physical scale, but enhanced, for it is the guarantee of portability, ease of acquisition,

willingness to be sorted, annotated, arranged, and contextualized. The experiences they provide are as broad as memory can be, and far beyond, since the postcard, by journeying from the museum's chaste halls to the messily quotidian reality of any individual's home, is entering a realm where the image-meaning-idea reproduction of the work engages with the totality of the life of the viewer. In that space of interaction, much can happen.

If art-reproduction postcards continue to beguile amateurs and individuals, the majority of scholars and academics increasingly have begun to address the unstoppable turn toward digital image repositories. In writing on the rise of such fine-art digital image archives, Hal Foster has observed that while these may seem to be ultimately aura-destroying propositions, they may in fact also operate in dialectical reverse, so "the artwork might become more auratic, not less, as it becomes more simulacral in the electronic archive."[45] This projection of the future would seem to reflect a parallel case to that engendered by postcard reproductions in a former age. In my reading, however, postcards serve a happier and more stable purpose on the way to this conception than Foster anticipates digital images will do. His sense, shared by so many contemporary critics, that museums have become mere spectacle, an image "to be circulated in the media in the service of brand equity and cultural capital," is shockingly shortsighted.[46] Let museum postcards, with their many uses and purposes and freedoms, remind us that all institutions are what we make of them, and that art, museums, and fine-art-reproduction postcards may as readily offer pleasure and liberation as subjection and betrayal.

CHAPTER TEN

LES PLUS

BELLES CARTES

POSTALES

Paul Éluard

INTRODUCTION BY ELIZABETH B. HEUER

TRANSLATION BY DAVID PROCHASKA WITH NANCY BLAKE

AND ELIZABETH HEUER

From 1929 until the mid-1930s, French poet and Surrealist Paul Éluard was captivated by vintage postcards; over this period, he accumulated nearly five thousand of them. Éluard organized a large portion of his collection into a series of albums and published, in 1933, in the lavish Surrealist journal *Minotaure,* "Les plus belles cartes postales," an early, influential essay spread that we reprint here.[1] Éluard's enthusiasm for these "treasures of nothing" was aided by fellow Surrealists André Breton, René Char, Georges Sadoul, Roland Penrose, and Salvador Dalí. Collecting postcards exemplifies the Surrealists' fascination with found objects, or *trouvailles*. The Surrealists gathered postcards from the street stalls, junk shops, and flea markets of Paris. In his pursuit, Éluard disassembled old postcard albums, since these often yielded large numbers of postcards. He even salvaged a group of cards, "all very indecent and filthy," that he discovered papering the bedroom walls of an old home.[2] He frequently traded, shared, and negotiated exchanges of single and multiple cards from his colleagues. Éluard started his collection with a large gift from Breton's own cache. Occasionally, he and Breton took long weekend excursions driving outside Paris to scour outlying communities for cards.[3] He also sought them out while on holidays in Marseilles and Nice. Char often returned from his travels "covered in cards," and regularly contributed to Éluard's growing collection.[4] Admiring the collection of Sadoul, Éluard eagerly arranged on one occasion to trade a painting by Dalí for two hundred prime postcards.

Éluard assembled and pasted a selection of cards into a series of six albums.[5] Typically, the album format allowed collectors to creatively organize, embellish, and caption pictures in order to create personal narratives. Each page in Éluard's albums features six cards hand-tipped and pasted onto paper album leaves and organized in either horizontal or vertical arrangements.[6] Affixing the correspondence side of cards to the page, Éluard presents the viewer with single- and double-page compositions. The mix of postmarks on the cards indicates that the albums are not organized chronologically. Instead, they are designed thematically, especially around the feminine figure (fig. 10.1). "Child-women, flower-women, star-women, flame-women, sea waves, great waves of love and dreams, flesh of poets, solar statues, nocturnal masks, white rose bushes in the snow, serving maids, dominatrixes, chimeras, illuminated virgins, perfect courtesans, legendary princesses, [and] passersby," as he writes in his *Minotaure* essay.[7] Interspersed amid these representations of women in the albums is a disparate mix of other subjects, including flowers, locomotives, ships, holiday themes, and religious motifs. Yet the arrangements are not arbitrary. Rather, formal elements such as

10.1. Paul Éluard, *Postcard Album*, ca. 1930s.

10.2. Paul Éluard, *Postcard Album*, ca. 1930s.

scale of objects, perspective, pose of figures, gestures, symbolism, gazes, featured texts, and colors are carefully orchestrated to create the visual equivalent of poetic syntax. In many instances, cards with similar images or formal qualities are arranged along diagonals, thus resisting a traditional reading of left to right and top to bottom (fig. 10.2).[8] Echoing the visual paradoxes of dreams, these shifting and disjointed montages form collage-poems about passionate love, seduction, betrayal, desire, abandonment, and reconciliation. Éluard annotated at least one of his poem-albums, saying, "I write on all the particularly Erotic pages of my albums."[9]

Éluard's compulsion to collect and arrange risqué cards coincided with the departure of his wife, Gala, which devastated him. In 1929 she began an affair with Dalí, which led to a permanent separation and divorce in 1932. Prominent in Éluard's poetry, Gala had served as his muse, and she inspired his love poems.[10] Desperately lovelorn, he found solace in his chromos: "[I] stay in this apartment arranging my cards. In postcard style, I am crowned with melancholy, decline and neglect."[11] During their separation, they maintained a connection by exchanging erotic postcards. For Éluard the postcard was an abstraction of the heart, exchanged in the game of love, in which "the hand of a woman and the hand of a man emerge and embrace."[12] In Gala's absence he found poetic inspiration in the fantasy women of postcards. In "Nuits partagées," he writes: "I have identified you with beings whose variety alone justified their name, always the same, your own, with which I wanted to name them, beings I transformed as I transformed you.... I persist in mixing fictions with dreadful realities. Uninhabited houses, I have peopled you with exceptional women, neither fat nor thin, neither blonde nor brunette, neither mad nor wise, what matter, the most seductive women possible, by a detail. Useless objects, even the stupidity which led to your fabrication was a source of enchantment to me."[13] In 1932 Éluard presented three of his completed poem-albums to Gala as a gift.[14]

Éluard's involvement with postcards culminated in the publication of his article "Les plus belles cartes postales" in 1933.[15] A three page, introductory essay, presented here in translation, offers a poetic overview on postcard collecting, which is complemented by a twelve-page layout with single- and double-page montages including over 120 vintage cards drawn from his personal collection.[16] Éluard was attracted to older cards, especially from the so-called golden age of postcards, ca. 1898–1918, for their imaginative and diverse range of themes, as well as their generally high quality. Eschewing certain

stereotypical conventions and sentimental clichés, he emphasizes innovative images depicting the odd, eccentric, and fantastic. He displays an assortment of cards featuring unexpected views, distorted images of popular monuments, rare and exotic flowers, provocative holiday cards, impassioned domestic dramas, offbeat language, peculiar advertisements, costumed performers, and humorous spectacles. In particular, he privileges cards featuring images of women, especially those steeped in sexual innuendo, lewd visual puns, and double entendres. Éluard describes the chromos of women as dream-laden fetishes, noting that they "are man's strength and raison d'être; they beautify his feebleness, bring joy, and make cares disappear."[17] He arranges montages of fantasy postcards featuring composite photographs of women transformed into mermaids or butterflies, and satirical political cards, known as *arcimboldos,* which feature female nudes morphing into the faces of animals, popular figures, and political leaders such as Napoleon III, anarchist Francisco Ferrer, and politician Joseph Caillaux. He also includes so-called French cards of erotic nudes and seductive, multicard narratives, such as those produced by Reutlinger Studio, Olivier Nantes-Ore, and Jean Angelou, as well as fashionable ladies and delicate nudes by artists including Raphaël Kirchner, Alfonse Mucha, Ernst Lessieux, and Henri Meunier. Other prized chromos feature contemporary beauties, such as the performer Lola Montez, the dancer Cléo de Mérode, the singer Lina Cavalieri, and the actress Colonna Romero.[18]

Éluard considered postcards as documents in dialogue with popular unconscious thought, reflecting the unfettered imagination, the secret desires and uninhibited fantasies of the masses—all Surrealist themes.[19] Indeed, at the very time when Sigmund Freud and Havelock Ellis were developing their theories of sexual symbolism, postcard producers were consciously incorporating these symbols and popularizing them in a myriad of visual clichés. Negotiating a place for the postcard between the detritus of mass culture and modern art, Éluard cautioned against fetishizing the medium merely as a nostalgic thing-in-itself. Instead, he encouraged artists to reconsider postcards and to recognize the potential of these diminutive pictures as raw material for aesthetic experiments. "Ordered up by the exploiters to distract the exploited," he writes, "postcards do not constitute a popular art. At most, they are the small change left over from art and poetry. But this small change sometimes suggests the idea of gold."[20]

Paul Éluard

The Most Wonderful Postcards

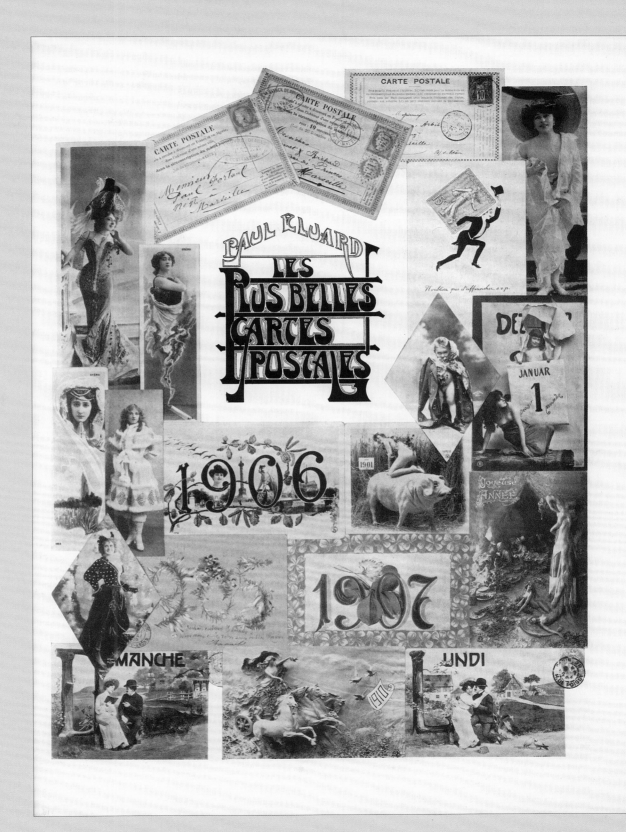

These insignificant treasures for which children developed a taste from color prints, postage stamps, pictures on chicory tins, in catechisms, on chocolate bars, or from those that are parceled out in series by the big department stores; soon adults learned to love postcards because of their lack of sophistication, and even more so, unfortunately, for that sort of reduction to the lowest common denominator that they establish between sender and receiver. Among the millions of postcards (Germany alone produced as many as nine million per month) in circulation throughout Europe between 1891 and 1914, few are lovely, touching, or strange. Yet these are the ones we have searched for diligently, while trying as much as possible to minimize the enormous extent to which we are discouraged by the incredible stupidity, the idiotic humor, the sheer horror of most cards, which we do by sublimating the reasons we feel this profound, inevitable pessimism.

Topographical postcards are all alike. They try to unify all memories, to immortalize every city, every village, to form a Homeland from all the little homelands, a Church from all the unknown little churches which make even the smallest hamlet sad (the only good "view" is the one we have reproduced here of the homeland "on the soul of a shoe"). [22]

April Fool's Day cards are vulgar, ugly, aggressive, and anonymous.

Happy Easter cards are usually pornographic.

There are New Year's cards that are nice enough, even though the symbolism is facile. The way numerals are conventionally treated is not always entirely bad. [23]

In a tree, the old year, in the form of an elegant lady, somewhat lacking in freshness, perched on a branch, casts a tender look at a nest where the four eggs she has laid, numbered 1.9.0.5., have just hatched. Four adorable little girls peep out. Or in another one, a ship is swallowed up by a storm while another vessel sails on a calm sea, etc.... However, the New Year *[Bonne année]* remains a fine joke *[bonne plaisanterie]*. When will we have Bad Year *[Mauvaise année]* cards, which will mix the centuries with the months, the years with the weeks, the days with the nights, to the detriment of time and in favor of feelings?

Ordered up by the exploiters to distract the exploited, postcards do not constitute a popular art. At most, they are the small change left over from art and poetry. But this small change sometimes suggests the idea of gold.

Flowers

An avalanche of roses, of forget-me-nots and of violets, in silk, velvet, plush, in celluloid, lace, or metal, embossed, polished, sequined, gilded, nacreous, stamped, schools of forget-me-nots, pools of violets, hearts of

roses. Sometimes daisies, poppies, lilies-of-the-valley and pansies as well. Flowers are pleasing. Still, an abominable tradition assigns almost exclusive rights to the queen of flowers, a cliché of either sentimentality or modesty. No imagination is expended on other flowers, which are always reproduced photographically or from deplorable watercolors. It would seem dangerous to the jealous guardians of the people's mediocrity to venture into the flowery fairy garden where the pasqueflower grows, Venus's looking glass, the snapdragon, the Michaelmas daisy, sweet William, nasturtium, canary creeper, larkspur, adonidin, snowdrops, blue convolvulus with pink and white throats, the pretty-by-night, the star-of-Bethlehem with the perfume of orange blossoms, the stripped slipperwort, the fritillary, the dwarf double zinnia with its degenerate colors, centaurea, the ten-week stock, the London pride, love-lies-bleeding, honeysuckle, maritime diamond cineraria, the Iceland poppy, all the rare flowers, and, to cloak the walls, the Dutchman's pipe—to open this fairy garden where all the flowers which give rise to visions grow.

Women

Child-women, flower-women, [24] star-women, [25] flame-women, sea waves, great waves of love and dreams, flesh of poets, solar statues, nocturnal masks, white rose bushes in the snow, serving maids, dominatrixes, chimeras, illuminated virgins, perfect courtesans, legendary princesses, passersby, they furnish the power, the faces, and the motivation of man, beautify his weakness, make his joy tremble, and overcome his sorrow.

A proud girl with a peacock headdress, a cat with a woman's head, a dark beauty at the gate of a cemetery, a naked adolescent lying in a rocking chair, another at the bottom of the sea, sitting at a table in an indecent pose, smoking a cigarette and pouring a glass of wine, another flies over some flowers, another one flirts with a butterfly, one speaks as if in a dream, [26] and one puts her stockings on. This one is entirely green and, with her whip, she makes a heart go around like a top, this one, Winter in the mind's eye, symbolizes the Dragonfly, this one is frightened of a crab that climbs toward her stomach, this one compares her breasts to those of a marble Venus, this one emerges from the smoke of a cigarette, [27] this one, indomitable, is nevertheless in chains, this one sweeps the street, this one struggles with a monkey.

And even more idealized, all the women of Raphaël Kirchner, the pearly water nymphs, with their swollen upper lips, their eyes the size of the rainbow, their hair like twisting morning glories, their wasp waists, their naïve and perverse charms.

Everything is a pretext to show us female nudity. The General Psychological Institute publishes cards where *Science*, completely dressed, *unveils*

Trésors de rien du tout, dont le goût était donné aux enfants par les chromos, les timbres, les images de chicorée, de catéchisme, de chocolat ou par celles, en séries, que l'on distribuait dans les Grands Magasins, les cartes postales plurent rapidement aux grandes personnes par leur naïveté et plus encore, hélas ! par l'espèce d'égalité par en bas qu'elles établissaient entre l'envoyeur et le destinataire. Parmi les milliards de cartes postales (l'Allemagne seule en fabriqua jusqu'à neuf millions par mois) qui circulèrent en Europe de 1891 à 1914, il en est peu qui soient belles, touchantes ou curieuses. Nous les avons recherchées avec acharnement, en essayant de réduire autant que possible la part énorme que le découragement pouvait faire à l'excès d'imbécillité, au plus bas comique, à l'horreur, en sublimisant les raisons d'un pessimisme profond, inévitable.

Les cartes-vue sont toutes pareilles. Elles tendent à unifier tous les souvenirs, à immortaliser toutes les villes, tous les villages, à composer une Patrie de toutes les petites patries, une Eglise de toutes les églises obscures qui attristent la moindre agglomération (la seule « vue » sympathique est celle, reproduite plus loin, de la patrie « à la semelle d'un soulier »).

Les cartes de 1er Avril sont grossières, laides, agressives, anonymes.

Les cartes de Joyeuses Pâques sont généralement pornographiques.

Il y a des cartes assez convenables, quoique d'un symbolisme facile, de Bonne Année. L'usage conventionnel des chiffres n'est pas toujours absolument mauvais.

Dans un arbre, l'année écoulée, sous la forme d'une femme d'une élégance assez défraîchie, juchée sur une branche, regarde d'un œil tendre un nid où les quatre œufs qu'elle a pondus, numérotés 1.9.0.5., viennent d'éclore. Quatre ravissantes fillettes en sortent. Ou bien une nef s'engloutit dans la tempête pendant qu'une autre avance sur la mer calmée, etc... Mais enfin, la Bonne année reste une bonne plaisanterie. A quand les cartes de Mauvaise année, qui mêleront les siècles aux mois, les années aux semaines et les jours aux nuits au grand détriment du temps et au bénéfice des sensations ?

Commandées par les exploiteurs pour distraire les exploités, les cartes postales ne constituent pas un art populaire. Tout au plus la petite monnaie de l'art tout court et de la poésie. Mais cette petite monnaie donne parfois idée de l'or.

Les Fleurs.

Une avalanche de roses, de myosotis et de violettes, en soie, en velours, en peluche, en celluloïd, en dentelle, en métal, gaufrées, glacées, pailletées, dorées, nacrées, en relief, des poissons de myosotis, des tanks de violettes, des cœurs de roses. Quelquefois aussi

des marguerites, des coquelicots, du muguet, des pensées. La fleur plaît. Mais une tradition détestable impose presque exclusivement la reine des fleurs, le cliché sentimental et la modestie. La fantaisie ne s'exerce pas sur les autres fleurs qui sont toujours reproduites photographiquement ou d'après de misérables aquarelles. Il semble redoutable aux conservateurs jaloux de la médiocrité populaire d'ouvrir ce jardin floribond, féerique où poussent l'anémone pulsatille, la campanule miroir de Vénus, la gueule-de-loup, la marguerite bleue, l'œillet-de-poète géant, la capucine coccinée, la capucine caméléon, les pieds-d'alouette, l'adonide goutte-de-sang, le perce-neige, la belle-de-jour bleue à la gorge blanche et rose, la belle-de-nuit, belle de rêve au parfum de fleur d'oranger, la calcéolaire tigrée, l'œuf-de-vanneau, le pas-du-fantôme, le zinnia double nain aux couleurs dégénérées, la centaurée candidissima, la giroflée quarantaine mammouth nuit-d'été, le désespoir-du-peintre, l'amarante queue-de-renard, le chèvrefeuille, le cinéraire maritime diamant, le pavot d'Islande, toutes les fleurs rares et, pour cacher les murs, l'aristoloche siphon — d'ouvrir ce jardin féerique où poussent toutes les fleurs qui baptisent des visions.

Les Femmes.

Femmes-enfants, femmes-fleurs, femmes-étoiles, femmes-flammes, flots de la mer, grandes vagues de l'amour et du rêve, chair des poètes, statues solaires, masques nocturnes, rosiers blancs dans la neige, servantes, dominatrices, chimères, vierges illuminées, courtisanes parfaites, princesses de légende, passantes, elles construisent la force, les visages et la raison d'être de l'homme, béatifient sa faiblesse, font faillir la joie et croupir le chagrin.

Une fille altière coiffée d'un paon, un chat à tête de femme, une beauté noiraude à la porte d'un cimetière, une jeunesse nue renversée sur un rocking-chair, une autre au fond de la mer, assise sur une table dans une pose indécente, fume une cigarette et se verse un verre de vin, une autre vole sur les fleurs, une autre flirte avec un papillon, une autre parle comme dans un rêve, une autre enfile ses bas,

celle-ci, toute verte, faisant, à coups de fouet, tourner un cœur comme une toupie, c'est l'Hiver, celle-ci, dans une pensée, symbolise la Libellule, celle-ci s'épouvante d'un crabe qui monte vers son ventre, celle-ci compare ses seins à ceux d'une Vénus de marbre, celle-ci surgit de la fumée d'une cigarette, celle-ci, l'indomptable, est pourtant enchaînée, celle-ci balaie la rue, celle-ci lutte avec un singe.

Et plus idéalisées encore, toutes les femmes de Raphaël Kirchner, les sylphides nacrées, à la lèvre supérieure gonflée, aux yeux grands comme des arc-en-ciel, à la chevelure de liserons, à la taille de guêpe, aux charmes naïfs et pervers.

Tout est prétexte à nous montrer la nudité féminine. L'Institut général Psychologique édite des cartes où *la Science*, très habillée,

Nature, who, *freed from her veils, stands radiantly as the true incarnation of Beauty.* Eve is in the apple. Innumerable naked women, in unbelievable postures, form various faces and animals.[28]

More than any other in modern times, this period was favorable to women. It exalted dress, in its details and its broad outlines: *What a Woman wants—A week later, she appears before her husband, in a ravishing dress, pointing out to him that a Louis XVI hat, decorated with pink and black velvet wings would marvelously complete her look.*

Another, Mucha's Muse:
Pure profile of the virgin. Deep ecstatic gaze. Abundant and decorative hair, originally teased. The impeccable lines of her supple body molded by silky fabrics knowingly draped. She inhabits the mind of the poet of the pencil.

The Society for the Protection of Birds, shocked to see women growing wings, tried to oppose this and introduced hats decorated with onions, turnips, carrots, Japanese artichokes, but no one took them seriously, and they were ridiculed in the street.

It was the season for wispy tulle, black lace, ostrich feathers, jet, cherries, and aigrettes.

Women of bygone times, what pretty names you have: Stella, Palma, Obole, Oeilleuse, Lilly, Tsemad, Beryl, Nymphée, Daga, Epeire-Diadème, Somnia, Dianelle, Epave, Venusia, Digitale, Lutécite, Hybrida, Virida, Pandora, Cosmopolita, Liane, Pistillarine.

Love

Heart abstract in shape, the language of playing cards, of graffiti. From two hearts, a woman's hand and a man's emerge and clasp one another.

She was not thinking of the future, when He carved a heart on the trunk of an old oak tree with their interlaced initials.

A heart which marries a thought. Under two burning hearts, the inscription: *United for Life,* the sender had crossed out *for Life,* thus depriving the Other of the idea of death, of that last drop of living blood.

I love you in spring is written by hand, in summer with kisses, in autumn with dead leaves, in winter walking in the snow.

My pen can enchant
Lover and beloved

The mysterious kiss, the most beautiful, the most troubling of kisses.[29]

We are sorry that we did not reproduce here a facsimile of the folded card, "*good for two hundred and fifty kisses to the bearer from the Sentimental Society of Love, the first, the oldest Society of the Universe. Loan of 5,250,000,000*

Kisses, contracted under the guarantee of the government of the Empire of Love, the oldest, and the biggest country of the World, with inexhaustible resources. Approved by the Secretary: Kissingyou, the Director: Count de Well Loved, the Cashier: Among Hugs. Each coupon is worth a kiss at the next encounter." Childish, touching old-fashioned masterpiece. Or else this parcel sent by mail of a thousand sweet things which goes *directly to its target, through all of space.*

All languages are good for love: the language of playing cards, of rings, of precious stones, of colors, of ribbons,
If you wish from a distance to maintain our idyll
Let me know with a mauve ribbon of flowers, trousers, spiders, stamps, birds, canes, bows, seals, hats,

They say: The hat is the man
Nothing could be truer in fact
For it will always be used
As the Thermometer of Love.

The Orchid House. A new language to communicate the feelings of your heart to the one you love. Arcade of flowers.

Love and labor. Love at work. How can you talk like that, you who are my brothers because we have known the same women.

And two cards back to back, enemies. One represents a woman on a couch, languid: She brings joy to all the young men she meets. The other is divided into four parts and shows a woman sitting on her bed bored to tears: *I am thinking of you—And I can't sleep—I seem to hear your steps on the stairs—When will that happy day come?*

Dross

Not many birds. Doves in love, a few ridiculous sparrows, some grotesque storks. However, there is a veritable downpour of swallows. As the messengers of happiness, they carry letters and horseshoes, four-leaf clovers, lilies-of-the-valley, mushrooms. Everyone knows how to draw a swallow, a reassuring anchor, a crossbow, an arrow.

Cards with moving parts and in combinations. A child is born during a sea voyage,[30] flaps open, and a couple kissing is revealed, a woman is fishing and catches a husband, a recumbent odalisque emerges from a tobacco pouch, old ladies enter the Mill of Youth and come out young and gallantly undressed, an oyster yawns and shows us a bathing beauty, a child is overjoyed to produce a twenty-franc coin.[31]

The engraved cards by Frédillo are worth a special mention. Their erotic realism is in the best of taste (see *The Kiss* nude and dressed, *The Collector of Statuettes, The Conversation*).

Shrieks of joy, the most horribly eloquent clichés, always given as literally as possible: *Have you seen Lambert?—And your sister?—Look, there's Matthew—Would you like some lobster?—Looks like veal.—Have you seen the*

dévoile la Nature, où la Nature, délivrée de ses voiles, se dresse radieuse, véritable incarnation de la Beauté. Eve est dans la pomme. D'innombrables femmes nues, dans des postures invraisemblables, composent des visages et des animaux.

Plus qu'aucune autre dans les temps modernes, cette époque fut favorable à la femme. Elle exalte la toilette, dans ses détails, dans ses grandes lignes :

Ce que Femme veut — Huit jours plus tard, elle se présentait aux yeux de son mari, parée de la robe ravissante, lui faisant remarquer qu'un chapeau Louis XVI, orné de croisillons de velours noir et de roses, complèterait à ravir sa toilette.

Une autre, la Muse de Mucha :

Profil pur de vierge. Regard profond et extatique. Chevelure abondante et décorative, originalement tourmentée. Corps souple aux lignes impeccables, moulé dans des étoffes soyeuses savamment drapées.

Elle habite *le cerveau du poète du crayon.*

La Ligue pour la protection des Oiseaux, choquée de voir la femme prendre des ailes, tenta de réagir et lança des chapeaux ornés d'oignons, de navets, de carottes, de crosnes auxquels personne ne crût et dont on se moqua dans la rue.

C'est le temps du tulle illusion, des dentelles noires et des plumes d'autruche, du jais, des cerises et des aigrettes.

Femmes de l'ancien monde, que de jolis noms pour vous : Stella, Palma, Obole, Œilleuse, Lily, Tsemad, Béryl, Nymphée, Daga, Epeire-Diadème, Somnia, Dianelle, Epave, Vénusia, Digitale, Lutécite, Hybrida, Virida, Pandore, Cosmopolita, Liane, Pistillarine.

L'Amour.

Forme abstraite du cœur, langage des cartes à jouer, des graffiti. De deux cœurs, la main d'une femme et la main d'un homme sortent et s'étreignent.

Elle ne pensait pas au lendemain, alors que Lui gravait sur le tronc d'un vieux chêne un cœur renfermant leurs initiales entrelacées.

Un cœur qui se marie à une pensée. Sous deux cœurs qui brûlaient, de l'inscription : *Unis pour la vie*, l'envoyeur avait rayé *pour la vie*, privant ainsi l'Autre de l'idée de la mort, de la dernière goutte de sang vif.

Je t'aime au printemps s'écrit avec la main, en été avec des baisers, en automne avec des feuilles mortes, en hiver en marchant dans la neige.

Ma plume fait l'enchantement
De l'amoureuse et de l'amant.

Le baiser mystérieux, le plus beau, le plus troublant des baisers.

Nous regrettons de ne pas avoir reproduit ici en fac-similé cette carte dépliante, *obligation de deux cent cinquante baisers au porteur de la Société sentimentale des Amours, la première, la plus ancienne des Sociétés de l'Univers. Emprunt de 5.250.000.000 de Baisers,*

Lune de Moutarde

contracté avec la haute garantie du gouvernement de l'Empire de l'Amour, le plus ancien, le plus vaste pays du Monde, possédant des ressources intarissables. Vu et approuvé : le Secrétaire : Hembrasévoux, le Directeur : Comte de Sbienaimer, le Caissier : Parmilbécau. Chaque coupon étant d'un baiser à payer à la première rencontre.* Chef-d'œuvre de puérilité et de gentillesse archaïque. Ou bien ce colis-postal de mille douceurs qui va *droit au but, à travers l'espace.*

Tous les langages sont bons à l'amour : langage des cartes à jouer, des bagues, des pierres précieuses, des couleurs, des rubans,

Si vous voulez qu'au loin notre idylle se sauve
Je le saurai par le ruban mauve

des fleurs, des pantalons, des araignées, des timbres, des oiseaux, des cannes, des nœuds, des cachets, des chapeaux,

Chacun dit : Le chapeau, c'est l'homme.
Rien de plus véritable en somme
Car il servira toujours
De Thermomètre de l'Amour.

Maison de l'Orchidée. Langage nouveau pour faire comprendre à celui ou à celle que vous aimez les sentiments de votre cœur. Passage des fleurs.

Amour et travail. L'Amour au travail. Comment pouvez-vous parler ainsi, ô vous qui êtes mes frères parce que nous avons connu les mêmes femmes.

Et deux cartes dos-à-dos, antagonistes. L'une représente une femme sur un divan, alanguie : *Elle veut la joie de tous les jeunes hommes qu'elle rencontre.* L'autre, divisée en quatre, nous montre une femme qui s'asseoit sur son lit et qui s'ennuie : *Je pense à toi — Et je ne puis dormir — Il me semble entendre tes pas dans l'escalier — A quand cet heureux jour ?*

Scories.

Peu d'oiseaux. Des colombes amoureuses, quelques moineaux ridicules, quelques cigognes grotesques. Mais un véritable orage d'hirondelles. Messagères de bonheur, elles apportent les lettres et des fers à cheval, des trèfles à quatre feuilles, du muguet, des champignons. Tout le monde sait dessiner une hirondelle, ancre bénéfique, arbalète, flèche.

Cartes mobiles et à combinaisons. Un enfant naît pendant un voyage en barque, des volets s'ouvrent et un couple qui s'embrasse apparaît, une femme pêche à la ligne un mari, une odalisque couchée surgit d'une blague à tabac, les vieilles qui entrent dans le Moulin de la Jeunesse en sortent jeunes et galamment déshabillées, une huître qui bâille montre une jolie baigneuse, un enfant se réjouit de faire une pièce de vingt francs.

Les cartes gravées de Frédillo méritent une mention spéciale. Leur réalisme érotique est du meilleur goût (voir *le Baiser* nu et habillé, *l'Amateur de statuettes, la Conversation*).

Les cris du jour, clichés de la plus détestable éloquence, toujours figurés aussi littéralement que possible : *As-tu vu Lambert ?* --

farm?—Go on, that's not my father!—Come on, sweetie.—What eyes you have!—Open your mouth, baby.—Oh, the tiara.—You're nuts—Thanks for the lobster tail.—Oh, rats.—L'a-é-ou-u?—No, don't say that's custard?

Disgusting postcards from the Archives of Parasitology.

The most obvious truths are in abundance: sober as a camel, smart as a monkey, finicky as a cat, etc....

There is nothing in this heart but a pair of majestic mustaches.

Luxury cards where the crease of the trousers is marked by a golden line.

Postcards have often made excellent use of collage, which predated them by a bit. Example: the centaur family,[32] the head of a little girl in a sardine can,[33] Mona Lisa,[34] the telegraph wires,[35] the kiss in the monocle,[36] Napoleon III,[37] the bicycle race in reverse perspective.[38]

One would never have guessed that cards could include objects, real objects: a belt buckle, a handkerchief, a chain, a cigar, a fan.[39]

Cards illuminated from behind, the exquisite other side of the coin.

Unfathomable riddles: *Innocence persecuted, The birdbrain is not where you think, Fish are always ready to eat a lonely grasshopper...,*[40] *Slippers are good for playing*

footsie under the table. As for the laces...Quiet! The pun: *Cello which resists*, pronounced at all costs, achieves the dignity of a poetic image.[41]

Analogies are passionately sought after, whether in the delineation of islands[42] or borderlands, in spots on the wall, in the form and the color of flowers or in everyday objects, landscapes, or animals.

Stereotypes, which flatter the law governing the limits to developing a thought, have the best chance of success, in spite of the invincible boredom that they provoke. To wit: the Ascent of the Great Pyramid,[43] the Nursing School,[44] the Undertaker, the same woman infinitely reproduced,[45] plants on stamps, all of the leaves bearing the head of a king or a Sower.

Lilliputian hallucinations of a woman: the man is an insect,[46] a bird that she tames,[47] that she wounds, that she crushes.[48]

A landscape in a fish, a fish in an automobile, violets in a shoe, a woman in a bottle, two women in a horse...and the innumerable "series," all the more interesting for being incomplete.

We are often that man in the street who bends down to get a better look at children, or insects, flowers, or women, that domesticated man of the world, that man who bends over in order to stand tall again, lifting higher than himself everything he used to dominate.

Paul ÉLUARD

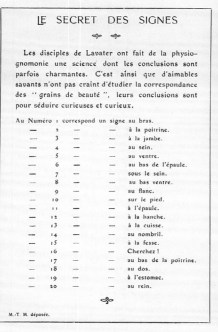

LE SECRET DES SIGNES

Les disciples de Lavater ont fait de la physiognomonie une science dont les conclusions sont parfois charmantes. C'est ainsi que d'aimables savants n'ont pas craint d'étudier la correspondance des " grains de beauté ", leurs conclusions sont pour séduire curieuses et curieux.

Au Numéro 1 correspond un signe au bras.

—	2	—	—	à la poitrine.
—	3	—	—	à la jambe.
—	4	—	—	au sein.
—	5	—	—	au ventre.
—	6	—	—	au bas de l'épaule.
—	7	—	—	sous le sein.
—	8	—	—	au bas ventre.
—	9	—	—	au flanc.
—	10	—	—	sur le pied.
—	11	—	—	à l'épaule.
—	12	—	—	à la hanche.
—	13	—	—	à la cuisse.
—	14	—	—	au nombril.
—	15	—	—	à la fesse.
—	16	—	—	Cherchez !
—	17	—	—	au bas de la poitrine.
—	18	—	—	au dos.
—	19	—	—	à l'estomac.
—	20	—	—	au rein.

M.-T. M. déposée.

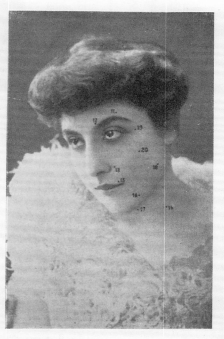

Et ta sœur ? — Tiens ! voilà Mathieu. — En voulez-vous des z'homards ? — On dirait du veau. — As-tu vu la ferme ? — Eh ! allez donc, c'est pas mon père ! — Viens, poupoule. — T'en as un œil ! — Ta bouche, bébé. — Oh !! la Tiare. — T'en as un grain. — Merci pour la langouste. — Ah ! la barbe. — L'a-é-ou-u ? — Non ! mais alors, c'est du flan ?

Les cartes postales répugnantes des Archives de Parasitologie.

Il pleut des vérités premières : sobre comme un chameau, malin comme un singe, gourmande comme une chatte, etc...

Il n'y a encore rien dans ce cœur qu'une paire de majestueuses moustaches.

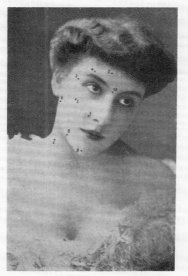

Les cartes de luxe où le pli du pantalon est marqué par un trait d'or.

La carte postale a beaucoup utilisé, et le plus souvent de façon très heureuse, le collage, né d'ailleurs bien avant elle. Voir : la famille de centaures, la tête de petite fille dans une boîte à sardines, la Joconde, les fils télégraphiques, le baiser dans le monocle, Napoléon III, la course cycliste avec perspective renversée.

On ne doute plus de rien. Les cartes supportent des objets, de vrais objets : une boucle de ceinture, un mouchoir, une chaîne, un cigare, un éventail.

Cartes transparentes, délicieux revers de la médaille.

Les énigmes insolubles : *l'Innocence persécutée, Le plus serin des deux n'est pas celui qu'on pense, Poissons prêts à manger toujours la sauterelle solitaire..., les Brodequins servent à se* faire du pied sous la table. Quant aux lacets... Chut ! Le calembour : *Violoncelle qui résiste*, réalisé coûte que coûte, s'élève à la dignité d'une grande image poétique.

L'analogie est recherchée avec fureur, aussi bien dans la délimitation des îles que dans les frontières, dans les taches de murs, la forme et la couleur des fleurs que dans les objets familiers, les paysages ou les animaux.

La stéréotypie, qui flatte la loi d'arrêt de développement de la pensée, a toutes les chances de séduire, malgré l'ennui invincible qu'elle dégage. Voir : l'Ascension de la Grande Pyramide, l'Ecole des Infirmières, les Croque-Morts, la même femme à l'infini, des plantes en timbres, toutes leurs feuilles portant la tête d'un roi ou la Semeuse.

Hallucinations lilliputiennes de la femme : l'homme est un insecte, un oiseau qu'elle dresse, qu'elle blesse, qu'elle écrase.

Un paysage dans un poisson, un poisson dans une automobile, des violettes dans un soulier, une femme dans une bouteille, deux femmes dans un cheval...

et les « séries » innombrables, d'autant plus intéressantes qu'elles sont incomplètes.

*
*

Nous sommes souvent cet homme dans la rue, qui se baisse pour mieux voir les enfants, les insectes, les fleurs et les femmes, cet homme domestique du monde, cet homme qui se baisse pour mieux se redresser ensuite, en portant plus haut que lui tout ce qu'il dominait.

Paul ELUARD.

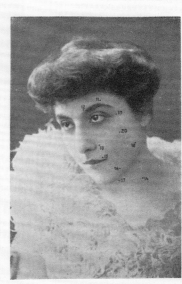

LE SECRET DES SIGNES

Les disciples de Lavater ont fait de la physiognomonie une science dont les conclusions sont parfois charmantes. C'est ainsi que d'aimables savants n'ont pas craint d'étudier la correspondance des " grains de beauté ", leurs conclusions sont pour séduire curieuses et curieux.

Au Numéro 1 correspond un signe au bras.

— 2 —	—	à la poitrine.
— 3 —	—	à la jambe.
— 4 —	—	au sein.
— 5 —	—	au ventre.
— 6 —	—	au bas de l'épaule.
— 7 —	—	sous le sein.
— 8 —	—	au bas ventre.
— 9 —	—	au flanc.
— 10 —	—	sur le pied.
— 11 —	—	à l'épaule.
— 12 —	—	à la hanche.
— 13 —	—	à la cuisse.
— 14 —	—	au nombril.
— 15 —	—	à la fesse.
— 16 —	—	Cherchez !
— 17 —	—	au bas de la poitrine.
— 18 —	—	au dos.
— 19 —	—	à l'estomac.
— 20 —	—	au rein.

M.-T. M. déposée.

Sous son baiser de feu, un ongle rose poussé

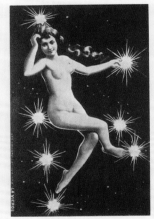

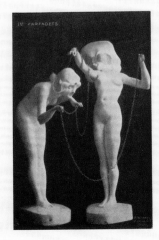

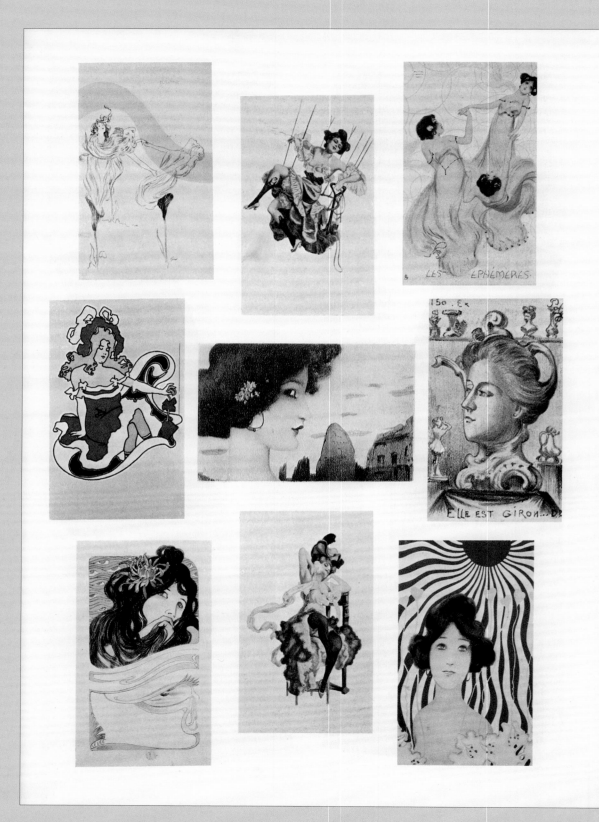

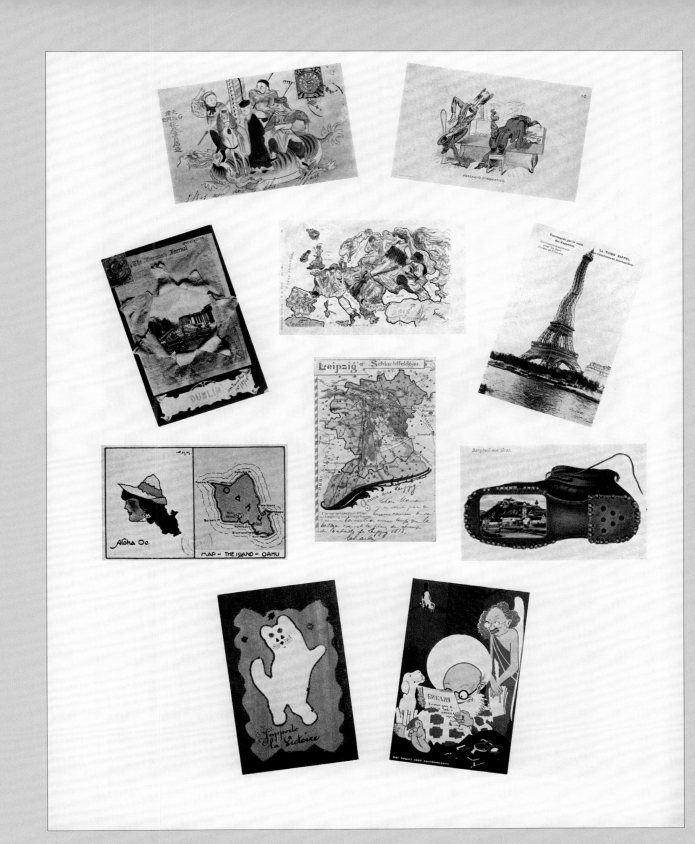

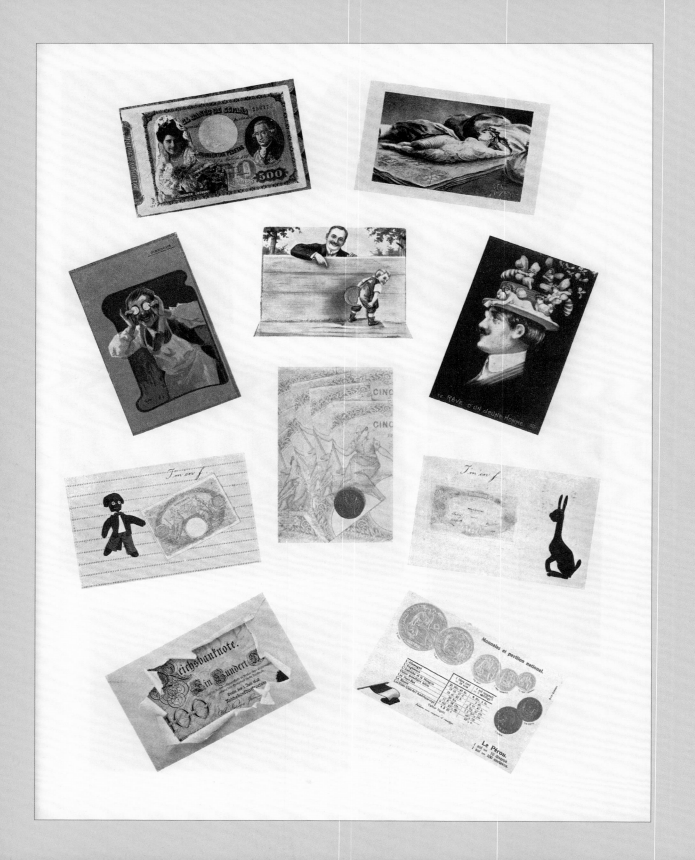

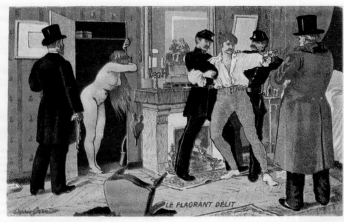

LE FLAGRANT DÉLIT

Quand on s'en va à deux

Souvent on revient trois.

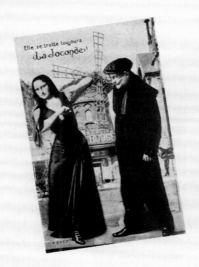

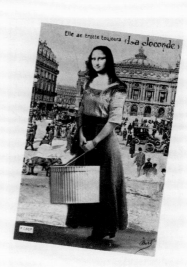

MAIN STREET LOOKING

NORTH FROM

COURTHOUSE SQUARE

Walker Evans

INTRODUCTION BY ELIZABETH B. HEUER

Walker Evans began collecting postcards around the age of ten. He picked up picture postcards in towns he visited during summer road trips across the Midwest with his family and also purchased new cards from local drugstores, such as Kresge's and Woolworths.[1] Later, friends and colleagues, familiar with his collecting habit, sent Evans used cards discovered in flea markets and secondhand shops. Evans's interest in photographic postcards expanded rapidly throughout the 1920s and 1930s. In particular, he sought commercially printed photographic postcards produced between 1905 and 1915. Eventually, he amassed over nine thousand cards, featuring a broad range of subjects, from transportation, architecture, national monuments, and natural attractions to disasters and views of landscapes and cities. Evans stored his cards in shoeboxes and an old leather briefcase and arranged them in a file format. He frequently visited the New York Public Library Picture Collection, where he was influenced by the extensive postcard collection and the innovative file system, which was arranged by subject.[2] Evans created nearly thirty tabbed dividers to separate his cards into the following subject categories: "Railroad stations," "Detroit Publishing Company," "Detroits," "Flatiron," "State Capitols," "Boats," "Lighthouses," "San Francisco Earthquake," "Factories," "London," "Europe Vintage," "Europe," "Riviera," "Madness," "Painting," "Fancy Architecture and Arch Extravaganza," "Automobiles," "Street Scenes," "Outdoor Pleasures and Sports," "Curiosities," "Vintage," "Seascape," "Summer Hotels," "Hotels," "Cities," "Comic," and "Persons."

For Evans, postcards were "the truest visual records ever made of any period."[3] As such, they offered him a means to view the American past through images, and at the same time study images of that past. As he explained in a 1973 lecture at the Museum of Modern Art:

There has emerged from this collection, really a picture of American history—of a period, let's say, prior to World War I and beginning around the turn of the century. I felt I was making a discovery and I still do. Lots of people don't look at these things in any other way other than through the eyes of nostalgia. These [are] documents of things that interest me and they haven't been recorded in any other way. So here's a hidden treasure of not only American photography and documented history, but American history and life of the period—social history.[4]

Nearly a decade earlier, in a lecture at Yale University, Evans had described the postcard as a unique photographic document: "The medium was hack photography, but those honest direct little pictures have a quality that today is more than social history. Among collectors of Americana, much is made of the nation's folk art. The picture postcard is folk document."[5]

As far as Evans was concerned, the Detroit Publishing Company produced the best postcards. They "outdistance all others in quality, with a huge series of straight U.S. views of every conceivable subject from Arizona mountains to New England cotton mills…. In its heyday [the company] employed and trained a fleet of itinerant photographers whose simple, careful work stands today with the best 'straight' view photography this country has ever produced."[6] Evans preferred the elegance and restraint of black-and-white photography in his own photographs, but he also praised "Detroits" for their delicate and refined coloration. "In the early century days color photography was of course in its infancy. Cards were usually made from black-and-white photography subsequently tinted by hand lithography. Withal, the best ones achieved a fidelity and a restraint that most color photographer printers have yet to match—notably in flesh tints and in the rendering of patina and the soft tones of buildings and streets."[7] What Evans appreciated were the rich, multicolored lithographic prints, were prized for their beauty but also their truthfulness to detail, produced by the Detroit Publishing Company's distinctive Photochrom printing process, a closely guarded company secret.

Evans's interest in photographic postcards developed in tandem with his career as a documentary photographer. While traveling on photographic assignments, he often collected cards from various locations. In 1933 he was hired to document the social scene in Havana for left-wing journalist Carleton Beals's book *The Crime of Cuba*, and while there he acquired a number of postcards from Cuba.[8] In 1934 Evans was commissioned by Gifford Cochran to travel in the American South and photograph Greek Revival architecture for a proposed book on classical architecture.[9] For Evans, the assignment was the start of a two-year journey through the South that overlapped with his tenure at the Resettlement Administration (later the Farm Security Administration) recording social conditions during the Great Depression. In the course of these travels, he collected postcards from Savannah, Georgia; Natchez, Mississippi; and Hale City, Alabama. In later years, Evans acquired photographic cards while working on projects in Florida and New England.

Evans not only collected postcards, he used them to identify subjects, themes, and specific views in his own photographic work. On numerous occasions Evans rephotographed subjects that were depicted in cards from his collection. Consider, for example, Evans's "Morgan City, Louisiana" (1935) and the postcard "Front Street, Looking North, Morgan City, LA." (1929; fig. 11.1).[10] The similarities

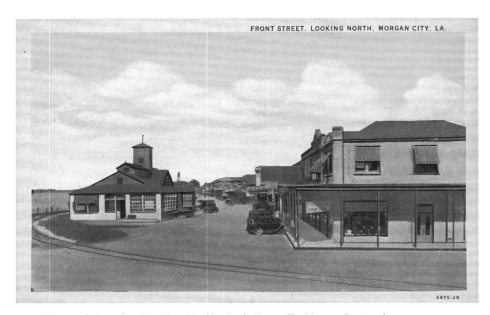

11.1. Unknown photographer, "Front Street Looking North, Morgan City, LA., 1929," postcard.

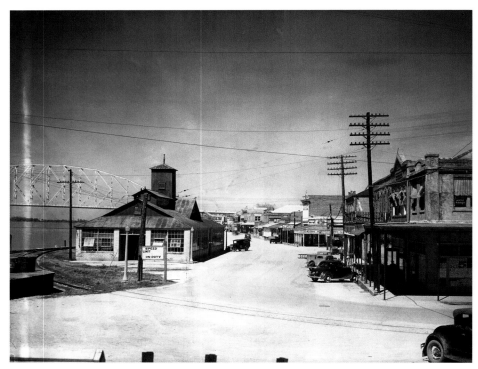

11.2. Walker Evans, "Main Street, from Across Railroad Tracks, Morgan, Louisiana," 1935.

between Evans's image of Morgan City, located two hours outside of New Orleans, and the postcard view are certainly not coincidental (fig. 11.2). The card's perspective view of Front Street is juxtaposed with the sweeping curve of the railroad tracks. Evans photographed the view from the same vantage point; it was altered only by the encroachment of modernity, as evidenced by the telephone poles and a railroad bridge in the distance. Similarly, a postcard of "Poland Spring House, South Poland, Maine" (ca. 1900) provided a model for Evans's "Poland Spring House, Poland Spring, Maine" (1949).[11] In this case, Evans's picture of the Gilded Age nineteenth-century resort hotel documents the passage of time, evidenced by several trees that have grown up on the resort grounds.

In addition, Evans also made his own postcards. In 1936 he and Tom Mabry, then executive director of the Museum of Modern Art, devised a plan to publish a suite of photographs Evans had made for the Resettlement Administration as postcards.[12] A. Conger Goodyear, president of the museum's board of trustees, advanced Evans two hundred dollars for the project. However, Evans and Mabry could not agree on which images to reproduce, and a series of on-again, off-again negotiations ensued. Later in 1936, Mabry suggested that Evans drop the RA photos and produce postcards featuring his photographs of nineteenth-century New England houses.[13] Not having received a response, Mabry contacted Evans again in 1937. By contract, if Evans abandoned the project, he was obligated to give the museum twenty-five prints from his collection. Evans renewed the project, but only temporarily. In February 1938 Mabry demanded that Evans fulfill his contractual obligation, and Evans responded by submitting twenty-six photos, seven of which were printed as black-and-white postcards.

Unlike topographical postcards, which feature noteworthy geographical locations or buildings, Evans's cards present an array of anonymous sites. "Detail of Negro Church, Beaufort, South Carolina," is drawn from a series of photographs Evans took of African American churches he found in South Carolina (fig. 11.3). Evans appreciated the simple wood-frame architecture, describing such structures as "amplified by understatement." Resisting the typical postcard image of a church, Evans, through careful editing, emphasizes the bell tower, the church's "most rewarding feature." He positions the tower off center and places it in a horizontal format. The horizontal pattern of the wooden siding, complemented by the horizontal format, is counterbalanced by the angle of the roof's pitch, which is then repeated in the tower's sawtooth detailing and shingled cap. "Even the unbeliever must feel their [country churches'] force," Evans writes. "Consecration

here speaks tenfold over such labored glorifications as Saint Patrick's on Fifth Avenue or the Cathedral of St. John the Divine."[14] His "Detail of Pediment, Charleston, South Carolina" can be considered a pendant to the Beaufort church tower. Here Evans captured an architectural detail of an eagle with extended wings. Again cropping the view, Evans accentuated the relationship between the line of the wings and the diagonals of the pediment.

In another postcard, "Detail of Frame Houses in Virginia," Evans captures a neat row of simple wood-frame buildings. The vertical lines of the plain, rectangular structures are intersected by the horizontal lines of flat roof and wood siding. The grid patterning is repeated in the windows, doors, and surrounding fence. Of the seven postcards Evans made, six feature images from the south. The exception is his photograph of modest homes in the steel town of Easton, Pennsylvania. In contrast to his images of architecture, "Detail of Mississippi Town Negro Street" features a contemporary view of an African American community. Resisting stereotypical postcard images of African Americans, "Mississippi Town Negro Street" presents a different perspective in an angled view that emphasizes the horizontal patterning of wooden clapboards and hand-painted signs, such as "S.G. Gramam's Bargain-Store" and "Brother in Law Barber Shop." His "Detail of Penny Picture Display, Savannah," an image of a photogra-

11.3. Walker Evans, "Detail of Negro Church, Beaufort, South Carolina," 1936.

pher's window filled with small snapshots of town locals, presents a community portrait of Depression-era white Southerners. Reflecting back on this photograph many years later, Evans stated, "All these people had posed in front of the local studio camera, and I bring my camera, and they all pose again together for me. I look at them and think, and think, and think about all those people."[15]

Evans featured postcards on other occasions in his photographic work. "Postcard Display" is the last plate in his photo essay for Karl Bickel's travel guide to Florida's west coast, *The Mangrove Coast* (fig. 11.4).[16] In the photo, a simple plywood display rack contains various Florida tourist postcards ranging from bushels of oranges, the John Ringling residence known as the Cà d'Zan, and views of the Everglades to the shuffleboard courts at Sarasota Municipal Auditorium and tropical sunsets. Through judicious cropping, Evans emphasizes the grid-like composition of the display rack and focuses on the postcard montage. Evans bought several of these postcards for his own collection, and used them as sources for a number of his own photographs, which he then included elsewhere in the book. As the last plate in *The Mangrove Coast*, "Postcard Display" represents, therefore, an essay within an essay.

Yet another use Evans made of postcards from his collection was in a series of photo essays published during his tenure at Fortune and later as a freelance writer for *Architectural Forum*. Evans joined *Fortune* in 1945 as a staff photographer and three years later was promoted to Special Photographic Editor.[17] For Evans, two photo essays he produced at Fortune that utilized postcards stood out in particular. "[They] are not even my photography at all. I love the two postcard ones; they're purely mine."[18] Here we reproduce in its entirety one of these photo essays, "Main Street Looking North from Courthouse Square" (1948). Evans's brief introduction about postcard photography accompanies a four-page spread with eighteen color reproductions of cards Evans selected from his personal collection and that of the New York Public Library. "On these pages are a dozen and a half samples from the rich postcard field of realism, sentiment, comedy, fantasy, and minor historical document," he writes.[19] Reminiscent of a postcard album page, the essay displays an assortment of images, including the Amelia Palace in Salt Lake City, Utah, and the Tampa Bay Hotel against an image of a giant cactus from the Southwest and the city square in Belfast, Maine. He combines unexpected juxtapositions of images with fragments of handwritten conversations, such as "Your's 11 & Beer St, J.F.C" and "Having a fine time, Mrs. D." Evans reveals here a predilection for brief handwritten postcard messages.

The cards "arrived from the next town up the line, or from across the continent, inscribed for all to see: 'Your Ma and I stopped at this hotel before you were ever heard of,' or, shamelessly: 'Well if she doesn't care any more than that I don't either. See you Tues.'"[20] Evans published a second portfolio of postcards in *Fortune* in 1962 titled "When Downtown Was a Beautiful Mess." The essay includes a six-page layout featuring eight cards from his collection; one image is enlarged and reproduced as a full double page spread, permitting the viewer to clearly study and probe the image. In his text, Evans discusses how postcards recorded the architecture and streets of America's turn-of-the-century cities. Also in 1962, Evans published a postcard photo essay in *Architectural Forum*, "Come on Down." The title drawn from a common communication found on tourist postcards, "Come on Down" celebrates America's grand summer resorts. Evans focuses attention on a postcard of a Rhode Island resort with a brief handwritten message. Quoting the postcard message, Evans writes, "'Stopping here tonight 7/25/06,' becomes for us a blue-green dream of Sunday baseball salted by the Atlantic spray."[21] Rather than marring the picture, these message fragments clearly lend an authentic voice for Evans to these turn-of-the-century images.[22]

A final use Evans made of postcards was in slide shows and public lectures during his later years. Significantly, when he was asked to discuss photography or present his photographic work, he often lectured on postcards instead. Throughout the 1950s, for example, he performed a postcard slide show for friends in his New York City apartment. Blowing up images from his collection to nearly life-size proportions, he flashed the images in a sequential flow on the wall in the dark.[23] Jack Tworkov, head of the Yale Art Department, invited Evans in 1964 to perform his postcard slide show for students and faculty. In 1973 Evans presented a similar lecture at the Museum of Modern Art. Evans orchestrated these events as cinematic performances. He invited members of his audience to project themselves onto the main streets and boardwalks of turn-of-the-century America. As he put it, "One can, in effect, re-enter these printed images and situate oneself upon the pavement in downtown Cleveland, Omaha, or Chicopee Falls, Massachusetts…. In the street the trolleys clang. The air is not entirely free of horse smells…. You are reminded of some of the facts of life that bedeviled citizens under Teddy Roosevelt and William Howard Taft."[24]

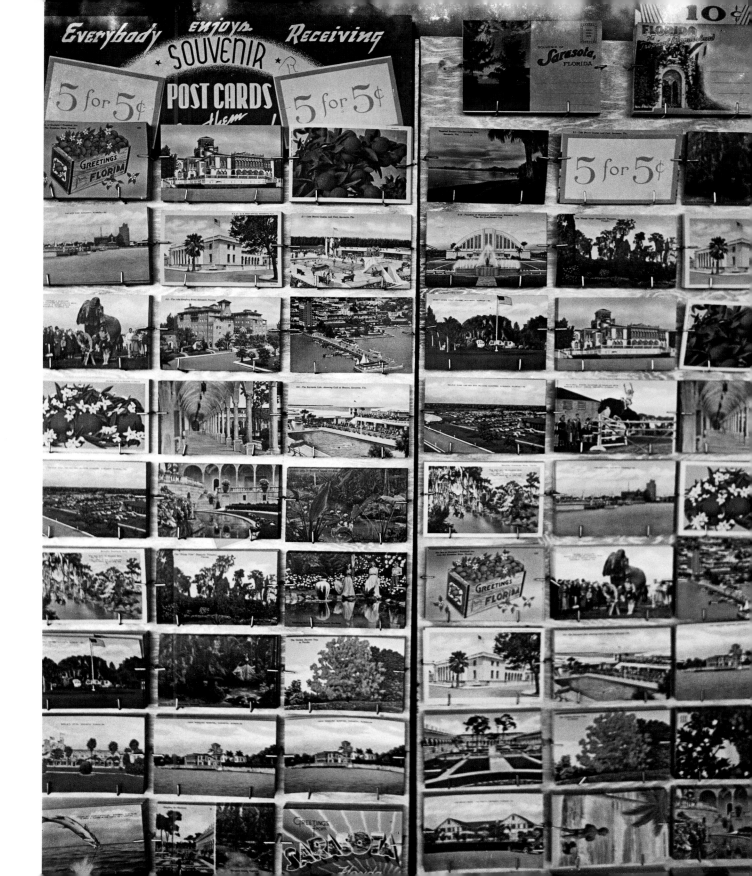

11.4. Walker Evans, "Postcard Display, Florida," 1941.

"MAIN STREET LOOKING NORTH FROM COURTHOUSE SQUARE"

A portfolio of American picture postcards from the trolley-car period.

———◆———

THE mood is quiet, innocent, and honest beyond words. This, faithfully, is the way East Main Street looked on a midweek summer afternoon. This is how the county courthouse rose from the pavement in sharp, endearing ugliness. These, precisely, are the downtown telegraph poles fretting the sky, looped and threaded from High Street to the depot and back again, humming of deaths and transactions. Not everyone could love these avenues just emerged from the mud-rut period, or those trolley cars under the high elms. But those who did loved well, and were somehow nourished thereby.

What has become of the frank, five-a-nickel postcards that fixed the images of all these things? They arrived from the next town up the line, or from across the continent, inscribed for all to see: "Your Ma and I stopped at this hotel before you were ever heard of," or, shamelessly: "Well if she doesn't care any more than that I don't either. See you Tues." On their tinted surfaces were some of the truest visual records ever made of any period.

They are still around. Tens of thousands of them lie in the dust of attics and junk shops; here and there, files of good ones are carefully ranged in libraries, museums, and in the homes of serious private collectors. Postcard collectors today are a knowing and organized lot, well aware of what to look for, where to look, and how much to pay. As hobbies go, collecting early cards (circa 1890-1910) is financially reasonable: prices range from a penny to a dollar an item.

In the 1900's, sending and saving picture postcards was a prevalent and often a deadly boring fad in a million middle-class family homes. Yet the plethora of cards printed in that period now forms a solid bank from which to draw some of the most charming and, on occasion, the most horrid mementos ever bequeathed one generation by another. At their best, the purity of the humble vintage American cards shines exceeding bright in 1948. For postcards are now in an aesthetic slump from which they may never recover. Quintessence of gimcrack, most recent postcards serve largely as gaudy boasts that such and such a person visited such and such a place, and for some reason had a fine time. Gone is all feeling for actual appearance of street, of lived architecture, or of human mien. In the early-century days color photography was of course in its infancy. Cards were usually made from black-and-white photographs subsequently tinted by hand lithography. Withal, the best ones achieved a fidelity and a restraint that most current color-photography printers have yet to match—notably in flesh tints and in the rendering of patina and the soft tones of town buildings and streets.

But here in the mild morning of forty years ago is "Bank Square, 'Five Corners,' Fishkill-on-Hudson, N. Y.," epitome of Yankee utilitarianism in subject, in execution, and in mood. Made as a routine chore by heaven knows what anonymous photographer, the picture survives as a passable composition, a competent handling of color, and a well-nigh perfect record of place. Indeed, transcending place, it rings a classic note on the theme of small-town main streets. On these pages are a dozen and a half samples from the rich postcard field of realism, sentiment, comedy, fantasy, and minor historical document. They invite you to consider them as fondly, as patriotically, or as historically as you like. If you don't think there is such a thing as period physiognomy, look at the faces in the dice-game scene entitled "Where All Men Are Equal" on page 104. Reflect on the sensuous possibilities of "Listening to the Band, Hazle Park, Hazleton, Pa.," under those sun-mottled leaves, watching the movement of those white dresses. And alas, what were the ghastly events leading to that fateful walk in the woods recorded on page 105? What black anguish under that derby hat? How, with his masculine logic, did that pitiable male come up against the maddening cross-purposes met beneath that intractable sailor straw? **WALKER EVANS**

Bank Square, "Five Corners", Fishkill-on-Hudson, N.Y.

SAGINAW, MICH. COURT HOUSE

11654. FRIENDS MEETING HOUSE, PHILADELPHIA, PA. DETROIT PUBLISHING CO.

Chapel Street,
looking east,
New Haven,
Conn.

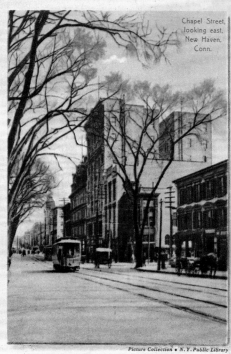

Salisbury, Beach, Mass.

S. H. Oct. 8. Dear Cousin I received your photo
many thanks, will exchange one of mine if ever I
get around to have them taken I hope it will be soon. Cousin
Nellie

962 — AMELIA PALACE, SALT LAKE CITY, UTAH.

Picture postcards originated in Germany, and it was the Germans who printed most of the American cards made at the turn of the century. Yet one American firm grew to outdistance all others in quality, with a huge series of straight U.S. views of every conceivable subject from Arizona mountains to New England cotton mills. This was the Detroit Publishing Co., which in its peak production years distributed millions of beautifully colored, painstakingly printed card views. This company was forced out of the postcard business in 1924 by the advent of cheap machine lithography. In its heyday it employed and trained a fleet of itinerant photographers whose simple, careful work stands today with the best "straight" view photography this country has ever produced. Most of the original Detroit negatives were purchased by Henry Ford's Edison Institute—but these are still uncatalogued and unavailable to the public. Today the Detroit Publishing Co.'s cards are much sought after by collectors, who refer to them as "Detroits." There are four typical "Detroits" reproduced on these pages, identifiable by the small-letter signification in the margin of each card.

571 Tampa Bay Hotel, Tampa, Florida.

Picture Collection • N.Y. Public Library

7789 "WHERE ALL MEN ARE EQUAL." DETROIT PUBLISHING CO.

2034—Post Office New York.

Copyright 1895 by A. Loeffler.

Having a fine time. Mort Aug 31/06

Listening to the Band, Hazle Park
Hazleton, Pa

FOOT OF THE SQUARE, BELFAST, ME.

8854. FRONT STREET, MARQUETTE, MICH.

Giant Cactus

6570. ST. JOHN'S CHURCH, PORTSMOUTH, N. H.

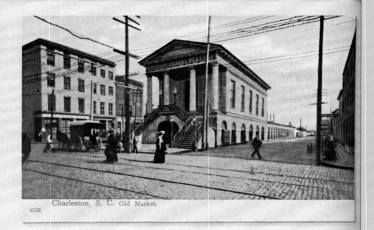

4539. Charleston, S. C. Old Market.

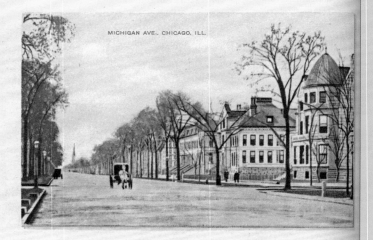

MICHIGAN AVE., CHICAGO, ILL.

ELKTON MINES, CRIPPLE CREEK DIST COLO.

Through World War I the postcard business remained flourishing, but picture cards lost face to a considerable extent when Americans developed a certain degree of taste and sophistication—or thought they did—during the late twenties. For this and for other, economic, reasons, the business bogged down even before the depression, and stayed stalled for several years. Currently it is back in fine shape, with something like 700 million cards mailed each year in the U.S. (exclusive of the Post Office official, blank, 1-cent message card). Postal employees call postcards "slop," although cards are rated as first-class matter.

Recently the hobby of collecting postcards has been given the staggering name "deltiology"—custom-made word from the Greek *deltos* (writing tablet). But this step in no wise diminishes the real dignity and importance of good collections in the eyes of their custodians. Two notable postcard exhibitions of late years were that of the Museum of the City of New York in 1943 and one held at the Atwater Kent Museum, Philadelphia, in 1944.

LOVE YOUR PANZER CORPS:
...

REDISCOVERING THE
...

WARTIME POEM POSTCARD
...

Cary Nelson

It is the midst of World War II. Invaded by Adolf Hitler's army in 1941, the Soviet Union has suffered three years of death and blood on Russian soil, but finally victory is imaginable. The Germans had regrouped with astonishing speed after their major defeat at Stalingrad in the winter of 1942–43. But massive and often costly Soviet counterattacks had pushed them back to their 1939 borders along most of the eastern front over the next year. Though the siege of Leningrad had been lifted earlier, the city continued to be under bombardment for months. Now, in 1944, the Soviets finally had control over the skies above their cities. Yet in one place—at the very center of the eastern front—the Germans occupied a substantial piece of Russian territory. Deceiving the Germans into thinking they were planning their main action in the north, the Russians instead launched an attack against the German-held salient in the center.[1]

Meanwhile, a Russian poet known before the war for writing children's literature was now composing wartime propaganda, including poems printed on thin paper folded over, secured with a glued flap—structurally similar to an air letter but on heavier paper—and sent like postcards. In what seems an entirely straightforward poem, he is actually seeking a sea change in his readers' expectations. The thunder of artillery, the bursting of shells, the sky lit with flames—all this for three years has signified the burning of cities and the approach of death. Now, opposite a predominantly blue portrait of the Kremlin's Spasskaya (Savior's) clock tower, with its twenty-five-ton clock installed in 1851, he asks his countrymen to imagine the same effects of light and sound to herald a victory celebration (fig. 12.1). Uncomplicated though the poem may appear, it is an effort to turn established figures of terror into prospective figures of joy:

Every day the Kremlin fireworks
Grow brighter, more decisive, more splendid!
Soon the day will come when their last reverberations
Herald our victory throughout the land.

We will declare victory over fallen enemies
Crushed against the granite of our will.
And once again the flag of Lenin
Will light up all the corners of our native land.

As our villages rise from ruin,
the cities will bloom even brighter.
Soon Stalin will command
"Fireworks for the triumphant motherland!"

The poem, by Samuel Yákolevich Marshák, is on a folded sheet sent from the field on July 28, 1944, by a soldier who signs himself only "Your father Kolya," Kolya being a diminutive form of Nikolai. If the text seems programmatic, formulaic, it nonetheless provides warrant for a more intimate message. The soldier choosing to send the poem card gets the politically and historically appropriate and necessary words said for him by the poet, then composes a kind of prose poem of his own for his daughter Vera Ivanova (fig. 12.2). What might have seemed a wartime indulgence in personal sentiment is thus offered in a zone of permission opened up and protected by Marshák's poem. Whatever we may want to say about Marshák's text on its own, it acquires an additional set of meanings by virtue of its use. As others have noted, the sender appropriates the postcard with a signature.[2] It is with use, as well, that the postcard regains the aura it has lost, in Walter Benjamin's model, as a work of mechanical reproduction.[3] Its aura, however, is not that of a work of art but rather that of historical and human presence.

Here is Kolya's handwritten message:

Dear Vera,

I am writing to you even though I really have nothing to say. But I write so as not to break the chain that connects us. I write this letter while hiding from the sun under a little bush. I just took a swim in the sea and soon I will have lunch. There, I can hear the lunch trolley approaching. So we will eat, and then the war will begin again. I am fighting in a field, or rather in a mountain valley. When will I see the last of these damn mountains? Mountains and more mountains! When will I see a plain stretched out before us? But there is nothing for it. Soon we must advance and draw closer to the enemy. Otherwise we'd have to wait here for them forever.

There, lunch has arrived. So I will eat. And thus I end my letter. Say hello to everyone.

I send big kisses.

Part of what is uncanny about this little paragraph is its characteristic wartime negotiation of the relationship between the incidental and the monumental—the bush, the swim, the lunch wagon surface amidst the impending clash of armies—along with its translation of grim battlefield necessity, "soon we must advance and draw closer to the enemy," into an apparently childlike logic: "otherwise we'd have to wait here for them forever." The initial

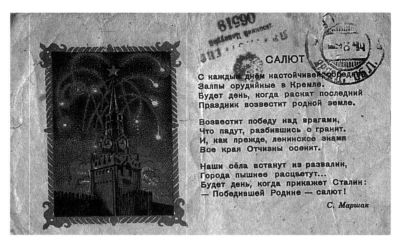

12.1. Russian World War II poem card featuring a poem by Samuel Yákolevich Marshák and Spasskaya ("Savior's") Clock Tower.

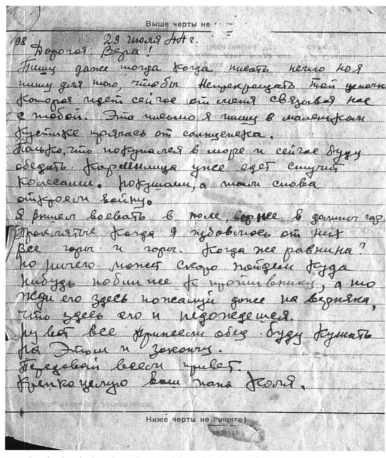

12.2. Russian handwritten letter from a soldier to his daughter (verso of fig. 12.1).

dichotomy—between a pastoral respite and imminent battle—follows the logic Paul Fussell notes in many World War I poems, which structured their intelligibility around an opposition between a pastoral prewar world and the carnage of trench warfare.[4] Whether Kolya was consciously emulating a literary tradition is impossible to say, but the contending tropes certainly help give his letter the character of a prose poem. In any case, he then amends his pastoralism with the logic of childhood. If this results in a kind of grim fairy tale, with childlike surrealism overlaying the mad fatefulness of battlefield action, it also hints at the way Russians had to deal with a specific late Nazi tactic. Early in 1944, in a costly delaying tactic, the German army was ordered to pick arbitrarily chosen sites and hold them as "fortresses" until death.[5] Marshák's poem also reinforces the juxtaposition of historical process with personal experience, invoking the larger canvas on which Nikolai Mikhailovich Troshin inscribes his family communication. Whether this particular Nikolai survived the war I do not know, although many Nikolais did not. For the rest of the twentieth century, we believed an astonishing twenty million Russians died as a consequence of Hitler's invasion. Recent research has increased the estimate to nearly fifty million Russian dead.

Marshák, the poet, did survive the war. Born in Voronezh in 1887, his father a factory foreman, Marshák lived until 1964, eventually becoming well known both for his own work and for his translations of Shakespeare and Blake, among others, into Russian. He began publishing at about age twenty, studied at the University of London from 1912 to 1914, and in the 1920s began issuing children's books. Whether Kolya knew he was sending his daughter a wartime poem by a former children's author is impossible to say. Marshák was actually one of the few survivors of the wartime Jewish anti-Nazi Committee. Most of its members were either shot outright or died more slowly in Stalin's Gulag. Marshák had not only his Jewish heritage but his foreign experience working against him, but he wrote in Russian rather than Yiddish, which granted him some cultural difference, and he had done wartime service for the state. He wrote, whether he realized it or not, not only to help save his homeland but to save his life. Not all these ironies were in play for the pertinent actors in 1944, but they are part of the context in which we can receive their joint product now.

It is notable, with this and other wartime cards, how far we are from the familiar tourist postcard. In the golden age of postcards, as David Prochaska has pointed out, "the sum total of all cards available from all publishers was intended to 'cover' the world, to constitute an archive of all possible places and people."[6] It was, as Ellen Handy puts it, "a kind of microcosmic recapitulation of the world through pictures, a containment, ordering and possession of the vast, multifarious, intricate, diverse messiness of the world at large."[7] Naomi Schor reports a similar phenomenon in her study of turn-of-the-century Paris postcards.[8] Their power is partly that of comprehensive seriality, of an effort to create a postcard simulacrum of the city—reconstructed as a totality, but differentially represented, with certain neighborhoods and monuments increased in scale. The wartime postcard—even when issued as a short sequence of three to six cards—never aims for coverage of any terrain or for ambitious seriality. There are no poem card series aiming for a comprehensive portraits of wartime Berlin or London, no poem card series designed to form maps of major battles. There are, on the other hand, no lack of single-poem postcards devoted to cities and battles. The wartime postcard consistently seeks essences, embodiments of first and last messages. The wartime postcard needs to say everything at once.

Perhaps Nikolai, who sent his poem home, was in battle later that day. Perhaps he confronted Germans who sent their own poem cards home. The Third Reich made over five hundred different poem or song cards available both to its troops and to civilians during the Second World War. They are consistently cheerful and upbeat. The German soldier enjoys his work, or so each correspondent is to suggest and each recipient to believe. Thus, on October 12, 1942, a woman who signs herself "Your Leni" writes from the German city of Mulhausen to one Private Gerol V. Wulben to send her best wishes. Her message is written on the back of a lieder card (song card) celebrating the achievements and capabilities of Germany's tanks (fig. 12.3). The words to "Panzer rollen in Afrika vor" are by an unknown soldier, set to music by the well-known composer Norbert Schulze (1911–2002), who also set "Lili Marlene" to music, wrote the scores for several Nazi propaganda films, and composed such aggressive tunes as "Bomben auf Engeland."

Across the Scheldt, the Meuse, and the River Rhine
The Führer's hussars cloaked in black
Rode tanks thrust into France
And took it by storm.
 The chains are still clanking…the motors hum…
 The Panzers are rolling through Africa!
 Our tanks are rolling through Africa!

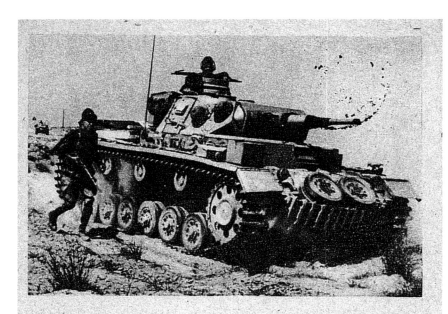

Panzer rollen in Afrika vor

Worte von einem unbekannten Soldaten

Musik von Norbert Schultze

Über die Schelde, die Maas und den Rhein
stießen die Panzer nach Frankreich hinein.
Husaren des Führers, im schwarzen Gewand,
so haben sie Frankreich im Sturm überrannt.
 Es rasseln die Ketten . . . es dröhnt der Motor . . .
 Panzer rollen in Afrika vor!
 Panzer rollen in Afrika vor!

Heiß über Afrikas Boden die Sonne glüht.
Unsere Panzermotoren singen ihr Lied!
Deutsche Panzer im Sonnenbrand
stehen zur Schlacht gegen Engeland.
 Es rasseln die Ketten . . . es dröhnt der Motor . . .
 Panzer rollen in Afrika vor!
 Panzer rollen in Afrika vor!

Panzer des Führers, ihr Briten habt acht!
Die sind zu eurer Vernichtung erdacht!
Sie fürchten vor Tod und vor Teufel sich nicht!
An ihnen der britische Hochmut zerbricht!
 Es rasseln die Ketten . . . es dröhnt der Motor . . .
 Panzer rollen in Afrika vor!
 Panzer rollen in Afrika vor!

12.3. "Panzer rollen in Afrika vor," German World War II poem card.

While the sun burns hot over African ground,
Our tank engines sing their song!
They are scorching hot and
Ready to take on England.
 The chains are clanking...the motors hum...
 Panzers are rolling through Africa!
 Our tanks are rolling through Africa!

Beware, you Brits, the Führer's tanks
Were made to destroy you!
They fear neither death nor the devil
And they'll break your arrogance at will.
 The chains are clanking...the motors hum...
 Panzers are rolling through Africa!
 Our tanks are rolling through Africa!

Whatever affection Leni has for Gerol, we may surmise, may now have become a supplement to her love for the tanks. And the Panzer card traveled the other direction as well—civilian to soldier, soldier to civilian—enabling lovers to meet symbolically tank to tank in mechanized frenzy. It is not only Hitler's hussars who ride on tanks; so too do poems. And German lovers project themselves into tanks to carry their messages to one another. Sometimes it was a song to the tank, sometimes a paean to the U-boat or a long-range bomber. Or a cheerful soldier might be pictured playing a musical instrument above the text, as if being at war was one long songfest on the campground.

The lyrics on these lieder cards are officially songs, not poems. The profession of literary studies has long tried to maintain a categorical distinction between the two. But we are in the domain of the popular, where poems are set to music to become songs and songs are reprinted without music to become poems. And for centuries popular poetry has been read aloud, the musicality of its rhymes and rhythms enhanced by the human voice. The same texts are read silently and read aloud. There were Germans alive at the end of the twentieth century who remembered reading the song to the Panzer Corps during the war, and others who remembered hearing it sung. Whether the distinction between song and poem has helped or hindered the profession is another matter, but it seems clear that for popular poetry and the postcard the distinction is disabling. But the fusion of the categories that I am urging also undoes deeper values. Not all songs are sung by angels. In Germany one can still find such happy-to-be-on-the-job lieder cards mailed back home by SS guards at Buchenwald, in arguably the darkest use of poetry our century has seen.

The Nazis began using poetry early in their quest for power. They would come to issue poems of fierce devotion to Hitler, but at first they also distributed somewhat less fervent texts designed to meet their political needs in the first half of the 1930s. A 1933 poem card was designed to link Hitler with the aging German president, Paul von Hindenburg (1847–1934). Long resistant to Hitler assuming power, especially in the absence of a clear majority vote for the National Socialist Party, Hindenburg finally agreed to Hitler becoming German chancellor in January 1933. On March 21, less than a month after the infamous Reichstag fire of February 27, Hitler and Hindenburg met on the steps of Potsdam Garrison Church prior to a major state ceremony and shook hands for photographers.[9] Among the postcards distributed to commemorate Hitler's chancellorship and cement public recognition of the symbolic bond between the two men was "Die Retter der Nation" (The Saviors of the Nation; fig. 12.4). Although the card was published on January 30,[10] immediately following von Hindenburg's agreement about the Chancellorship, my copy was posted in Berlin on July 7, which demonstrates that people kept using the card to join in the continuing celebration of Hitler's accession to power.

The German people can see the signs:
The shackles imposed by desperate need are falling off,
Bondage is giving way to the rising sun of freedom—
A new Germany welcomes a rosy dawn.

The shackles that were actually coming off were those limiting Hitler's freedom of action, but the poem helped the German people see them differently, as the collective national triumph over the multiple humiliations imposed after the country's defeat in World War I. On the card, Hindenburg, hero of the earlier war, and Hitler, six years later to initiate World War II in Europe, together bookend a Teutonic eagle. Meanwhile, Hitler had secured an emergency decree eliminating all constitutional freedoms for citizens, and the country had been subjected to months of Nazi violence against Jews and the political Left. Absurdly, it was Nazi violence that established the threat of public disorder that helped win public assent for Hitler's decrees.[11] In a speech carried on German radio shortly after he won legal warrant for the Gestapo to imprison at will without trial, the text of which was published in the *Deutsche Allgemeine Zeitung* on March 5, Hitler

declared, "Now you are no longer enslaved and in bondage; now you are free again."[12] His words were soon echoed on the poem card, but the poem does not duplicate the most virulent rhetoric of either Hitler's *Mein Kampf* or various Nazi party speeches. It is designed in part to help less passionately committed Germans rationalize the events of 1933, to facilitate their own inclinations to historical self-deception writ large. The poem is a model for the various ways ordinary citizens could articulate their identities to the rise of National Socialism without themselves beating Jews to death on German streets. The poem's simple rhymes pose compelling alternatives, the pink dawn echoing dire need but also replacing it. And so we learn that a political poem, far from being a culturally self-contained text, is articulated to a whole series of additional discourses and events.[13] Here a nation-state rapidly descending into criminality uses a poem to link its actions to natural figures of renewal and rebirth. Across the field of contemporary events in which it acts, the poem idealizes murder. And those who love poetry are given modest warrant to love death as well.

Yet the copy of the poem card I have was used in a still more complicated way. It was mailed from Berlin to one F. W. Michaelis, addressed here by his nickname Michel, at his address on Niebuhrstrasse in Charlottenburg, which is now also a part of Berlin. It was a fairly upscale community, which I point out because the message embodies a series of class markers. Both Michel and his friend Lutz who writes to him are Waffenstudenten, members of a dueling or weapons-carrying fraternity, perhaps Germany's most notoriously hypermasculine subculture. The fencing matches the fraternities sponsored celebrated a ritual slashing of the opponent's cheek, and the resultant scar was considered a badge of honor. Lutz is writing with anger about those who cannot honor the tradition (fig. 12.5): "Those who really are cowards never even become a Waffenstudent. The ones who purposely miss their aim in the duel have weak nerves; they are exactly the people who are supposed to be eliminated. We need real men, not 'nice' members, whether they have a Junker's estate or not. One could talk about this for hours—but not without a healthy Wurstbrot" (a Wurstbrot is an open-faced sandwich). Along the side of the card he addresses the illustrated poem on the reverse: "Excuse the corny card, I bought it from a beggar." And then he delivers the coup-de-grace: he signs the card "With greetings and Heil Hitler!" So the poem card operates as a kind of pivot point, by way of which he can confirm his superiority at once to the kitsch

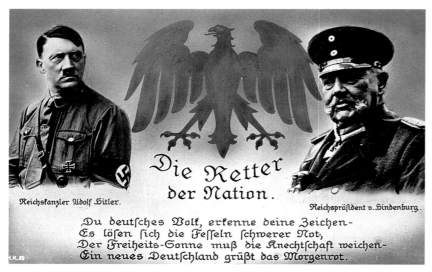

12.4. "Die Retter der Nation," 1933.

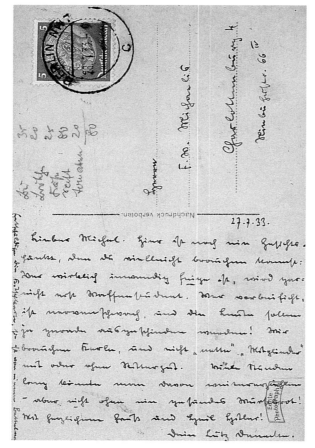

12.5. German handwritten letter between Waffenstudenten (verso of fig. 12.4).

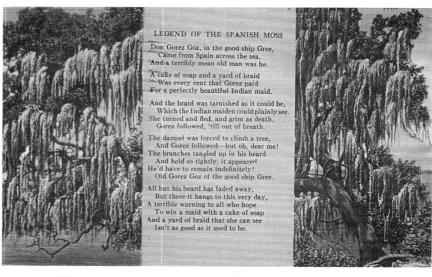

12.6. "Legend of the Spanish Moss," American World War II poem card.

accoutrements of mass emotion and popular authoritarianism[14] at the same time as he affirms the Führer from the vantage point of a member of a privileged caste. Whether he is a member of the Prussian aristocracy—the "Junkers" traditionally dedicated to a life of military service—is impossible to say, though he makes it clear they do not deserve his loyalty unless they adopt the warrior's code. By affirming the dueling fraternity, he cements a joint allegiance to a form of militarism as exaggerated as the one the card promotes, and he signals unwittingly that he is well positioned for the forthcoming slide into national madness.

Meanwhile the mails were carrying poem cards back and forth in other countries as well. Exactly a year before Nikolai Trushin sent his poem card home from a mountain valley in Russia—quite possibly in the Carpathian Mountains—Private First Class Ken Carpenter sent a poem postcard, postmarked July 30, 1943, home from Camp Blanding, Florida, to his wife in Meriden, Connecticut (fig. 12.6). Carpenter was training in the 366th medical battalion, probably as a medic, and thus was likely headed for service abroad. "Hi Sweet," he wrote, "Just a card to let you see what the moss in the trees look like. Someday we'll see it together." Carpenter had a large number of cards to choose from, but I am willing to guess that the exoticism of Spanish moss evoked, whether consciously or not, the exoticism of his current profession. It is an exoticism, a form of radical otherness, transferred to and shared within their marriage by way of the postcard. Spanish moss also suggests human hair, thereby turning the card into an intimate erotic communication, but one appropriately disguised for a card bared to postmen's eyes. Seeing the moss entangled is effectively a figure for intercourse. As it happens, the poem on the other side of the card, "Legend of the Spanish Moss," helps to sexualize the message:

Don Gorez Goz, in the good ship Gree,
 Came from Spain across the sea,
And a terribly mean old man was he.

A cake of soap and a yard of braid
 Was every cent that Gorez paid
For a perfectly beautiful Indian maid.

And the braid was tarnished as it could be,
 Which the Indian maiden could plainly see.
She turned and fled, and grim as death,
 Gorez followed, 'till out of breath.

The damsel was forced to climb a tree,
 And Gorez followed—but oh, dear me!
The branches tangled up in his beard
 And held so tightly, it appeared
He'd have to remain indefinitely!
 Old Gorez Goz of the good ship Gree.

All but his beard has faded away,
 But there it hangs to this very day,
A terrible warning to all who hope
 To win a maid with a cake of soap
And a yard of braid that she can see
 Isn't as good as it used to be.

This particular card was published by Tichnor Brothers in Boston, but there are other versions published by the E. C. Kropp Company in Milwaukee, the Curt Teich Company in Chicago, the H. S. Crocker Company in San Francisco, Deep South Specialties in Jackson, Mississippi, and the Asheville Postcard Company in Asheville, North Carolina. In the manner much beloved in popular culture, the poem is unattributed on the card sent by Private Carpenter. Anonymity may facilitate the appropriation of the image by the sender; there is no originary name in the way. Other cards, however, attribute it to "T.S.Y." "Legend of the Spanish Moss" is also a thoroughly and richly corrupted text. But legends cannot be copyrighted, so the story has been retold and revised in poem after poem. In some Captain Gorez makes no appearance, the couple instead being an Indian chief and his bride-to-be. When the chief dies in battle, his lover dies of grief. They are buried beneath an old oak tree, and her black locks are draped on the branches above. In time her hair turns gray and becomes the Spanish moss that tourists ill-advisedly stuff in their pockets and suitcases. As the handwritten note on one of the postcard versions I have points out, Spanish moss can be full of little red bugs that bite. In any case, in the total textual field generated by these multiple cards, the gender of the moss's source is reversible, its referents unstable.

These few poem postcards begin to give us a glimpse of how such ephemera were used during the lead-up to World War II and during the war itself, though the largest number of surviving postally used cards are actually from World War I, when thousands of different poem postcards were in circulation. The total number of poem postcards sent by soldiers and civilians in all the combatant countries can be conservatively estimated at well over a million.

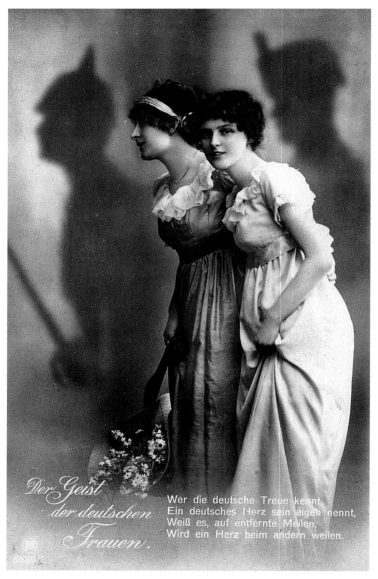

12.7. "Der Geist der deutschen Frauen," German World War I poem card.

Postally used cards present us with both a largely forgotten form of literature—the printed poem card—and the messages that soldiers and civilians wrote on them. For the recipients of the original cards, the message from a family member was almost certainly their first concern. For us, with those of the cards that are elaborately illustrated, the first impact is visual. The illustrations often initially dominate the gestalt of poem and image, and the illustrations—whether poignant, decorative, melodramatic, amusing, unsettling, or informative—are often striking and inventive. Early in the century the postcard was accepted as an art form in a number of countries; many wartime postcard illustrations embody that belief.

Even a simple black-and-white image can be compelling. Consider a First World War card from Germany: two women in a cautious, slightly crouched stance move forward while their inner devotions—their differently gendered doubles, their others in the realm of the nation-state—are cast as shadows on a screen behind them (fig. 12.7). It is an astonishing image: the women's shadows are men-at-arms. It is as if the German shadow soldiers in spiked helmets complement and complete the three-dimensional women. The profile of the lead woman roughly matches the profile of the shadow soldier before her, while the shadow of his sword comes roughly to rest in her hat, which holds a scoop of flowers. The women are lit from behind, but no simple light source would account for their shadow companions, for one shadow precedes the two women, while the other follows them. It is an inner light, the structural intelligibility of their identities, that creates this image and its eerie effects. In the midst of the war, this is now the structured form the gender system takes. The poem, "Der Geist der deutschen Frauen" (The Spirit of German Women), reinforces the image, perhaps suggesting that a wartime man and woman together make one person:

He who knows German loyalty
And calls a German heart his own
Will know that even over distant miles
Each heart will rest within another.

Yet the pairs are also paired. There are two women and two men. So these shadowed pairs exist in a collective world of serial duplication, the collective nation-state whose people are at war. And in this first—and ever thereafter unique—instance of total war, all civilian life is haunted by the half-life and the life in death of the trenches. The image of the shadowed women, haunted by men at war, linked inextricably to their fates, is partly strengthened by the poem, but the relationship

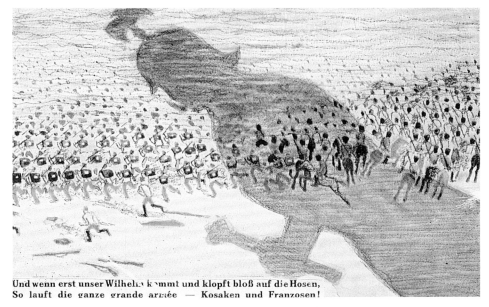

Und wenn erst unser Wilhelm kommt und klopft bloß auf die Hosen,
So lauft die ganze grande armée — Kosaken und Franzosen!

12.8. "Und wenn erst unser Wilhelm kommt," German World War I poem card.

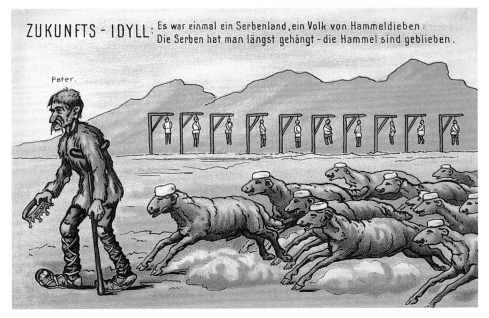

ZUKUNFTS - IDYLL: Es war einmal ein Serbenland, ein Volk von Hammeldieben:
Die Serben hat man längst gehängt - die Hammel sind geblieben.

Peter.

12.9. "Zukunfts-Idyll," German World War I poem card.

between the poem and the illustration is also uneasy. For the poem aims simply to testify to commitment sustained at a distance, whereas the illustration inflects commitment with possession.

The added use of color can provide an additional wartime service, making terror beautiful, or at least awesome. That is one of the effects of a card that aims for black comedy and braggadocio, as an immense shadow of the Kaiser falls over fleeing enemy troops: "Und wenn erst unser Wilhelm kommt und klopft bloss auf die Hosen / So l[ä]uft die ganze grande armée—Kosaken und Franzosen!" (When our Wilhelm arrives to give them a walloping / Both Cossacks and Frenchmen will all go galloping!). The greenish-yellow ground gives way to French infantry with red leggings on the left and Cossack cavalry on the right, but the red pants and brown horses largely disappear by the second row, for the color spectrum has succumbed to black, as everything gives way to the deadly force of the Kaiser's shadow (fig. 12.8). Granting violence a certain beauty was something of a German specialty. A card titled "Zukunfts-Idyll" (Future Idyll) focuses on Serbia's 1915 defeat in the war by combined German, Austro-Hungarian, and Bulgarian forces (fig. 12.9). A crestfallen King Peter I Karadjordjević of Serbia (1844–1921), his crown no longer on his head but held by his side, hobbles forward in his new role as shepherd. The couplet provides an explanation: "Once there was Serbia, a country of mutton thieves: / The Serbs were hanged long ago, but the mutton survives." In the background, ten gallows insist on the literal character of the violence, while the sheep wear little hats that tell us they represent what is left of the Serbian people. Although the card, therefore, combines literal and metaphoric violence, it renders it all in quite charming pastels, echoing the "idyll" of the title and suggesting all this grants a sugary pleasure to a German spectator. The cartoon violence of a card hailing the September 1914 German victory in the Battle of the Masurian Lakes, published by Selmar Bayer in Berlin, also presents itself to the eye as visual candy (fig. 12.10). Its luminous red and pink, framed by black, partially offsets the subject matter—drunken Russians drowning. Confused fighting amidst lakeland, swamp, and forest continued there through February 1915, with losses from exposure on both sides. The text turns it all into a celebration:

Hindenburg bravely
Sends the Russians to take a cure.
In the mud and moors of Masuria
They're stuck up to their ears.

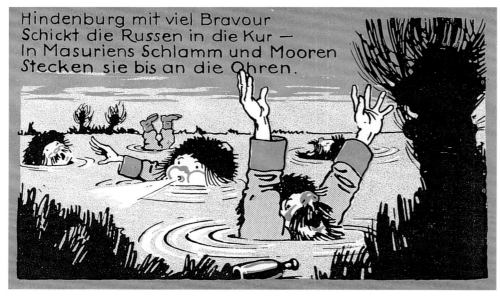

Hindenburg mit viel Bravour
Schickt die Russen in die Kur —
In Masuriens Schlamm und Mooren
Stecken sie bis an die Ohren.

12.10. Victory in the Battle of the Masurian Lakes, German World War I poem card.

This kind of postcard braggadocio enabled citizens and soldiers alike to share in triumphing over the enemy. Among the poem cards debunking or vanquishing Germany's Kaiser Wilhelm—and there were scores of such cards in Britain, France, Russia, and the United States—was a series issued by the firm Bamforth in Britain. Adapting traditional nursery rhymes and producing numerous original rhymed couplets and quatrains, Bamforth made the Kaiser an object of ridicule, built confidence in the certainty of his defeat, and subjected him to a slapstick-style form of violence (fig. 12.11). The Bamforth style was picked up both in individual cards, such as the Regent Publishing Company's "Click, Click, Click, Willy's Up the Stick," in which Wilhelm is a stick soldier in a red uniform (fig. 12.12), and in other card series, among them one offering variations on a British bulldog pursuing a German sausage (fig. 12.13), sometimes in order to preserve the honor of a British variety of sausage (Saveloy).

In both these series, the mix of repetition and variation is central, which is why it is preferable to reproduce a representative range of the cards, not just a single example.[15] There was a certain sense of security produced by the mix of familiarity and surprise, similarity and difference. A new card hailed a reader by activating and amplifying what he or she had already internalized, producing the sense of participating in a public chorus of rhyme and representation.[16] As one sender says on the card showing John Bull bayonetting the Kaiser in the rear, "You can see what it says on this card. Well I wish I was doing the same." Sent to Blackpool from Wakefield on August 23, 1916, it is signed "Grandma." The cards let everyone pick up a weapon. The circuit of reinforcements produced a far stronger result than a single image could have achieved. Wilhelm, as a result, was effectively turned into a cartoon character who could be bayonetted in the rear, sat on, and variously disposed of in ways that kept the reality of wartime violence at a distance.

The anti-Kaiser card that Grandma sent remains readable only in a very specific sense. We do not know who Grandma is and are not likely to be able to find out. Having her name would not necessarily help much. Of course, postcards do not arrive accompanied by convenient capsule biographies of the sender and the recipient. Moreover, the original correspondents most often know one another well enough so there is no need to provide any biographical context for the message to be comprehensible to them (as opposed to us).

I have been lucky enough, on a few occasions, to be able to reach a surviving relative and thereby learn more about the people involved in the original exchange, but that is the exception rather

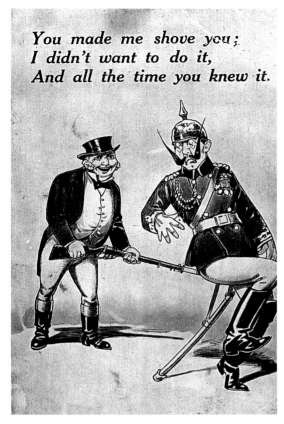

12.11. "You made me shove you," British World War I poem card.

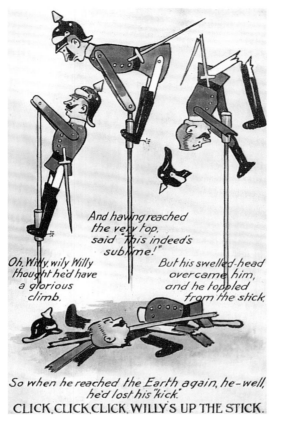

12.12. "Click, Click, Click, Willy's Up the Stick," British World War I poem card.

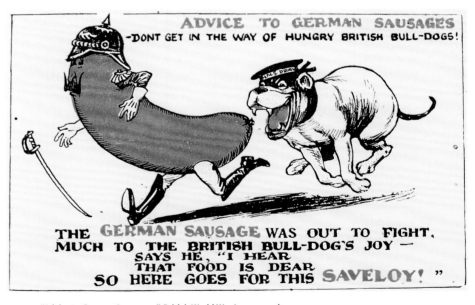

12.13. "Advice to German Sausages," British World War I poem card.

than the rule. When the cards give a sender's or recipient's full name, which they often do not, military records, census data, city directories, and other kinds of records will sometimes yield additional information, but even then, one is most often dealing at best with biographical fragments rather than detailed accounts of people's lives.

Most such cards were sent by working-class people who have left few traces in the historical record. Moreover, their messages, like postcard messages from all social classes, are most often fragmentary, though some messages, like the virtual prose poem by Nikolai Troshin that opens this essay, may seem more like self-sufficient texts, despite the fissures opened by uncertainties about message authorship. Yet when placed in the relevant historical context, even the more fragmentary wartime cards can speak to us in significant ways. In talking about them, one finds innumerable topics about which one simply must remain silent. Yet these fragments can also be powerfully evocative. The fragmentary nature of postcard messages is Jacques Derrida's focus in *The Post Card*. Derrida is persuasive about the substantially unreadable character of many postcard messages, but it is also possible to pursue what *can* be reconstructed from these artifacts, despite their being riddled with gaps, erasures, and unsolvable mysteries.[17]

More perhaps than any other form of communication, a postcard message foregrounds its fragmentary character. It is often like a single piece of a conversation whose other pieces have been lost. It never seems more than a *trace,* to use another term Derrida has popularized. We generally have to question our assumptions about presence and communicative coherence before we recognize that all linguistic performance is riddled with traces of multiple past meanings and that further interpretation generates still further semiosis. A postcard message, however, is clearly part of a larger life history whose details are unknown to us. A postally used postcard poem adds another level of complication, since it appears to combine textual coherence (the poem) with relative incoherence (the message). As these two texts, one printed, one handwritten, interact with one another, they may alter one another's import. Yet wartime cards are embedded in overriding powerful historical contexts, contexts that make otherwise fragmentary messages significant.

Although the contemporary recipients of wartime postcard messages are most likely to have experienced the authors of messages to be speaking for themselves—even when the messages

were clichés—for us at a remove of half a century or more, they speak for their generation. The erasure of interpersonal context is compensated for by the addition of a rich historical context. And the historical context is enriched by our knowledge of subsequent events. At the very least, a single wartime card is enhanced by our knowledge of the war as a whole, albeit itself a knowledge reshaped by the war's outcome and by the subsequent contest of interpretations.

Wartime poetry postcards (and earlier, envelopes) offer us unique—and largely unstudied—access to knowledge about how ordinary people actually used poetry over nearly two centuries. They thus, for the first time, give us detailed information about popular poetry and human agency. Although a small percentage of poem cards include texts by well-known authors, both canonical and popular—among them Dante, Shakespeare, Goethe, Heine, Kipling, Tennyson, Wordsworth, Tolstoy, Emerson, and Mayakovsky—the overwhelming majority are by unknown or little-known authors. Some poem cards, among them many Russian cards from World War I and romantic verses from all countries, are anonymous. Most of the poems reproduced on poem cards have been mentioned in no literary histories. Yet they were not only read but also used. People purchased them—often enough people who might never purchase an entire book of poems—sometimes wrote messages on them, and mailed them to friends, neighbors, or enemies.

Although information on print runs is scarce, it is clear that many cards were widely used and collected. Some poem cards were extensively advertised and marketed. Some wartime poem cards in the Soviet Union had regular print runs of fifty thousand copies and were regularly reprinted. After 1915 in France, individual printings of one hundred thousand copies of a wartime postcard were not rare, and such cards were sometimes reprinted.[18] The cards, as a result, offer powerful insights into the personal and social functions poetry has served in the modern world.

Do these cards, then, matter? Do they have historical weight, cultural and political consequences? One cannot reliably assign quantitative value to the influence poem cards wielded, but certainly no small effort was put into their production and distribution. By the time Germany entered World War II, to take one example, it had a major postcard industry with nearly fifty years of experience behind it. Like the firms that produced trucks and railway cars for the Holocaust, the postcard industry was pressed into service for the state. The production of over six hundred different poem and song cards is a significant piece of cultural work. Texts were to be revived or newly

written. Artists were employed to produce graphic images. State agencies supplied photographs. The entire process was overseen by Goebbels's propaganda ministry. The cards certainly helped define the sort of consensus the Third Reich sought; they were among the many ways the German state penetrated daily life. They distributed the texts of songs to be performed; they allowed citizens and soldiers at a distance from one another to urge these texts and their sentiments on each other.

Such poem postcards also force a reconsideration of what poetry mattered at the time. Among academics, a selective canon of ironic poems has come to stand in for the whole history of modern wartime poetry. The exceptional antiwar ironic poem is falsely constructed as characteristic, a consensus that reflects the taste of succeeding generations, not the deluge of poetry read during the war, most of which was either militaristic or romantic. Poem postcards give us a better picture of the roles poetry played in the Great Wars themselves.

That said, it is perhaps equally important to emphasize that many of these poems are by no means of high literary quality. While the study of popular poetry benefits from developing broader taste than that literary scholars have traditionally exhibited, it is hardly necessary to marshal the resources needed to take pleasure in a racist or fascist poem. The key issue here is historical interest, not literary merit. Part of what such poems teach us, however, is that it is a fatal error to dismiss influential or indicative texts on the basis of literary merit or even fundamental moral value. Poems that people read and shared and used need to be remembered and studied, not only because they tell us how literariness functioned outside high literary culture and within history but also because the lines of influence do not stop at the borders of the popular. The full cultural meaning of poetry was shaped by a wider range of poems than the academy has chosen to remember.

The anti-Semitic poem cards issued by the Nazis present the most unremitting challenge to the transcendent image of poetry widely promoted since the Romantics. The Nazis issued "Wenn alle Menschen Juden wären" (If All People Were Jews"), headlined "a thoughtful song," late in their struggle for power during the Weimar Republic (fig. 12.14). Some may recognize it as a precursor to American poet Ezra Pound's well-known—and apocalyptically obsessed—Canto 45, devoted to his belief that Usura, loaned money, destroys all natural inclination to creative labor:

If all people were Jews,
What would become of the world?
No grain would grow,
No plow would move through the fields,
No forester would tend the woods,
No miner would start his shift.
What's more, Jews don't like
To sail the seas.

The steamboat would never have been invented,
Nor would the train.
No dirigible would rise
Shining into the sky.
We wouldn't have gunpowder,
Nor electric lights.
For the Jew can barter,
But he cannot invent.

No nurse would set out
To treat the sick,
And if fire broke out,
No fire truck would come,
No lifeboat would leap across the waves
If mast and anchorage broke.
For the Jew always seeks help,
But he will not help others!

What can the Jew give,
He who has nothing,
Yet presumes to
Call himself "elect"?
Only the devil knows,
For he loves pride and arrogance.
Thank God there are still
Other people on earth!

Perhaps one may say that the first Holocaust poems were, in effect, produced by the Nazis themselves, though they were not poems of despairing witness but rather of demonic affirmation. In the shadow cast by such cards—arguably the darkest use of poetry our century has seen, as I suggested above—one may well wonder if Adorno was literally, not metaphorically, right that to write poetry after Auschwitz

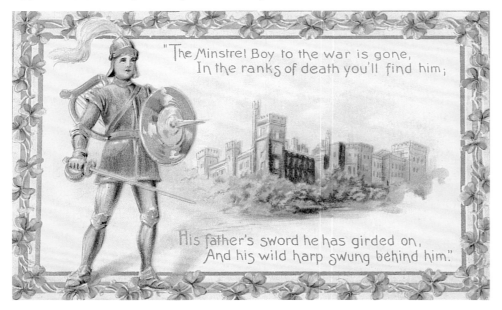

Wenn alle Menschen Juden wären . . .

Ein Volkslied zum Nachdenken.

Wenn alle Menschen Juden wären,
Was würde aus der Welt?
Kein Acker ständ in Ähren,
Kein Pflug schnitt mehr durch's Feld,
Kein Förster schritt im Walde,
Kein Bergmann mehr zur Schicht,
Auch auf dem Meer zu segeln,
Behagt den Juden nicht!

Kein Dampfschiff wär' erfunden
Und keine Eisenbahn,
Kein Luftschiff ungebunden
Stieg leuchtend himmelan;
Wir hätten auch kein Pulver
Auch kein elektrisch Licht,
Denn handeln kann der Jude,
Erfinden kann er nicht!

Zu unsrer Kranken Pflege
Käm keine „Schwester" mehr,
Und brennt es im Gehege,
Auch keine Feuerwehr,
Kein Rettungsboot flög brausend,
Wenn Mast und Anker bricht,
Stets braucht der Jude Hilfe,
Doch helfen will er nicht!

Was kann der Jude geben,
Dem selber alles fehlt?
Im frechen überheben
Sich selbst nennt „auserwählt"?
Der Teufel mag es wissen,
Der Stolz und Hochmut liebt,
Gottlob, daß es auf Erden
Noch andre Menschen gibt!

Max Bewer.

F. Berger in Horn.

12.14. "Wenn alle Menschen Juden wären," Nazi anti-Semitic poem card.

12.15. "The Minstrel Boy to the War has gone."

is obscene.[19] Was the genre so marked by its demonic uses that its myths of transcendence became a cruel joke? When people debate the meaning of Adorno's challenge, they usually wonder whether poetry's capacity for witness has been so decisively outmatched by the Holocaust that it cannot rise to the occasion, that the events are beyond description or understanding. Or they wonder whether the history of literariness serving the will to transcendence now speaks to a human capacity become meaningless. But we might also ask whether poetry can be corrupted by its own uses.

Such cards were different from other German poems not primarily in the texts they disseminated but rather in their capacity to offer large numbers of ordinary Germans the opportunity to help distribute anti-Semitic sentiments, to endorse the Nazi project by purchasing the cards cheaply and sending them to others. Like the poem postcard celebrating Hitler discussed above, this one comes not from World War II, but from the cultural and political struggles in Germany that were part of its prelude. Nazi anti-Semitic cards became perhaps even more vulgar once the war began.

The democratic countries, however, were not immune to certain other kinds of prewar indoctrination. For a modest but telling example of how we can be prepared for war, one may turn to the period between wars at the end of the nineteenth century—including the Spanish-American War and the Boer War—and the outbreak of World War I. During the interwar years, the work of the poetic postcard helped make fatal nationalism available to political leaders. Links between masculinity and sacrifice, between heterosexuality and the eroticization of military service, between imperialism and national identity, were all reinforced by poem cards willingly distributed from citizen to citizen.

So let me end with a haunting, lyrical fragment from the twentieth century's first interwar period. The card, issued by Raphael Tuck in its Shamrock series, is, to my taste, at least charming if not beautiful. A frame of beribboned shamrocks, the series signature, marks the outer edges of the card, but the minstrel boy stands forward of the frame, his plumed helmet waving jauntily in the winds that herald war, his bronzed shield untarnished (fig. 12.15). Romanticized castle battlements are in the background, but they are appointed with flowers, not lessons about whose interests the minstrel boy's death will serve. The card's text is the first quatrain of Thomas Moore's 1813 Irish poem "The Minstrel Boy":

The Minstrel Boy to the war is gone,
In the ranks of death you'll find him;
His father's sword he has girded on,
And his wild harp slung behind him.

Here again the card is partly a mnemonic device. And the poem has been set to music and sung or imitated by every generation since Moore wrote it. More recently, in World War I, the popular song "The ASC to the War Have Gone" used the same music and adapted the opening lines:

The ASC to the war have gone,
At the base at Havre you will find them,
Their shining spurs they have girded on;
But they have left their bayonets behind them.

Recite the lines and remember the rest of the original poem. Perform the poem on your tongue and in your memory and in your life. Is it not written that the minstrel boy shall go off to war? Is it not written that each generation faces its crisis of responsibility? The minstrel boy puts on his father's sword, so it is not just a weapon but an identity, a patrimony, and an imperative that passes from generation to generation. In Moore's poem, the dying minstrel boy destroys his Irish harp rather than see it fall to the enemy:

The Minstrel Boy to the war is gone,
In the ranks of death you'll find him;
His father's sword he hath girded on,
And his wild harp slung behind him.
"Land of song!" said the warrior bard,
"Tho' all the world betrays thee,
One sword, at least, thy rights shall guard,
One faithful harp shall praise thee!"

The Minstrel fell! But the foeman's steel
Could not bring that proud soul under;
The harp he lov'd ne'er spoke again,
For he tore its chords asunder;
And said "No chains shall sully thee,
Thou soul of love and brav'ry!
Thy songs were made for the pure and free,
They shall never sound in slav'ry!"

Although "The Minstrel Boy" has been repeatedly performed in wartime—it was popular, for example, among Irish soldiers in the U.S. Civil War—here it is not wartime nationalism, cultural identity, and solidarity that are at stake, for it was sent by one "Evelyn," from Carleton Place to Rideau Ferry, in Ontario, Canada. On March 16, 1910, she hails her cousin Les with "just a few lines from a little Irish girl." And so it is that we were ready to enlist again.

CHAPTER THIRTEEN

...

POSTCARD TO

...

MOSCOW

...

...

John O'Brian

You give us those nice bright colors,
You give us the greens of summer,
Makes you think all the world's a sunny day.
—PAUL SIMON, "Kodachrome"

In the mid-1950s, the protocols of the Cold War were still being worked through. During the Formosa crisis in 1955, factions within the Eisenhower administration argued for deploying nuclear warheads against an Asian nation for the second time in a decade.[1] The split between the Chinese Communists and the Chinese Nationalists had escalated into military attacks and counterattacks, and the United States was alarmed at the spiraling intensity of the conflict. President Eisenhower feared that if Formosa (now Taiwan) fell, its loss would "seriously jeopardize the anti-Communist barrier... in the Western Pacific."[2] The anxiety of the Eisenhower administration over the Formosa crisis came close to leading the United States into a war against mainland China. In a bellicose speech delivered on March 20, Secretary of State John Foster Dulles announced that if war were necessary, the United States would deploy nuclear armaments, "new and powerful weapons of precision, which can utterly destroy military targets without endangering civilian centers."[3] Dulles was not afraid to engage in nuclear brinkmanship. He was the "original misguided missile," in the opinion of Democratic Senator Henry Jackson, "traveling fast, making lots of noise, and never hitting the target."[4]

Dulles's disclaimer about Chinese civilian populations being unharmed by nuclear weapons of mass destruction, as they are now routinely called, was never tested. In the end, Eisenhower resorted to diplomacy instead of bombs, but not before the world was forced to fix its eyes on the Doomsday Clock. Even though China possessed no nuclear weapons of its own with which it could have retaliated against the United States—it did not conduct its first atomic test until 1964—the Soviet Union by 1955 had assembled an arsenal of two hundred nuclear warheads. Had the United States detonated an atomic bomb over the outskirts of Beijing, the attack would have been read in the Soviet Union as a radioactive postcard to Moscow. Dulles, it seems, was not averse to the specter of Armageddon.

Fifty years later, as the United States began to develop a new generation of nuclear weapons and to withdraw from nuclear arms treaties it negotiated during the Cold War, the period of the Formosa crisis is worth reflecting upon. The protocols worked out during the Cold War by the Eastern and Western blocs to contain the possibility of nuclear annihilation no longer pertain. A new nuclear age has

arrived, characterized by the proliferation of nuclear capabilities, a reconfigured nuclear arms race, and only slightly rejigged forms of official insanity.

Even before the attacks of September 11, 2001, and the Iraq invasion of March 2003, that intense span of superpatriotism in the United States, the Bush administration had begun revising the American policy on nuclear weapons. Three months after the suicide bombings of the World Trade Center towers, the United States withdrew from the Anti-Ballistic Missile Treaty, the landmark agreement it signed with the Soviet Union in 1972 to formalize the principle of "Mutual Assured Destruction" (MAD) as a means of inhibiting nuclear war. At the same time, it campaigned to erase ethical distinctions between nuclear and conventional weapons, never secure at the best of times, advocating the use of nuclear weapons in both preventive and preemptive attacks.[5] The Nuclear Posture Review leaked in 2002 called for the development of low-yield nuclear weapons, so-called mini-nukes, such as the Robust Nuclear Earth Penetrator, to burrow deep into the ground before detonating, for use in war against rogue states such as Iran, North Korea, Syria, and the now-rehabilitated Libya. Nineteen billion dollars was assigned to the Department of Energy to develop the weapons.[6] The threat of radioactive postcards had been revived.

At the time of the Formosa crisis, the protocols for representing the Cold War visually were also being worked through. Nuclear blast postcards and photographs made during the first two decades of the Cold War, especially blasts reproduced on American color postcards published in the 1950s, form the central interest of this essay. The postcards surfaced from oblivion when I was assembling an archive on shifting American responses to nuclearization. Although I am wary of these postcards and photographs, unsure of their excesses and of their logic, I am convinced they have something to say about photography and post–Cold War developments, as well as about photography and Cold War ideologies and anxieties at the time of their making. There is a substantial literature on atomic imagery and its dissemination, but nothing on the postcard's supporting role in underwriting a public image of the bomb. The lacuna has consequences for how the protocols of nuclear representation should be understood. The atomic postcard is a product of tourism—in this case of memories constructed in miniature—and its modes of address and reception differ from those of mass-circulation magazines or photographs exhibited in art galleries. Categories of atomic photography may overlap, but the fit from one category to the next is not precise.

In this essay, I hope to bring the atomic postcard within the orbit of nuclear visibility, and at the same time to discuss similarities and differences between it and some other forms of atomic representation. Are there historical meanings that can be attributed to atomic postcards, for example, but that cannot be attributed to other forms of nuclear imagery? To what degree was the imagery of atomic postcards controlled and edited by American authorities for public circulation? Did the deployment of color, notably the intense chromatic properties of Kodachrome, alter how the images were read at the time of their initial distribution? What themes were inscribed in the handwritten messages on the backs of the cards carried from sender to receiver? In short, what were the conditions under which atomic postcards were produced and received? My discursive answers to these questions draw on a range of visual and textual material from the 1940s to the 1960s, in particular a 1955 photograph taken not far from the Nevada Test Site by Robert Frank. I will conclude with an analysis of three color postcards dating from the early to mid-1950s.

The Nuclear Landscape

While President Eisenhower was deciding whether or not to bomb China, the uprooted Swiss photographer Robert Frank was producing a black-and-white photograph of a souvenir postcard rack, set on a worn plywood shelf outside a store near the Hoover Dam in Nevada (fig. 13.1). The photograph shows nine sets of color postcards on a triangular revolving rack, of which the fronts of only three are visible. The cards are selling for ten cents apiece, the cost of top-of-the-line color cards at the time. In ranked descending order, the three cards offer a generic view of the Grand Canyon, the Hoover Dam itself—pictured with the American flag at the dead center of the image—and an atomic explosion mushrooming over ground zero to the west of the canyon and the dam (fig. 13.2). On the left side of Frank's photograph, fragments of words and numbers struggle to announce the cost of a "Pictorial Tour of the Dam" for thirty-five cents, and in the background an automobile, no less a symbol of American industrial progress than the Hoover Dam, is parked at an angle on the tarmac.[7] The automobile's right front light and license plate are cut off by the middle postcard, making it seem one-eyed—not unlike the camera recording it—and stateless—again, not unlike the camera.

Frank executed the photograph in 1955 while driving across the United States on a Guggenheim Foundation grant, an excursion that resulted in his 1958 book *The Americans*.[8] He photographed

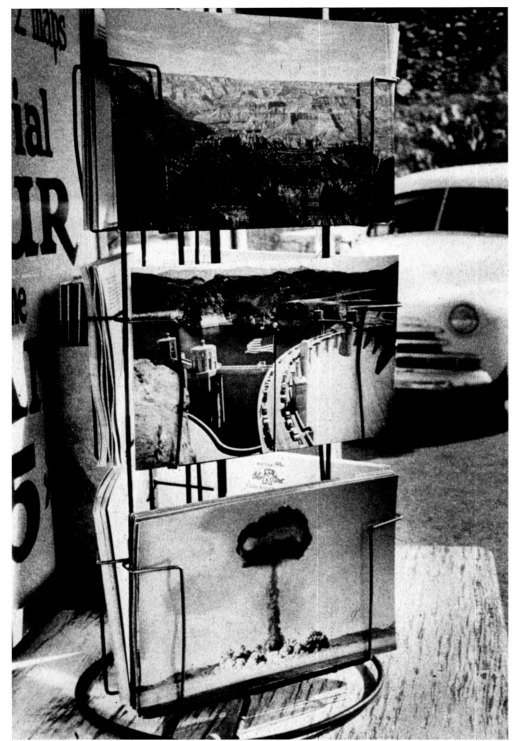

13.1. Robert Frank, "Hoover Dam, Nevada, 1955," gelatin silver print. © Robert Frank.

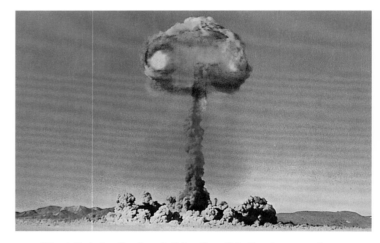

13.2. "Atomic Explosion: Frenchman's Flat, or Yucca Flats, Nevada, ca. 1955," Kodachrome postcard.

other postcard stands during his journey, but was so drawn to the Hoover Dam rack that he shot five negatives of it from slightly different viewpoints.[9] He did not print any of the five for inclusion in the book, though he had originally considered them. He edited them out, possibly because he considered their connotations too emphatic, and therefore inconsistent with what he wished to convey in the volume. I am not sure that he was correct in that assessment. *The Americans* is underwritten by the signs and signage of everyday life, not unlike the work of Walker Evans before him and William Eggleston after, and the photographs are redolent with both. They are what the photographer and critic Nathan Lyons has described as "social landscapes," which is to say, photographs that take a self-consciously ironic and critical approach to documentary material.[10] They even include the aforementioned flag, the bunting of American patriotism, which is a recurrent motif in *The Americans*.

Since it was first published in 1972, Frank's *Hoover Dam, Nevada* and its variations have attracted substantial commentary.[11] This may be in part because the photographs are photographs of other photographs, sequenced in a way that invites narrative interpretation. It is possible that Frank altered the sequence, and hence the narrative, himself. Although the postcard sequence looks random, the photographer may have reshuffled the deck, changing its order by sleight of hand. What looks like a chance arrangement may be carefully deliberated. But even if the arrangement were carefully deliberated, it remains difficult to find a single, stable narrative in the photographs. Instead, the sequencing tells many narratives; the photographs are plural representations.[12] The published stories and readings that have been given to the images attest to their unfixity, and extend from the historical to the sublime to the apocalyptic.

According to several readings, the photographs are an encapsulation of the changing American West in the 1950s. They represent the impact of postwar modernity on the contemporary uses of the landscape, in which the sequential organization of the cards puts forward a commodified touristic panorama, a source of energy for human consumption, and "the figurehead of the exuberant new Atomic Age."[13] Another reading sees them as representations that combine the imagery of nature worship, patriotism, and mushroom-cloud symbolism to produce the "atomic sublime."[14] In this reading, the manufactured destructive force of the bomb and the material histories that accompany it are subsumed beneath the colors and shapes of the mushroom cloud. Yet another understands them as a metaphor for the United States—its hopes, realities, nightmares—that offers viewers a choice between unadulterated nature, industrial advancement, and nuclear catastrophe.[15] And a further reading views them as an elliptical narrative of potential catastrophe, turned comically upside down.[16]

The comedy identified in Frank's photograph strikes me as leaning in the right direction. It seems to me that by having the story of nuclear annihilation played out by postcards on a stage made of plywood, a roadside stand, Frank's images situate themselves as prime expressions of postwar absurdity. Samuel Beckett's Vladimir and Estragon would not be out of place waiting and watching at this American roadside stand. What we see is a flimsily mounted nuclear drama presented for the pleasure of tourists who may not come, and if they do come, may not appreciate the absurdity of what has been staged for them. The small built-in archive of postcards in the photographs was, of course, assembled in the shadow of Hiroshima and Nagasaki, a tragedy only ten years past, while down the road at the Nevada proving grounds nuclear weapons many times more powerful than those detonated in Japan were being tested. Here in the American Southwest, as Marx commented about the Second Empire, history was repeating itself as farce.

The photograph derives part of its complexity from the juxtaposition of postcard imagery and residual war imagery. The tension is between the message of "wish-you-were-here" and the message of "glad-you-are-not-here." In the sense that a postcard connects a receiver-subject to an object-sender, Jacques Derrida observes in his book *The Post Card*, it is a materialized form of a Lacanian screen.[17] The image on the front of a card comes in the form of a proposition, according to Derrida, deciphering the receiver in advance of its arrival. The preexisting group of symbols of nature, engineering, and atomic force that constitutes the "screen" projected onto viewers in Frank's photograph, by this reading, deciphers viewers before they encounter it. Above all, they are constructed by the mushroom cloud. (It is worth remembering that mushrooms can be either nutritious or poisonous, and the spores they throw, like the radioactive isotopes emitted by atomic explosions, are invisible.)

By shooting with monochromatic film, Frank converts the compulsively overheated Kodachrome palette of the postcards into the tonal properties of a black-and white-photograph. Or, to put it in terms of photographic aesthetics, he converts the high-chroma imagery of the American consumerist vernacular into the monochrome contrasts and shadings demanded by art photography in his era.

Whatever else it was in the 1950s, art photography was not rainbow-colored, and Frank had no desire to contravene the dominant aesthetic of black and white. Even Walker Evans, who sometimes deployed color in his photographic work for *Fortune* magazine after the war, decried the "screeching hues" that in his opinion debased most color photographs. They were, he said, a "bebop of electric blues, furious reds, and poison greens."[18] In the years leading up to the war, color had become coded as the photographic medium particular to Madison Avenue and popular magazines. It was associated with a commercialized vision of modernity, and such a vision was anathema to serious photography.[19]

Color television, after it was introduced in 1954, was also associated with a commercialism mistrusted by serious photographers. The corporations involved in developing the medium, which included General Electric and Westinghouse, were the same corporations receiving defense contracts to develop the American nuclear program. As Joyce Nelson points out, "the twinned ideological interests" of the corporations intersected where television sets and warheads met.[20] Both devices emitted massive levels of ionizing radiation, levels denied both by the corporations and the government. Some television sets manufactured by General Electric gave off one hundred thousand times the recommended standard.[21] Corporations also commissioned made-for-television films on the benefits of nuclear power, which they then provided free of charge to domestic television stations. In the decade or so after President Eisenhower's "Atoms for Peace" speech in 1953, which promoted "the sunny side of the atom," nuclear postcards and films such as *The Atom Comes to Town* (1957) and *The Atom and Eve* (1965) were common fare (fig. 13.3). The latter film promoted nuclear-generated electricity for the home by following a housewife through the now-made-easy tasks of her electrified day, all of it presented in living color.[22]

Atomic Visibilities

"Black and white is the vision of hope and despair," Robert Frank wrote. "This is what I want in my photographs."[23] In a peculiar way, *Hoover Dam, Nevada* draws color and monochrome photography together, just as it draws popular and art photography together. The image critically appropriates three postwar color postcards, commonly known in the trade as chromes, as signifiers of the present. Both the postcards and Frank's photograph, I would suggest, are also signifiers of the current nuclear era.

Writing shortly after the Cuban Missile Crisis, Marshall McLuhan observed in *Understanding Media* that "if the cold war in 1964 is being fought by informational technology, that is because all wars have been fought by the latest technology available."[24] Color photography is as much a medium of informational technology as monochrome photography, and it is important to recognize that both participated in the ideological conflicts of the time. Photography symptomatically engages the technological with the social.[25] You would be hard-pressed, however, to discern any acknowledgment of such a symptomatic engagement in reviews of a 2003 book of photographs devoted to nuclear test explosions. This is partly because the book presents itself as a coffee-table volume, notwithstanding the useful information it contains. Entitled *100 Suns* and written by the artist Michael Light, the book reproduces one hundred photographs of atomic test detonations, many in double-page spreads, conducted from 1945 to 1962 on the atolls of the South Pacific and in the deserts of New Mexico and Nevada. Of the 216 atmospheric tests conducted by the United States, *100 Suns* documents 69. The photographs have been drawn from the U.S. National Archives and the archives of the Los Alamos National Laboratory and include formerly classified material taken by a secret unit of film directors, cameramen, and still photographers based at Lookout Mountain Air Force Station in Hollywood.[26] The startling revelation that Hollywood was "at work in the fields of the Bomb," to borrow Robert Del Tredici's evocative phrase, demonstrates that from the outset the American entertainment machine was training its cameras not only on fictive but also on actual weapons of mass destruction.[27] Working with the U.S. Army and the Atomic Energy Commission, Hollywood helped to mediate how atomic tests were received visually.

As one might expect, Hollywood performed its task with an emphasis on cinematic production values and with a flair for the melodramatic. The photographs, or at least those edited down for inclusion in the book, frame the nuclear age in terms of grand spectacle. A notice on the book in the *New Yorker* follows the lead suggested to it by *100 Suns*. It gives a whole page to one of the most aesthetically compelling photographs, "Climax, 61 Kilotons, Nevada, 1953," but only a few sentences to the book itself (fig. 13.4). The illustrated photograph represents the blast shortly after detonation, showing the white cloud of the mushroom cap about to meet its orange-gray stem. The rising smoke trails on the left are from rockets fired for the purpose of making photographic measurements of shock waves. The magazine notice comments that "the apocalyptic visual narrative in '100 Suns' escalates…to the over-the-top splendor of Wagnerian nuclear sunsets on the Enewetak and Bikini atolls."[28]

13.3. "Atoms for Peace," 1955, postcard.

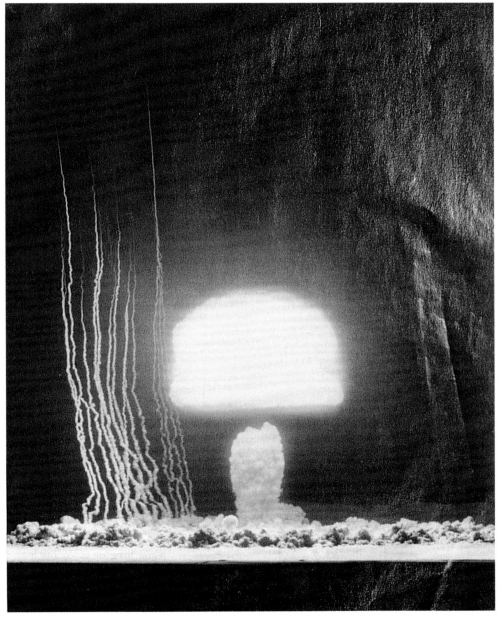

13.4. "Climax, Operation UPSHOT-KNOTHOLE, June 4, 1953," Nevada test site.

The *New Yorker*'s linking of visual apocalypse to Wagnerian Sturm und Drang is part of a narrowly circumscribed tradition of atomic visibility. The photographic spectacle is the main story, the text a sidebar. If it were not for the elevated prose style of the *New Yorker* article, it could be mistaken for a *Life* magazine article on the same subject from September 12, 1949, entitled "Biggest Atomic Explosions," in which blast photographs, including a full-page color spread, are accompanied by a brief notice on the measurable force of the latest A-bombs. Frank's *Hoover Dam, Nevada* breaks with that tradition, as does the work of a small number of other photographers and photo-based artists such as Peter Goin, Emmet Gowin, Richard Misrach, and the members of the Atomic Photographers Guild.[29] The same can be said for Harold E. Edgerton's rapatronic photographs of nuclear explosions, many of which have been published and exhibited only recently.[30] But the conventions of how atomic weapons are represented are deeply entrenched. As Scott Kirsch demonstrates in his article "Watching the Bombs Go Off," the "flash and bang" of atomic photographs separates the spectacle from the socially produced environment in which it occurs. It takes "*place* out of the *landscape*" (Kirsch's emphasis).[31]

The iconography of atomic explosions began with the first detonation, at the Trinity test site in Alamogordo on July 16, 1946. Approximately one hundred thousand photographic exposures were taken of the explosion, and all but a few of those that survived were in black and white. Those in color blistered and solarized from the heat and light. The only color images to escape immolation were made by Jack Aeby, a technician in a Los Alamos research group charged with setting up radiation detectors near the detonation tower, who subsequently gave a symbolic copy of his most successful print to Enrico Fermi, the Italian-born physicist responsible for obtaining the first self-sustaining nuclear chain reaction in Chicago in 1942.[32] Aeby's photograph was released to the media shortly afterwards. It was published as the front cover of the *New York Sunday Mirror* tabloid, with the following caption: "Atomic Bomb Burst That Changed the World: First Color Photo!" (fig. 13.5). At least the tabloid recognized that something *historic* had occurred, which was not always the case at the time. A sizable contingent of commentators preferred the kind of rhetoric favored by J. Robert Oppenheimer and William L. Laurence.

After witnessing the explosion, Oppenheimer, head of the Manhattan laboratory in Los Alamos and a practiced prose stylist, quoted from the *Bhagavad Gita:* "If the radiance of a thousand suns

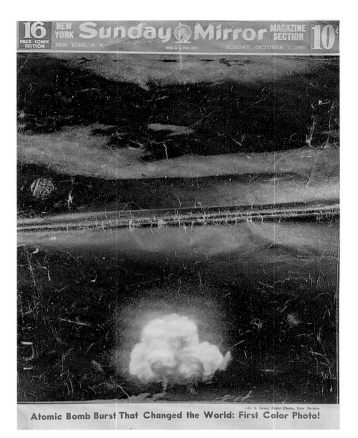

Atomic Bomb Burst That Changed the World: First Color Photo!

13.5. *New York Sunday Mirror,* October 7, 1945.

were to burst forth at once in the sky, that would be like the splendor of the Mighty One."[33] And Laurence, the *New York Times* science reporter who flew on the Nagasaki mission and became known as "Atomic Bill" for his devotion to the nuclear beat, said it was "like being present at the moment of creation when God said, 'Let there be light.'"[34] As I. F. Stone has observed, such references to God were an indication that "Faith in an overwhelming force [was] being made into [the United States'] real national religion."[35]

Nuclear tests are almost always presented and received as spectacles of transcendent nature—sometimes divine, sometimes malign, sometimes benign—rather than as planned events that include scientific evaluations of manufactured weapons produced by human engineering. The desire for transcendence is, it seems to me, consistent with the American pursuit of Manifest Destiny in the nineteenth century, when the sublime gave visual form to the political agenda of westward expansion while effacing acts of dispossession. The so-called atomic sublime represented in blast photographs is

an extension of Manifest Destiny carried into the politics of the Cold War, into the agenda for capitalist expansion under the protection of the Pax Americana, though it is rarely stated in such blunt terms. Relatively few images circulate of the extensive preparations leading up to a detonation or of the aftermath on the ground once the clouds have dispersed. Like photographs of flag-draped coffins of American soldiers returning from Iraq, they have been edited out of atomic visibility by government censors.

The meta-symbol of the nuclear spectacle is the "mushroom cloud." It is the logo of logos in the nuclear age. The shape of the cloud, which is made up of vapor, steam, soot, smoke, and at the crest ice crystals, was sometimes referred to at the beginning as a "cauliflower cloud," especially in relation to underwater tests, as well as a mushroom cloud.[36] The cauliflower metaphor did not stick. How the photographic iconography of the mushroom cloud became "firmly embedded in the consciousness (or, more accurately unconscious) of an age" has been examined by Peter B. Hales.[37] As the mushroom cloud became iconic, Hales argues, photographers began timing their exposures "to produce the most spectacularly moody and impressive skies."[38] While Hales's general argument holds up, he is mistaken about the procedures of the photographers. Tens of thousands of photographic exposures were taken of each test explosion as a means of verifying the scientific stages of the blast, and only a tiny fraction of them were of grandiose skies. It was the U.S. Atomic Energy Commission and not the photographers that decided mushroom-cloud images would be released to the national media as the recurrent symbol of the nuclear program.[39]

Nuclear testing and the development of increasingly sophisticated camera and film equipment to document what otherwise could not be recorded went hand in hand. Operation Crossroads in 1946, the first Bikini Atoll tests and a staged media event with the world press in attendance, was mounted to dispel reports about the dangers of radiation. Seven hundred and fifty cameras were deployed. Among them were the world's largest still camera, with a forty-eight-inch focal-length telephoto lens, and an ultra-high-speed motion camera capable of shooting ten thousand frames per second. "The multiplicity of cameras was necessary to insure full records of results," the Office of the Historian, Joint Task Force One stated, "particularly damage results."[40] A sizable number of these photographs were released for public consumption; there was even an "official pictorial record," containing several hundred before-and-after images, in the form of a widely circulated book.[41] The two color photographs reproduced in the book, one as the dust jacket and the other as the frontispiece, are of mushroom clouds. It was the last time the Atomic Energy Commission was so free with its photographs. In the future, the few—the very few—photographs selected for general release tended to be of "moody and impressive skies." Such images helped to secure the spectacle as iconic—and safe.

The Second Nuclear Age

The past does not reorder itself into words, Walter Benjamin once remarked, but breaks down into images that flash up at moments of danger. Since the turn of the millennium, images of nuclear explosions that had for a time receded into an invalid region have been flashing up in the global mind. Hence the publication of *100 Suns* and the *New Yorker*'s notice about the book, and perhaps the desire to aestheticize the danger represented by the images in the volume. The acceleration of a new nuclear arms race, along with the American plan to conventionalize nuclear weapons, has been designated "the second nuclear age" by Bill Keller, in a *New York Times Magazine* article of the same name.[42] The nuclear genie has escaped the bottle for a second time, and it is unclear how and when it will be recorked. John Bolton, American undersecretary of state for arms control and international security in the first Bush administration, was the official initially charged with driving the agenda for conventionalizing atomic weapons. His appointment was endorsed by Senator Jesse Helms, who stated at the time of his nomination in 2001 that "John Bolton is the kind of man with whom I would want to stand at Armageddon... for the final battle between good and evil."[43] The American penchant for viewing nuclear holocaust as an egress to spiritual redemption, in which the sheep will be sorted from the goats and sinners consumed by fire, was alive and well in Washington, D.C.

Helms's invocation of Armageddon did not raise many eyebrows within the Bush administration. Condoleezza Rice, President Bush's national security advisor at the time, supported Bolton's policy initiatives and hard-line stance on North Korea and other rogue states by commenting, "We don't want to wait for the mushroom cloud."[44] Even though photographs of American atmospheric tests producing the mushroom cloud all date from before 1963 and the signing of the Limited Test Ban Treaty on October 10, no one misunderstood the drift of Rice's comment. Nor did they misunderstand the visual iconography it evoked, an iconography that remains frozen, strangely contained

by Cold War conditioning. This is not to say that the attitudes of the American public to nuclear weapons have been unchanging. On the contrary, they have been highly unstable over the past sixty years, swinging wildly between the extreme of loving the bomb as a guardian shield and of fearing it as an apocalyptic avenger.[45] What has not altered is nuclear iconography.

"Photography is a system of visual editing," John Szarkowski has observed.[46] Mass-media photographic representations of nuclear detonations have entailed visual editing with a vengeance. Less vengeful editing is possible, of course, as indicated by the self-reflexive work of the photographer William Eggleston, about whom Szarkowski was writing when he made his remark. Eggleston's Los Alamos series of photographs, produced between 1964 and 1974, calls up radioactive thoughts without referring to the sublime or the transcendental or even the Los Alamos National Laboratory and its part in the production of atomic weapons. In one of the photographs, now collected in a book of the same name as the series, there is a painted sign warning passing motorists of a school zone.[47] The sign is part red text, part black-and-white startled child, and it is placed in shadows cast by trees falling across an empty sidewalk. It gives one pause: the sign blocks the beholder's view down the street, but to what purpose? Where, one might ask, have all the children gone? In another, stains disfigure the freshly tarmacked surface of a parking lot, streaking from beneath a car. They may be from an overflowing, leaky radiator, or maybe not; perhaps the staining fluid is more toxic. The frontispiece is an untitled photograph of rising cumulus clouds set against a deep blue sky, an innocent skyscape, so it appears, except that the shape of the clouds conjures up the Los Alamos National Laboratory.

Postcards at the Edge of Danger

The regulation of photographic meaning is controlled by framing devices. Sometimes such devices are deployed with historical rigor, more often they are not. By pairing framing devices with "historical rigor," I mean to emphasize the photographer's (or editor's or publisher's) critical engagement with the varied practices of the medium, not excluding the selection of subject matter, such as nuclear landscapes. Processes of enframement encompass not only the selection and visual editing of individual images, but also the selection and arrangement of groups of photographs that are presented in books, such as The Americans by Frank or Los Alamos

by Eggleston, or in exhibition spaces, such as those of the Museum of Modern Art, New York, or in popular magazines, such as Life. Ways of seeing the bomb shape ways of knowing it.

Variations on the mushroom-cloud form reproduced on postcards during the 1950s helped Americans to know the bomb as a spectacle rather than as an agent of destruction (fig. 13.6). The postcards on the metal rack photographed by Robert Frank were manufactured in Berkeley, California, by Mike Roberts Color Production, using a Kodachrome process, and were distributed by the Desert Supply Company, Las Vegas. The information is printed on the reverse side of the atomic card, which is no longer in production but may be purchased with persistence on eBay, under the category "Militaria." The postcards come in two sizes, regular and jumbo.[48] The bottom card on the rack is the jumbo card "Atomic Explosion: Frenchman's Flat, or Yucca Flats, Nevada," and customers of the time who wanted to reorder it were supplied with the stock number J563 printed on the reverse side, in which the "J" stands for "jumbo." A small textual slice on the back of one of the cards is just legible in Frank's photograph. Squeezed between the concrete buttress of the Hoover Dam in the middle card and the nuclear fireball in the bottom card are the words "Natural Color Card from Kodak." The legend on the postcard reads: "One of the many atomic detonations that have been released in the large Atomic weapons testing area of Southern Nevada."

Nowhere on the postcard is there any information about which atomic test is represented or which official body released the image for public use. This heightens the image's detachment from reality, its removal from Hiroshima and Nagasaki, its distance from the American program of building a larger and deadlier arsenal of nuclear weapons than that possessed by the Soviet Union. The image was almost certainly sold to Mike Roberts Color Production by the U.S. Army Photographic Signal Corps under the aegis of the Atomic Energy Commission, but even now the particular test represented remains unidentified. The authorities refused even to say whether the explosion was at Frenchman Flat or Yucca Flats, Nevada. The emphasis is on spectacle at the expense of information and discussion. This was part of the Atomic Energy Commission's stated strategy in 1950 "to make the atom routine in the continental United States and make the public at home with atomic blasts and radiation hazards."[49]

The image on the postcard is unlikely to have been from Operation Ranger, undertaken on January 27, 1951, which consisted of the first five tests conducted on the American continent since the Trinity test at Alamogordo in 1945. Two days after completion of the tests, snow fell on the Eastman Kodak Company in Rochester, New

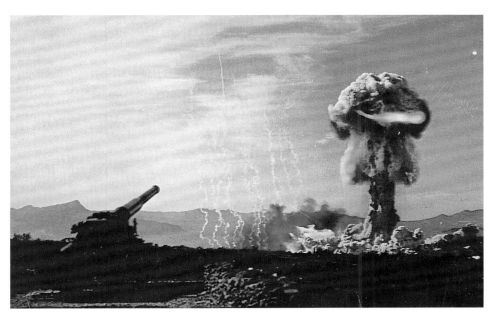

13.6. "Atomic Cannon and Nuclear Test, 25 May 1953," Shelton Color Process postcard, Hackensack, New Jersey.

York, depositing a white radioactive blanket on its film-manufacturing plant. Photographic stock was ruined.[50] The company traced the fallout to Operation Ranger, more than eighteen hundred miles away to the southwest. Eastman Kodak considered suing the government, but instead struck a deal that provided it with privileged information about future tests. There are no postcards of the plant at the time of contamination or of the individuals working at the plant during the snowfall. And there are no officially approved postcards of the tests themselves.

Atomic blast postcards were produced in sizable quantities. What can be said about the hopes and desires they fulfilled for their object-senders and receiver-subjects? Here is a beginning: the atomic jumbo postcard was suitable for framing, or so a handwritten message on the back of one of the cards indicates. The message reads:

Dearest Freda,

Knowing you like I do, I know that you will have this picture framed. That is why I am sending it to you. I have said most of what I wanted to say in a letter. Suffice it to say that we miss you and the rest of the family. God bless and keep you all.

Love & kisses
Fiord & family

This note to Dearest Freda from Fiord & family represents a codified act of intimacy, the meaning of which is not easily deciphered.[51] A postcard mailed to family and friends requires a handwritten message to be complete, for without a supplemental written narrative it is a homeless object rather than an item of memory and desire capable of marking an experience. But what does the message on this card convey? That the picture should be framed as a source of pleasure, or that it should be framed as a source of caution? Even though it may have been the former, there is no way of ascertaining that, for the letter referred to in the postcard message could have instructed otherwise. Another message, on the back of a second eBay card of the same subject, refers obliquely to the community of soldiers, workers, scientists, and photographers employed in the vicinity of ground zero: "Where this was set off is where Elmo use [*sic*] to work when they were here in Las Vegas." In atomic photography we rarely see Elmo, unless he is a mannequin or a soldier with his back turned to the explosion or the camera. Images are not released of generals pressing the red button to set off the bomb—a fantasy device that retains its currency in the popular imagination because there are no other images to contradict it—or of scientists and workers designing and manufacturing the device. Like the bomb's potential victims and the radiation produced by it, they too are invisible.

It is characteristic of the two messages that they are written in the approved language of their medium, the postcard. Messages on the backs of cards are almost invariably positive, like the photographic images on the front of them, not excluding those picturing nuclear detonations. Rectos and versos, fronts and backs, tend to reinforce one another's reassuring tone. Were Elmo sick with "A-bomb disease" and seeking compensation for maladies caused by nuclear testing in Nevada, as some soldiers and civilians were doing at the time, it is unlikely the message would have mentioned it.[52] Even postcards mailed at the edge of danger rarely stray from a lingua franca of mandated cheerfulness. As Susan Stewart has observed, souvenirs and postcards speak in the nostalgic language of longing.[53] They provide a miniaturized, hold-in-the-hand colored spectacle that domesticates what is pictured, even if the pictured is implicated in traumatic historical events. If the authority of the state is identified with vastness, the bourgeois subject is associated with miniaturization. Here pleasure displaces anxiety. Photographs of nuclear explosions released by the Atomic Energy Commission were intended to make "you think all the world's a sunny day," in

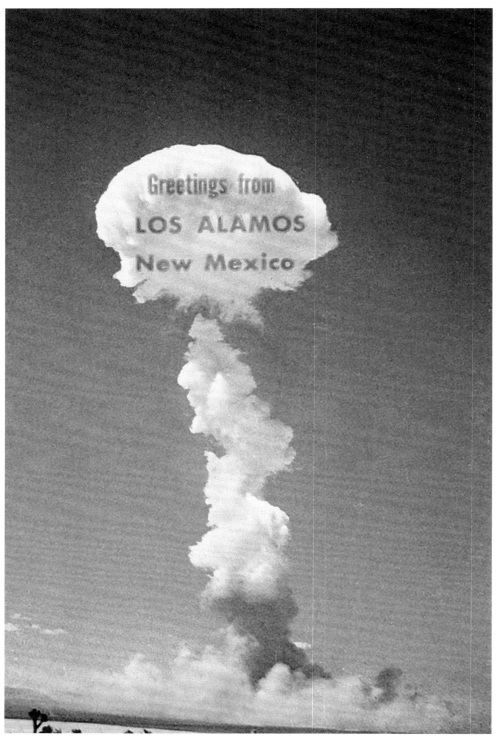

13.7. "Atomic Bomb Explosion: Mushroom Cloud," ca. 1952, Mirro-Krome postcard.

the melancholy phrasing of Paul Simon's song "Kodachrome." If the public wished to frame them for display, then the agency's program of "making the atom routine" was succeeding.

One of the most widely circulated mushroom-cloud postcards from the 1950s was "Atomic Bomb Explosion, Mushroom Cloud, Yucca Flats, Nevada," published by H. S. Crocker Co., Inc., San Francisco, one of the largest printing companies in California at the time. The back of the card states where the test took place and also that the color photograph was supplied to the company by the U.S. Army. As with the previous card, however, there is no information on which test is represented. (By chance, I have been able to narrow the test down to one that occurred in 1951 or 1952, and have learned that the photograph was taken by the Signal Corps from Camp Mercury.[54]) A handwritten message on the back of this chrome, mailed by Betty to her sister, Miss Agnes Julian of Kansas City, on August 16, 1954, says, "Dear Sis, Having a wonderful time with Bud and Emma—really swell to be here." The sentiments of the message and the picture would seem to run together. The trademark Mirro-Krome reproduction of a spectacularized atomic explosion matches Betty's assurances to her sister that she and Bud and Emma are having a swell time. Just in case senders and recipients of the card might misunderstand the message of the image, the publishers produced a version of it with greetings emblazoned in red letters across the top of the image: "Greetings from Los Alamos, New Mexico" (fig. 13.7).

This is not an image of the atomic sublime. Like Robert Frank's photograph, it is a representation of the ludicrously improbable, of the farcical inversion of tragedy, though in this case the farce and the tragedy are unintended. The greetings might just as well say, "Greetings from Formosa" or "Greetings from Hiroshima." Absurdity is rarely absent from popular images of nuclear explosions, as yet another atomic chrome demonstrates. Las Vegas, a new type of urban form constructed in the name of postwar commerce and tourism, as the authors of *Learning from Las Vegas* point out, is no more than sixty-five miles south of Yucca Flats, the principal atomic test site.[55] The spectacle of "watching the bombs go off" was one of the attractions Las Vegas offered tourists from 1951, when above-ground testing resumed in the United States, until 1962, when it stopped. A 1957 travel guide informed its readers that "the Atomic Energy Commission's Nevada test program...extend[s] through the summer tourist season, [and] the AEC has released a partial schedule, so that tourists interested in seeing a nuclear explosion can adjust their itineraries accordingly."[56] Sights and itineraries attract not only tourists, but also markers of what has

been seen. Benny Binion's Horseshoe Club, a casino-saloon-restaurant in "downtown Las Vegas" known for the gimcrackery of its marketing schemes, commissioned a postcard in the early 1950s depicting an atomic blast in five serial stages, photographed from the top of Mount Charleston not far from the city.[57] It was a courtesy card, manufactured in Boston using the "ShiniColor" process—more shiny than colorful, which is perhaps why the process failed commercially—given away free to customers (fig. 13.8).

At Benny Binion's, the spectacle of recurring nuclear detonations took its place at the same table as eating, drinking, and gambling. If the conditions of modernity have brought about a fragmentation of the human sensorium, in which the senses have become increasingly isolated from another, Benny Binion's must count as a prime instance of the phenomenon at work.[58] Accompanying such fragmentation has been the compartmentalization of information amassed in technocratic societies. The secrecy and ultimate success of the Manhattan Project depended upon it. The "self-alienation" of mass audiences under these conditions, Walter Benjamin observed in 1936, with an eye on the rise of fascism and the likelihood of war, "has reached such a degree that it can experience its own destruction as an aesthetic pleasure of the first order."[59] The mix of pleasures offered at Benny Binion's does nothing to contradict Benjamin's observation.

In an article entitled "Nagasaki Was the Climax of the New Mexico Test," "Atomic Bill" Laurence drew on the properties of color to describe his reaction to the explosions. "Bluish-green light" illuminated a sky in which there were "white smoke rings" and "a pillar of purple fire." "As the first mushroom cloud floated off into the blue," he continued, "it changed its shape into a flowerlike form, its giant petal curving downward, creamy-white outside, rose-colored inside."[60] The chrome postcards I have been discussing are the pictorial equivalent of Laurence's purple prose. They facilitate disavowal, substituting bathos for whatever else might be said or pictured.[61] They are visually excessive and conceptually impoverished. They smooth the way for public misinformation, such as that issued by John Foster Dulles in 1955, to the effect that atomic bombs directed at "military targets" pose no threat to "civilian centers." They offer up an unchanging spectacle of the bomb as nature, caught in a pacifying web of visual containment where time and history are collapsed. In the face of recent nuclear developments, these postcards from the past are flashing red with danger.

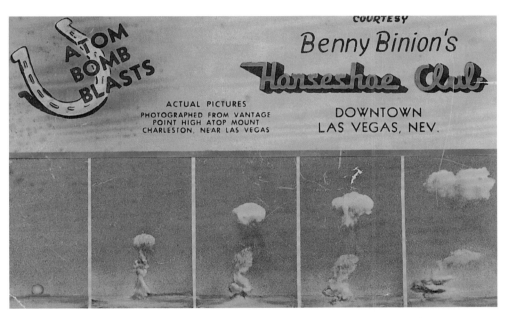

13.8. "Atom Bomb Blasts," ca. 1951, Shini-Color postcard distributed by Benny Binion's Horseshoe Club, Las Vegas.

Timothy Van Laar

The enemy is a mode of seeing which thinks it knows in advance what is worth looking at and what is not: against that, the image presents the constant surprise of things seen for the first time.
—NORMAN BRYSON, *Looking at the Overlooked*

The postcard I plan to use in my next artwork is a representation of Harpers Ferry, West Virginia. It is an image of stupefying banality. To be fair, the image is probably intended more as a representation of the Baltimore and Ohio Railroad Bridge into Harpers Ferry than as an image of the town, but the back of the card announces both subjects. Because the photographer stood on top of the bridge in the middle of the tracks, providing a fine example of the extreme foreshortening possibilities of linear perspective, it seems more like an image of a switching yard than a bridge, and the distant forested hills, speckled with a few houses, hardly seem like a town. The image fails to represent either Harpers Ferry or the B&O railroad bridge in any adequate way. In addition to its odd point of view, the image has a serious formal flaw that goes to the heart of its vacuity. The dramatic potential of the railroad's vanishing point, a place of powerful emphasis and expectation, is instead a deflating moment in our looking, a disappointing emptiness. We are sucked into this image with such ferocity, only to be left contemplating a tiny parking lot, a telephone pole, and an empty expanse of hillside. I like this image very much (fig. 14.1).

I have used these kinds of images in my work for the past seven years, incorporating them directly into small collages, or digitally enlarging them, sometimes to as much as eight by ten feet, and then painting on them. It is always these glossy, full-color, but banal, ordinary images like this one of Harpers Ferry that attract me. They are the quietly mundane postcard views that fail to acknowledge and adopt the standard conventions of postcards. They are not to be confused with self-conscious, ironic images *of* failure, the kinds of images that amusingly celebrate the trashiness of our culture. They are, instead, proud, flawed views of places that someone considers important. For example, another image that I have used is an aerial view of a suburban Chicago retirement community, too distant to see as more than a numbing, repetitious geometry of white roofs.[1]

I collect postcards from the last few decades that deal with specific places, primarily North American landscapes, architecture, and interiors, and I am amazed at the range of places these postcards represent: bars, motels, bridges, dams, museums, schools, factories,

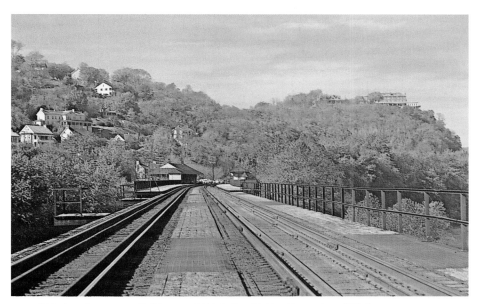

14.1.　"Telephoto from center of Baltimore and Ohio Railroad Bridge, Harpers Ferry, W.Va."

With postcards of places, we are somewhere else, we are not at the scene; or someone else was at the scene, and we were not there; or we were at this scene once, but we aren't now. Often heightening the sense of dislocation is the fact that these images of places are commonly made from a point of view that is inaccessible to us, like the center track of the B&O railroad bridge, or the sky above an Illinois retirement community. We accept these views as an attempt to get the best overall representation of a place, but they have an additional effect of distancing us from it. Short of chartering a helicopter or gaining access to rooftops or private property, we often can't experience the place in the way it is represented.

This effort to find the best point of view with which to represent a place reveals something very important about these images: every postcard of a place has some ambition to be a paradigmatic representation. A postcard of a particular motel would attempt to represent the motel in a way that most completely typifies it, showcasing its unique qualities, perhaps the pool or the convenient parking, but always in the context of its motelness. Searching the racks of postcards of Mount Rushmore, or the Chicago skyline, or Gettysburg, we want to find the image that typifies our understanding of the place. We want a single image that somehow either best summarizes the essential features of a place or is most comprehensive of a place and through either of these approaches best communicates the experience of it. This is an effort to describe something as completely as possible in order to convey its exceptional importance, its importance as a place and as an experience. The importance of the subject is such a strong assumption about postcards that it can work powerfully in the other direction—a postcard of something *makes* the thing important, *confers* importance.[3] Postcards are intended to be the best possible representation of something worth communicating and remembering.

In this establishment of a paradigmatic representation, the scene is idealized—the sky is always sunny, the water is always blue. Part of the process of arriving at a typifying image is that the extraneous details and distracting blemishes are eradicated so that a scenic postcard is like a high school graduation photo, and never like a driver's license mug shot. The fact that a mug shot serves the process of identification better than a studio portrait suggests, however, that some other values are at work in the construction of the postcard image.

gardens, mines, battlefields, highways, and every kind of natural scenery. In this essay, I am only discussing postcards that represent places, first characterizing what postcards of places need to be successful, and secondly noticing how some of them fail.[2] In my own work, I have been attracted to these failed postcards, but successful and failed postcards both have their own attractions and complications as material for artworks. My interest in the success or failure of postcard images is directly related to the production of my own work. This is how I think about postcards when I am out collecting them in flea markets, used bookstores, and antique malls, and when I am working with them in my studio.

I

Postcards of places have some peculiar qualities. They set up a relationship between the place, the image, and the viewer that is different than what a postcard of, say, a bouquet of flowers does. This relationship has to do with location: postcards of places establish a clear contrast between a permanent place and the portable representation of it. The location of a place is determinate, and that of a postcard image is distant and indeterminate, meant to be taken away from the place, and therefore the viewer of the postcard experiences a sense of dislocation and absence. This quality of absence is an essential feature of the postcard of a place, and it is summed up in the purest of all postcard messages: "Wish you were here."

One such value is marketability. In order to make attractive postcards, the images are constructed using many of the same conventions of representing places found in art. Referencing art is a way of making these images important. More practically, postcards use the conventions of art because the photographers making postcard images are aware of art history, and postcard consumers are attracted to traditional methods of composing pictures and certain conventional approaches to subject matter. I am not suggesting that this is always a conscious decision on the part of postcard makers; it could be due to the way various art imagery has been broadly assimilated within our culture. It is fair to say, however, that one way or the other postcard images have art aspirations.

I have often heard friendly viewers remark while looking at a friend's vacation snapshots, "Oh, this one could be a postcard." Invariably this means it is an image that indulges in the formulas of traditional representation of places—perhaps the middle ground and background are lovingly framed by tree branches. Or perhaps the image makes specific art-historical references, references too specific for most viewers to identify but that echo through the culture as "art." I have a simple postcard of a lake that is a pastiche of visual tropes from German Romanticism and the Hudson River School to the Impressionists: a lonely figure with his back to us contemplates a sublime space in a modest north woods version of a Caspar David Friedrich painting. Likewise, postcard makers seem to think that a sunset will improve almost any subject, perhaps giving a postcard of Chicago's skyline a Frederic Church dose of the sublime. We can't understand the typical postcard of a panoramic, scenic vista without acknowledging the likes of grand landscape painters as Church, Albert Bierstadt, and Thomas Moran or landscape photographers from Timothy O'Sullivan to Ansel Adams and Eliot Porter. But postcards don't always pursue scenic grandeur. They can just as easily reference the more intimate beauty or picturesque loveliness of a seventeenth-century Dutch landscape like, for example, a Meindert Hobbema view of a farmer's cottage nestled in trees.

The relationship of postcards to fine art is obvious early in the history of postcards. In her article "Postcard Sublime: William Henry Jackson's Western Landscapes," Ellen Handy writes about the highly influential late nineteenth-century postcards of the Detroit Publishing Company. She notes that "their marketing often emphasized a relation to the fine arts" and adds, "these postcards aspired to some of the prestige of fine art while claiming the indexical authority of the photograph."[4]

So in addition to the way idealization helps construct a paradigmatic image through the elimination of extraneous and "imperfect" information, pursuit of the ideal is also present in the way scenic postcards appropriate the rhetorical tropes of traditional, representational art. This is rhetoric engaged in various idealizing interests such as the beautiful, the sublime, the exotic, and the heroic.[5] Postcards use the traditions and conventions of art to do work in addition to best exemplifying a place; they use the rhetorical moves of art to make the place represented in the postcard image more important and memorable (and the postcard itself more saleable).

A paradigmatic representation gives us instant recognition of a place or kind of place of which we are familiar. This familiarity doesn't have to come from firsthand knowledge; it can come from secondary sources, like other postcards, and it can come from our familiarity with a relevant category of postcard representation, such as the category of mountain postcards. If we are unfamiliar with the actual place, any references in the image's construction to the sublime, heroic, etc. give us instant recognition of the place's legitimate "postcard status." We don't necessarily have to be familiar with the specific place to recognize it as important; after all, it is deserving of a postcard. We can see this in the "artistic merit" of the image, and, well, in the fact that it *is* a postcard. So we either recognize the place because it clearly represents (gives the essential features of) something or some kind of thing with which we are familiar, or we recognize the worthiness of the image, and therefore the place, because we are familiar with its artistic conventions of beauty and the like. It is a beautiful image of a tree, a sublime image of the mountains, an exotic image of a tropical beach, a heroic image of a bridge.

Postcard images of places are successful images if they achieve a paradigmatic representation of a place and skillfully engage the various powerful rhetorical devices of art. These are images that have "postcard status." As we will see later, an understanding of the expectations we have for postcard images is important in understanding how some postcards fail. And we do have certain expectations regarding postcards, or the phrase "it's as pretty as a postcard" would be useless.

I have found that it is very difficult to work with these paradigmatic postcards. Our familiarity with the places, or at least the kinds of places, and our familiarity with their tired art ideas mean that these are images that primarily reinforce what we already know and

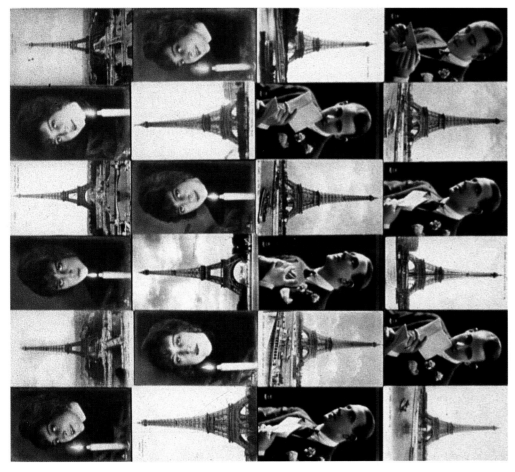

14.2. Buzz Spector, *French Letters*, 1991.

expect. They reinforce certain prejudices that inevitably give way to cliché. Any use of these mass-produced, clichéd images struggles with or must embrace their status as kitsch and the resulting campy ironies. The artworks that do successfully use such postcards are those that tend to do certain kinds of things, like investigate the relationship of art and mass culture, examine various issues of representation, and of course, exploit the specifics of a particular postcard image. But always, even in this latter example, our attention is first given to the postcard status of the image. In these idealized, paradigmatic postcards, what we could call the best examples of postcards, we are first of all aware of them as postcards with all of the cultural references they carry *as* postcards. The actual image is a closely related, almost simultaneous, but secondary attention. This results in a kind of artwork that is very self-reflexive, where art issues are in the foreground and where irony is the overwhelming strategy of meaning. Such works are always saying, and saying loudly: this image isn't what you think it is.

Certainly, postcards can be successfully used this way to make artworks, and the issues of representation most often referenced and critiqued in such works—usually those postcard notions of such things as the beautiful, sublime, exotic, and heroic—are very important. But it takes enormous skill to avoid the traps of one-liner, easy irony, to avoid the simple jokes that are so quick to come by in the use of the inflated, clichéd rhetoric of so many postcard images of places. The work of Buzz Spector is an example of the way such images can be used successfully. His postcard collages are complicated, witty examinations of the nature of visual representation, but they operate on so many levels, the formal elements are so sharply focused, and selection of images so surprising and combined with such restrained elegance that they manage to use the visual clichés to make something else. He knows how to use a cliché the way a painter uses color[6] (fig. 14.2).

Another problem in the use of postcards goes back to those qualities of absence and dislocation inherent in the very nature and purpose of postcards—postcards are souvenirs. As Susan Stewart points out, "The souvenir speaks to a context of origin through a language of longing...it is an object arising out of the necessarily insatiable demands of nostalgia."[7] The postcard is necessarily nostalgic, and the problem with nostalgia is twofold: it is an overwhelming presence whenever it appears in an artwork, and as a form of narrative it is corruptive in its longing for a past that never existed. As Stewart writes, "Nostalgia is a sadness without an object, a sadness which creates a longing that of necessity is inauthentic

because it does not take part in lived experience."[8] The use of postcards in the construction of artworks automatically triggers the problem of nostalgia. And the older the card or the more obvious the traces of personal possession (writing, smudges), the stronger its capacity to suggest nostalgia.

Various strategies can mitigate this problem. For example, like the clichéd image, the nostalgic can be accepted and used, always ironically, in some critical capacity that questions the cultural role of nostalgia. Spector's *French Letters* does this. Or very new postcards can be used, minimizing nostalgia by leaving less room, less of a gap between present and past for narratives of desire. And finally, as we shall see, there is a kind of postcard that is less suggestive of nostalgia and also less given to cliché—less suggestive of nostalgia because it is less available for the creation of utopian longings, and less given to cliché because it fails in its idealization of its subject. These are postcards that are nonparadigmatic representations of a place, in fact, they are likely to be scenic disappointments. They are postcards like the ones I described with images of the Baltimore and Ohio Railroad Bridge leading to Harpers Ferry and of the aerial roof patterns of the Covenant Village Retirement Center in Northbrook, Illinois.

II

Not every postcard is a paradigmatic representation of a place. Some postcards, for one reason or another, fail to exemplify a place and fail to present us convincingly with an image that seems important or memorable. This kind of postcard image fails to achieve real postcard status.

Consider a postcard in my collection where the image is described on the back as "Scenic Drive along Turner Turnpike between Oklahoma City and Tulsa, Oklahoma" (fig. 14.3). Coincidentally, it shares the zooming one-point perspective technique of the Harpers Ferry card (it is worth considering the possibility that this perspective strategy automatically sets up a disappointing image). This is a postcard of such utter banality that it comes close to possessing a kind of winsome charm. In this image of a scenic drive, we do not see what is generally thought of as scenery, that is, the view *from* the road, but we see the road itself and from a place no one would choose to venture—the grassy median. Even the possibility of depicting one of those sublime experiences of the road, a contemplation of its terrifying infinity, say, is subverted in this image by the little sign/reflector in the foreground. It's like someone's cell phone going off during a high school band concert—it makes a questionable aesthetic situation

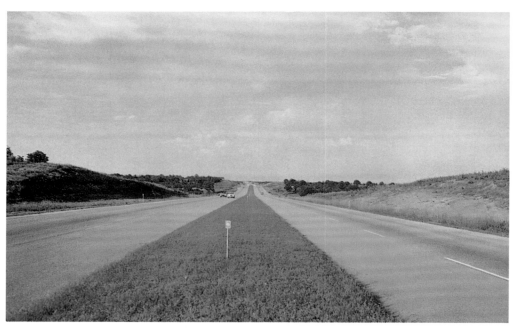

14.3. "Scenic Drive along Turner Turnpike between Oklahoma City and Tulsa, Oklahoma."

completely impossible. And finally, any possible scenic view from the chosen vantage point is blocked by two very uninteresting eroded road cuts. What this image is really about is the grassy median. I suspect that Turner Turnpike has some very scenic views: beautiful landscapes, sublime vistas, heroic bridges (or even road cuts), but the median? What were they thinking?

This image, then, is not a paradigmatic representation of the scenic qualities of the Turner Turnpike. Despite its use on a postcard, the image does not seem important as a place, a place worth remembering. It fails to summarize the essential features, in this case, of the view along the Turner Turnpike. Now, some may be tempted to argue that the Turner Turnpike image *is* paradigmatic, that the Turner Turnpike *itself* is exceedingly banal, and therefore the image is successful. But banality is never a chosen, intentional value in postcards—it is not something people generally choose to celebrate. And such an argument uses the image ironically. People don't purposely choose the mundane for a postcard. Scenic postcards are about the importance of a place.

Sometimes, then, there is a disparity between the way postcards as a medium confer importance and the triviality or banality of some postcard images. We are likely amused with the way in which such a postcard fails to meet our expectations of a postcard. I would like to examine just where the failures occur. In my search for materials for my artwork, I have mulled this over in numerous dusty used bookstores: Are they formal, organizational failures, failures of viewpoint, or failures inherent in the subject matter itself? Are there places that are just plain unimportant, so that to mistakenly choose to make a postcard of such a place, even if it is a paradigmatic, formally excellent representation, still results in a failed postcard? This last question suggests that the source of failure in these postcards could be in the mistaken choice of the subject, the place.

It is possible that some failed postcards are mistakes of subject matter, that something generally considered banal or trivial was taken for something important by the postcard maker. This is the common response to my postcard collection. But there are some problems in attributing failure to subject matter. For example, judging the importance of subjects is difficult, and it is questionable that anything is inherently ordinary or trivial. My failure to find anything important in a postcard of Sweet Briar College's tennis courts (which is in my collection) may have to do with a more general, personal lack of interest in tennis. Images of tennis courts are not necessarily

boring, I suppose. Another problem in considering mistakes of subject is that if everything else is perfect, if the image is a perfect orchestration of formal elements and rhetorical allusions and is a perfect paradigmatic representation of a place, the image of the trivial subject will come across as pretentious, pompous, *overly* important, not ordinary. These cards are immediately understood as ironic. So to be ordinary, the card would likely have to fail in other ways than in its subject. And finally, in a somewhat related observation, it is possible that the difficulty in finding these mistakes of subject comes about because, if they are well made, they will not be seen as mistakes. If even the most trivial thing is made beautiful, it can persuade us of its importance. For example, central Illinois photographer Larry Kanfer produces postcards of expansive cornfields, endowing them with all the qualities of the sublime. While we are looking, we believe it.

But are there places that can't make it as a postcard no matter what, whose selection as a subject can only be a mistake? Most of the time, when I think I've found one, I realize that I can imagine a different view of the place—different light, different scale, etc.—that could make the subject interesting enough to suggest its importance. Most postcards are motivated by places genuinely considered important or noteworthy by someone, and it is the job of postcards to communicate that importance. Making a postcard image isn't a passive act of receiving an image (although the most well-known, clichéd images of famous, important places approach this kind of passivity—the view of the Grand Tetons from the Snake River, for example). It is an act of deciding the importance of something and how best to represent that importance.

So point of view is the paramount concern. Although it is sometimes useful, the distinction between the subject and the point of view is a tenuous one. The difference between a mistaken subject matter and mistaken view of that subject matter is usually indistinguishable. Unless it is contradicted by a title or blurb on the back like the turnpike card, the view *is* the subject matter. We have no other way to know the card's intention. Whenever we look at a postcard and think it is unimportant or boring, just an ordinary view, the failure of importance comes from selection problems arising from the point of view and/or formal problems. With the Turner Turnpike postcard, the failure has to do with the selection of view, resulting in a misplaced emphasis like the median and the road cuts, and with related formal organization problems, giving us things like the sign in the foreground, but not something inherently wrong with the subject matter itself.

In failed postcards, then, these two closely related problems are usually present: the inappropriate selection of the essential features of a place (those things that make it important and unique), and the inadequate formal organization of the image space to best communicate this importance. Organizing the image, which has to do with all the physical properties of the image, like color, light, texture, balance, and so on, necessarily involves selecting a point of view, and vice versa. When one or both of these processes are flawed, we can't figure out what's important, and therefore nothing is memorable. In the turnpike image, the grassy median is visually the most important feature, but we know this can't be right, the postcard says it's about scenery. And why would anyone want to remember a median strip? The failed postcard, then, is a formally inept, nonparadigmatic representation of a place, a place whose importance becomes open to question.

Something interesting happens when a postcard image of a place lacks the appropriate suggestions of importance, when it lacks postcard status—the image becomes an anonymous and unfamiliar place. If we don't know what's important, we don't understand the purpose of the image, and therefore, we don't know what to do with it. This unfamiliarity does not stem from not knowing where a place is or what its name is. It comes from an inability to recognize what an image is supposed to be doing and therefore how to interpret it. This anonymity of place is, in fact, a peculiar kind of unfamiliarity. This kind of anonymous, unfamiliar image is different from the larger category of unknown, unfamiliar images. The latter can be a superficial unfamiliarity, merely lacking a name, if the viewer recognizes the image as important. And unknown, unnamed places *can* be recognized as important. The unknown is understood as important if it is somehow contextualized—we know it is important because its skillful rhetoric, references, and formal construction convince us of its postcard status. In a way, these unknown images aren't totally unfamiliar. But the image of an anonymous place is an image bereft of such contextualization. Often in these cards, it isn't clear what in the image we would name as the subject. If nothing in the image is important, we aren't sure what to name. This is a more serious condition than mere namelessness; it is a deeper kind of anonymity. Instead of merely not knowing *what* an image is, we don't even know what's what. This is why the cards I collect and use are often referred to as boring.[9] It is the unrelenting anonymity of the images of the Baltimore and Ohio Railroad Bridge, the Covenant Village Retirement Center, and the Turner Turnpike that bores the viewer, that gives the images their banality.

Issues of the familiar and the unfamiliar crop up in the work of many artists who use postcards in their work. For example, in the recent postcard works of William Wegman, recognizable places lose their identity (fig. 14.4). Although these works don't necessarily build on what I have called postcards of anonymous places, it seems to me that they are predicated on the way postcards are supposed to represent real, recognizable places. He creates a new, entirely imaginary context for a postcard, extending its edges with paint into a fantastic, irrational world. The contrast between the fragment of the world that the postcard represents and the new imagined place of which it is a part is intense because what we thought the image was is lost, and it becomes unfamiliar. The work succeeds because postcards are supposed to be knowable places, places with some importance. Wegman undermines this assumption, losing these places in their new unknown world.

Failed postcards like the Turner Turnpike, however, outright contradict this assumption. At the same time, they never create the anxiety of the unfamiliar that would label them uncanny.[10] They aren't strange, they're just ordinary. The notion of the uncanny would make these postcards too ambitious, and therefore too susceptible to ironic camp usages. These postcards violate the conventions of the postcard, not in oppositional ways (which would be heroic, and in which pursuit of the uncanny would be useful) but simply as failures.

But the unfamiliar postcard is strangely melancholic. This is a melancholy that is deeper than the sadness of failure. In fact, it is a mistake to think that recognition of their failure is the source of melancholy. Their failure results in disappointment and maybe a sense of how easy it to fail. But as we look closely at the unfamiliar image, searching for what is important and not finding it, we think for a moment that we have forgotten. The image is melancholic in the way it suggests a failure of memory. *We* fail here. We are supposed to recognize this place as important, but we don't. And when we decide the image is unimportant, we may then choose to forget it. But there is a further problem: as a postcard, the insignificant, anonymous place has been memorialized. It isn't going away. The melancholy of the failed postcard derives from an irresolvable tension of remembering and forgetting.

In *Looking at the Overlooked: Four Essays on Still Life Painting,* Norman Bryson defines the concept of rhopography as it relates to the practice of still life painting and the representation of trivial

14.4. William Wegman, *Way to Go,* 2003.

But then, the *use* of the postcard in the construction of an artwork has the potential to bring an intense focus of attention on the card itself, and in this re-representation introduces the paradox of banality made interesting. Here again when the banal becomes obvious and scrutinized, its ordinariness dissipates. But something very different happens in the contemplation of a failed postcard as an object in an artwork compared to the objects in a painting like Francisco de Zurbarán's 1633 *Lemons, Orange, Cup, and Rose.* Bryson says that this painting "shows a visual field so purified and so perfectly composed that the familiar objects seem on the brink of transfiguration or (the inevitable word) transubstantiation."[14] We do not contemplate the failed postcard as a thing of overlooked importance that becomes transcendent. When we examine it, we notice its failure. It is pathetic, abject, and clumsy.

In my work, I am not interested in using these banal images to make the ordinary transcendent, to lift it up. From Zurbarán to John Ruskin, William Carlos Williams, and Claus Oldenburg, this has been the most frequent use of the ordinary in art—to give the ordinary new status. With these failed postcards, however, this is next to impossible. Under scrutiny, they simply seem inadequate. I prefer to let them remain as they are, mundane, unfamiliar, boring. Very little art makes use of and approaches the banal this way (maybe the poems of Frank O'Hara). To slow down further any recognition and to sustain their anonymity, I use these postcards as backgrounds, or I turn horizontal images to vertical (fig. 14.5).

There are some other issues regarding the use of failed post-cards to make artworks. The naïve or amateur quality of these cards is problematic. The appropriation of such images can place the artist in a position of superiority and control that can be condescending. But a deeper and subtler problem related to their naïve construction is the way they can be used to suggest an authenticity that is similar to the way "primitive" art and outsider art have been used in the art world.[15] As in the use of those kinds of work, the use of these cards as some-how authentic and innocent puts the artist in a position of authority regarding these images. This can result in an ironic use, emphasiz-ing the fact that these images aren't what (or as good as) the makers thought they were.

This irony is strongly present when the cards are looked at individually and the viewer simply responds, "I can't believe they made this into a postcard." But it starts to drop away as soon as the image is put to work doing something else, when the image is

objects. Rhopography, he says, "is the depiction of those things which lack importance, the unassuming material base of life that 'importance' constantly overlooks."[11] Using failed postcards of the kind I have been describing is an act of rhopography, but with some interesting differences from still-life images and the way they observe the unimportant. Bryson points out that an intense examination of ordinary things makes them "appear radically *un*familiar and estranged."[12] This is different, however, from the unfamiliarity I have described. In still life, this unfamiliarity creates a "dramatic objecthood" where "the intensity of the perception at work makes for such an excess of brilliance and focus that the image and its objects seem not quite of this world."[13] The unfamiliar postcard image results in anonymity, a far cry from the intense visibility that occurs in still life. This is because the postcard image, in contrast to, say, an image of a cabbage, is supposed to be important but somehow isn't. The still-life painter makes the cabbage important.

combined with other elements. But anyway, it is never the overwhelming kind of irony present in the use of successful postcards. In that case, when we are looking at something described as important, the consequences of suggesting that it isn't what we think it is are far reaching. The suggestion that an inadequate image is somehow something else lacks any such subversive effect.

I am attracted to and use these failed postcard images for several reasons: because they surprise me, because their banality gives them a plasticity, a potential for new uses, and because, rare among the materials of popular culture, their failure, their abject inadequacy, sidesteps the problems of cliché and nostalgia. These are images that are full of blank potential: unfamiliar but not uncanny, narrative and personal but minimally nostalgic, memorialized but anonymous. Because their purpose is inscrutable, the images are open-ended and available for use.

I am looking at a card I found recently at a local used bookstore. On the back it is titled: "GRACEFUL ARCHES of Highway 65 Bridge at Branson, Mo. beckon the tourist across beautiful Lake Taneycomo to the heights of Baptist Hill" (fig. 14.6). Very little beckoning seems to be happening in this image. A pine tree, making the bridge seem inaccessible, obstructs the near end of the bridge. The first visible arch rises from an extensive area of swampy ground; in fact, beautiful Lake Taneycomo is hardly noticeable. Where the bridge crosses the water, a willow tree on the shore obscures the arches. And, well, the heights of Baptist Hill (which seem more like a riverbank) provide a barrier wall, a dead end for the bridge. Highway 65 Bridge appears to be a bridge to nowhere. In its failures as a postcard, but put another way, in its witness of the ordinary, this postcard is an object of both disappointment and limitless wonder.

14.5. Timothy Van Laar, *Comparing Theories*, 2003.

14.6. "GRACEFUL ARCHES of Highway 65 Bridge at Branson, Mo. beckon the tourist across beautiful Lake Taneycomo to the heights of Baptist Hill."

REBECCA J. DEROO

is Assistant Professor of Art History at Washington University in St. Louis. Her book *The Museum Establishment and Contemporary Art* (2006), which explains how the political protests of 1968 in France triggered a redefinition of museums and artistic practice, was awarded the 2008 Laurence Wylie Prize in French Cultural Studies. Professor DeRoo has contributed to journals including *The Oxford Art Journal*, *Parallax*, and *Studies in French Cinema*. She has received Killam and Fulbright Fellowships, as well as an award from the National Endowment for the Humanities.

ELLEN HANDY

teaches in the Art Department at the City College of New York, CUNY. She is a critic and historian of art, particularly photography, and has published on a wide variety of topics. She was curator of collections at the International Center of Photography and executive curator of photography and visual collections at the Harry Ransom Humanities Center at the University of Texas at Austin, as well as program director for Christie's Masters of Art degree program.

ELIZABETH B. HEUER

is Assistant Professor of Art History at the University of North Florida, Jacksonville. She received her Ph.D. from Florida State University in 2008, where she wrote her disseration, "Going Postal: Surrealism and the Discourses of Mail Art." She is currently organizing an exhibition examining art and the postal age.

JORDANA MENDELSON

is Associate Professor in the Department of Spanish and Portuguese at New York University. She is the author of *Documenting Spain: Artists, Exhibition Culture, and the Modern Nation, 1929–1939* (2005), *Magazines and War, 1936–1939/Revistas y Guerra, 1936–1939* (2007), and has published extensively on early twentieth-century Spanish art and mass media. She was also the guest editor of the "From Albums to the Academy: Postcards and Art History," a special issue of *Visual Resources: An International Journal of Documentation* (2001).

ANNELIES MOORS

is an anthropologist and holds the chair on contemporary Muslim societies at the University of Amsterdam. She is the author of *Women, Property, and Islam* (1995); coeditor of *Discourse and Palestine* (1995); editor of "Public Debates on Family Law Reform," a special issue of *Islamic Law and Society* (2003); coeditor of *Religion, Media, and the Public Sphere* (2006); and co-editor of "Muslim Fashions," a special issue of *Fashion Theory* (2007).

CARY NELSON

is Jubilee Professor of Liberal Arts and Sciences, University of Illinois, Urbana-Champaign, and President of the American Association of University Professors. A founder of the Unit for Criticism and Interpretive Theory at Illinois, Nelson is the author or editor of twenty-three books and over 150

articles, including *Marxism and the Interpretation of Culture* (coedited with Lawrence Grossberg; 1988); and *Cultural Studies* (coedited with Lawrence Grossberg and Paula A. Treichler; 1992). He has also written extensively on the subject of visual culture and the Spanish Civil War. Among his publications on this topic are *The Aura of the Cause: A Photo Album for North American Volunteers in the Spanish Civil War* (1997) and *Shouts from the Wall: Posters and Photographs Brought Back from the Spanish Civil War by American Volunteers* (1996). His comprehensive survey of international poem cards, *When Death Rhymed: Poem Cards and Poetry Panics of the Great Wars,* is forthcoming from the University of Illinois Press.

JOHN O'BRIAN

is Professor of Art History and Brenda and David McLean Chair in Canadian Studies at the University of British Columbia, Vancouver. He has published more than a dozen books, including *Beyond Wilderness* (co-edited with Peter White; 2007), *Ruthless Hedonism: The American Reception of Matisse* (1999); *Voices of Fire: Art, Rage, Power, and the State* (co-edited with Bruce Barber and Serge Guilbaut; 1996); and *Clement Greenberg: The Collected Essays and Criticism* (1986 and 1993). His current research is on the engagement of photography with the atomic era. He is organizing an exhibition, *Camera Atomica*, for the Art Gallery of Ontario, and a monograph, *The Bomb in the Wilderness*, for the University of British Columbia Press.

DAVID PROCHASKA

teaches history and postcolonial studies at the University of Illinois, Urbana-Champaign. His books include *Making Algeria French: Colonialism in Bône, 1870–1920* (1990), an exhibition catalogue, *Beyond East and West: Seven Transnational Artists* (with David O'Brien; 2003), and *Genealogies of Orientalism: History, Theory, Politics* (coedited with Terry Burke; 2008). His research concerns colonial visual culture; among his essays on the history of photography, he has published numerous articles on postcards.

NAOMI SCHOR

was the Benjamin F. Barge Professor of French at Yale University when she died in 2001. Prior to that she was a distinguished professor at Brown University, Duke University, and Harvard University. Schor was a noted feminist scholar who wrote extensively on French theory and culture. She was the author of numerous books and articles, among them *Reading in Detail: Aesthetics and the Feminine* (1987) and *Bad Objects: Essays Popular and Unpopular* (1995).

KIMBERLY A. SMITH

is Associate Professor of Art History at Southwestern University and the author of *Between Ruin and Renewal: Egon Schiele's Landscapes* (2004). Her articles on modern visual culture in central Europe have appeared in *Art History, Aurora,* the *Austrian History Yearbook,* and *Centropa.* She is currently working on a study of the Expressionist turn in art history in the early twentieth century.

RACHEL SNOW

is Assistant Professor of Art History at the University of South Carolina Upstate. She received her Ph.D. from the City University of New York Graduate Center in 2006, where she wrote her dissertation, "Incidental Tourists," on travel books that are illustrated with tourists' own snapshots. Her previous publications include "Postscript to a Postcard," *Afterimage* (May 2002), "A Second Look," *Afterimage* (July/August 2002), and "Tourism and American Identity," *Journal of American Culture* (March 2008), which deals with how photography and tourism relate to issues of American class identity and conspicuous consumption. She is currently writing a book about snapshot photography.

NANCY STIEBER

teaches architectural history in the Art Department of the University of Massachusetts, Boston. Her research considers the built environment as it is experienced and observed. Her book *Housing Design and Society in Amsterdam: Reconfiguring Urban Order and Identity, 1900–1920* was awarded the Spiro Kostof prize in 1999. She is currently writing a book on the visual image of Amsterdam around 1900, *The Metaphorical City: Representations of Fin-de-Siècle Amsterdam.* Professor Stieber edited the *Journal of the Society of Architectural Historians* from 2003 to 2006. She is the recipient of numerous fellowships and grants, including ones from the Getty, the Radcliffe Institute for Advanced Study, the National Endowment for the Humanities, and the Netherlands Institute for Advanced Study.

TIMOTHY VAN LAAR

is Professor of Art in the School of Art and Design at the University of Illinois, Urbana-Champaign. He has exhibited his paintings, collages, and digital works throughout the United States and Europe. He has coauthored two books, *Active Sights: Art as Social Interaction* (1998) and *Art with a Difference: Looking at Difficult and Unfamiliar Art* (2001).

ANDRÉS MARIO ZERVIGÓN

is Assistant Professor of Art History at Rutgers University where he teaches the history of photography. His recent publications include "'A Political Struwwelpeter?' John Heartfield's Early Film Animation and the Crisis of Photography" (*New German Critique*, Summer 2009) and "Die Buchumschläge Heartfields" (in exhibition catalogue: *John Heartfield: Zeitausschnitte*, Berlinische Galerie, 2009). His book manuscript "The Agitated Image. John Heartfield, Photomontage, and the German Avant-Garde 1915–1929" is currently under review.

Introduction

1. For the role of the Museum of Modern Art in the establishment of the history of photography as a discipline in the academy and as practiced by museums, see, for example, Christopher Phillips, "The Judgment Seat of Photography," *October* 22 (Autumn 1982): 27–63; and Douglas R. Nickel, "History of Photography: State of Research," *Art Bulletin* 83, no. 3 (September 2001): 548–58. More recently, and as a response to the limiting art-historical and museological discourses around photography, Geoff Batchen's work on vernacular photography has sought to expand the discipline of the history of photography to include commercial and anonymous photographs. See Batchen's *Forget Me Not: Photography and Remembrance,* exh. cat. (Amsterdam: Van Gogh Museum; New York: Princeton Architectural Press, 2004).

2. Among the exhibitions and institutions that could be highlighted, the shows held by these three museums, and their accompanying catalogues, are notable contributions to the history of postcards: *Art of the Japanese Postcard: The Leonard A. Lauder Collection at the Museum of Fine Arts, Boston* (Museum of Fine Arts, Boston, 2004); *We Are the People* (National Portrait Gallery, London, 2006); and *Walker Evans and the Picture Postcard* (Metropolitan Museum of Art, New York, 2009).

3. Carol Shloss, "Algeria, Conquered by Postcard," *New York Times Book Review,* January 11, 1987.

Chapter 1: Schor

My thanks to Janell Watson, my resourceful research assistant, for her help in preparing this text. I also wish to thank Abigail Solomon-Godeau for her expert editorial assistance and Richard Klein for his patient logistical support. All the postcards reproduced here are from my personal collection.

1. Maurice Blanchot, "Everyday Speech," trans. Susan Hanson, in "Everyday Life," ed. Alice Kaplan and Kristin Ross, special issue, *Yale French Studies,* no. 73 (1987): 17.

2. Wolfgang Schivelbusch, "The Policing of Street Lighting," in Kaplan and Ross, "Everyday Life," 62. See also his *The Railway Journey: Trains and Travel in the Nineteenth Century,* trans. Anselm Hollo (New York: Urizen, 1979), 176, with regard to the "'modernity' of the traffic function of Haussmann's streets."

3. See Georg Simmel, "The Metropolis and Mental Life," trans. H. H. Gerth, in *Classic Essays on the Culture of Cities,* ed. Richard Sennett (Englewood Cliffs, N.J.: Prentice Hall, 1969), 47–60.

4. At the conference at which a briefer version of this paper was originally presented (The Problematics of Daily Life, University of California, Davis, November 1990, organized by Marc Blanchard), a current trend in feminist studies emerged through the convergence of my talk and that of historian Mary Ryan, which was entitled "From Everyday to Election Day: The Politics of the Street in the 1870s": a noticeable and overdetermined shift in focus away from the place of women in the thoroughly explored private to the largely neglected public sphere, from the home to the street.

5. See André Rouillé, *L'Empire de la photographie: Photographie et pouvoir bourgeois, 1839–1870* (Paris: Le Sycomore, 1982); Abigail Solomon-Godeau, "The Legs of the Countess," *October,* no. 39 (Winter 1986): 65–108; and Allan Sekula, "The Body and the Archive," *October,* no. 39 (Winter 1986): 3–64.

6. Sekula, "Body and the Archive," 16.

7. In a recent article, Paul Bové responds to this line of attack by arguing that there is especially in Foucault's late work a theorization of "being against," a "freedom/power" paradigm that is the very ground for the "power/knowledge" configuration. See Paul A. Bové, "Power and Freedom: Opposition and the Humanities," *October,* no. 53 (Summer 1990): 78–92. There is no question but that Foucault's conceptualization of power and resistance evolved over the years;

I am not persuaded, however, that one can, or indeed must, as Bové argues, read early or middle Foucault in the light of his later writings in order to correct a false "repressive" reading of a work such as *Discipline and Punish.*

8. I take the notion of "representation" from Johannes Fabian's stimulating article "Presence and Representation: The Other and Anthropological Writing," *Critical Inquiry* 16 (Summer 1990): 753–72, esp. 755–56. Though Fabian doesn't cite him, Christopher Prendergast, taking off from Paul Ricoeur, also proposes to dislodge the mimetic interpretation of representation in favor of representation as praxis in his *Order of Mimesis: Balzac, Stendhal, Nerval, Flaubert* (Cambridge: Cambridge University Press, 1986).

9. Perhaps not so idiosyncratic after all: in a book I read after having completed this article, Laurie Langbauer's *Women and Romance: The Consolations of Gender in the English Novel* (Ithaca: Cornell University Press, 1990), I find quite similar sentiments expressed regarding the paradoxically consoling virtues of Foucault's (and Foucault-inspired) "reassuring totalizations" (235). See also 245.

10. See Gilles Deleuze, *Pourparlers, 1972–1990* (Paris: Editions de Minuit, 1990), 229–47.

11. John Tagg, *The Burden of Representation: Essays on Photographies and Histories* (Amherst: University of Massachusetts Press, 1988), 2.

12. Barbara Harlow, introduction to Malek Alloula, *The Colonial Harem,* trans. Myrna Godzich and Wlad Godzich (Minneapolis: University of Minnesota Press, 1986), xiv.

13. Benjamin's childhood collection includes one of postcards; see *Sens unique: Précédé de enfance berlinoise et suivi de paysages urbains,* trans. Jean Lacoste (Paris: Les Lettres Nouvelles/Maurice Nadeau, 1978), 61, also 67, 105. Included in the series called Topographie de Paris, which Benjamin worked on at the Bibliothèque Nationale's Cabinet des Estampes, were postcards of Paris, no doubt the same ones still available there today.

 Incidentally, Benjamin raises the question of the conflict between stamp and postcard collecting, that is, between the two sides of the postcard: "Sometimes you come across them on postcards and are unsure whether you should detach them or keep the card as it is, like a page by an old master that has different but equally precious drawings on both sides." Benjamin, *One-Way Street and Other Writings,* trans. Edmund Jephcott and Kingsley Shorter (London: Verso, 1985), 91–92.

14. Benjamin, "Unpacking My Library: A Talk About Book Collecting," in *Illuminations,* trans. Harry Zohn, ed. Hannah Arendt (New York: Harcourt, Brace and World, 1968), 60; hereafter abbreviated "U."

15. One anamnesis provokes another. Recently, as I was preparing to write this text, my sister Mira Schor said to me: "You know you really should take a look at the postcards in Mama's bureau." There, to my surprise, I found a small group of postcards my parents had brought with them in rucksacks, as they called them, which was their baggage on arriving in the United States from Europe in December 1941. Mostly the cards were disappointing, poor prewar-quality reproductions of paintings my artist parents had preciously saved. But among these "worthless" cards was a small series, no doubt incomplete, of hand-painted cards representing the costumes of Provence, where my parents had spent a year waiting for visas to emigrate to the United States. They have become, retroactively, the matrix of *my* collection.

16. Susan Stewart, *On Longing: Narratives of the Miniature, the Gigantic, the Souvenir, the Collection* (Baltimore: Johns Hopkins University Press, 1984), 135; hereafter abbreviated *OL.*

17. Dean MacCannell, *The Tourist: A New Theory of the Leisure Class* (New York: Schocken Books, 1989), 79.

18. Jean Baudrillard, *Le Système des objets* (Paris: Gallimard, 1968), 125; hereafter abbreviated *SO;* all translations mine except where otherwise noted.

19. See Emily Apter, "Splitting Hairs: Female Fetishism and Postpartum Sentimentality in the Fin de Siècle," in *Eroticism and the Body Politic,* ed. Lynn Hunt (Baltimore: Johns Hopkins University Press, 1991), 164–90. The literature on female fetishism is growing rapidly; see also my "Female Fetishism: The Case of George Sand," in *The Female Body in Western Culture: Contemporary Perspectives,* ed. Susan Suleiman (Cambridge, Mass.: Harvard University Press, 1986), 363–72; Elizabeth Grosz, "Lesbian Fetishism?" in *Fetishism as a Cultural Discourse,* ed. Emily Apter and William Pietz (Ithaca: Cornell University Press, 1993); and Marjorie Garber, "Fetish Envy," *October,* no. 54 (Fall 1990): 45–56.

20. See Emily Apter, "Cabinet Secrets: Fetishism, Prostitution, and the Fin de Siècle Interior," *assemblage* 9 (June 1989): 7–19, esp. 15–16.

21. William Dûval, with Valerie Monahan, *Collecting Postcards in Colour: 1894–1914* (Poole, England: Blandford Press, 1978), 28; hereafter abbreviated *CP.*

22. Jack H. Smith, *Postcard Companion: The Collector's Reference* (Radnor, Pa.: Wallace-Homestead, 1989), ix; hereafter abbreviated *PC.*

23. Gérard Neudin, *Les Meilleures Cartes postales de France* (Paris, 1989), 324: "One meets specialized collectors for every street, every *quartier* (e.g. Montmartre, the Bièvre), or every *arrondissement.*"

24. Ibid.

25. Biddy Martin and Chandra Talpade Mohanty, "Feminist Politics: What's Home Got to Do with It?" in *Feminist Studies/Critical Studies,* ed. Teresa de Lauretis (Bloomington: Indiana University Press, 1986), 196.

26. Such is the claim made in some of the LL promotional literature. Basing himself on information available at the Bibliothèque Nationale, José Huguet of the Sociedad Valenciana de Historia de la Fotografia traces the origins of the Maison Lévy back to one Charles Soulier. In 1864 Soulier turned over his business to his students and assistants, Léon and Lévy (LL?). Nothing much more is known of Léon. I want to take this opportunity to thank both Huguet and Yves Beauregard (editor of *Cape-aux-Diamants: Revue d'histoire du Québec*) for generously sharing with me what information they had already gleaned regarding LL and the Maison Lévy before I undertook my own research.

27. The issue of *auteur*ship is a tricky one. The tendency to transform heretofore anonymous producers of "documentary" or commercial photographs into authors of an oeuvre, thereby endowing them with the prerogatives of the romantic artist (genius, individual vision, originality, self-expression, aesthetic value, and so on) has been fiercely resisted by critics who want to stave off the invasion of photography by the commodification endemic to the fine arts. See, for example, Rosalind Krauss, "Photography's Discursive Spaces: Landscape/View," *Art Journal* 42 (Winter 1982): 311–19; Allan Sekula, "Photography Between Labour and Capital," in *Mining Photographs and Other Pictures, 1948–1968: A Selection from the Negative Archives of Shedden Studio, Glace Bay, Cape Breton,* ed. Benjamin H. D. Buchloh and Robert Wilkie (Halifax: Press of the Nova Scotia College of Art and Design, 1983), 193–268; and Sekula, *Photography Against the Grain: Essays and Photo Works, 1973–1983* (Halifax: Press of the Nova Scotia College of Art and Design, 1984).

 At the same time, my attempt to reconstitute the LL series on Paris and to obtain some minimal information about its producers has been constantly impeded by their nonstatus as artists. Whether in the archives of the library (Bibliothèque Nationale, Bibliothèque Historique de la Ville de Paris) or in the marketplace, postcards of Paris are organized topographically, by *arrondissements,* irrespective of editors. Searching out the cards produced by a single editor—when they are not the highly prized "Petits Métiers" or "Paris Vécu" series—is tedious work, which goes against the grain of conventional classification.

 The question that arises is, how can one reconstitute the discursive network within which the LL cards were produced and circulated without claiming for them some sort of privileged status, which may or may not enhance their value?

View cards remain one of the last sanctuaries of photography untouched by the gilding hand of aestheticization. The price of Parisian (and other) view cards is based strictly on their value as social documents (*studium* here is prized over *punctum*) and, of course, their scarcity, and according to this scale of values, architectural renderings of buildings (especially still standing), however prolix in details, represent a degree zone of value. As it will become apparent below, for me the discursive and the aesthetic are inseparable, for part of what constitutes the interest of the LL series is its distinctive and ideologically inflected aesthetics.

28. Examples of such materials include "the trade cards of the seventeenth century, the visiting cards of the eighteenth century with their exquisite engravings, vignettes of cupids, musical instruments and the like, tradesmen's letter heads of the early nineteenth century, the pictorial writing paper of the 1850s and 1860s and, of course, the famous Mulready envelope," as well as the famous cartes-de-visites popularized by André Disdéri. James Laver, foreword to Frank Staff, *The Picture Postcard and Its Origins* (London: Lutterworth Press, 1966), 7. Because Staff's is by far the most serious and substantial work on the postcard I shall be relying heavily on it throughout what follows.

29. Staff, *The Picture Postcard and Its Origins,* 8; hereafter abbreviated *PP*.

30. The defining association of the postcard with openness is precisely what Derrida calls into question in the "Envois" section of *The Post Card: From Socrates to Freud and Beyond,* trans. Alan Bates (Chicago: University of Chicago Press, 1987). The notion that the postcard can be distinguished from the letter on the basis of the former's openness is revealed as illusory because, following the same logic as that of "The Purloined Letter"—and as *The Post Card* provocatively illustrates—it is the postcard's very openness that makes it the ideal vehicle for putting encrypted messages into circulation. Furthermore, the very opposition between the letter and the postcard is undone by the realization that all letters are in fact subject to the economy of the postcard; the postcard is but the manifestation of the laws at work in the letter: "letters are always post cards: neither legible nor illegible, open and radically unintelligible" (79). There is what we might call a "becoming post card" that is inscribed in letters, which are all destined to be fractured, "morcellized," to go to pieces, to be caught up in a generalized "postcardization" (104).

31. Griseline, *Le Cartophile* 3 (December 1900): 7.

32. See Guy Feinstein, introduction to Michael Cabaud and Ronald Hubscher, *1900: La Française au quotidien* (Paris: Armand Colin, 1985), 6.

33. We can perhaps grasp the significance of this "advance" if we consider the fact that even today there exist two types of postcards, those with divided backs, generally the most touristic, and those, generally reproductions of works of art or arty photographs, with no divisions. So firmly anchored in our minds is the postcard's function as a conveyor of messages that when confronted with an undivided postcard we would never think of writing some brief message directly on the image and using the blank back for the address. Rather, we either use the entire back as a writing surface and slip the card into an envelope, or create our own division on the back, or finally simply file the card away in our private collections.

34. Claude Bourgeois and Michel Melot, *Les Cartes postales: Nouveau guide du collectionneur* (Paris: Éditions Atlas, 1983), 28.

35. Maurice Normand, "Coup d'oeil sur l'Exposition," in *Les Grands Dossiers de l'illustration: Les Expositions universelles: Histoire d'un siècle, 1843–1944* (Paris: Sefag et l'Illustration, 1987), 134. Compare Jean-Jacques Bloch and Marianna Delort, who write: "Paris is a woman who welcomes her visitors at the main door of the Exposition…with a monumental statue…. She is neither an allegory nor a goddess, she's la Parisienne, that Paquin the couturier has dressed according to the latest fashion. One can ironize at length about this woman with arms outstretched but she is the very symbol of the Belle Epoque." Jean-Jacques Bloch and Marianna Delort, *Quand Paris allait "à la Expo"* (Paris: Fayard, 1980), 105.

36. "A travers l'exposition: La Rue de Paris," in *Les Grands Dossiers de l'illustration,* 152.

37. Paul Greenhalgh, *Ephemeral Vistas: The "Expositions Universelles," Great Exhibitions, and World's Fairs, 1851–1939* (Manchester: Manchester University Press, 1988), 118, 119.

38. A. Albalat, *Le Cartophile* 3 (December 1900): 5.

39. Philippe Hamon, *Expositions: Littérature et architecture au XIXè siècle* (Paris: J. Corti, 1989), 72.

40. MacCannell, *Tourist,* 63.

41. Daniel Oster and Jean Goulemot, *La Vie parisienne: Anthologie des moeurs du XIXè siècle* (Paris: Sand/Conti, 1989), 6, 5. "Classifying, declassifying, outclassing, such are the obsessions of the era…. Flânerie and classification keep post-1848 literature alive." The discourse on Paris is "a descriptive discourse with totalizing claims" (7, 19).

42. Hamon, *Expositions,* 97.

43. See Sennett, *The Fall of Public Man* (New York: Vintage Books, 1978), 135.

44. Ibid., 160.

45. See Janet Wolff, "The Invisible *Flâneuse:* Women and the Literature of Modernity," in *Feminine Sentences: Essays on Women and Culture* (Berkeley and Los Angeles: University of California Press, 1990), 34–50.

46. It follows that the postcard inherits the archeological pretensions of the realist novel; the following echoes the claims of all realists from Balzac to Duane Hanson: "When the archaeologists of the thirtieth century begin to excavate the ruins of London, they will fasten upon the Picture Postcard as the best guide to the spirit of the Edwardian Era. They will collect and collate thousands of these pieces of pasteboard, and they will reconstruct our age from the strange hieroglyhps and pictures that time has spared" (Douglas, quoted in *PP,* 76, 79). Compare "Duane Hanson: Truth in Sculpture," in my *Reading in Detail: Aesthetics and the Feminine* (New York: Methuen, 1987), esp. 131, 134.

47. Thanks to the kind cooperation of Alan Bonhoure of the Roget-Viollet photographic agency, which inherited the complete Lévy-Neurdein archives—consisting mainly of thousands of glass plates—when the Compagnie des Arts Méchaniques (who had taken over Lévy-Neurdein in 1932) went out of business (ca. 1974), I was able to consult the albums containing the complete or near-complete sequence of LL cards of Paris. Based on the sartorial evidence provided by some of the most recent views included in these albums, they were assembled sometime in the twenties. Though the albums, with postcards pasted three by three on their crumbling pages, are not themselves complete and are occasionally unreliable, they provide extraordinarily precious information about the organization of the series. Even though the cards are numbered, and certain numbers correspond to sites whose image was repeatedly rephotographed and undated, others do not: a single number may in fact correspond to two wildly different sites (for example, 256: "La Rue Saint-Jacques" and "L'Entrée du Bois de Boulogne"). Though the collection strives toward exhaustiveness, its representation of Paris is anything but systematic, shifting, for example, without any apparent logic from the fancy rue de la Paix (81) to the less elegant Pigalle (82).

48. In terms of urban representations, one might usefully contrast this transitional age with the age of decadence, which immediately precedes it and which is marked by the absence of a reassuring historical sense. In the words of Marie-Claire Bancquart, who has written extensively on literary representations of fin-de-siècle Paris: "all the writers of the *fin de siècle* experience an unease, feel that intimacy with the Self is impossible;…and this malaise is projected onto Paris, a disassociated Paris which has forgotten its history. Intermittencies of the heart of the city: one is struck

by the small number of evocations of the past, of monuments, in this capital where money has replaced culture." Marie-Claire Bancquart, "Du Paris Second Empire au Paris des écrivains fin-de-siècle," in *Écrire Paris,* ed. Daniel Oster and Jean-Marie Goulemot (Paris: Seesam, 1990).

Today's postcards can be said to represent a new shift in representations of Paris as nostalgic; even retro-postcards (always black and white, or a grainy, milky gray) of a fast-disappearing "Vieux Paris" (chiefly that of the twenties and fifties) are juxtaposed on the racks with bright color images of the new Paris, the Paris of Mitterrand with its Pei Pyramid and Arche de la Défense. It is through this ubiquitous postcarding of our fin-de-siècle Paris that the naturalizing functions of the postcard are most clearly displayed.

49. See T. J. Clark, *The Painting of Modern Life: Paris in the Art of Manet and His Followers* (New York: Alfred A. Knopf, 1984).

50. George Guyonnet, *La Carte postale illustrée: Son histoire, sa valeur documentaire* (Nancy, 1947), 19.

51. Frédéric Vitoux, *Cartes postales* (Paris: Gallimard, 1973), 34; hereafter abbreviated *C.*

52. In his little-known belated nouveau roman, *Cartes postales,* Vitoux prefaces his imaginative reconstruction of the story told by a collection of eight hundred postcards, dating from 1902 to 1920, by a superb and to my mind highly accurate section devoted to the information that can be gleaned from these postcards as to the monotonous preoccupations, distinctive class membership, and typical relationships of the correspondents. Here is how the unidentified narrator describes the messages: "Thank-yous, trip, health worries, invitations, announcements of visits, etc. One card, one idea…. One desire, one card"; "Disappointment: the great poverty of information provided by these post cards. Health, health, health" (*C,* 19, 26). The authors of this impoverished prose belong mainly to a petit bourgeoisie who recently emerged from the peasantry and occupy a very special position in the kinship system: "The most frequent epistolary relationships entered into via post cards are generally those of aunts and uncles with their nephews and nieces. The degree of kinship is sufficiently close to justify such care. At the same time the entirely normal distance separating this one from that one favors epistolary exchange" (*C,* 33). One final note: the collector of this fictional collection turns out to be, not surprisingly, a "collectionneuse" (*C,* 38).

53. Despite its promising title, *Walter Benjamin et Paris: Colloque international 27–29 juin 1983,* ed. Heinz Wismann (Paris: Cerf, 1986), contains no articles dealing with the Paris of the thirties, except in terms of its intellectual and political climate.

54. Were this text not already very long, one would have to (re)consider here the crucial relationship between Benjamin and the surrealists in relation to the representation of Paris. It is significant that for the surrealists, Paul Éluard especially but also André Breton, postcards were a key form of urban representation.

55. See Susan Buck-Morss, *The Dialectics of Seeing: Walter Benjamin and the Arcades Project* (Cambridge, Mass.: MIT Press, 1989), 304–7. Buck-Morss makes a tantalizing attempt at retracing Benjamin's steps as he goes to work at the Bibliothèque Nationale (see 342), but her imaginative reconstruction of Paris of the thirties is limited to that neighborhood and its remaining arcades. The first image reproduced in Buck-Morss's "Afterimage" section is, fittingly, a postcard portrait of Benjamin in Ibiza (see 341).

Chapter 2: Stieber

I am grateful to Aagje Gosliga and Alfred Marks for their assistance in compiling the postcards published by the Commissie voor het Stadsschoon, and to Rob Joghems for providing information about John Anthony Jochems. Simon van Blokland kindly shared his extensive knowledge of Amsterdam postcards.

1. *Vivat's Aankondiger voor den Boekhandel,* November 2, 1901, 3. There were 112 million letters sent in 1901, and of those, 66 million were postcards—although the number that were topographical cannot be determined.

2. The best sources on the history of the Dutch postcard are H. J. Haverkate, *De geschiedenis van de Nederlandse prentbriefkaart* (Oud-Zuilen: Vereniging Documentatie Prentbriefkaarten, 1987–90); Haverkate, *Encyclopedie van de Nederlandse Prentbriefkaart* (Oud-Zuilen: Vereniging Documentatie Prentbriefkaarten, 1998); and other publications of the Vereniging Documentatie Prentbriefkaarten.

3. Postcard publishers active in Amsterdam around 1900 included Abrahamson and van Straaten, N. J. Boon, L. Cnobloch, Wilfried Deyle, Louis van Hasselt, Herz-Kunstanstalt, the International Trading Company, Jos. Nuss, Gebr. van Rijkom, J. Sleding, J. H. Schaefer, J. H. Schalekamp, H. S. Speelman, A. Vigevano, Vivat, and Vlieger. The Vereniging Documentatie Prentbriefkaarten has published a list of Dutch postcard manufacturers: "Alfabetische lijst van uitgevers van in Nederland uitgegeven prentbriefkaarten" (typescript, 1980).

4. Postcard photographs also were republished in illustrated magazines. For instance, images from a series on orphans were published in the March 17, 1906, issue of the *Graphic,* probably simultaneous with their publication as postcards.

5. This process is described in the *Bulletin Vereniging Documentatie Prentbriefkaarten,* no. 10 (September 1986): 6.

6. All quotations are from postcards in the author's collection. Most of the conclusions about postcards of Amsterdam have been drawn on the basis of that collection of approximately sixteen hundred postcards published between 1895 and 1925, the postcard collection of the Gemeentearchief, and published compilations of Amsterdam postcards, including L. C. Schade van Westrum, *Groeten uit Amsterdam, prentbriefkaarten uit grootvader's album* (Amsterdam: De Bussy, 1964); Simon van Blokland, *Amsterdamse grachten op oude prentbriefkaarten* (Amsterdam: Heuff, 1995); Van Blokland, *Nakaarten met oude prentbriefkaarten: Amsterdam rond de eeuwwisseling* (Amsterdam: Amsterdam, 1996); Van Blokland, *Nakaarten II met oude prentbriefkaarten: Amsterdam rond de eeuwwisseling* (Amsterdam: Amsterdam, 1997); G. A. M. de Regt-Admiraal, *Amsterdam straat- en marktleven zo het was* (Hoevelaken: Verba, 2003); De Regt-Admiraal, *Amsterdam zo was het,* vol. 1 (Hoevelaken: Verba, 2003).

7. At a meeting in 1907 of the Vereeniging tot bevordering van de prentbriefkaarten-handel (Society for the Advancement of the Postcard Trade), based in Amsterdam, the members decided to set the wholesale price for postcards at 4.50 per hundred for black-and-white or matte cards and 6.00 guilders for color cards. H. J. Haverkate, *De Geschiedenis van de Nederlandse Prentbriefkaart,* vol. II-A (Oud-Zuilen: Vereniging Documentatie Prentbriefkaarten, 1988), 32. In 1901 the Amsterdam-based postcard publisher Vivat offered topographical postcards at one hundred for 1.50 guilders, hand-colored for 2.50 guilders. A catalogue of the publisher Schalekamp dated around 1902 lists these prices: a cabinet photo 50 cents, a stereoscope 50 cents, a glass lantern slide 1 guilder, and an album of 12 cartes de visite 2.50 guilders. N. J. Boon offered postcards in 1914 for 5 cents net.

8. See, e.g., *Nieuwsbode uit de Ansichtkaartenwereld,* published from February to December 1902. Several clubs for collectors were established in the Netherlands around 1900, including Wilhelmina, Ansicht, and the Nederlandsche Vereeniging voor Ansichtkaart verzamelaars.

9. *Nieuwsbode uit de Ansichtkaartenwereld,* February 15, 1902, 1.

10. On the history of Amsterdam topographical atlases, see R. W. P. de Vries, "Amsterdamsche Atlassen," in *Amsterdamsche Bijzonderheden,* by N. de Roever et al., vol. 2 (Amsterdam: L. J. Veen, 1889), 25–37; Bert Gerlagh and J. F. Heijbroek, "De Atlas Amsterdam," in *Voor Nederland Bewaard: De Verzamelingen van het Koninklijk Oudheidkundig Genootschap in het Rijksmuseum,* Leids Kunsthistorisch Jaarboek 10 (Baarn: de Prom, 1995), 199–220.

11. D. C. Meijer Jr., "Prentverzamelingen over Amsterdam," in *Amsterdamsche Bijzonderheden,* by E. W. Moes et al., vol. 12 (Amsterdam: L. J. Veen, 1904), 1–3.

12. Justus van Maurik, *Toen ik nog jong was* [When I Was Still Young] (Amsterdam: Van Holkema and Warendorf, 1901), 8–12.

13. For a listing of Amsterdam skylines, see A. E. d'Ailly, *Repertorium van de profielen der stad Amsterdam en van de plattegronden der schutterswijken* (Amsterdam: Stadsdrukkerij, 1953). Other vantage points for panoramic postcards were from the tower of the Westerkerk and other high points in the city. At least two of the panorama photographs of G. H. Heinen were issued as outsized postcards.

14. *Weekblad voor den Boek-, Papier-, Muziek-, Kunst-, en Kantoorboekhandel en de Papier verwerkende Industrie,* July 25, 1903, 167.

15. *Weekblad,* July 18, 1903, 157.

16. The postcards were published by the International Trading Company.

17. The card is titled "Extra Tijding" (Extra News) and reproduces a standard view of the Exchange with cracks across its facades drawn in. The printed message on the front of the card reads: "Mijn waarde, Hierbij eene afbeelding van de Amsterdamsche Beurs met de noodige scheuren, ook mijne Beurs is zoo gescheurd, weet U voor beide Beurzen geen afdoende raad? Want de Amsterdamsche Gemeenteraad, en mijn Familieraad zijn ten einde raad. Bij voorbaat dank, Uw toegenegen Vrind [*sic*]."

18. John Anthony Jochems was born in Amsterdam on September 1, 1836, and died there on January 1, 1920. After a career in the Dutch army, he took a post in the civil militia of Amsterdam in 1883. A. J. J. Ph. Haas, "J. A. Jochems," *Maandblad Amstelodamum* 7 (1920): 14–15; Rob Joghems, "John Anthony Jochems, Kapitein Adjudant, Eén van de twee oprichters van de Historische Verzameling der Schutterij te Amsterdam," *Gens Nostra* 55, no. 8 (2000): 448–62; Koen Kleijn, "'Equipementstukken van vervallen model': De Historische Verzameling der Schutterij te Amsterdam," in *Voor Nederland Bewaard, De Verzamelingen van hat Koninklijk Oudheidkundig Genootschap in het Rijksmuseum,* Leids Kunsthistorisch Jaarboek 10 (1995), 391–410. The scrapbook is in the collection of the author. For a more extensive discussion of Jochems's relationship to Amsterdam, see Nancy Stieber, "Amsterdam Eternal and Fleeting: The Individual and the Representations of Urban Space," in *Biographies and Space: Placing the Subject in Art and Architecture,* ed. Dana Arnold and Joanna Sofaer (London: Routledge, 2008), 73–98.

19. J. A. Jochems, "Amsterdam van Vroeger, van 1911–1915" (manuscript with newspaper and magazine clippings, postcards, and photographs).

20. Postcards of the new districts appeared in the 1920s with the publication by the Housing Authority of postcards showing the architect-designed workers' housing built under the auspices of the city. The painter and photographer Georg Breitner was one of the few artists around 1900 to take up the theme of Amsterdam under construction.

21. This analysis was made drawing on the Amsterdam Image Database, a database I have developed of four thousand images, not including postcards, drawn from one hundred sources dating between 1611 and 1925.

22. "Van welk land immers kunnen de A.K. belangwekkender zijn dan van Nederland? Waar anders ter wereld vindt men immers zoo prachtige oude steden met zoo prachtige oude gebouwen en kerken?" *Nieuwsbode uit de Ansichtskaartenwereld,* April 15, 1902, 17. On the complex history of the notion of the picturesque in Dutch culture, see Caroline van Eck and Jeroen van den Eynde, eds., *Het Schilderachtige: Studies over het schilderachtige in de Nederlandse kunsttheorie en architectuur 1650–1900* (Amsterdam: Architectura et Natura, 1994).

23. *Weekblad,* October 31, 1903, 282. The card was published by J. F. A. Vlanderen of Amsterdam.

24. The original drawing by H. J. M. Walenkamp accompanied the 1898 contract for the Exchange and was published widely in the architectural and popular press. For a reproduction, see Sergio Polano, *Hendrik Petrus Berlage, Complete Works* (New York: Rizzoli, 1988), 144, fig. 205.

25. On J. H. Schaefer, see Haverkate, *De geschiedenis van de Nederlandse Prentbriefkaart,* vol. II-A, 101–4.

26. On A. J. W. de Veer and B. Brouwer, see Simon van Blokland, *B. Brouwer en Brouwer & De Veer Amsterdam* (The Hague: Vereniging Documentatie Prentbriefkaarten, 2002). After De Veer departed for Cologne in 1912, Brouwer alone published an additional 134 postcards in the same vein. Brouwer also published a set of twelve postcards with views of Amsterdam in eighteenth- and nineteenth-century prints.

27. Of the one hundred cards, fifty-four were of the Oude Zijds, fourteen depicted the Nieuwe Zijds, fifteen the Grachtengordel, eleven the Damrak, Dam, and Rokin, and three the Amstel.

28. Specifically, Brouwer and De Veer numbers 3, 8, 10, 14, 16, 18, 20, 43, 52, and 58 correspond directly to drawings by Wenckebach. According to Van Blokland, this connection was first noted by L. C. Schade van Westrum in his *Groeten uit Amsterdam, Prentbriefkaarten uit grootvaders album* (Amsterdam: J. H. de Bussy, 1964), 6. Other publishers such as Louis Diefenthal adopted the same blue and sepia tinting as Brouwer and De Veer, sharing as well their photographic reconstitution of Wenckebach's compositions, subject matter, and aesthetic approach.

29. L. W. R. Wenckebach, *Oud-Amsterdam: 100 stadsgezichten* (Amsterdam: Het Nieuws van den dag, 1907).

30. Wenckebach's use of postcards is described in Han de Vries, *Amsterdam omstreeks 1900, getekend door L. W. R. Wenckebach tussen 1898 en 1907 en verzameld door A. M. van de Waal* (Amsterdam: De Bezige Bij, 1974), 4.

31. The committee was established in March 1911 on the initiative of the historical society Amstelodamum and consisted of members representing the Koninklijk Oudheidkundig Genootschap; the two architectural societies Architectura and the Amsterdam branch of the Maatschappij tot Bevordering der Bouwkunst; the historical society Amstelodamum; the artists' societies Sint Lucas and Katholieken Kunstkring "De Violier"; and Arti et Amicitiae. The committee was fused with the Schoonheidscommissie in 1924. The archive of the committee is located at the Gemeentearchief Amsterdam. On the workings of the committee see Vincent van Rossum, "Bouwkunst en welstand in de Amsterdamse binnenstad," in *Schoonheid: Architectuur, omgeving, landschap,* ed. Marijke Beek (Zwolle: Het Oversticht, 2000), 146–55, and "De Commissie voor het Stadsschoon te Amsterdam," *De Bouwwereld* 15, no. 29 (July 19, 1916): 225–27.

32. Commissie voor het Stadsschoon, form letter to potential supporters, June 1917, Gemeentearchief, archive 458/1. This letter was sent to a list of potential supporters of the committee's efforts that included George Breitner and L. W. R. Wenckebach among other historians, artists, and architects.

33. "Jaarverslag over 1915 van de handelingen der commissie voor het stadsschoon te Amsterdam," 1–2.

34. Correspondence in the archives of the Commissie voor het Stadsschoon (Gemeentearchief, archive 458/4) indicates that the committee received quotes for postcard production from several printers starting in December 1915. The first series of cards was produced in 1916 by the Amsterdam firm A. J. Nuss, already well established as a publisher of postcards. A bill from A. J. Nuss dated July 29, 1916, charges the committee 210 guilders for ten thousand postcards of twenty different city views. For the second series of cards, published in 1917, the committee turned to the Leiden printer Nederlandsche Rotogravure Maatschappij.

35. "Jaarverslag over 1916 en 1917 van de handelingen der commissie voor het stadsschoon te Amsterdam," 20.

36. *De Bouwwereld* 15, no. 34 (23 August 23, 1916): 270. The publication was also noted in *Bouwkundig Weekblad* 37, no. 19 (September 16, 1916): 152 and *Architectura* 24, no. 35 (August 26, 1916): 275.

37. I have identified and found images for thirty-nine of the forty postcards published by the committee in 1916 and 1917. Of those, nearly half are locations in the major canals and only one-quarter are in the oldest district of the city. The committee sought permission from Queen Wilhelmina to take photographs of the Amsterdam Town Hall (officially in use as the Royal Palace). The locations of the first series of postcards are Vinkenstraat, 6; Keizersgracht, 397–403; Singel, 83–85; Herengracht, 35–39; Nes hoek Enge Lombardsteeg; Palmgracht, 22–38; Vijzelstraat, 14; Herengracht, 170–72; Roomolenstraat, 9; O.Z. Kapelsteeg, 18; Keizersgracht, 40–44; Turfmarkt, 145; Anjeliersstraat, 214–16; Noordermarkt, 20–33; Enge Lombardsteeg; Nieuwe Teertuinen, 24–26; Roomolenstraat, 9; Singel, 421–23; Sint Olofssteeg. A set of the first series is in the postcard collection of the Netherlands Architecture Institute. The locations of the second series of postcards are Gelderschekade, 95–107; Stroomarkt hoek Gouwenaarstraat, 15–17; Binnen Wieringerstraat, 20–28; Langestraat, 72; Amstelsluizen (Binnen Amstel); O.Z. Achterburgwal, 52–54; O.Z. Achterburgwal, 74–78; Bagijnhof, 23–24; Roomolenstraat, 11; Herengracht, 199–205; Herengracht, 71–77; O.Z. Enge Kapelsteeg Kapelpoortje; Egelantiersgracht hoek Eerste Egelantiersdwarsstraat, 8–10; Handboogstraat, 16–18; Prinsengracht hoek Brouwersgracht; Prins Hendrikkade, 28–30; N.Z. Voorburgwal; Oostelijke wand in de groote zaal (1ste verdieping gezien vanaf portaal) (city hall); Galerij in het Noorden gezien van het Westen naar het Oosten (city hall); Noordelijke wand in de Vierschaar (city hall). This list was sent to the Nederlandsche Rotogravure Maatschappij on October 9, 1917. Gemeentearchief, archive 458/4.

38. Johan Herman Rössing, *Verdwijnend Oud-Amsterdam* (Amsterdam: Bernard Houthakker, 1916), 5.

Chapter 3: Snow

1. Although the 3A Folding Pocket Kodak was marketed as particularly suited for making real photo postcards, any negative from any camera could be turned into a real photo postcard simply by printing it on postcard paper in the developing stage. It should also be noted that photomechanical reproductions, halftone reproductions in particular, are often misidentified as real photo postcards. When viewed under magnification, the surface of halftone reproductions will appear as a matrix of tiny dots, whereas real photo postcards have a unified surface appearance.

2. Some of the most critical and academically rigorous discussions on postcards have dealt with themes of tourism and ethnographic representations of cultural and racial "otherness." See Maalek Alloula, *The Colonial Harem* (Minneapolis: University of Minnesota Press, 1986); Christraud Geary and Virginia-Lee Webb, eds., *Delivering Views: Distant Cultures in Early Postcards* (Washington: Smithsonian Institution Press, 1998); Brooke Baldwin, "On the Verso: Postcard Messages as a Key to Popular Prejudices," *Journal of Popular Culture* 22, no. 3 (1988): 15–27; Wayne Martin Mellinger, "Toward a Critical Analysis of Tourism Representations," *Annals of Tourism Research* 21, no. 4 (1994): 756–79; Elizabeth Edwards, "Postcards—Greetings from Another World," in *The Tourist Image: Myths and Myth Making in Tourism,* ed. Tom Selwyn (London: John Wiley and Sons, 1996), 197–221; Marion Markwick, "Postcards from Malta: Image, Consumption, Context," *Annals of Tourism Research* 28, no. 2 (2001): 417–38; and Alison Devine Nordström, "Early Photography in Samoa," *History of Photography* 15, no. 4 (1991): 272–86.

3. One sign that things are changing is the mention of real photo postcards in four revisionist history-of-photography survey texts. See Liz Wells, ed., *Photography: A Critical Introduction* (London: Routledge, 1997), 122–27; Mary Warner Marien, *Photography: A Cultural History* (Upper Saddle River, N.J.: Prentice Hall, 2002), 171;

Michel Frizot, ed., *A New History of Photography* (Milan: Könemann, 1998), 527–32; and Naomi Rosenblum, *A World History of Photography* (New York: Abbeville Press, 1984), 274–75.

4. Although brief, the essays in Hal Morgan and Andreas Brown, *Prairie Fires and Paper Moons: The American Photographic Postcard, 1900–1920* (Boston: David R. Godine, 1981) offer some useful insights into the historical development of both studio and amateur real photo postcards. Jody Blake and Jay Ruby have also written informative historical essays on American real photo postcards. See Jody Blake, "Photographic Correspondence: Picture Postcards in Historical Context," in *Rural Delivery: Real Photo Postcards from Central Pennsylvania, 1905–1935,* by Jody Blake and Jeannette Lasansky (Lewisburg, Pa.: Union County Historical Society, 1996); and Jay Ruby, "Images of Rural America: View Photographs and Picture Postcards," *History of Photography* 12, no. 4 (1988): 327–41. Also see Rosamond Vaule, *As We Were: American Photographic Postcards, 1905–1930* (Boston: David R. Godine, 2004). For survey-style, pictorially centered books, see David Chen, *About 85 Years Ago* (Niwot, Colo.: Roberts Rinehart, 1997); and Martin Parr and Jack Stasiak, "*The Actual Boot*": The Photographic Postcard Boom, 1900–1920 (Northampton: A. H. Jolly, 1986).

5. Tom Phillips, *The Postcard Century: 2000 Cards and Their Messages* (London: Thames and Hudson, 2000) is an excellent pictorial resource, in which thousands of postcards from his collection representing the years 1900–2000, including real photo postcards, are reproduced. His book is also exceptional for the emphasis it places on textual additions to postcards. Selections from Phillips's real photo postcard collection were displayed in a 2004 exhibit entitled We Are The People at the National Portrait Gallery in London. In the catalogue of the exhibition, Elizabeth Edwards's essay approaches real photo postcards as a means to understand broader social history. See Elizabeth Edwards, "Little Theatres of Self Thinking About the Social," in *We Are the People: Postcards from the Collection of Tom Phillips* (London: National Portrait Gallery, 2004). The most recent survey of a private collection is Todd Alden, *Real Photo Postcards: Unbelievable Images from the Collection of Harvey Tulcensky* (New York: Princeton Architectural Press, 2005).

6. This essay expands upon my past efforts to apply a method of close formal analysis to real photo postcards. In an earlier essay, I performed a close visual and textual analysis on one real photo postcard in order to understand how the specificity of the postcard/photograph format affects the already complicated relationship between photography and personal memory. See Rachel Snow, "Postscript to a Postcard," *Afterimage* 29, no. 6 (2002): 6. While my work has focused on close analysis, it is just one of several methods that need to be explored and developed.

7. While real photo postcards cover a diverse range of topics, most of my examples are portraits, as they make up a significant portion of the genre. From these I have selected typical examples of both studio and amateur real photo postcards in order to study the differences and similarities between commercial and private practices. I have chosen examples without text because many real photo postcards have no writing and were never actually used as postcards, but I have also chosen representative examples with text to understand how they were used as a means of communication and how the inclusion of text "activates" the photograph as a three-dimensional object. I have selected only American examples, even though real photo postcards were popular in many places throughout the world, because I wanted to understand what (if any) specific impact American values and history might have upon their creation and use. Finally, I have selected examples from ca. 1900–1920 because this was the height of the real photo postcard's popularity.

8. For more on snapshot photography, see Patricia Holland, "Sweet It Is to Scan: Personal Photographs and Popular Photography," in *Photography: A Critical Introduction,* ed. Wells, 105–50; Brian Coe and Paul Gates, *The Snapshot Photograph: The Rise of Popular Photography, 1888–1939* (London: Ash and Grant, 1977);

Douglas Collins, *The Story of Kodak* (New York: Harry N. Abrams, 1990); Jonathan Green, ed., "The Snap-Shot," special issue, *Aperture* 19, no. 1 (1974); Jeremy Seabrook, "My Life Is in That Box: Photography and Popular Consciousness," *Ten-8,* no. 34 (Autumn 1989); Douglas R. Nickel, *Snapshots: The Photography of Everyday Life, 1888 to the Present* (San Francisco: San Francisco Museum of Modern Art, 1998); and Colin Ford, ed., *The Story of Popular Photography* (North Pomfret, Vt.: Trafalgar Square, 1989).

9. For more on the American consumer's quest for distinction through consumption of mass-produced goods during this time, see Stuart Ewen, *All Consuming Images: The Politics of Style in Contemporary Culture* (New York: Basic Books, 1988), 57–108.

10. Nancy West has written about Kodak's advertisements and their emphasis on possession and ownership. See Nancy Martha West, *Kodak and the Lens of Nostalgia* (Charlottesville: University Press of Virginia, 2000).

11. Eastman Kodak Company, "A Little Cousin of the Post Card," *Kodakery* 1, no. 9 (1914): 19–21.

12. Eastman Kodak Company, "Kodak Portraits I-VI," *Kodakery* (October–March 1914–15).

13. Eastman Kodak Company, *At Home with the Kodak* (Rochester: Eastman Kodak, ca. 1910), 4.

14. Ibid., 15.

15. This image originally appeared in Blake, "Photographic Correspondence," 13. She discusses it in terms of the competition inexpensive real photo postcards posed to traditional studio portrait studios.

16. Martha Langford makes this same claim in relation to viewing photograph albums. See Martha Langford, *Suspended Conversations: The Afterlife of Memory in Photographic Albums* (Montreal: McGill–Queen's University Press, 2001).

17. There has been a relatively recent and growing appreciation of such photographic practices. Several important texts by Geoffrey Batchen have addressed these early modes of production, including *Forget Me Not: Photography and Remembrance* (New York: Princeton Architectural Press, 2004); "Vernacular Photographies," in *Each Wild Idea: Writing, Photography, History* (Cambridge, Mass.: MIT Press, 2001), 56–80, 199–204, and *Photography's Objects,* exh. cat. (Albuquerque: University of New Mexico Art Museum, 1997). Also see Elizabeth Edwards and Janice Hart, eds., *Photographs, Objects, Histories: On the Materiality of Images* (London: Routledge, 2004).

Chapter 4: Zervigón

1. Wieland Herzfelde, *John Heartfield: Leben und Werk* (Leipzig: Verlag der Kunst, 1962), 18. Here I use the translation produced by Brigid Doherty in "Berlin Dada: Montage and the Embodiment of Modernity, 1916–1920" (Ph.D. diss., University of California, Berkeley, 1996), 5–6. This essay works very much in dialogue with Doherty's own work on World War I–era photomontage. It also follows on the heels of her two journal articles discussing specific discursive moments of Dada montage, "See: *'We Are All Neurasthenics!'* or, The Trauma of Dada Montage," *Critical Inquiry* 24, no. 1 (1997): 82–132, and "Figures of Pseudorevolution," *October,* no. 84 (Spring 1998): 65–90.

2. As Herzfelde explained, "[Grosz] had specialized in sending care-packages to annoy soldiers at the front. As far as he was concerned, they weren't annoyed enough." Doherty, "Berlin Dada," 5. For an analysis of Grosz's opposition to the war and his postwar radicalization, see Barbara McCloskey, *George Grosz and the Communist Party: Art and Radicalism in Crisis, 1918–1936* (Princeton: Princeton University Press, 1997).

3. Doherty, "Berlin Dada," 6.

4. Ibid.

5. For more on this history, see David Welch, *Germany, Propaganda, and Total War, 1914–1918: The Sins of Omission* (London: Athlone Press, 2000). Welch proposes that Germany came to value propaganda relatively late, well after England and France had initiated campaigns highlighting the Reich's war crimes in Belgium and elsewhere. The German response, however, was as much domestically focused as it was directed against Allied defamation. The armed forces high command, led by the men Robert Paxton describes as the "virtual dictators of the German war effort," Erich Ludendorff and Paul von Hindenburg, had from 1917 determined that internal propaganda could specifically defer discussion of Germany's war aims and governmental reforms while also distracting from the deprivations of Britain's naval blockade. It was in this context that the publication of war photographs was severely restricted. Paxton's description of these generals can be found in his *Europe in the 20th Century,* 4th ed. (New York: Harcourt Brace, 2002), 97.

6. As Doherty points out, this is particularly true concerning the excised advertisement for enriched dog food, a product whose luxury seemed all the more obscene when great numbers of Germans, suffering under the British naval blockade, were now going hungry. Doherty, "Berlin Dada," 6.

7. Heartfield's original name was Helmut Herzfeld, but he unofficially anglicized it during the war as a personal protest again German nationalist chauvinism. At the war's conclusion, he began the process of making this change legal. His brother Wieland also made a name change during the war, adding an "e" to Herzfeld in what he saw as a poetic softening of the consonant "d" with which his name had ended. And not to be outdone, Georg Gross transformed his name to the vaguely anglicized and distinctly exotic George Grosz. For more reflections on these name changes, see further translations of Herzfelde's biography in Lucy Lippard, ed., *Dadas on Art,* trans. Gabriele Bennett (Englewood Cliffs, N.J.: Prentice Hall, 1971), 90. Herzfelde's son George Wyland also offers an interesting and personal analysis of his family's change of names. See Wyland, "Bekanntmachung eines offenen Geheimnisses," in *Montage als Kunstprinzip,* ed. Hilmar Frank (Berlin: Akademie der Künste zu Berlin, 1991), 11. For a thorough analysis of Heartfield's larger project, particularly his later collaboration with the *Arbeiter Illustrierte Zeitung,* see Sabine Kriebel, "Revolutionary Beauty: John Heartfield, Political Photomontage, and the Crisis of the European Left, 1929–1938" (Ph.D. diss., University of California, Berkeley, 2003).

8. Here, Herzfelde is recounting Heartfield's recollection that soldiers, as well as the artist duo, were creating montaged correspondence in order to sneak illicit messages past the military censor's eyes. Doherty, "Berlin Dada," 6.

9. John Heartfield, quoted in "Rundfunkgespräch (DDR) mit Renate Stoelpe und John Heartfield, 2: Erfindung der Fotomontage" (part two of a two-part radio interview, broadcast on September 12, 1966), typed transcript with handwritten corrections, John Heartfield Archive, Akademie der Künste zu Berlin, 6–7. Translated in Doherty, "Berlin Dada," 1.

10. George Grosz later recounted his joint "discovery" of photomontage with Heartfield by ironically supplying an exact time and place for the event. He thereby withdrew from the debates swirling around this issue, refusing to engage Raoul Hausmann, for example, who vigorously asserted that he and Höch had actually devised the technique first. For a reprinting of the various statements in this debate, see "Die Streit um die Erfindung der Fotomontage," in Roland März and Gertrud Heartfield, eds., *Der Schnitt entlang der Zeit: Selbstzeugnisse, Erinnerungen, Interpretationen* (Dresden: VEB Verlag der Kunst, 1981), 29–31.

11. Sergei Tret'iakov, *John Heartfield: A Monograph* (Moscow: Moscow State Publishing House, 1936), translation from Russian by Devin Fore. I am currently editing Fore's full English translation of this Russian-language monograph. It should offer an

12. Doherty, "Berlin Dada," 6.

13. Ibid.; see chap. 1, 10–28.

14. Sherwin Simmons, "Advertising Seizes Control of Life: Berlin Dada and the Power of Advertising," *Oxford Art Journal* 22, no. 1 (1999): 119–46.

15. Eckhard Siepmann, *Montage: John Heartfield vom Club Dada zur "Arbeiter-Illustrierte Zeitung"* (Berlin: Elefanten Press Verlag, 1977), 16.

16. According to Herbert Leclerc, for instance, the first maker of picture postcards, Mr. A. Schwartz from Oldenburg, devised his images specifically in support of Germany during the Franco-Prussian war. These designs, initially featuring a cannon with laurel wreaths resting on either side, quickly became a sensation that the Prussian government encouraged. The repertoire of images on these cards correspondingly expanded, making the Franco-Prussian war the first conflict to see picture postcards produced on a mass scale. Herbert Leclerc, "Ansichten über Ansichtskarten," *Archiv für deutsche Postgeschichte* 2 (1986): 17–18. This important article on Germany's history of picture postcards runs almost the entire issue, from pp. 3–65.

17. On the first, see Jean Sagne, "All Kinds of Portraits: The Photographer's Studio," and on the second, see Pierre Albert and Gilles Feyel, "Photography and the Media: Changes in the Illustrated Press," both in *A New History of Photography,* ed. Michel Frizot (Cologne: Könnemann Verlagsgesellschaft, 1998), 103–22, 359–69, respectively.

18. By the turn of the century, Leclerc confirms, picture postcards had become so popular in Germany that, as a nation, it became the largest manufacturer and sender of these small items. Leclerc, "Ansichten," 31.

19. His collection shows that he was particularly fascinated by the pornographic images that flourished on turn-of-the-century postcards. For more on this, see Kathrin Hoffmann-Curtius, "Erotik im Blick des George Grosz," in *George Grosz: Berlin, New York,* ed. Peter-Klaus Schuster (Berlin: Nationalgalerie Berlin, 1994), 182–89.

20. The Grosz Archive is housed at the Stiftung Archiv der Akademie der Künste, Berlin.

21. Grosz's early work was also heavily inspired by the Italian Futurist movement in exactly the same disjunctions and dynamism that could be seen in these popular postcards. In fact, Futurism likely inspired the compositionally radical montage style that Herzfelde describes seeing on the cardboard piece he received in Grosz's care package. Before the war, Heartfield and Grosz had separately visited exhibitions of the movement's paintings and drawings held at Der Sturm gallery. The effect on both artists was clear. Grosz quickly transformed his prewar graffiti-like drawing style into a chaos of force—lines whose visual strength, in works such as *Metropolis* (1916–17), signified the social breakdown of wartime Berlin. Heartfield was also heavily affected by Italy's Futurist movement. He remarked later that Carlo Carra's *Burial of the Anarchist Galli* (1911) inspired him deeply when he first saw it at an earlier 1912 Der Sturm exhibition. This last comment was recorded in an interview with Stockholm's Modern Museum curator Bengt Dahlbäck in 1967, now housed at the Heartfield Archive, Stiftung Archive der Akademie der Künste. The interview is partially reproduced in März, *Der Schnitt,* 464. This, then, would offer the scenario that Siepmann describes, in which the formal contrasts of Cubism/Futurism become the social contrast of subversive postcards.

22. This advertising program was housed at Berlin's Charlottenburg Arts and Crafts School and was headed by Ernst Neumann. On the significance of this program to both Germany and Heartfield's career, see Simmons, "Advertising Seizes Control."

23. On the contribution of Odol to modern advertising and more specifically, its use of picture postcards, see Henriette Väth-Hinz, *Odol: Reklame-Kunst um 1900* (Gießen: Anabas Verlag, 1985). See also the section on Odol in Michael Weisser, *Deutsche Reklame: 100 Jahre Werbung 1870–1970* (Bassum: Doell Verlag, 2002), 165–76.

24. Sigrid Metken, "'Ich hab' diese Karte im Schützengraben geschrieben…' Bildpostkarten im Ersten Weltkrieg," in *Die letzten Tage der Menschheit: Bilder des Ersten Weltkrieges,* ed. Rainer Rother (Berlin: Deutsches Historisches Museum, 1994), 148.

25. For more on Germany's censorship and propaganda during the First World War, see Welch, *Germany, Propaganda.*

26. For an analysis of this norm and for a general introduction to the history of picture postcards in Germany during World War I, see Deutsches Historisches Museum, ed., *Der Erste Weltkrieg in deutschen Bildpostkarten* (Berlin: Directmedia, 2002). This is volume 66 of the German Historical Museum's CD-ROM project, the intention of which is to digitize the institution's large holdings. The comprehensive introduction and the individual commentaries are written by the postal historian Katrin Kilian. Her discussion of montage in these postcards can be found under the heading "Zeichen und Schriftzeichen."

27. Welch, *Germany, Propaganda,* 128–30. A discussion of the government's censorship restrictions, specifically what could and could not be reproduced, appears on 178–83.

28. Apparently, many of the imperial personality postcards appearing up to the year 1914 were produced by E. Bieber, "der Kaiserliche Hoffotograf." Bieber was the house photographer of the royal family. See Marlies Ebert, "Bildpostkarten als Mittel der ideologischen Massenbeeinflussung. Gendanken zur Kartensammlung des Märkischen Museums," *Jarhbuch des Märkischen Museums* 10 (1984): 43, and Metken, "'Ich hab' diese Karte,'" 42.

29. This card is also from the Grosz Archive.

30. März, *Der Schnitt,* 464.

31. Ibid. There is still some dispute as to whether or not Heartfield actually created this composition during the war. It first appeared in a 1920 issue of *Die Freie Welt* (vol. 2, no. 29: 5), a publication of the German Independent Socialist Party to which Grosz frequently contributed. This might indicate its origins in Grosz's and Heartfield's orbit. But Heartfield's reflections on this composition largely came after World War II, when he was being forced to distance himself from a Berlin Dada that postwar Stalinism considered "bourgeois decadence." Photomontage's birth in World War I, therefore, would offer a more acceptable alternative to its incubation in Berlin Dada.

32. Welch, *Germany, Propaganda,* 128–83, and Budo von Dewitz, "Zur Geschichte der Kriegsphotographie des Ersten Weltkrieges," in Rother, *Die letzten Tage,* 163–76.

33. The government and military kept the consequences for these publishing transgressions vague so as to intimidate press and postcard outlets with what was essentially an arbitrary power. The country's private media, however, consistently demanded clear guidelines and finally forced the government to publish a censorship code in 1917. The resulting pamphlet makes for fascinating, if dense, reading. Oberzensurstelle des Kriegspresseamts, ed., *Zensurbuch für die deutsche Presse* (Berlin: Kriegspresseamt, 1917).

34. Erich Maria Remarque, *All Quiet on the Western Front* (New York: Buccaneer Books, 1983), 113.

35. Heartfield wrote the date of 1916 on the back of this photo-juxtaposition, although he likely did not begin producing the balance of these works until 1917. Based on an August 2002 conversation with Michael Krejsa, head of the Heartfield Archive in Berlin.

36. Grosz's composition did not remain a postcard, intended for the consumption of a few individuals. Instead, he published it in *Die Freie Welt,* a weekly illustrated magazine produced as a supplement to the daily newspaper *Die Freiheit.* Both periodicals were published by the German Independent Social Democratic Party—another radical offshoot of the German Social Democratic Party that was inspired by communism but remained wary of the official German Communist Party itself.



anglophone audience access to one of the most sophisticated early analyses of Heartfield's work.

37. This monograph was composed by Fritz Freiherr von Ostini, *Grützner* (Bielefeld: Velhagen und Klasing, 1902). Grosz's montage frequently cited from books and magazines lying in his collection.

38. The question "Who is the most beautiful?" was, in fact, a competition. Readers were invited to submit written responses, and the best would be publicly recognized in the following issue.

39. Lippard, *Dadas,* 73.

40. This cabinet card is catalogued in Cornelia Thater-Schulz, ed., *Hannah Höch: Ein Lebenscollage,* vol. 1 (Berlin: Berlinische Galerie, 1989), 439 and 472.

41. Similar photomontages often featured individual soldiers paired with the Kaiser or whole platoons in numerous settings. These images were normally assembled in private portrait studios, and the resulting products were posted to families back home. See Bodo von Dewitz, *"So wird bei uns der Krieg geführt!" Amateurfotografie im Ersten Weltkrieg* (Munich: Tuduv-Verlag, 1989), 125–29. See also Doherty's fantastic explanation of this frontline industry in chapter 1 of her dissertation. Doherty also points out that Georg Scholz's *Industrial Peasants* (1920), a photomontage likely exhibited in Berlin Dada's 1920 First Great International Fair, features a family living room with an actual version of such a postcard affixed to the background. Doherty, "Berlin Dada," 17.

42. Wieland Herzfelde, "Introduction to the First International Dada Fair," in *First International Dada Fair* (Berlin: Art Dealership Otto Burchard, 1920), trans. Brigid Doherty, *October,* no. 105 (Summer 2003): 102.

43. *First Dada Manifesto (Berlin),* 1918, reprinted in Richard Huelsenbeck, *En Avant Dada: Eine Geschichte des Dadaismus* (Hanover: Steegmann, 1920), translated by Ralph Manheim in *Dada Painters and Poets,* ed. Robert Motherwell (New York: Wittenborn, Schultz, 1951), 32.

44. Herzfelde, *John Heartfield,* 102.

Chapter 5: Smith

1. See Magdalena Bushart, *Der Geist der Gotik und die Expressionistische Kunst, 1911–1925* (Munich: Verlag Silke Schreiber, 1990); Jill Lloyd, *German Expressionism: Primitivism and Modernity* (New Haven: Yale University Press, 1991); and Peg Weiss, *Kandinsky and Old Russia: The Artist as Ethnographer and Shaman* (New Haven: Yale University Press, 1995).

2. Mark Rosenthal, for example, writes: "Marc's turn to this subject [animals] was a feeling that animals were somehow more natural or pure than people. Moreover, Marc believed that through animals he could represent his own spiritual feeling." Mark Rosenthal, *Franz Marc* (Munich: Prestel Verlag, 2004), 13.

3. Peter-Klaus Schuster, *Franz Marc: Postcards to Prince Jussuf,* trans. David Britt (Munich: Prestel Verlag, 1988), 23. A more extensive version of this book, which also includes Lasker-Schüler's letters and postcards to Marc, was published in German as *Franz Marc—Else Lasker-Schüler: "Der Blaue Reiter präsentiert Eurer Hoheit sein Blaues Pferd": Karten und Briefe* (Munich: Prestel Verlag, 1986). On the postcards, see also Karl E. Webb, "Else Lasker-Schüler and Franz Marc: A Comparison," *Orbis Litterarum* 33 (1978): 280–98.

4. Schuster, *Franz Marc,* 21. See also Peter-Klaus Schuster, "Vom Tier zum Tod: Zur Ideologie des Geistigen bei Franz Marc," in *Franz Marc, Kräfte der Natur: Werke 1912–1915,* ed. Erich Franz (Ostfildern: Verlag Gerd Hatje, 1993), 179.

5. Sigrid Bauschinger, *Else Lasker-Schüler: Ihr Werk und ihre Zeit* (Heidelberg: Stiehm, 1980), 102.

6. "Wie schön ist die Karte—ich habe mir zu meinen Schimmeln immer solche meiner Lieblingsfarbe gewünscht. Fabelhaft künstlerisch sind die Mondsicheln, egypt. Kronprinzendolche, in der Haut der wiehernden Sagen. Wie soll ich Ihnen danken!!" Franz and Maria Marc to Else Lasker-Schüler, January 3, 1913, in *Else Lasker-Schüler,*

Franz Marc. Mein lieber, wundervoller blauer Reiter: Privater Briefwechsel, ed. Ulrike Marquardt and Heinz Rölleke (Zurich: Artemis and Winkler, 1998), 40. Unless otherwise noted, this and all other translations are by the author.

7. Webb, "Else Lasker-Schüler and Franz Marc," 287–88.

8. Frederick S. Levine, "The Image of the Animal in the Art of Franz Marc," in *Franz Marc: 1880–1916,* ed. Mark Rosenthal (Berkeley: University of California Art Museum, 1980), 41.

9. Marc to Reinhard Piper, April 20, 1910, in *Franz Marc: Briefe, Schriften und Aufzeichnungen,* ed. Günter Meissner (Leipzig: Gustav Kiepenheuer Verlag, 1989), 30, translated in *Franz Marc: Horses,* ed. Christian von Holst (Ostfildern-Ruit: Hatje Cantz Verlag; Cambridge, Mass.: Harvard University Art Museums, 2000).

10. Schuster, "Vom Tier zum Tod," 173.

11. Weiss, *Kandinsky and Old Russia,* 105.

12. "Ich kann ein Bild malen: das Reh.... Ich kann aber auch ein Bild malen wollen: 'das Reh fühlt'. Wie unendlich feinere Sinne muß ein Maler haben, das zu malen! Die Ägypter haben es gemacht." Marc, "Aufzeichnungen in Quartz" (1911/12), in Meissner, *Franz Marc,* 233.

13. Anon., Kunstchronik, *Münchner Neueste Nachrichten,* May 12, 1911, 2.

14. Klaus Lankheit, *Franz Marc: Sein Leben und seine Kunst* (Cologne: Dumont Buchverlag, 1976), 74; and Lankheit, "Zur Bildtradition bei Franz Marc," in *Festschrift für Herbert von Einem,* ed. Gert van der Osten (Berlin: Gebr. Mann, 1965), 129.

15. "Herrliche Karte, ich habe alle in einen Schmuckkasten gelegt…Da *kann* ich nicht mehr danken!" Lasker-Schüler to Franz Marc, February 17, 1913, in *Mein lieber, wundervoller blauer Reiter,* 50.

16. "Die Stadt Theben ist *enttzückt* von der Gemse und ich der Kaiser im höchsten Maße gerührt." Lasker-Schüler to Franz and Maria Marc, November 1, 1913, in *Mein lieber, wundervoller blauer Reiter,* 88.

17. "Du bist ja gerade der, der formt lauter heilige Tiere, die meine Haine nun bewohnen;—dem kleinen Muhkälbchen, ein süß dick Tierchen, hab ich extra einen Stall aus Gold bauen lassen. Also verherrliche ich deine Tiere." Lasker-Schüler to Franz and Maria Marc, April 10, 1913, in *Mein lieber, wundervoller blauer Reiter,* 64.

18. "O, Ihr teuren Brüder, die Elephanten Karte wird auf die Fahne meiner Stadt gedruckt werden. Wie soll ich danken!!" Lasker-Schüler to Franz and Maria Marc, October 15, 1913, in *Mein lieber, wundervoller blauer Reiter,* 86.

19. Gottfried Benn, *Gesammelte Werke* 1 (Wiesbaden: Limes Verlag, 1959), 537–38, trans. in Schuster, *Franz Marc,* 11.

20. See Antje Lindenmeyer, "'I am Prince Jussuf': Else Lasker-Schüler's Autobiographical Performance," *Biography* 24, no. 1 (2001): 24–34.

21. Katrina Sieg, "Queers, Tramps, and Savages: Else Lasker-Schüler," in *Exiles, Eccentrics, Activists: Women in Contemporary German Theater* (Ann Arbor: University of Michigan Press, 1994), 92.

22. Steven M. Lowenstein, "Ideology and Identity," in *Integration in Dispute, 1871–1918,* German-Jewish History in Modern Times 3 (New York: Columbia University Press, 1997), 290–304.

23. Jan Assmann, *Moses the Egyptian: The Memory of Egypt in Western Monotheism* (Cambridge, Mass.: Harvard University Press, 1997), 11.

24. Donna Heizer, *Jewish-German Identity in the Orientalist Literature of Else Lasker-Schüler, Friedrich Wolf, and Franz Werfel* (Columbia, S.C.: Camden House, 1996), 14.

25. Michael Brenner, *The Renaissance of Jewish Culture in Weimar Germany* (New Haven: Yale University Press, 1996), 25–27.

26. Lasker-Schüler to Franz Marc, November 9, 1912, November 14, 1912, and November 28, 1912, in *Mein lieber, wundervoller blauer Reiter,* 28–30.

27. Sieg, "Queers, Tramps, and Savages," 92.

28. "Ich sage dir, mein blauer Reiter, ein wilder, zottiger Kerl ist das neue Prachtpferd. Ich habs aufs Maul geküßt. Zu viel Geschenke!…Euer wilder Jude Jussuf." Lasker-Schüler to Franz and Maria Marc, May 30, 1913, in *Mein lieber, wundervoller blauer Reiter,* 73.

29. Heizer, *Jewish-German Identity,* 37–38.

30. Lasker-Schüler, "Zebaoth," in *Hebräische Balladen* (1913), reprinted in *Sämtliche Gedichte* (Munich: Kösel-Verlag, 1966), 181; cited in Steven M. Lowenstein, "Jewish Participation in German Culture," in *Integration in Dispute,* 319.

31. Nina Berman, *Orientalismus, Kolonialismus und Moderne: Zum Bild des Orients in der deutschsprachigen Kultur um 1900* (Stuttgart: M and P, 1997), 329–30.

32. On the Jewish family name of Marc and its ties to Arolsen, see Lankheit, *Franz Marc,* 11.

33. Peter Paret, "Modernism and the 'Alien Element' in German Art," in *Berlin Metropolis: Jews and the New Culture, 1890–1918,* ed. Emily D. Bilski (Berkeley and Los Angeles: University of California Press, 1999), 33–34.

34. The poem and the woodcut were published in the September 1912 issue of *Der Sturm.* Sigrid Bauschinger, "The Berlin Moderns: Else Lasker-Schüler and Café Culture," in Bilski, *Berlin Metropolis,* 72.

35. Edward Said, *Orientalism* (New York: Vintage Books, 1979).

36. Nina Berman, "Orientalism, Imperialism, and Nationalism: Karl May's *Orientzyklus,*" in *The Imperialist Imagination: German Colonialism and Its Legacy,* ed. Sara Friedrichsmeyer, Sara Lennox, and Susanne Zantop (Ann Arbor: University of Michigan Press, 1998), 53.

37. See Friedrichsmeyer, Lennox, and Zantop, introduction to *Imperialist Imagination,* 18.

38. Ernst Curtius, "Richard Lepsius," in *Unter drei Kaisern* (Berlin: Hertz, 1889), 156, cited in Suzanne L. Marchand, *Down from Olympus: Archaeology and Philhellenism in Germany, 1750–1970* (Princeton: Princeton University Press, 1996), 63.

39. I'm borrowing a phrase used by Berman in "Orientalism, Imperialism, and Nationalism," 53.

40. Suzanne L. Marchand, "The End of Egyptomania: German Scholarship and the Banalization of Egypt, 1830–1914," in *Ägyptomanie: Europäische Ägyptenimagination von der Antike bis heute,* ed. Wilfried Seipel (Vienna: Kunsthistorisches Museum Wien, 2000), 131.

41. Bauschinger, *Else Lasker-Schüler,* 101.

42. Bauschinger, "Berlin Moderns," 72.

43. Marc to Else Lasker-Schüler, April 1913, in Schuster, *Franz Marc–Elske Lasker-Schüler,* 150.

44. On Hagenbeck, see David Hancocks, *A Different Nature: The Paradoxical World of Zoos and Their Uncertain Future* (Berkeley and Los Angeles: University of California Press, 2001), 62–69; and Nigel Rothfels, *Savages and Beasts: The Birth of the Modern Zoo* (Baltimore: Johns Hopkins University Press, 2002).

45. K., "Ueber die Ausgestaltung des zoologischen Gartens in München," *Münchner Neueste Nachrichten,* November 30, 1910, 1.

46. Peter Nisbet, introduction to Holst, *Franz Marc,* 18.

47. Harro Strehlow, "Zoos and Aquariums of Berlin," in *New Worlds, New Animals: From Menagerie to Zoological Park in the Nineteenth Century,* ed. R. J. Hoage and William A. Deiss (Baltimore: Johns Hopkins University Press, 1996), 66–69.

48. Eric Baratay and Elisabeth Hardouin-Fugier, *Zoo: A History of Zoological Gardens in the West* (London: Reaktion Books, 2002), 135–36.

49. Rothfels, *Savages and Beasts,* 68.

50. Strehlow, "Zoos and Aquariums of Berlin," 66–68.

51. Patrick H. Wirtz, "Zoo City: Bourgeois Values and Scientific Culture in the Industrial Landscape," *Journal of Urban Design* 2, no. 1 (1997): 10.

52. Berman, *Orientalismus, Kolonialismus und Moderne,* 297.

53. Ludwig Justi, *Deutsche Zeichenkunst im neunzehnten Jahrhundert: Ein Führer zur Sammlung der Handzeichnungen in der Nationalgalerie,* 2nd ed. (Berlin: Julius Bard Verlag, 1922), 117, cited and trans. in Schuster, *Franz Marc,* 26.

54. Lasker-Schüler to Ludwig Justi, undated, in Schuster, *Franz Marc,* 27.

55. Homi Bhabha, "Articulating the Archaic," in *The Location of Culture* (London: Routledge, 1994), 125, 128.

56. Ibid., 131.

Chapter 6: DeRoo

I would like to thank Martha Ward, Joel Snyder, and Katie Trumpener for their helpful comments on this essay, and David Prochaska, who generously shared his research with me. I am grateful for the support of a Kathleen J. Shelton research fellowship, which enabled me to visit archives in France in 1994. This is a somewhat revised version of an essay that originally appeared in *Parallax* 4, no. 2 (April–June 1998): 145–57, and was reprinted in *Colonialist Photography: Imag(in)ing Race and Place,* ed. Eleanor M. Hight and Gary D. Sampson (New York: Routledge, 2002), 159–71.

1. See Frank Staff, *The Picture Postcard and Its Origins* (New York: Frederick A. Praeger, 1966), 53–81. The 1900 World's Fair, at which millions of postcards were sold, is usually considered the beginning of the golden age of the postcard in France. Aline Ripert and Claude Frère, *La Carte postale: Son histoire, sa fonction sociale* (Paris: Editions du CNRS; Lyon: Presses Universitaires de Lyon, 1983), 26. By 1902, David Prochaska believes, 60 million postcards were produced in France. David Prochaska, "The Archive of *Algérie Imaginaire,*" *History and Anthropology* 4 (1990): 375. Naomi Schor argues that through sales at world exhibitions in France, the postcard was not only popularized, but also came to be associated with commercial exchange and nationalistic self-promotion. See Naomi Schor, "Cartes Postales: Representing Paris 1900," *Critical Inquiry* 18 (Winter 1992): 213, reprinted as chapter 1 of this work.

2. Alloula and Monti take this anti-Orientalist approach; Banta and Hinsley examine colonial imagery in the context of anthropology, but are ambivalent about the circumstances in which the images were produced. See Malek Alloula, *The Colonial Harem,* trans. Myrna Godzich and Wlad Godzich (Minneapolis: University of Minnesota Press, 1986); Melissa Banta and Curtis M. Hinsley, *From Site to Sight: Anthropology and the Power of Imagery* (Cambridge, Mass.: Peabody Museum Press, 1986); and Nicolas Monti, *Africa Then: Photographs, 1840–1918* (New York: Knopf, 1987). In their review of the literature on colonial photography, Annie Coombes and Steve Edwards call for an account that would investigate the sale and circulation of the images; I take up their challenge in this essay. See Annie E. Coombes and Steve Edwards, "Site Unseen: Photography in the Colonial Empire: Images of a Subconscious Eroticism," *Art History* 12, no. 4 (1989): 511. Other critiques of Alloula include Irvin Cemil Schick, "Representing Middle Eastern Women: Representation and Colonial Discourse," *Feminist Studies* 16 (1990): 345–80; Winifred Woodhull, *Transfigurations of the Maghreb* (Minneapolis: University of Minnesota Press, 1993), 37–45; Carol Shloss, "Algeria, Conquered by Postcard," *New York Times Book Review,* January 11, 1987, 24; and Jean-Noël Ferrié and Gilles Boëtsch, "Contre Alloula: Le '*Harem colonial*' revisité," in *L'Image dans le monde arabe,* ed. G. Beaugé and J.-F. Clément (Paris: CNRS, 1995), 299–304.

3. Because Algerian women were typically veiled in public, foreigners and especially foreign males rarely if ever encountered unveiled women. Postcard imagery filled this void with staged studio photographs and courtyard scenes in which women were often posed partially unclothed or seminude. For the sake of convenience, I use "harem" here to refer to such Orientalist postcard images depicting women in a female private sphere, although strictly speaking few, if any, were taken in quarters where at this time women were still secluded.

4. Anon., *La France Africaine: Le Tourisme et l'hivernage en Algérie-Tunisie* (Paris: Compagnie Générale Transatlantique, 1908); and Pierre Batail, *Le Tourisme en Algérie* (Algiers: Gouvernement Générale de l'Algérie, 1906). ND printed and sold images not only to French and other foreign tourists as well as to colonials resident in Algeria, but also to large businesses and branches of government involved in the tourism industry. Here I focus on the ties between ND, the French colonial government, and tourism. In addition, some ND postcards originally purchased by individuals were exchanged among postcard collectors and ended up in postcard albums assembled by people, especially women, who had never visited Algeria. On the issue of colonial residents in Algeria, see David Prochaska, *Making Algeria French: Colonialism in Bône, 1870–1920* (New York: Cambridge University Press, 1990, 2004).

5. Prochaska has argued that ND and Levy studios sent photographers "into the field" (Prochaska, "Archive of *Algérie Imaginaire*,"376).

6. Neurdein Frères, *Catalogue des collections et sujets édités dans le format carte postale* (Paris: Neurdein Frères, 1905). To my knowledge, this is the only extant record of postcards published by the studio.

7. In fact, to make way for these monuments to French culture, indigenous quarters were often destroyed, with streets renamed and reconstructed to converge in French strategic and commercial centers. See, among others, Michèle Salinas, *Voyages et voyageurs en Algérie, 1830–1930* (Toulouse: Privat, 1989), 182–86; Zeynep Çelik, *Urban Forms and Colonial Confrontations: Algiers Under French Rule* (Berkeley and Los Angeles: University of California Press, 1997); Jean-Jacques Deluz, *L'Urbanisme et l'architecture d'Alger: Aperçu critique* (Algiers: Office des Publications Universitaires; Liège: Pierre Mardaga, 1988).

8. "La Casbah…a toujours son même air mystérieux. Elle est toujours semblable à ces Mauresques dont le voile ne laisse voir que les yeux. Ce sont toujours les mêmes portes basses qui semblent ne s'ouvrir jamais" (Batail, *Le Tourisme en Algérie,* 9); and "la casbah dont les maisons accrochées les unes aux autres guident le regard vers la ville européenne aux jardins merveilleux, aux voies vastes et claires bourdonnantes d'animation, aux immeubles de style" (Anon., *La France Africaine,* n.p.), respectively.

9. ND produced work and type postcards in Algeria *and* France. Prochaska ("Archive of *Algérie Imaginaire*," 373–420) has shown how the work scenes of Algeria presented a folkloric view of work, similar to representations of people in provincial France: both emphasize handicrafts and portray a precapitalist, preindustrial age. Strategies for "typing," however, diverge dramatically: in France, people are labeled by provincial region, whereas in Algeria, the population is typed by ethnicity.

10. Although the postcard captions that labeled the subjects according to race and ethnicity evoked ethnographic practices, the images were not intended to constitute a scientific study of race; a number of postcards classified the same models as different ethnic types and recycled the models' "ethnic" costumes. For a discussion of French ethnology, focusing on William Edwards's work and its impact on subsequent studies of race in nineteenth-century France, see Claude Blanckaert, "On the Origins of French Ethnology: William Edwards and the Doctrine of Race," in *Bones, Bodies, Behavior,* ed. George W. Stocking Jr. (Madison: University of Wisconsin Press, 1988), 18–55. Nélia Dias situates late nineteenth-century practices of anthropology, ethnology, and ethnography in their institutional contexts. Nélia Dias, *Le Musée d'ethnographie du Trocadéro (1878–1908)* (Paris: CNRS, 1991). On more popular representations of ethnography and race, see Zeynep Çelik and Leila Kinney, "Ethnography and Exhibitionism at the *Expositions Universelles,*" *Assemblage* 13 (December 1990): 34–59; and William H. Schneider, *An Empire for the Masses: The French Popular Image of Africa, 1870–1900* (Westport: Greenwood Press, 1982).

11. I am indebted to Alloula's analysis of the erotics of staged images of Algerian women for my argument here. See Alloula, *Colonial Harem,* 105–22.

12. See "Échange et Correspondance," *Le Cartophile* 8 (May 1901): 1–3.

13. Anon., *La France Africaine,* 3.

14. G. Jacqueton, Augustin Bernard, and Stéphane Gsell, *Guides Joanne: Algérie-Tunisie* (Paris: Hachette, 1903), 5.

15. This research draws on the postcard collections of dealers, the Bibliothèque Nationale, and the Centre des Archives d'Outre Mer in France.

16. "Depuis peu, il s'est établi entre jeunes gens et jeunes filles un véritable commerce de politesses et de courtoisie dû aux cartes postales…pour une jeune personne bien élevée…il y a là mille manières de donner des preuves de tact et de savoir-vivre." Griseline, *Le Cartophile* 3 (December 1900): 7, trans. Schor, *"Cartes Postales,"* 212.

17. Pierre Sarrazin, "L'Art de collectionner: Le Classement," *La Gazette Cartophile* 7: 104.

18. Ibid.

19. "Je ne saurais contempler ces merveilles sans éprouver une satisfaction intime!…J'ai sous les yeux cette même vallée et le cliché…est si bien reproduit que toute une légion de souvenirs s'éveille en moi" (Marie-Thérèse, in *L'Intermédiaire des cartophiles,* 5 [November 1904]: 1); and "Ce n'est plus seulement l'album banal de photographies, c'est en même temps celui des souvenirs" (Mary Florian, in *La Famille,* reprinted in *Le Cartophile* 14 [November 1901]: 7), respectively.

20. "Feuilleter un album, c'est presque faire un voyage; même mieux, c'est faire un voyage durant lequel on ne verrait que ce qu'il y a de digne d'être vu." *Revue Illustrée de la carte postale,* January 15, 1901, 123.

21. Jean Pomerol, "Femmes du désert," *Femina* (September 15, 1902): 288–89.

22. "Elle a de longs, longs loisirs…. Elle les emploie…à se parer. Et quelle parure!… Des draperies flottantes, rattachées par des profusions de bijoux barbares…. Du henné sur les mains, qui deviennent couleur acajou…. Du fard aux joues, mis sans aucun intention d'imiter la nature…. Des voiles de mousseline traînant à terre" (ibid., 289).

Chapter 7: Moors

Parts of this chapter have been published previously as Annelies Moors and Steven Wachlin, "Dealing with the Past, Creating a Presence: Picture Postcards of Palestine," in *Discourse and Palestine: Power, Text, and Context,* ed. Annelies Moors, Toine van Teeffelen, Ilham Abu Ghazaleh, and Sherif Kanaana (Amsterdam: Het Spinhuis, 1995), 11–26; Annelies Moors, "Embodying the Nation: Maha Saca's Post-Intifada Postcards," *Ethnic and Racial Studies* 23, no. 5 (2000): 871–87; Moors, "Presenting Palestine's Population: Premonitions of the Nakba," *MIT-EJMES* 1, no. 1 (2001): 14–26; and Moors, "From 'Women's Lib.' to 'Palestinian Women': The Politics of Picture Postcards in Palestine/Israel," in *Visual Culture and Tourism,* ed. David Crouch and Nina Lubbren (Oxford: Berg, 2003), 23–39. Special thanks are due to Steven Wachlin for photo-historical research and the use of his collection of over five thousand picture postcards of pre-1948 Palestine.

1. This is similar to David Prochaska, "The Archive of *Algérie Imaginaire*," *History and Anthropology* 4 (1990): 373–420, who compared postcards of Algerians at work with postcards of Europeans at work.

2. For such an emphasis on photography as a technology of surveillance, see, e.g., John Tagg, *The Burden of Representation: Essays on Photographies and Histories* (Amherst: University of Massachusetts Press, 1988).

3. See, e.g., John Berger, *Ways of Seeing* (New York: Viking Press, 1972); and Stuart Hall, "Encoding/Decoding," in *Culture, Media, Language,* ed. Stuart Hall, Dorothy Hobson, Andrew Lowe, and Paul Willis (London: Hutchinson, 1980), 128–38.

4. As argued by, e.g., Walter Benjamin, "Little History of Photography" (1931), in *Selected Writings,* vol. 2, *1927–34* (Cambridge, Mass.: Harvard University Press, 1999), 507–30; and Roland Barthes, *Image, Music, Text* (New York: Hill and Wang, 1977).

5. For these developments, see Kenneth Bendiner, "David Roberts in the Near East: Social and Religious Themes," *Art History* 6 (1983): 67–81; and especially Malcolm Warner, "The Question of Faith: Orientalism, Christianity, and Islam," in *The Orientalists: Delacroix to Matisse,* ed. Mary Anne Stevens (London: Royal Academy of Arts, 1984), 32–41. For the centrality of such notions in the nineteenth-century discourse on photography, see, e.g., Abigail Solomon-Godeau, "A Photographer in Jerusalem, 1855: Auguste Salzmann and His Times," *October,* no. 18 (1981): 90–107; and Allan Sekula, "On the Invention of Photographic Meaning," in *Thinking Photography,* ed. Victor Burgin (London: Macmillan, 1982), 84–109.

6. *Palestine and Syria: Handbook for Travellers* (Leipzig: Karl Baedeker, 1876), ix.

7. Ibid., 20. See also editions, such as 1876, 1894, 1898, as well as *Palestine and Syria, with Routes Through Mesopotamia and Babylonia and the Island of Cyprus* (Leipzig: Karl Baedeker, 1912).

8. Eyal Onne, *Photographic Heritage of the Holy Land, 1839–1914* (Manchester: Institute of Advanced Studies, Manchester Polytechnic, 1980), 15.

9. Carney Gavin, Elizabeth Carella, and Ingeborg O'Reilly, "The Photographers Bonfils of Beirut and Alès, 1867–1916," *Camera* 60 (1981): 13.

10. As mentioned in Matson's *Catalogue of Photographs and Lantern Slides* (Jerusalem: Matson Photo Service, 1935); see Eric Matson, *The Middle East in Pictures* (New York: Arno Press, 1980), 28.

11. John Whiting, "Village Life in the Holy Land," *National Geographic* 25, no. 3 (1914): 249.

12. Ibid., 311.

13. For the notions of coevalness and the spatialization of time, see Johannes Fabian, *Time and the Other: How Anthropology Makes Its Object* (New York: Columbia University Press, 1983).

14. Warner, "Question of Faith," 32–35.

15. Lawrence Davidson, "Biblical Archaeology and the Press: Shaping American Perceptions of Palestine in the First Decade of the Mandate," *Biblical Archaeologist* 59, no. 2 (1996): 104–14.

16. As such, it is part and parcel of the process of Orientalizing the East, as analyzed by Edward Said in his seminal work, *Orientalism* (New York: Vintage Books, 1978).

17. For the notion of types, see, e.g., Christopher Pinney, "Classification and Fantasy in the Photographic Construction of Caste and Tribe," *Visual Anthropology* 3, nos. 2–3 (1990): 259–89; Elizabeth Edwards, "Photographic 'Types': The Pursuit of Method," *Visual Anthropology* 3, nos. 2–3 (1990): 235–59; Deborah Poole, *Vision, Race, and Modernity: A Visual Economy of the Andean Image World* (Princeton: Princeton University Press, 1997).

18. In Algeria, for instance, there was a genre of postcards depicting scantily clad women in erotic poses. See Malek Alloula, *The Colonial Harem* (Minneapolis: University of Minnesota Press, 1986). Such a style of representation was not popular in the case of Palestine, which was first and foremost defined as the Holy Land.

19. See the 1907 Bonfils catalogue, *Catalogue général des vues photographiques de l'Orient* (Beirut: Imprimerie Catholique, 1907). Other catalogues had similar entries; see, e.g., Richie Thomas, "Bonfils and Son, Egypt, Greece, and the Levant; 1867–1894," *History of Photography* 3, no. 1 (1979): 41.

20. For the crucial importance of captions in constructing types, see Edwards, "Photographic 'Types.'"

21. Whiting, "Village Life in the Holy Land," 299.

22. See, e.g., Yeshayahu Nir, *The Bible and the Image* (Philadelphia: University of Pennsylvania Press, 1985), 148ff.; and Sarah Graham-Brown, *The Portrayal of Women in Photography of the Middle East, 1860–1950* (New York: Columbia University Press, 1988), 118ff., who also points to studios using the same models and even the same styles of dress with different captions.

23. See Gerard Silvain, *Images et traditions juives* (Paris: Editions Astrid, 1980), 14–19, who refers to the biblical quotation "When you till the ground, it shall no longer yield to you its strength; you shall be a fugitive and a wanderer on the earth" (Genesis 4:12).

24. See Ruth Oren, "Zionist Photography, 1910–1941: Constructing a Landscape," *History of Photography* 19, no. 3 (1995): 201–10.

25. The individual postcards mentioned below were either part of this series or produced by S. Adler, Haifa, from photographs by Benor-Kalter.

26. Quoted in Lev Bearfield, "The Nation's Family Album," *Jerusalem Post,* January 2, 1985, 5.

27. For constructions of the pioneer in early Israeli films, see Ella Shohat, *Israeli Cinema: East/West and the Politics of Representation* (Austin: University of Texas Press, 1989).

28. Quoted in Bearfield, "Nation's Family Album."

29. Significantly, the most likely exotic group for the Israelis is the *mizrahim,* Jews from the Arab world, but they are rarely represented in exoticist ways, because for the Zionist project Euro-American Jewishness was normative; the *mizrahim* remain largely invisible. See, for example, Ella Shohat, "Sephardim in Israel: Zionism from the Standpoint of Its Jewish Victims," *Social Text* 19/20 (1988): 1–37.

30. I interviewed Maha Saca extensively in Bethlehem, June 1998. Her project is discussed in more in detail in Moors, "Embodying the Nation."

31. For the ways in which the peasantry has signified the Palestinian nation, see Ted Swedenburg, "The Palestinian Peasant as National Signifier," *Anthropological Quarterly* 63, no. 1 (1990): 18–30; and Salim Tamari, "Soul of the Nation: The Fallah in the Eyes of the Urban Intelligentsia," *Review of Middle East Studies* 5 (1992): 74–84.

32. Said, *Orientalism,* 307.

Chapter 8: Prochaska

Somewhat different versions of this essay have appeared as "Postscript: Exhibiting Hawai'i," in *Postcolonial America,* ed. C. Richard King (Urbana: University of Illinois Press, 2000), 321–52; and "Exhibiting the Museum," *Journal of Historical Sociology* 13, no. 4 (2000): 391–438.

1. On visual Orientalism, see Frederick N. Bohrer, *Orientalism and Visual Culture* (New York: Cambridge University Press, 2003); Jill Beaulieu and Mary Roberts, eds., *Orientalism's Interlocutors: Painting, Architecture, Photography* (Durham: Duke University Press, 2002); Roger Benjamin, *Orientalist Aesthetics: Art, Colonialism, and North Africa, 1880–1930* (Berkeley and Los Angeles: University of California Press, 2003); Linda Nochlin, "The Imaginary Orient," in *The Politics of Vision* (New York: Harper and Row, 1989), 33–59 ; Malek Alloula, *The Colonial Harem* (Minneapolis: University of Minnesota Press, 1986); John M. MacKenzie, *Orientalism: History, Theory, and the Arts* (Manchester: Manchester University Press, 1995); Zeynep Çelik and Leila Kinney, "Ethnography and Exhibitionism at the *Expositions Universelles,*" in *Genealogies of Orientalism: History, Theory, Politics,* ed. Edmund Burke III and David Prochaska (Lincoln: University of Nebraska Press, 2008); Prochaska, "The Archive of *Algérie Imaginaire,*" *History and Anthropology* 4 (1990): 373–420; Prochaska, "Art of Colonialism, Colonialism of Art: The *Description de l'Égypte* (1809–1828)," *L'Esprit Créateur* 34 (1994): 69–91; and Prochaska, "Telling Photos," in Burke and Prochaska, *Genealogies of Orientalism.* On Alloula's problematic approach to Algerian women

depicted on postcards, see, e.g., Annie Coombes and Steve Edwards, "Site Unseen: Photography in the Colonial Empire, Images of Subconscious Eroticism," *Art History* 12 (1989): 510–16; and Irvin Cemil Schick, "Representing Middle Eastern Women," *Feminist Studies* 16 (1990): 345–80.

2. See, e.g., Michael Kioni Dudley and Keoni Kealoha Agard, *A Call for Hawaiian Sovereignty* (Honolulu: Na Kane O Ka Malo Press, 1990); Robert H. Mast and Anne B. Mast, *Autobiography of Protest in Hawai'i* (Honolulu: University of Hawai'i Press, 1996); Noel J. Kent, *Hawaii: Islands Under the Influence* (Honolulu: University of Hawai'i Press, 1993); and Noenoe K. Silva, *Aloha Betrayed: Native Hawaiian Resistance to American Colonialism* (Durham: Duke University Press, 2004).

3. For background on colonial Hawai'i, see Patrick Kirch and Marshall Sahlins, *Anahulu: The Anthropology of History in the Kingdom of Hawaii,* 2 vols. (Chicago: University of Chicago Press, 1992); Kirch, *Feathered Gods and Fishhooks* (Honolulu: University of Hawai'i Press, 1985); Sahlins, *Islands of History* (Chicago: University of Chicago Press, 1985); Sahlins, "Cosmologies of Capitalism: The Trans-Pacific Sector of 'The World System,'" in *Culture in Practice: Selected Essays* (New York: Zone Books, 2000), 415–69; Sahlins, *How "Natives" Think: About Captain Cook, for Example* (Chicago: University of Chicago Press, 1995); Gananath Obeyesekere, *The Apotheosis of Captain Cook: European Mythmaking in the Pacific* (Princeton: Princeton University Press, 1992); Valerio Valeri, *Kingship and Sacrifice* (Chicago: University of Chicago Press, 1985); David Malo, *Hawaiian Antiquities* (Honolulu: Bishop Museum Press, 1951); John Papa I'i, *Fragments of Hawaiian History* (Honolulu: Bishop Museum Press, 1983); Ralph Kuykendall, *The Hawaiian Kingdom,* 3 vols. (Honolulu: University of Hawai'i Press, 1938–67); Lawrence H. Fuchs, *Hawaii Pono* (1961; repr., Honolulu: Bess Press, 1992); Eleanor C. Nordyke, *The Peopling of Hawai'i,* 2nd ed. (Honolulu: University of Hawai'i Press, 1989); Elizabeth Buck, *Paradise Remade: The Politics of Culture and History in Hawai'i* (Philadelphia: Temple University Press, 1993); Elvi Whittaker, *The Mainland Haole: The White Experience in Hawaii* (New York: Columbia University Press, 1986); Sally Engle Merry, *Colonizing Hawai'i: The Cultural Power of Law* (Princeton: Princeton University Press, 1999); and Adam McKeown, *Chinese Migrant Networks and Cultural Change: Peru, Chicago, and Hawaii, 1900–1936* (Chicago: University of Chicago Press, 2001).

4. For orientation, see Nicholas Mirzoeff, ed., *The Visual Culture Reader* (New York: Routledge, 1998); Lucien Taylor, ed., *Visualizing Theory* (New York: Routledge, 1994); Teresa Brennan and Martin Jay, *Vision in Context: Historical and Contemporary Perspectives on Sight* (New York: Routledge, 1996); Martin Jay, *Downcast Eyes: The Denigration of Vision in Twentieth-Century French Thought* (Berkeley and Los Angeles: University of California Press, 1993); Jonathan Crary, *Techniques of the Observer* (Cambridge, Mass.: MIT Press); Norman Bryson, *Vision and Painting: The Logic of the Gaze* (New Haven: Yale University Press, 1983); Norman Bryson, Michael Holly, and Keith Moxey, eds., *Visual Theory: Painting and Interpretation* (New York: HarperCollins, 1991); Thomas Crow, *Modern Art in the Common Culture* (New Haven: Yale University Press, 1996); W. J. T. Mitchell, "The Pictorial Turn," in *Picture Theory* (Chicago: University of Chicago Press, 1994), 11–34; Nelson Goodman, *Languages of Art* (New York: Bobbs-Merrill, 1968); Laura Mulvey, *Visual and Other Pleasures* (Bloomington: Indiana University Press, 1989); Nochlin, "Imaginary Orient"; Carol Squiers, ed., *The Critical Image* (Seattle: Bay Press, 1990), especially the essays by Christian Metz and Griselda Pollock; and David Prochaska, "Art of Colonialism, Colonialism of Art." On Euro-American photography, see Rosalind Krauss, "Photography's Discursive Spaces," in *The Originality of the Avant-Garde and Other Modernist Myths* (Cambridge, Mass.: MIT Press, 1985), 131–50; Rosalind Krauss and Jane Livingston, *L'Amour fou: Photography and Surrealism* (New York: Abbeville Press, 1985); Abigail Solomon-Godeau, *Photography at*

the Dock (Minneapolis: University of Minnesota Press, 1991); Allan Sekula, "The Body and the Archive," *October,* no. 39 (1986): 3–64; and Sekula, "The Traffic in Photographs," *Art Journal* 41 (1981): 15–25.

5. See Adrienne L. Kaeppler, "*Ali'i* and *Maka'ainana:* The Representation of Hawaiians in Museums at Home and Abroad," in *Museums and Communities: The Politics of Public Culture,* ed. Ivan Karp, Christine Mullen Kreamer, and Steven D. Lavine, 458–75 (Washington, D.C.: Smithsonian Institution Press, 1992); and Roger G. Rose, *Hawai'i: The Royal Isles* (Honolulu: Bishop Museum Press, 1980). "Exhibitions in Hawai'i are more culturally sensitive" than those outside Hawai'i. Nonetheless, "Hawaiian exhibitions celebrate the history of Hawaiians and are only beginning to celebrate their present. Indeed, most current selections of objects and the manner in which they are exhibited emphasize the romantic notion of an uncontaminated 'other'—a Hawai'i that does not exist today and probably never did" (467–68). This is the case even at the Bishop Museum in Honolulu, where exhibits on the lower floor of the great hall give "a late-nineteenth-century view of Hawaiian tradition" (468). On the Bishop Museum, see, e.g., Marjorie Kelly, "Scholarship Versus Showmanship at Hawaii's Bishop Museum: Reflections of Cultural Hegemony," *Museum Anthropology* 18, no. 2 (1994): 37–48.

6. Surveys of photography in Hawai'i or in which photographs figure prominently include Joseph Feher, *Hawai'i: A Pictorial History* (Honolulu: Bishop Museum Press, 1969); Jean Abramson, *Photographers of Old Hawaii* (Honolulu: Island Heritage, 1976); Palani Vaughan, *Na Leo I Ka Makani, Voices on the Wind: Historic Photographs of Hawaiians of Yesteryear* (Honolulu: Mutual, 1987); Joseph G. Mullins, *Hawaiian Journey* (Honolulu: Mutual Publishing, 1978); E. B. Scott, *The Saga of the Sandwich Islands* (Crystal Bay, Lake Tahoe, NE: Sierra-Tahoe Publishing Co., 1968); Gail Bartholomew, *Maui Remembers: A Local History* (Honolulu: Mutual Publishing, 1994); DeSoto Brown, *Aloha Waikiki: 100 Years of Pictures from Hawaii's Most Famous Beach* (Honolulu: Editions Limited, 1985); Grady Timmons, *Waikiki Beachboy* (Honolulu: Editions Limited, 1989). On painting in Hawai'i, see David W. Forbes, *Encounters with Paradise: Visions of Hawaii and Its People, 1778–1941* (Honolulu: Honolulu Academy of Arts, 1992). Monographs on photographers in Hawai'i include Ray Jerome Baker, *Hawaiian Yesterdays: Historical Photographs* (Honolulu: Mutual, 1982); Lynn Ann Davis, *A Photographer in the Kingdom: Christian J. Hedemann's Early Images of Hawai'i* (Honolulu: Bishop Museum Press, 1988); and Davis, *Na Pa'i Ki'i: The Photographers in the Hawaiian Islands, 1845–1900* (Honolulu: Bishop Museum Press, 1980). Among studies of non-Western photography, see Stephen White, *John Thomson: A Window to the Orient* (Albuquerque: University of New Mexico Press, 1989); Arthur Ollman, *Samuel Bourne: Images of India* (Carmel, Calif.: Friends of Photography, 1983); Clark Worswick, *Princely India: Photographs by Raja Deen Dayal, 1884–1910* (New York: Knopf, 1980); Edward Ranney, Publio Lopez Mondejar, and Mario Vargas Llosa, *Martín Chambi* (Washington, D.C.: Smithsonian Institution Press, 1993); and Roslyn Poignant and Axel Poignant, *Encounter at Nagalarramba* (Canberra: National Library of Australia, 1996).

7. Works that reproduce Hawaiian postcards or in which postcards are featured include Jack Edler and Edith Koplin, *26 Postcards of Early Hawaii* (Honolulu: Maile Press, 1989); Timmons, *Waikiki Beachboy;* and DeSoto Brown, *Hawaii Recalls: Selling Romance to America: Nostalgic Images of the Hawaiian Islands, 1910–1950* (Honolulu: Editions Limited, 1982). On "imperialist nostalgia," see Renato Rosaldo, "Imperialist Nostalgia," in *Culture and Truth* (Boston: Beacon Press, 1989), 68–87. "Imperialist nostalgia" is the effect produced by some collections of republished postcards where, through careful selection and decontextualizing practices such as the relative absence of text and lack of contemporary photos, readers and viewers are invited to "mourn the passing of what they themselves have transformed" (69). Although the term was applied originally to the colonial Philippines, it can be

applied equally to Hawai'i.

8. Among the surprisingly few analytic studies that do exist, see Christopher Pinney, *Camera Indica: The Social Life of Indian Photographs* (Chicago: University of Chicago Press, 1997); Deborah Poole, *Vision, Race, and Modernity: A Visual Economy of the Andean Image World* (Princeton: Princeton University Press, 1997); Abigail Solomon-Godeau, "A Photographer in Jerusalem, 1855: Auguste Salzmann and His Times," *October,* no. 18 (1981): 90–107; Elizabeth Edwards, ed., *Anthropology and Photography, 1860–1920* (New Haven: Yale University Press, 1992); Bohrer, *Orientalism and Visual Culture;* Christopher Pinney and Nicolas Peterson, eds., *Photography's Other Histories* (Durham: Duke University Press, 2003); Catherine A. Lutz and Jane L. Collins, *Reading National Geographic* (Chicago: University of Chicago Press, 1993); Alloula, *The Colonial Harem;* Prochaska, "*Algérie Imaginaire*"; Prochaska, "Fantasia of the *Photothèque:* French Postcard Views of Colonial Senegal," *African Arts,* vol. 24 (1991): 40–47; and Prochaska, "Telling Photos."

9. A focus on the art object—imagery—underscores issues such as iconography, genre, taste, connossieurship, and aesthetics more generally. A discussion of the conditions and context of production raises issues of (mechanical) reproduction, copy, imitation, originality, and authenticity. Circulation and reception focus attention on viewer and audience, buyer and market. In addition to works cited above by Krauss, Squier, Sekula, and Bryson, see Roland Barthes, "The Photographic Message" and "Rhetoric of the Image," in *Image, Music, Text* (New York: Hill and Wang, 1977), 15–31 and 32–51; Walter Benjamin, "The Work of Art in the Age of Mechanical Reproduction," in *Illuminations,* trans. Harry Zohn, ed. Hannah Arendt (New York: Schocken Books, 1969); Francis Haskell, "A Turk and His Pictures in Nineteenth Century France," in his *Past and Present in Art and Taste* (New Haven: Yale University Press, 1987); Pierre Bourdieu, *Distinction: A Social Critique of the Judgment of Taste* (Cambridge, Mass.: Harvard University Press, 1984); and Janice Radway, *Reading the Romance* (Chapel Hill: University of North Carolina Press, 1984)

10. On the construction of postcards, see Prochaska, "*Algérie Imaginaire,*" "Fantasia of the *Photothèque,*" and "Thinking Postcards," *Visual Resources* 17 (2001): 383–99; and Virginia Lee-Webb, "Manipulated Images: European Photographs of Pacific Peoples," in *Prehistories of the Future: The Primitivist Project and the Culture of Modernism,* ed. Elazar Barkan and Ronald Bush (Stanford: Stanford University Press, 1995), 175–201. Although Lee-Webb is talking about nineteenth-century photographs, much of what she says applies to postcards, since "with the rise of the picture postcard, nineteenth-century photographs endured into the twentieth century by being appropriated, repainted, recaptioned, and reproduced for sale as souvenirs" (186).

11. *Art/Artifact: African Art in Anthropology Collections,* exh. cat. (New York: Center for African Art, 1988); and Lisa G. Corrin, *Mining the Museum: An Installation by Fred Wilson,* exh. cat. (New York: New Press, 1994). See also Allan Sekula, *Fish Story,* exh. cat. (Düsseldorf: Richter Verlag, 1995).

12. Reproduced in *Image File* 8 (1995): 10. Most Teich postcards were commissioned by retail businesses for advertising purposes. They may not include advertising slogans, but their commercial purpose is clear.

13. In no other case of a postcard publisher anywhere in the world that I am aware of do we have extensive information regarding the production process in addition to the final postcard itself. For other postcard publishers, researchers are forced to try to reconstruct a catalogue of postcards by tedious, time-consuming, and painstaking searching in public collections and among private collectors, a hit-or-miss process with no guarantee of success. In contrast, we have copies of all 1,582 Teich postcards of Hawai'i. Moreover, we can determine the year of production for the vast majority of them, and for which local retailer they were produced. On one

of the most ambitious projects to catalogue the output of a postcard publisher, that of Edmond Fortier in Dakar, Senegal, see Philippe David, *Inventaire général des cartes postales Fortier,* 3 vols. (Paris: Philippe David, 1986–88).

14. "Guide to Dating Curt Teich Postcards" (typescript, Teich Archives).

15. Again, nothing comparable to these geographical indexes exists for any other postcard publisher that I know. The Teich geographical indexes not only document the retailers who ordered the cards, but also give the name and address of the retailer, the number ordered, and, in exceptional cases, subsequent reprint information.

16. Moreover, we know the year of production for the vast majority of them, and along with the job folders and geographical indexes we often know the local retailer for whom they were produced.

17. On Williams, see Baker, *Hawaiian Yesterdays,* 238–39; and "Statement of James A. Williams, Photographer, May 10, 1939," in "Race Relations, Lind, Baker Notes, May 1939" (typescript, Bishop Museum), 77–78.

18. See John Falconer, "Ethnographical Photography in India, 1850–1900," *History of Photography* 5 (1984): 16–46. For an Ottoman album of generic types produced for the 1873 Vienna World's Fair, see Hamdy Bey and Marie de Launay, *Les costumes populaires de la Turquie en 1873* (Constantinople: Imprimerie du "Levant Times and Shipping Gazette," 1873). For suggestive reflections on Irving Penn's "ethnographic" types, see Edmund Carpenter, "Love Thy Label as Thyself," in *Irving Penn: A Career in Photography,* ed. Colin Westerbeck (Chicago: Art Institute of Chicago, 1997), 54–62.

19. Increasingly, anthropologists and other researchers seek this kind of information. In 1994, I showed people living on Lake Turkana in northern Kenya photographs in two pamphlets, and they were able to identify several individuals, an unfortunately high number of whom had died since the photographs were taken. See P. Giuseppe Quattrocchio, *El Molo* (Turin: Stamperia Artistica Nazionale, n.d.); and Quattrocchio, *Rendille* (Turin: Stamperia Artistica Nazionale, n.d.).

20. On Char (1889–1976), the son of immigrant sugar field workers, learned photography from Roscoe Perkins and operated his own studio, City Photo Company, from 1911 to 1954 on Hotel Street in Honolulu, where he made more than ninety thousand photographs in catering to several ethnic groups (brochure, *The On Char Collection;* "Biographical Note, On Char Business Records," manuscript group 184; and "How I Became a Photographer," manuscript group 184, box 5, folder 7, all Bishop Museum). "From 1908 until 1938 Morito Koga operated the Koga Arts Studio on the main street of Ola'a, a small sugar town on the island of Hawai'i now known as Kea'au. Most of Koga's customers were the plantation families who lived in the area. Koga made portraits in his studio, photographed festivities in the town or took his equipment out to the plantation camps to photograph families standing in front of their homes" (brochure, "The Morito Koga Collection," n.d., Bishop Museum). Tai Sing Loo (b. 1886) was for numerous years the official photographer at Pearl Harbor naval base (Memoirs of Tai Sing Loo, typewritten ms., 1962, Bishop Museum).

21. No. 5, A Hilo Home, Hilo, Hawaii; No. 10, Forest Near Hilo; and No. 23, Water Hyacinths, Hilo, were all hand-tinted in Japan and published by Hilo Drug Co., Hilo, Hawaii. Others, such as Lahaina Hawaii, No. 1, Lahaina Hawaii, No. 2, and Cowt House Lahaina Hawaii, all have captions in Japanese as well as English. On the reverse or mailing side it is stated in Japanese that the cards were made at the main branch of the Kamigata-ya store in Ginza, Tokyo, the most westernized section of Tokyo (postcard collection, Bishop Museum). Thanks to Jason Karlin for the Japanese translations.

22. J. J. Williams won a lucrative contract to make identity photos of contract laborers. "Baker found photographers in Honolulu already [when he arrived in 1908], so went

to the outside islands; found no *haoles* there, only Oriental photographers, mostly Japanese. The ideal photograph at that time, for Japanese, was a very stiff pose. Baker took a different approach; went to the homes of people and got natural shots, intimate, casual" ("Notes taken directly from Mr. Baker, April, 1965," Ms. group 16 [Baker] 1.2, archives, Bishop Museum).

23. I have not yet been able to determine the function of the character boards the individuals are holding. Many early Japanese contract laborers lived at Wainaku village, island of Hawai'i. For photographs of Japanese at Wainaku in the 1890s by C. Furneaux and J. A. Gonsalves, see Franklin Odo and Kazuko Sinoto, *A Pictorial History of the Japanese in Hawai'i, 1885–1924* (Honolulu: Bishop Museum Press, 1985): 82–84. This book also includes a facsimile labor contract. The practice of Japanese choosing spouses based on the exchange of photographs is depicted in the film *Picture Bride* (1994, dir. Kayo Hatta).

24. Reproduced in Forbes, *Encounters with Paradise,* 39. See Bernard Smith, *European Vision and the South,* 2nd ed. (New Haven: Yale University Press, 1985), 108–14, 116, 120, 131, 134, 191, 278, 317–21; and Rüdiger Joppien and Bernard Smith, *The Art of Captain Cook's Voyages* (New Haven: Yale University Press, 1988), 3:171–203.

25. Reproduced in Herb Kawainui Kane, *Voyagers* (Bellevue, Wash.: Whale Song, 1991), 154.

26. As representations of representations, exposition postcards constitute third-order simulacra in Baudrillard's terms. See Jean Baudrillard, *Simulations* (New York: Semiotext(e), 1983). On the 1915 fair, see Burton Benedict et al., *The Anthropology of World's Fairs: San Francisco's Panama Pacific International Exposition of 1915* (Berkeley: Scolar Press, 1983).

27. Gigantism entailed juxtaposing gigantic fruits, vegetables, fish, and the like alongside people and machinery, and was especially popular in the United States. See Cynthia Elyce Rubin and Morgan Williams, *Larger than Life: The American Tall-Tale Postcard, 1905–1915* (New York: Abbeville, 1990).

28. Reproduced in Elizabeth Tatar, *Strains of Change: The Impact of Tourism in Hawaiian Music* (Honolulu: Bishop Museum Press, 1987), 8.

29. Allan Sekula ("Traffic in Photographs") argues that one key way to "read" a photograph is to interpret the context in which it appears or is published. I push Sekula's argument a step further here, for what strikes me is the instability of the image, that it literally means something different when placed in a different context.

30. Room 4 constitutes a "back" region in the terminology of Erving Goffman and Dean MacCannell. On "front" and "back" regions, see Goffman, *The Presentation of Self in Everyday Life* (Garden City, N.Y.: Doubleday, 1959), 144–45; and MacCannell, *The Tourist: A New Theory of the Leisure Class,* rev. ed. (New York: Schocken Books, 1989), 91–107.

31. These are constituted by the nexus of production (room 1), imagery (room 2), and reception (room 3), echoing trends in the study of visual culture, especially work inflected by semiotics and poststructuralism. See, e.g., discussion in Burke and Prochaska, "Orientalism from Postcolonial Theory to World History," in *Genealogies of Orientalism.*

32. Thus, for example, James J. Williams bought the studio of another early photographer, Menzies Dickson, in 1880. Early in the twentieth century, Ray Jerome Baker sometimes used Williams's studio for developing and printing. On Baker, see Baker, *Hawaiian Yesterdays,* 238–39. Along with the "presences" in nineteenth-century French Orientalist paintings, Linda Nochlin ("Imaginary Orient") identifies the "absences."

33. On collecting, see John Elsner and Roger Cardinal, eds., *The Cultures of Collecting* (Cambridge, Mass.: Harvard University Press, 1994); and James Clifford, "On Collecting Art and Culture," in *The Predicament of Culture* (Cambridge, Mass.: Harvard University Press, 1988), 215–51. On imperialist nostalgia, see Rosaldo, "Imperialist Nostalgia."

34. On document, see Molly Nesbit, "Photography, Art, and Modernity," in *A History of Photography,* ed. Jean-Claude Lemagny and André Rouillé (New York: Cambridge University Press, 1987), 110–13.

35. Baker, "Hawaiian Yesterdays," 107.

36. Zaid, *Wish You Were Here,* 6–7. "One of the things that had always fascinated me about these cards was that even they were photographic images, they were obviously hand colored, not simply taken from color photographs. Here was a synthesis of painting and photography resulting in a photographic look, with the clarity of color and detail that only an artist could create" (7).

Chapter 9: Handy

1. The most recent editions of these texts are Penelope J. E. Davies et al., *Janson's History of Art: The Western Tradition,* 7th ed. (Upper Saddle River, N.J.: Pearson Prentice Hall, 2007); Marilyn Stokstad, *Art History,* rev. 2nd ed. (Upper Saddle River, N.J.: Pearson Prentice Hall, 2005); and Fred S. Kleiner and Christin J. Mamiya, *Gardner's Art Through the Ages,* 12th ed. (Belmont, Calif.: Wadsworth, 2006). [Editors' note.]

2. Hal Foster, "Archives of Modern Art," *October,* no. 99 (Winter 2002): 51.

3. An important early attempt to fulfill this need is Anthony Hamper's article "The Photography of the Visual Arts, 1839–1880," *Visual Resources* 6 (1989): 19–41.

4. James Elkins, "Art History and Images That Are Not Art," *Art Bulletin* 78, no. 4 (1995): 553–54.

5. Dan Karlholm, "Reading the Virtual Museum of General Art History," *Art History* 24, no. 4 (2001): 554.

6. Barbara E. Savedoff, "Looking at Art Through Photographs," *Journal of Aesthetics and Art Criticism* 51, no. 3 (1993): 460–61.

7. Jean Baudrillard, *Simulacra and Simulation,* trans. Sheila Faria Glaser (Ann Arbor: University of Michigan Press, 1994). [Editors' note.]

8. On the history of the Metropolitan, see, e.g., Calvin Tomkins, *Merchants and Masterpieces: The Story of the Metropolitan Museum of Art,* rev. ed. (New York: Henry Holt, 1989); and on collecting, see Thomas Hoving, *The Chase, the Capture: Collecting at the Metropolitan* (New York: Metropolitan Museum of Art, 1975). [Editors' note.]

9. See, e.g., Chuck Welch, ed., *Eternal Network: A Mail Art Anthology* (Calgary: University of Calgary Press, 1994). [Editors' note.]

10. Walter Benjamin, "The Work of Art in the Age of Mechanical Reproduction," in *Illuminations,* trans. Harry Zohn, ed. Hannah Arendt (New York: Schocken Books, 1969), 220.

11. Walter Benjamin, "Unpacking My Library," in *Illuminations,* 59–68.

12. André Malraux, "The Museum Without Walls," in *The Voices of Silence,* trans. Stuart Gilbert (Princeton: Princeton University Press, 1953).

13. Ibid., 21.

14. Douglas Crimp, *On the Museum's Ruins* (Cambridge, Mass.: MIT Press, 1993), 54–60.

15. Andrew E. Hershberger, "Malraux's Photography," *History of Photography* 26, no. 4 (2002): 273.

16. Malraux, "Museum Without Walls," 17.

17. Susan Sontag, *On Photography* (New York: Delta, 1973), 3.

18. On performance art, see, e.g., Roselee Goldberg, *Performance Art: From Futurism to the Present,* rev. ed. (London: Thames and Hudson, 2001); and Adrian Heathfield, ed., *Live: Art and Performance* (New York: Routledge, 2004). On conceptual art, see Blake Stimson and Alexander Alberro, eds., *Conceptual Art: A Critical Anthology*

(Cambridge, Mass.: MIT Press, 2000); and Tony Godfrey, *Conceptual Art* (London: Phaidon, 1998). On mail art, see Welch, *Eternal Network*. [Editors' note.]

19. John Dewey, *Art as Experience* (1934; repr., New York: Capricorn Books, 1958), 47.

20. Ibid., 48.

21. Ibid., 106. Later in the text, Dewey argues that art is a form of knowledge, an interesting extension of this idea into broader realms.

22. Ibid., 162.

23. Ibid., 24.

24. Benjamin, "Unpacking My Library," 60. Interestingly, a bit further on in the essay, Benjamin suggests that the act of purchasing works for the collection from book dealer's catalogues could be itself a creative act, thus allowing not only the nonoriginal but also the commercial transaction into the privileged realm.

25. Scarcely more scientific in approach than my personal anecdotes is the informal survey I have conducted of art-historical friends and colleagues. This small and unrepresentative sample nonetheless closely matches my thesis that postcard images are resonant, appealing, significant, and part of the formative experiences of many professionals, researchers, and scholars in our field.

26. Dewey, *Art as Experience,* 246. [Editors' note.]

27. Benjamin, "Unpacking My Library," 67.

28. On what could be termed "nostalgia of the collection," compare the remarks by Naomi Schor, "*Cartes Postales:* Representing Paris 1900," chapter 1 of this work. [Editors' note.]

29. See, e.g., Heinrich Wölfflin, *Principles of Art History: The Problem of the Development of Style in Later Art,* trans. M. D. Hottinger (1932; repr., New York: Dover, 1950). [Editors' note.]

30. See, e.g., Erwin Panofsky, *Meaning in the Visual Arts: Papers in and on Art History* (Chicago: University of Chicago Press, 1955). [Editors' note.]

31. See, e.g., T. J. Clark, *The Absolute Bourgeois: Artists and Politics in France, 1848–1851* (London: Thames and Hudson, 1973); and Clark, *Image of the People: Gustave Courbet and the 1848 Revolution* (London; Thames and Hudson, 1973). [Editors' note.]

32. Rosalind Krauss, "The Originality of the Avant-Garde" (1981), in *The Originality of the Avant-Garde and Other Modernist Myths* (Cambridge, Mass.: MIT Press, 1985), 152.

33. *Untitled (Medici Prince),* ca. 1952, construction, 15 1/2 x 11 1/2 x 5 in., collection Mr. and Mrs. Joseph Shapiro, Oak Park, Ill.; *Untitled (Medici Princess),* ca. 1948, construction, 17 5/8 x 11 1/8 x 4 3/8 in, private collection. [Editors' note.]

34. On Fluxus, see, e.g., Hannah Higgins, *Flux Experience* (Berkeley and Los Angeles: University of California Press, 2002); Jon Hendricks, *Fluxus Codex* (Detroit: Gilbert and Lila Silverman Fluxus Collection in association with H. N. Abrams, New York, 1988). [Editors' note.]

35. James Collins, "Bill Dane, The Museum of Modern Art," *Artforum* 12, no. 6 (1974): 76–77. [Editors' note.]

36. See Thomas McEvilley, *The Art of Dove Bradshaw: Nature, Change, and Indeterminacy* (West New York, N.J.: Mark Batty, 2003); and James Putnam, *Art and Artifact: The Museum as Medium* (New York: Thames and Hudson, 2001), 159–60. [Editors' note.]

37. One buyer was a display designer at New York's Saks Fifth Avenue who used blown-up, colorized versions of Bradshaw's fire-hose image for a store-wide campaign in 1979. Since her name was on it, Bradshaw asked Saks for a $100 gift certificate as a "small compensation," which they gave her. [Editors' note.]

38. I would like to record several debts of gratitude regarding this curious work and its reproduction. First, to Maria Morris Hambourg, who originally allowed me to work on this wonderful and highly eccentric project on her behalf. Second, to Malcolm Daniel, who succeeded Hambourg as curator in charge of the Department of Photographs, and who was exceptionally gracious to me during my recent research into this episode fifteen years ago. And lastly to Geannine Gutierrez-Guimaraes, intern in the Department of Photographs, who generously located departmental files and confirmed caption information for me on short notice.

39. The caption text was slightly revised by Bradshaw, who had changed the title of the photograph to *Fire Extinguisher* and replaced the phrase "smuggled them into" with "quietly placed them in." [Editors' note.]

40. Among those who purchased the card was the artist Sol LeWitt, who bought one without knowing who had done it. Later he told Bradshaw, whom he knew, that when he arrived home and read the text he immediately decided to obliterate it with a drawing and send it to her. Bradshaw sent a postcard to Ray Johnson, the inventor of "mail art," who returned it enriched with a triple pun. He had peeled the back halfway and written on three separate lines, "A," "PEE," and "LING." Anthony Haden-Guest, commentator on the New York art scene, burned a hole in the card and gave it to Bradshaw. Composer John Cage, upon returning from a trip to California, remarked to Bradshaw, "I see your work everywhere!" See Dove Bradshaw, *Performance: The Metropolitan Museum Fire Hose, 1976–Present,* edition of ten (New York: Dove Bradshaw, 2006–). The Metropolitan owns one copy, the Whitney Museum of American Art another, and several have sold privately. [Editors' note.]

41. Bradshaw asked the head of the New York Fire Department unit that services the Metropolitan's fire hoses whether a permanent label would disturb their use of it. After forty-five seconds of laughter, he replied, "It wouldn't be a problem in the least. In case of an emergency we would use it all the same." Bradshaw, *Performance.* [Editors' note.]

42. Art historian Francis Nauman writes, "The main reason why the Metropolitan Museum should purchase Dove Bradshaw's *Fire Hose* is because it would be wonderful to see them acquire something they already own." Ibid. [Editors' note.]

43. It is perhaps fitting that it was a Dada collector, Rosalind Jacobs, who donated Bradshaw's work (in memory of her late husband, Melvin Jacobs). The editors thank Dove Bradshaw for providing details and updates concerning her project. See also George Myers Jr., "Will Mighty Met Ever Put Out This Fire?" *Columbus Dispatch,* March 5, 1995, 4C; Stuart W. Little, "Guerrilla Artist at the Met," *New York Magazine,* February 5, 1979, 11; Putnam, *Art and Artifact,* 159–60; McEvilley, *Dove Bradshaw;* and Bradshaw, *Performance.* [Editors' note.]

44. When Rosalind Jacobs offered the Metropolitan its Northwest Mezzanine Fire Hose, and the right to call it a work of art, she received a letter from Gary Tinterow, Engelhard Curator in Charge of the Department of Nineteenth-Century, Modern and Contemporary Art, saying, "We are happy to accept Dove Bradshaw's work providing there are no strings attached." The donor and the artist have yet to hear what the museum means by "no strings attached." Information provided by Bradshaw in conversation with the editors. [Editors' note.]

45. Foster, "Archives of Modern Art," 94.

46. Ibid., 195.

Chapter 10: Éluard/Heuer

1. Paul Éluard, "Les Plus Belles Cartes postales," *Minotaure* 3–4 (December 1933): 85–100.

2. Éluard, *Letters to Gala,* trans. Jesse Browner (New York: Paragon House, 1989), 100.

3. Ibid., 65.

4. Ibid., 99.

5. Four albums from Éluard's postcard collection are currently held by the Musée de

la Poste, Paris, France. Three additional albums are in private collections.

6. While it is probable that other surrealists may have assisted in the organization of the albums, the extent of their involvement, if any, remains undocumented.

7. Éluard, "Les Plus Belles Cartes postales," 87.

8. This organization has been noted previously by José Pierre, "La Carte postale comme matériau du poème visible," in *Regards très particuliers sur la carte postale* (Paris: Le Musée de la Poste, 1992), 32; and Ailine Ripert and Claude Frère, *La Carte postale: Son histoire, sa fonction sociale* (Paris: Editions du CNRS; Lyon: Presses Universitaires de Lyon, 1983), 170–72.

9. Éluard, *Letters to Gala,* 118.

10. Charles G. Whiting, "Éluard's Poems for Gala," *French Review* 41, no. 4 (1968): 505–17; and English Showalter Jr., "Biographical Aspects of Éluard's Poetry," *PMLA* 78, no. 3 (1963): 280–86.

11. Éluard, *Letters to Gala,* 68.

12. Éluard, "Les Plus Belles Cartes postales," 87.

13. Paul Éluard, "Nuits partagées," in *La Vie immédiate* (Paris: Gallimard, 1932) and *Uninterrupted Poetry: Selected Writings,* trans. Lloyd Alexander (Westport, Conn.: Greenwood Press, 1975), 15–24.

14. Éluard, *Letters to Gala,* 148.

15. Louise K. Horowitz, "Éluard's Postcards," in *Dada/Surrealism,* no. 5 (1975): 44–48.

16. To highlight his article, Éluard originally planned to feature a sixteen-page booklet of over one hundred cards accompanied by a "secret" four-page supplement printed of "impossible cards" with several color reproductions. Éluard, *Letters to Gala,* 180.

17. Éluard, "Les Plus Belles Cartes postales," 88.

18. For examples of postcards, see Roger-Jean Ségalat, *Album Éluard* (Paris: Gallimard, 1968), 118. Éluard's second wife, Nusch (Maria Benz), was a former postcard model.

19. Paul Hammond, *French Undressing: Naughty Postcards from 1900 to 1920* (New York: Pyramid Books, 1976), 7–11, 97–103; and William Ouelette and Barbara Jones, *Erotic Postcards* (New York: Excalibur Books, 1977), 46–55.

20. Éluard, "Les Plus Belles Cartes postales," 87.

21. Breton is referring here to the working-class couples he observes in the park.

22. See page 96, third row right.

23. See the New Year's cards on page 85.

24. Page 94, top row right.

25. Page 94, middle row right.

26. Page 89, top row left.

27. Page 85, second row, second from left.

28. Page 93.

29. Page 100, bottom row left.

30. Pages 98–99, bottom.

31. Page 97, second row middle.

32. Page 89, middle row right.

33. Page 100, second row right.

34. Page 100, top row left and right.

35. Page 100, middle row left.

36. Page 90, bottom row right.

37. Page 93, bottom row middle.

38. Page 89, middle row left.

39. Or hair. See page 90, bottom row middle.

40. Page 90, top row left.

41. Page 90, top row middle. The postcard caption, "Violoncelle qui résiste" (The cello that resists), when pronounced in French sounds like "Viole celle qui résiste" (Rape

the one who resists). [Translators' note.]

42. Page 96, third row left.

43. Page 91, top row middle.

44. Page 91, middle row left.

45. Page 91, bottom row left.

46. Page 91, top row left.

47. Page 91, top row right.

48. Page 91, bottom row middle.

Chapter 11: Evans/Heuer

1. Jeff L. Rosenheim, "'The Cruel Radiance of What Is': Walker Evans and the South," in *Walker Evans,* by Jeff L. Rosenheim, Maria Morris Hambourg, Douglas Eklund, and Mia Fineman (New York: Metropolitan Museum of Art in association with Princeton University Press, 2000), 66.

2. Belinda Rathborne, *Walker Evans: A Biography* (New York: Houghton Mifflin, 1995), 83. The Metropolitan Museum of Art in New York acquired in 1994 Evans's entire collection of postcards, where it forms part of the Walker Evans Archive (hereafter WEA). Besides the postcards, the Evans archive includes his negative file, library, personal papers, family photographs, and scrapbooks. See Jeff L. Rosenheim and Douglas Eklund, *Unclassified: A Walker Evans Anthology* (New York: Metropolitan Museum of Art in association with Scalo, 2000).

3. Walker Evans, "Main Street Looking North from Courthouse Square," *Fortune,* May 1948, 102.

4. Walker Evans, transcript of lecture delivered at the Museum of Modern Art, November 7, 1973, WEA.

5. Walker Evans, "Lyric Documentary," transcript of lecture delivered at the Yale University Art Gallery, New Haven, March 11, 1964, WEA.

6. Evans, "Main Street," 105.

7. Ibid., 102.

8. Carleton Beals, *The Crime of Cuba* (Philadelphia: Lippincott, 1933), with thirty-one aquatone illustrations from photographs by Walker Evans.

9. Gifford A. Cochran and F. Burrall Hoffman, *Grandeur in Tennessee: Classical Revival Architecture in a Pioneer State* (New York: J. J. Augustin, 1946).

10. This comparison was first noted by Rosenheim, "Cruel Radiance of What Is," 66.

11. Evans's photograph was published as part of a photo essay on New England resorts titled "Summer North of Boston" in *Fortune* in 1949.

12. The Metropolitan Museum of Art displayed these cards as "Walker Evans: A Gallery of Postcards" in its Evans retrospective exhibition in 2000.

13. Mabry to Evans, November 27, 1936, WEA.

14. Walker Evans, "Primitive Churches," *Architectural Forum* 115, no. 6 (1961): 103.

15. Leslie Katz, "Interview with Walker Evans," *Art in America* 59 (March–April 1971): 83.

16. Karl Bickel, *The Mangrove Coast* (New York: Coward-McCann, 1942), with thirty-two photographs by Walker Evans.

17. Evans remained at *Fortune* until 1965, when he accepted a teaching position at Yale University. According to Evans's colleagues at *Fortune,* he usually prepared his own layouts, although after 1954 he worked with Ronald Campbell, then a member of the Fortune Art Department. See Lesley K. Baier, *Walker Evans at Fortune, 1945–1965.* (Wellesley, Mass.: Wellesley College Museum of Art, 1977), 13.

18. Walker Evans, interview by Paul Cummings, tape recording, Archives of American Art, October 13, 1971.

19. Evans, "Main Street," 102.

20. Ibid.

21. Walker Evans, "Come on Down," *Architectural Forum* 117 (July 1962): 98.

22. In the early 1970s, Evans began work on a never-finished photo book with editor

Hilton Kramer featuring selections from his postcard collection. See Rathbone, *Walker Evans*, 294.

23. Ibid., 255.

24. Evans, transcript of lecture delivered at the Museum of Modern Art, November 7, 1973, WEA.

Chapter 12: Nelson

See also "Material Lyrics: The Vexed History of the Wartime Poem Card," *American Literary History* 16, no. 2 (2004): 263–89, which contains some overlap with this essay.

1. Gerhard L. Weinberg, *A World at Arms: A Global History of World War II* (New York: Cambridge University Press, 1994), 601–9, 667–76, 703–21.

2. Aline Ripert and Claude Frère, *La Carte postale: Son histoire, sa fonction sociale* (Paris: Editions du CNRS; Lyon: Presses Universitaires de Lyon, 1983), 158–59.

3. Walter Benjamin, "The Work of Art in the Age of Mechanical Reproduction," in *Illuminations,* trans. Harry Zohn, ed. Hannah Arendt (New York: Harcourt, Brace and World, 1968).

4. Paul Fussell, *The Great War and Modern Memory* (New York: Oxford University Press, 1975), 36–74, 230–69.

5. Weinberg, *World at Arms,* 673.

6. David Prochaska, "Thinking Postcards," *Visual Resources* 17, no. 4 (2001): 391.

7. Ellen Handy, "Postcard Sublime: William Henry Jackson's Western Landscapes," in "From Albums to the Academy: Postcards and Art History," ed. Jordana Mendelson, special issue, *Visual Resources* 17, no. 4 (2001): 431.

8. Naomi Schor, "*Cartes Postales:* Representing Paris 1900," *Critical Inquiry* 18, no. 2 (1992): 188–244, reprinted as chapter 1 of this work.

9. Alan Bullock, *Hitler and Stalin: Parallel Lives* (New York: Vintage Books, 1993), 310–11.

10. James R. Bender, *Postcards of Hitler's Germany* (San José: James R. Bender, 1995), 1:147.

11. Bullock, *Hitler and Stalin,* 308.

12. Ibid., 307.

13. Cary Nelson, *Repression and Recovery: Modern American Poetry and the Politics of Cultural Memory, 1910–1945* (Madison: University of Wisconsin Press, 1989); Stuart Hall, *The Hard Road to Renewal: Thatcherism and the Crisis of the Left* (New York: Verso, 1988).

14. Hall, *Hard Road to Renewal.*

15. Cary Nelson, *When Death Rhymed: Poem Cards and Poetry Panics of the Great Wars* (Urbana: University of Illinois Press, forthcoming).

16. Louis Althusser, "Ideological State Apparatuses," *Lenin and Philosophy, and Other Essays,* trans. Ben Brewster (New York: Monthly Review Press, 1971).

17. Jacques Derrida, *The Post Card: From Socrates to Freud and Beyond,* trans. Alan Bass (Chicago: University of Chicago Press, 1987).

18. Marie-Monique Huss, "Pronatalism and the Popular Ideology of the Child in Wartime France: The Evidence of the Picture Postcard," in *The Upheaval of War: Family, Work, and Welfare in Europe, 1914–1918,* ed. Richard Wall and Jay Winter (New York: Cambridge University Press, 1988), 359.

19. Theodor W. Adorno, "Cultural Criticism and Society," in *Prisms,* trans. Samuel Weber and Shierry Weber (Cambridge, Mass.: MIT Press, 1981), 34.

Chapter 13: O'Brian

The initial version of this chapter was delivered as a paper at the Editing (Out) the Image symposium, University of Toronto, on November 7, 2003. Subsequent versions have been presented at the Central Academy of Fine Arts, Beijing; the University of Washington, Seattle; Presentation House Gallery, Vancouver; and the University of California, Berkeley. While undertaking research for the essay, I benefited from discussions with Claudia Beck, Iain Boal, Richard Cavell, Mark Cheetham, Elizabeth Legge, Carol Payne, and Jeremy Borsos. Jeremy Borsos also located many of the images. For some years, I have taught courses on postwar photography at the University of British Columbia, and I am indebted to students for contributions to my ideas, especially Juan A. Gaitán, Angela Johnston, Peter Mintchev, and Kate Steinmann.

1. The United States also considered using nuclear weapons in Korea in 1950. When President Harold Truman was asked by Merriman Smith of the United Press whether the atomic bomb was under consideration, he replied: "Always has been. It is one of our weapons." Quoted in Paul Boyer, *Fallout: A Historian Reflects on America's Half-Century Encounter with Nuclear Weapons* (Columbus: Ohio State University Press, 1998), 35.

2. President Dwight Eisenhower, quoted in Stephen E. Ambrose, *Rise to Globalism: American Foreign Policy Since 1938* (New York: Penguin Books, 1988), 147. The information in this paragraph is drawn from John Wilson Lewis and Xue Litai, *China Builds the Bomb* (Stanford: Stanford University Press, 1988), as well as from Ambrose.

3. John Foster Dulles, quoted in Ambrose, *Rise to Globalism,* 148.

4. Senator Henry Jackson, quoted by Joseph C. Harsch, "John Foster Dulles: A Very Complicated Man," *Harper's Magazine,* September 1956, 27.

5. The Bush administration's preparedness to use nuclear weapons in war is consistent with the policies, stated or unstated, of all post-1945 administrations. In 1954, Vice President Richard Nixon summarized the policy: "Rather than let the Communists nibble us to death all over the world in little wars, we would rely in the future primarily on our massive mobile retaliatory power, which we could use at our discretion against the major source of aggression at times and places that we could choose." Quoted in Gwynne Dyer, *War,* rev. ed. (New York: Random House, 2004), 300.

6. George Monbiot, "Playing the Tin Soldier," *Guardian Weekly,* October 23–29, 2003, 13. Monbiot calculated that the U.S. federal government in 2003 would spend $553 billion on the military and war machinery, equal to the total spending on "education, public health, housing, employment, pensions, food aid and welfare."

7. For Joan Didion, the Hoover Dam has an emotional resonance other dams lack. She refers to "a plaque dedicated to the 96 men who died building the first of the great high dams." The plaque states: "They died to make the desert bloom." Joan Didion, *The White Album* (New York: Simon and Schuster, 1979), 198.

8. Robert Frank, *The Americans* (New York: Scalo, 1995). The book was first published in 1958 in France, and then a year later in the United States.

9. Sarah Greenough, "Fragments That Make a Whole: Meaning in Photographic Sequences," in *Robert Frank: Moving Out,* ed. Sarah Greenough and Philip Brookman (Washington, D.C.: National Gallery of Art, 1994), 96–97.

10. Nathan Lyons, ed., *Toward a Social Landscape* (New York: Horizon Press, 1966).

11. *Hoover Dam, Nevada* was published in Robert Frank's *The Lines of My Hand* (New York: Lustrom Press, 1972).

12. Even though the archive is, as Pierre Nora says in "Between Memory and History," *Representations* (Spring 1989): 8, "the deliberate and calculated secretion of lost memory…a secondary memory, a prosthesis-memory," I am conscious of Allan Sekula's warning that archival memory insistently reproduces dominant cultural norms, even when broken up and reordered. "The Body and the Archive," *October,*

no. 39 (Winter 1986).

13. See, e.g., Sandra S. Phillips, "To Subdue the Continent: Photographs of the Developing West," in *Crossing the Frontier: Photographs of the Developing West, 1949 to the Present* (San Francisco: San Francisco Museum of Modern Art, 1997), 39.

14. Peter B. Hales, "The Atomic Sublime," *American Studies* 32 (Spring 1991): 5–31. Hales does not refer to *Hoover Dam, Between Nevada and Arizona* directly, but he is certainly aware of it. He draws on the work of Vincent Leo, "The Mushroom Cloud Photograph: From Fact to Symbol," *Afterimage* 13 (Summer 1985): 6–12, which devotes several paragraphs to the photograph.

15. Leo, "Mushroom Cloud Photograph," 11.

16. W. T. Lhamon Jr., *Deliberate Speed: The Origins of a Cultural Style in the American 1950s* (Washington, D.C.: Smithsonian Institution, 1990), 125. Lhamon stopped short of transforming the shelf on which the postcard rack stands into a theater stage, as I am inclined to do.

17. Jacques Derrida, *The Post Card: From Socrates to Freud and Beyond,* trans. Alan Bass (Chicago: University of Chicago Press, 1987). Derrida wrote about nuclear weaponry and the arms race a few years earlier in the article "No Apocalypse, Not Now (Full Speed Ahead, Seven Missiles, Seven Missives)," *Diacritics* 14, no. 2 (1984): 20–31. There he describes nuclear weapons as *fabulously textual*" (his emphasis) because more than the weaponry of the past, their making and use depend so much on "structures of language, including non-vocalizable language, structures of codes and graphic coding" (23).

18. Walker Evans, "Test Exposures: Six Photographs from a Film Manufacturer's Files," *Fortune,* July 1954, 80.

19. Sally Stein, "The Rhetoric of the Colorful and the Colorless: American Photography and Material Culture Between the Wars" (Ph.D. diss., Yale University, 1991). A revised version of Stein's study is forthcoming.

20. Joyce Nelson, *The Perfect Machine: TV in the Nuclear Age* (Toronto: Between the Lines, 1987), 118.

21. Ibid., 134.

22. Stephen Hilgartner, Rory O'Connor, and Richard Bell, *Nukespeak: Nuclear Language, Visions, and Mindset* (San Francisco: Sierra Club, 1982), 75.

23. Frank, quoted in Greenough and Brookman, *Robert Frank,* 54.

24. Marshall McLuhan, *Understanding Media: The Extensions of Man* (New York: McGraw-Hill, 1964), 339.

25. Scott McQuire, *Visions of Modernity: Representation, Memory, Time, and Space in the Age of Cinema* (London: Sage, 1998), is insightful on the relationship of photography to modernity.

26. Michael Light, *100 Suns: 1945–1962* (New York: Alfred A. Knopf, 2003), n.p. All but twenty-two of the photographs in the book were made by photographers in the U.S. Army Signal Corps, and most were the work of the 1352nd Photographic Group of the U.S. Air Force.

27. Robert Del Tredici's book *At Work in the Fields of the Bomb* (Vancouver: Douglas and McIntyre, 1987) contains documentation, photographs, and interviews of the kind that Hollywood is rarely able to provide.

28. Sharon DeLano, "On Photography: Darkness Visible," *New Yorker,* October 6, 2003, 90.

29. See Peter Goin, *Nuclear Landscapes* (Baltimore: Johns Hopkins University Press, 1991); Jock Reynolds et al., *Emmet Gowin: Changing the Earth* (New Haven: Yale University Press, 2002); Richard Misrach and Myriam Weisang Misrach, *Bravo 20: The Bombing of the American West* (Baltimore: Johns Hopkins University Press, 1990); and *The Atomic Photographers Guild: Visibility and Invisibility in the Nuclear Era,* exh. cat. (Toronto: Gallery TPW, 2001), which includes the work of thirteen

photographers.

30. The Edgerton estate released the photographs for an exhibition in New York City, *After and Before: Documenting the A-Bomb,* in 2003. James Elkins's essay for the catalogue is republished as an article, "Harold Edgerton's Rapatronic Photographs of Atomic Tests," *History of Photography* 28, no. 1 (2004): 74–81.

31. Scott Kirsch, "Watching the Bombs Go Off: Photography, Nuclear Landscapes, and Spectator Democracy," *Antipode* 29, no. 3 (1997): 229.

32. Jack Aeby was at base camp, about five and a half miles from ground zero, when he made four photographs of the blast. Three of the photographs, shot with a 35 mm camera and using the Anscochrome color process, turned out successfully. Joy Mitchell, "The Legacy of the Bombs," Australian Broadcasting Corporation, 1997. http://www.abc.net.au/science/slab/radiation/story.htm.

33. J. Robert Oppenheimer, as quoted by Light, *100 Suns,* n.p.

34. William L. Laurence, quoted by Spencer R. Weart, *Nuclear Fear: A History of Images* (Cambridge, Mass.: Harvard University Press, 1988), 101.

35. I. F. Stone, *The Haunted Fifties* (New York: Vintage, 1969), 120.

36. Office of the Historian, Joint Task Force One, *Operation Crossroads: The Official Pictorial Record* (New York: William H. Wise and Co., 1946), 215.

37. Hales, "Atomic Sublime," 5.

38. Ibid., 8.

39. Kirsch, "Watching the Bombs Go Off," 236–37.

40. *Operation Crossroads,* 73.

41. Ibid.

42. Bill Keller, "The Second Nuclear Age," *New York Times Magazine,* May 4, 2003, 48–53, 84, 94, 101–2.

43. Jesse Helms, quoted by John Pilger, "Brothers at Armageddon," Web article posted by iboal@socrates.berkeley.edu, August 14, 2003.

44. Condoleezza Rice, quoted by Pilger, "Brothers at Armageddon."

45. Weart (*Nuclear Fear*) exhaustively charts nuclear debates and "mentalities" in the United States from 1945 to the mid-1980s.

46. John Szarkowski, *William Eggleston's Guide* (New York: Museum of Modern Art, 1976), 6.

47. William Eggleston, *Los Alamos,* ed. Thomas Weski (Zurich: Scalo, 2003), 61. For an extended account of the book and the exhibition that generated it, see Shep Steiner, "Where World View and World Lines Converge: William Eggleston's *Los Alamos,*" *Fillip* 1 (Summer/Fall 2005): 1, 6–7.

48. Jumbo cards produced by Mike Roberts Color Production were 6 x 9 in. and regular cards were 3½ x 5½ in.

49. "Public Relations Conference Concerning Mercury," December 20, 1950, office memorandum, U.S. Government, DOE 29360, quoted in Kirsch, "Watching the Bombs Go Off," 231.

50. The incident is related in Nelson, *Perfect Machine,* 128.

51. A postcard is never readily decipherable. A postally used card is a complex semiotic carrying a surplus of imagery—recto picture, verso postage stamp—combined with textual legends and handwritten messages. The signs are often at odds with one another.

52. See Thomas H. Saffer and Orville E. Kelly, *Countdown Zero* (New York: Putnam, 1982). At some of the Nevada tests in the 1950s, soldiers were positioned less than three miles from ground zero.

53. Susan Stewart, *On Longing: Narratives of the Miniature, the Gigantic, the Souvenir, the Collection* (Durham: Duke University Press, 1993), 132–39.

54. My colleague Jeremy Borsos found the image on eBay, stamped with a Signal Corps stock number (C-7047).

55. Robert Venturi, Denise Scott Brown, and Steven Izenour, *Learning from Las Vegas: The Forgotten Symbolism of Architectural Form* (Cambridge, Mass.: MIT Press, 1972)

56. Reported by Gladwen Hill in an article, "Watching the Bombs Go Off," for the travel section of the *New York Times,* June 9, 1957, 43.
57. Binion's Horseshoe, www.binions.com/index1.htm, January 15, 2004. Among Benny Binion's customers were a sizable number of GI's from the Second World War.
58. See, e.g., Martin Heidegger, "The Question Concerning Technology," in *The Question Concerning Technology and Other Essays* (New York: Harper and Row, 1997); Walter Benjamin, "The Work of Art in the Age of Mechanical Reproduction," in *Illuminations,* trans. Harry Zohn, ed. Hannah Arendt (New York: Schocken Books, 1969); McLuhan, *Understanding Media;* and McQuire, *Visions of Modernity.*
59. Benjamin, "Work of Art in the Age of Mechanical Reproduction," 242.
60. William L. Laurence, "Nagasaki Was the Climax of the New Mexico Test," *Life,* September 24, 1945.
61. James Elkins has a favorable interpretation of Laurence's descriptions of atomic explosions, which is at odds with my reading of them ("Harold Edgerton's Rapatronic Photographs of Atomic Tests," 77).

Chapter 14: Van Laar

1. See the background image for fig. 14.5.
2. Two of the most important postcard genres are views ("topographicals") and types (ethnic, racial, and gender). I am only focusing on the former.
3. This is how postcards of motels work so well as advertisements. Enhancing their status as a souvenir, they are playing off of the standard role of postcards as images of important things.
4. Ellen Handy, "Postcard Sublime: William Henry Jackson's Western Landscapes," in "From Albums to the Academy: Postcards and Art History," ed. Jordana Mendelson, special issue, *Visual Resources* 17, no. 4 (2001): 423.
5. I recognize that these things can be both a subject matter and an implied attitude toward a subject matter. There are certainly more than these four. Two much less grand examples are the antique and the pastoral. A less common but related approach incorporates graphic design elements, particularly the glitzy tropes of advertising, to create idealized postcard images that represent all-out consumerist fantasies. These images most often represent cities or beaches.
6. For example, in *French Letters,* the clichés create a very melodramatic narrative of two lovers, one burning her letter, the other clasping it to his heart. But this

gameboard image can also be read as an accretion of postcards that themselves act as markers of sending and receiving.
7. Susan Stewart, *On Longing: Narratives of the Miniature, the Gigantic, the Souvenir, the Collection* (Baltimore: Johns Hopkins University Press, 1984), 135.
8. Ibid., 23.
9. My use of the term *boring* is not the same as its use in Martin Parr's book *Boring Postcards*. The book lacks a clear statement of what is meant by the term. In fact, many of the cards do not seem boring as much as they seem amusingly kitschy or nostalgic. And many of them seem to be (purported) mistakes of subject resulting in the ironies of the (supposedly) trivial made important. Martin Parr, ed., *Boring Postcards USA* (London: Phaidon, 2000).
10. Earlier in this essay, I noted that the sublime was one of the standard rhetorical moves of scenic postcard art aspirations. The uncanny developed out of Burkean notions of the sublime, where that terror of the infinite becomes a modern anxiety of the unfamiliar. It would be interesting if failed postcards would offer their unfamiliarity in a rhetorically interesting way as, say, estrangement. Unfortunately, they give us none of the anxious pleasures of the sublime or the uncanny. They're just ordinary.
11. Norman Bryson, *Looking at the Overlooked: Four Essays on Still Life Painting* (Cambridge, Mass.: Harvard University Press, 1990), 61.
12. Ibid., 87.
13. Ibid.
14. Ibid., 88.
15. For a discussion of how this authenticity and innocence are used in outsider art, see Leonard Diepeveen and Timothy Van Laar, *Art with a Difference: Looking at Difficult and Unfamiliar Art* (Moutain View, Calif.: Mayfield, 2001), 64–92.

ARCHIVO DE CARTEROS · RECIBIDO ·
HABANA ENE 10 1908

AMSTERDAM
-8. 1.08.11-12 N

Angelita y Eloisa Bousq

Manrique 56

Habana